DICTIONARY OF
GLASS

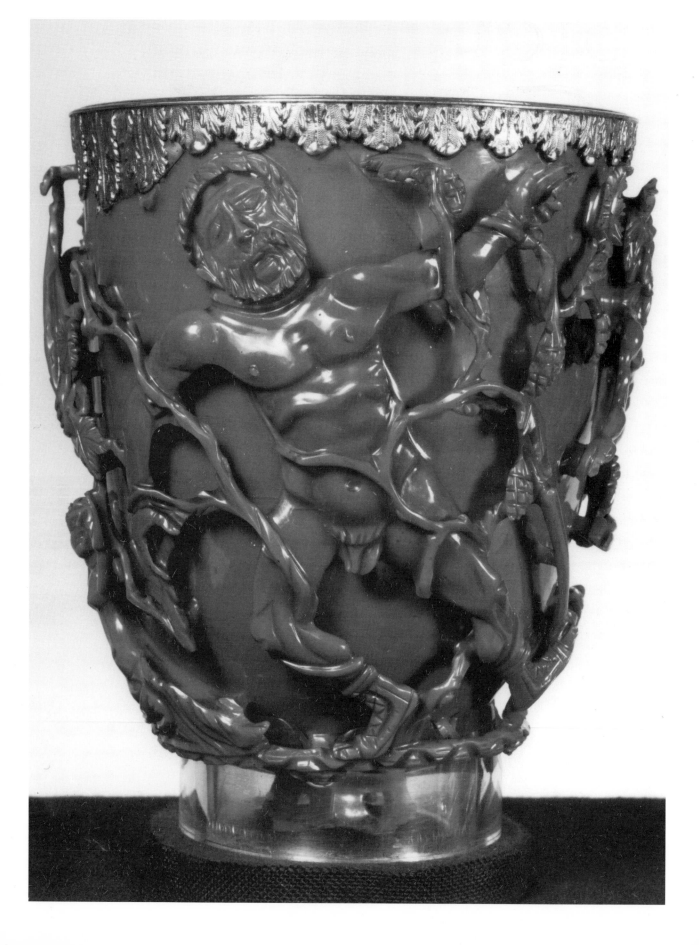

DICTIONARY OF
GLASS
MATERIALS AND TECHNIQUES

CHARLES BRAY

A & C Black • London

University of Pennsylvania Press • Philadelphia

First published in Great Britain 1995
A & C Black (Publishers) Limited
35 Bedford Row, London WC1R 4JH

ISBN 0 7136 4008 1

A CIP catalogue record for this book is available from the
British Library

First published in the USA by University of Pennsylvania
Press, 423 Guardian Drive, Philadelphia, PA 19104

ISBN 0-8122-3357-3

Typeset in Linotron 9$\frac{1}{2}$ on 11$\frac{1}{2}$ pt. Palatino by
Falcon Oast Graphic Art, Wallington, Surrey.
Printed and bound in Great Britain by
Butler and Tanner Ltd, Frome, Somerset

Frontispiece
The Lycurgis Cup. This is a cup made from green glass with a
mainly open work frieze. It shows the effect of colloidal disper-
sion to good effect as it changes to a wine colour when viewed
by transmitted light. It depicts the death of Lycurgus and dates
from the 4th century BC. *Photograph by courtesy of the British
Museum.*

CONTENTS

55-97 chem/DC

LIST OF COLOUR PLATES

PREFACE

This book is intended to be a source of reference for individuals operating in small glass workshops and studios, and teachers and students. It concentrates on the fundamentals and gives the necessary background information on the materials, processes and techniques relating to glassmaking, particularly emphasising those affecting individual glassmakers and small group enterprises.

It should be possible to use the book both for individual study and as a source of quick reference. It is therefore presented as a dictionary of key words and phrases which proceed to short articles. Related articles are cross referenced. As far as possible, the language has been left simple and non-technical and has been accompanied by numerous illustrations. Scientific and technical information has been limited to that considered to be necessary to provide a basic understanding of glass processes and developments. Temperature conversions from°C to °F have been rounded to convenient figures.

The book is intended to be a companion book to *The Potter's Dictionary of Materials and Techniques* by Frank and Janet Hamer and the format is similar. Ceramics and glass share many common source materials and many similar functions. They differ considerably in making processes and in the fact that ceramics relies heavily on the behaviour and characteristics of crystalline forms whilst glass evolves from crystalline materials but becomes an amorphous non-crystalline solid. Nevertheless, there is a fascinating relationship between the two materials which frequently emerges simply as a totally different change of emphasis or usage.

To most people, glass seems to be a very common and simple material. In many ways this is so as it can be made in the most basic circumstances from very simple and plentiful materials. It is also produced in great quantities by the glass industry, particularly for windows and containers. In fact, it can be most complex. It has a technology which is constantly developing and embracing more and more aspects of material science. Despite its apparent simplicity, it constantly throws up its own problems. Whenever a definition of its behaviour is made, there is almost always some exception or proviso to the rule. This is part of its fascination and to most people operating with glass there is a constant challenge and a need to be aware that the material does present a degree of unpredictable behaviour. This can be apparent both in the studio and in the most highly developed industrial situations.

The book by Frank and Janet Hamer has been a constant source of reference both in its content and in the manner of its presentation. The other major sources of information have been the various journals of the Society of Glass Technology and the book, *Conservation of Glass* by Roy Newton and Sandra Palmer which moves considerably outside the limits which might be suggested by its title and is a wealth of information on many aspects of glass and glassmaking.

I am indebted to the late John Stirling FSGT for the provision of various notes and information on glass structure and its basic chemistry.

I must also express my gratitude to the various people who have been kind enough to read and to check the text, to offer corrections and to provide additional material, in particular, to John Henderson FSGT who has covered the technology and to Vincent J. Craven who, with great patience and application, has proofread the whole text.

ABBREVIATIONS

cm	centimetre (s)	A	Ampere
cu	cube (cubic)	At No	Atomic number
cwt	hundredweight (s)	AW	Atomic weight
fl oz	fluid ounce (s)	BS	British standard
ft	foot – feet	°C	Degrees Centigrade or Celsius
gall	gallon (s)	CF	Conversion factor
gm or g	gram (s)	D	Density
Imp	imperial measure	EMF	Electromotive force
in	inch (es)	°F	Degrees Fahrenheit
kg	kilogramme (s)	H	Hardness on Mohs' scale
l	litre(s)	Hz	Hertz
lb	pound (s)	J	Joule
lm	lumen	°K	Degrees Kelvin
lx	lux	MF	Molecular formula
m	metre (s)	MW	Molecular weight
ml	millilitre (s)	N	Newton
mm	millimetre (s)	SG	Specific gravity
mol	mole	UK	United Kingdom
oz	ounce (s)	US or USA	United States of America
pt	pint (s)	V	Volts
qt	quart (s)	W	Watts
s	second (s)		
wt	weight		
yd	yard (s)		

A

Abrasion The technique of using wheels to cut shallow decorative areas in glass. It also refers to the process of using hard particles and stones in various ways to cut or matt the surface of glass or to shape glass objects.

Abrasive belts (linishers). These came into use in the early 1950s when suitably waterproof adhesives became available and enabled the grits to be glued successfully to a linen base. Early belts suffered initial problems in finding a method of joining a length into a suitable loop which could be fitted to, and which would not wander on, the pulleys in use. At first, the problem was solved by joining the belt with a diagonal cut which at least eased the other problem of a thick ridge travelling around and hitting the glass. The ridge still existed but the fact that it was now diagonal seemed to have the effect of reducing the impact. Many ready-made belts are still joined in this way with the overlapping ends suitably thinned to avoid the formation of a ridge. Latterly, belts have been joined with a system of interlocking fingers. Belts are now available in a wide range of sizes and grits, and cork belts are also available for polishing purposes.

Early machines were mostly massive affairs meant to take over or to complement the role of the horizontal grinding mill in factory production. However, currently several manufacturers make relatively small machines ideally suitable for studio production. Another recent development is the belt which is faced with diamonds and fits on to a circular rubber wheel which can either be given its own horizontal shaft or fitted on to a glass-cutting lathe. This is an admirable tool as it can be used at speed, it cuts very quickly and, because of the rubber

Linisher belts showing methods of joining.
a. Diagonal joints introduced to reduce the knocking effect produced by the old type of right angled joint.
b. The interlocked finger joints used in most modern belts.

backing, has sufficient flexibility to be less likely to damage the glass than the hard, abrasive-type of wheel.

Abrasive water jet systems. The use of water jet cutting systems has increased dramatically in recent times. They offer considerable advantage in the rapid cutting of complex shapes and are readily adapted to industrial production methods. They will cut glass of considerable thickness and one company quotes the successful cutting of glass blocks 12 inches (30 centimetres) thick. The aspect that would interest most artists is that the cutting angle need not be at the standard 90° and can be varied to produce almost any angle of cut. They are very useful in cutting other materials and can be readily used for cutting most refractory materials.

If abrasive particles are fed into the water stream as it leaves the nozzle, the system then uses the water as a driving force rather than as the cutting medium and the possibilities are enhanced.

Garnet is the abrasive most commonly used but combinations of silica sand and olivine, which are rather cheaper and suitable for cutting glass and softer materials are also used. Hard abrasives such as silicon carbide and alumina are sometimes used for the harder refractories.

The cutting is often carried out under a thin layer of water or in sprayed water directed at the cut. This is to stop damage to the surrounding glass areas from stray fragments of abrasive.

Water jet cutting can be carried out on most materials and there is some scope for determining the finish required. Unfortunately, at the moment this is a costly operation, which is likely to be out of reach of most small workshops. As the systems develop it may, in time, become a viable and exciting possibility.

Abrasive wheels. Wheels for grinding and cutting glass were traditionally, apart from soft iron wheels which were fed with sand, made from natural stones. The Romans used such wheels (often of considerable size), which they obtained from such places as Naxos, Egypt, Crete and Armenia. They are still popular with many craftsmen but they have been largely superseded by manufactured stones and by diamond wheels. Natural stones are still quarried and are preferred by many craftsmen who tend to have particular likes and dislikes. Most of the natural stones that are quarried in Britain are exported to the USA. Particularly fine stones came from areas of Scotland and even now they are preferred by many craftsmen to the manufactured replacements, par-

Natural stone wheels.

Silicon carbide grains on wheels tend to wear under pressure whereas bauxilite grains abrade to leave a surface of fresh cutting points.

Diamond wheels are rapidly replacing other abrasive wheels. They are much more expensive than both the natural and the manufactured abrasive wheels but they cut more efficiently. They also do not require any pressure which relieves the operator of a surprising amount of strain, and apart from the occasional need to clean the surface with a corundum stick to remove embedded par-

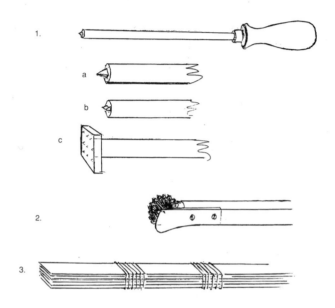

Stone dressing tools.

1. Diamond dressing tool. These can be fitted with different points as in:
 a. Common pyramid point.
 b. Chisel point.
 c. Multiple point.
2. The most common type of dressing tool composed of a series of steel discs with hardened teeth held together in a clamping handle.
3. A series of old hacksaw blades bound together with wire. This makes a cheap but effective dressing tool and is a type which has been used successfully for many years.

ticularly when they need something which will carry out a difficult or fine piece of work. There was a considerable demand for these from Germany where, to the probable and justifiable annoyance of the Scots, they were rather unfortunately, known as 'Engländer' whilst, perhaps more logically, the manufactured stones were known as 'Amerikaner'.

These artificial stones are made in the same range of materials as those of the grits and powders, namely silicon carbide (Carborundum, Urundum) and Alumina (Bauxilite, Corundum). The grain size is determined by the size of a mesh through which it will pass. For use on glass, the normal suitable range would be from 80 (Coarse) to 400 (Fine). The wheels are bonded by a variety of materials, the most common being known as 'Ceramic Bond' in which the abrasive is vitrified together with clay and similar materials. Others are bonded with resins, rubber or shellac.

The hardness of the bond is coded from 'A' (soft) to 'Z' (Hard). The grades in the centre of this range would be those normally used for glass. Wheels are stamped with a code which provides a quick identification. For instance, A 200 P V would indicate that the stone was made from alumina with a grit size of 200. The letter P would indicate a medium grade of hardness and V would show that it had a vitreous bond.

Modern wheels are manufactured to close tolerances but after being used for some time, they need to be re-profiled. This is carried out by running the wheel at a medium speed for its size against an abrasive dressing stick, or more commonly, against a diamond dressing tool. A rest for the dressing tool must be used to keep the point steady against the wheel at a level just below that of the spindle and there must be a constant flow of water or coolant running on to the wheel to provide cooling.

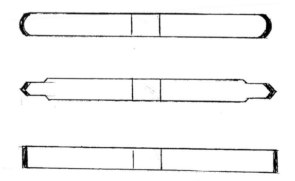

Diamond wheels showing three common profiles.

Coarse diamond wheel used for roughing out glass forms.

ticles, need little attention. In use there must be a constant and adequate supply of water, preferably including a suitable coolant. A diamond wheel consists of a metal disc to which diamonds have been sintered on to the working surface, or have been embedded in a suitable soft metal matrix. They are available in many sizes and profiles off the shelf but the manufacturers can supply wheels to a required specification very quickly.

There are statutory regulations relating to the use of abrasive wheels. These deal with the various safety aspects and are essential reading for anybody wishing to use them. Some European documents currently available are:

'Safety in the use of abrasive wheels', published by the Health and Safety Executive and obtainable from H.M. Stationery Office.
'The European Safety Code FEPA GB 12-87 for the care and protection of abrasive wheels'. Obtainable from the Universal Grinding Company of Stafford, England, who also publish an admirable small handbook called *The Grinding Data Book* which they currently supply free to applicants.

See also appendix on p. 228.

At this time (1994), the same company also offers one-day courses covering the requirements of the abrasive wheel regulations.

There are several other publications which are relevant. Some are produced by the Health and Safety

Wooden wheels. These are usually made from a diffuse porous hardwood.such as willow or poplar. Sometimes they consist of a straight slice across a bole or, more commonly, from sections glued together as shown.

The bristle wheel once popularly used with pumice for initial polishing operations.

Composite fibre wheel currently the most popular for use with pumice.

Felt polishing wheels. These are of two types: brown, coarse felt suitable for pumice and white felt which is now the most common type used for final polishing.

A paperweight cut and then polished.

Executive, some by the British Standards Institution and some by H.M. Stationery Office. They are all normally available from branches of H.M. Stationery Office.

Polishing wheels tend to be of materials which act as a vehicle for pastes containing polishing abrasives. Traditionally they were made either of bristles or of wood which was made from a slice across a log of poplar or made up from segments of the same material.

Cork wheels appeared in the late 1920s and became very popular. Initially they were cut from a segment of bark but soon progressed to being made from ground cork bonded together with waterproof glue. They are now being rapidly replaced with wheels made from polyurethane and bonded cloth but cork wheels will remain in some demand as many people still prefer them. These wheels are used mainly with applications of wet pumice which, particularly on hard glass, gives a polish adequate for most purposes. Contrary to common opinion, soft lead glass is more difficult to polish than a harder glass.

Finer polishing tends to be carried out on felt wheels using rouge (iron oxide), green chrome oxide, tin oxide, polishing grade alumina and latterly cerium oxide. Cerium oxide and commercial powders based on this material are the most popular materials for fine polishing at the current time.

Soft polishing wheels comprising rubber or silicone bonded powders are also becoming more readily available and increasingly popular. Wide discs or belts containing finely impregnated diamond dust are increasingly available as a replacement for the pumice and other materials leading up to the final polishing.

Abrasives. Materials for grinding and polishing stones and metal have been used almost since the beginnings of human existence so it was a natural progression that the same materials would eventually be used for exactly the same purpose when glass started to be produced. As glass grinding requires the use of progressively finer particles, it is remarkable that work of such wonderful quality was produced in relatively primitive times when the necessary sorting, crushing, levigating and grading of abrasives must have presented huge problems with the meagre facilities which were available. The patience and skill of many of the craftsmen must have been considerable.

Even in the early part of the 20th century sand was probably the most common grinding material. When it had been used for grinding glass, the resulting slurry was usually collected and sieved to allow for further use as a finer grinding material. The process continued until a fine mud known as polishing blue was left to be used on wooden wheels made from segments of poplar or lime for polishing purposes. We are lucky that in the present age, manufactured materials of specific quality and grade are readily and cheaply available, completely removing the need for all the hard work of preparing finer abrasives from the slurry.

The most common of these is silicon carbide, produced commercially as 'Carborundum' and 'Urundum'. It is made by heating a mixture of sand, fine coke and sawdust together with a little salt to a temperature of 2400°C (4350°F) in a long electric furnace in the form of a trough which could be more than 15 metres long and fitted with silicon carbide electrodes. The salt helps to counter the impurities in the coke and the sawdust burns out to leave a sufficiently porous mixture which will allow any gases to escape. The resulting core of silicon carbide is removed on cooling and then crushed and graded to provide a wide range of grits and powders.

The other material in common use is bauxilite. This is made by fusing bauxite, a soft, clay-like material consisting largely of alumina, in electric furnaces and then crushing and sorting it into a similar range of grits and powders.

There are conflicting opinions on the relative merits of the two materials but most craftsmen soon establish a personal preference. One advantage of bauxilite, a white powder sometimes sold as alumina, is that it does not become so obvious as silicon carbide which is black or dark grey when it becomes trapped in cracks and crevices. Also, if silicon carbide is not thoroughly cleaned from glass which is used for casting or fusing, it can cause discoloration, bloating and localised reduction.

Diamond is the hardest abrasive currently available. It is normally used on wheels or specific tools but finds occasional use as a powder.

Boron nitride and boron carbide are very hard. They are recent additions to the list of abrasives and they tend to be used on wheels and rarely as powders.

Corundum is a naturally occurring impure form of alumina known generally as 'Emery'.

Mohs' scale of hardness is often used as a table of comparison for abrasive materials and is based on the ability of a material to scratch the surface of those lower down the scale. See **Mohs' scale**.

Another scale which refers to the penetration hardness of a material is one which is becoming more popular in relation to the use of abrasives. It is as follows:

Material	Hardness
Diamond	8000
Borazon (cubic boron carbide)	4700
Boron carbide	2750
Silicon carbide	2500
Titanium carbide	2450
Alumina	2100
Tungsten carbide	1900
Garnet	1350
Silica	800

Finer abrasives are used at the polishing stage. The most common of these are:

Pumice	A form of volcanic ash.
Tripoli	A siliceous earth which breaks down to finer particles under pressure.
Rouge	Fine iron oxide made from decomposed iron sulphate.
Ceri-rouge	A composite, commercially-prepared material containing both cerium oxide and iron oxide.
Chrome oxide	Often used together with rouge.
Zirconium, tin and magnesium oxides	Used for finer polishing.
Cerium oxide	Used for extremely fine polishing.

Pumice is a natural form of foamed volcanic glass and most of it is imported from the Lipari Islands, north-west of Sicily. It is available in various grades from rough, which is used on wooden wheels for pre-polishing, to fine and very fine grades which will achieve a bright polish on hard glass. It is composed of approximately 70% silica, 15% alumina and the remainder of sodium and potassium oxides.

Tripoli powder was for a long time the material normally used to follow the application of pumice. It is very fine and can produce the various health problems associated with siliceous dust so nowadays it is largely replaced with polishing grade alumina.

There are several manufacturers who produce specific ranges of prepared polishing powders largely based on cerium oxide and containing appropriate suspension agents. These are rapidly taking the place of the natural grits. Cerium oxide reacts chemically with silica molecules on the glass surface. This interaction between the polishing wheel and the powder causes the surface to deform plastically.

Glass grinding and polishing is essentially a wet process because of the dangers inherent in generating heat in the glass. Various grits for grinding are used mainly on wide, horizontally rotating cast steel wheels or in shallow reciprocating cast steel pans. The water also ensures that problems of dust are minimal. Polishing powders are also used wet but they are usually applied to the wheels in the form of a wet slurry. This again minimises the dust problem but particular care should be taken with Tripoli powder as this is siliceous and an appropriate mask should be worn when handling the dry material. An efficient exhaust system is also recommended.

A recent innovation in the process of using abrasives has seen the introduction of very high pressure water jets, sometimes fed with abrasive powders, for the cutting of thick glass sheets. This system has an advantage in that it can be used to cut glass at any angle.

Absorbent. Material which can take in liquids by capilliary action.

Absorption. The taking up of a gas by a liquid or the taking up of a liquid by a solid. Absorption is different from

adsorption in that the adsorbed material penetrates most of the absorbing substance.

Accelerator. A material which speeds up a chemical action. In some circumstances it can act as a catalyst. Often used in mixtures of epoxy resins to hasten the setting times.

Acid. Glassworkers tend to think of acid as referring to the material used for acid etching. Chemically, it is a compound which has a tendency to lose (donate) positive electrical charges called protons (i.e. hydrogen ions) when it reacts chemically. It can react with various non-acidic materials (alkalis and amphoterics) to form salts.

Silica and boric oxide are technically bases and are sometimes noted as being weak acids in the founding process.

Glass has good resistance to many acids, the obvious exceptions being those of phosphoric acid (H_3PO_4) and hydrofluoric acid (HF) which readily eat into the surface of most glass and as a result are used for both etching and polishing.

Acid cut back. This is a term used to describe the process of producing designs in relief by etching away some of the glass with hydrofluoric acid. See **Acid etching**.

Acid etching (acid embossing). This process involves the use of hydrofluoric acid or various mixtures containing or derived from hydrofluoric acid. It cannot be over-emphasised that this is an extremely dangerous material for which the most stringent safety precautions are mandatory. It is certainly not an appropriate material for casual use in a studio. This acid attacks both flesh and

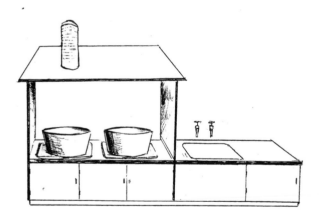

An acid etching compartment suitable for the small studio. It comprises a cabinet fitted with doors (not shown) which can be closed between operations whilst the acid is in its container, two plastic containers including one for acid and another for water, both set into splash trays and an extractor system. Outside the compartment there should be a sink with good washing facilities and a container with a suitable alkaline neutralising solution. Lockable storage cupboards could be situated under the working area.

bone. It moves into the flesh and whatever is applied to counter it often only succeeds in following its path. It also releases fumes which are both toxic and corrosive.

It may be difficult to understand such a strong emphasis on the dangers when it is obvious that huge amounts of etched glass, some of it astonishingly complex and beautiful, have been produced over the years. Much of this is bound to suggest exciting possibilities to glassworkers, many of whom are bound to be tempted to explore them. Some, like Ann Wolff will produce wonderful work and the example of such results can only increase the temptation to other artists to follow her lead. If there is a decision to proceed on an experimental basis or if the number of articles to be etched is small, it could be advantageous to do all the preparation in the studio and then to pass the glass on to a specialist firm for processing. To proceed individually towards establishing a continuing production, it becomes essential to ensure that the studio is comprehensively equipped with professionally-made extraction facilities, including a hood over the etching area to remove corrosive fumes, plastic trays, wide-mouth plastic containers for the acid and suitable storage and working facilities. A plastic ladle is useful but if a metal one is all that is available it should only be used if it is first coated with wax.

It is also essential to check the latest safety recommendations with the appropriate authority, to work slowly and deliberately and to proceed with some caution. Good washing-down facilities, full protective clothing including boots and face mask together with a recommended alkaline neutralising solution in case of accidents are essential.

One of the problems with acid etching is that different recipes are used on different glasses. That which gives a polished finish on one type of glass may only succeed in matting another. As a general rule, four parts of water to one of 60% strength hydrofluoric acid will give a good working etch with time to control the depth achieved. However, for really deep etching, called 'Rotting' in the trade, two parts of water to one of HF (hydrofluoric acid) is usual. It is important to add the acid to the water and never the other way round. The mixture of one part of acid to four parts of water should achieve a depth of approximately 1.5 mm in two hours. A recipe from Scandinavia suggests the use of three parts hydrofluoric acid (60%), five parts of water and one part of sulphuric acid (90%).

If a matt surface is required then there are other possibilities. Various finishes were commonly applied to electric light bulbs. One of the solutions which is used for producing a satin matt etch on soda-lime glass is:

hydrofluoric acid (60%)	1.0 kg	Alternatively	2 lb
ammonium bifluoride	0.2 kg		6 oz
sulphuric acid (95%)	0.2 kg		6 oz

Another for pearl etch is:

hydrofluoric acid (60%)	550 g		20.0 oz
ammonium bifluoride	400 g		14.5 oz

ammonium carbonate	200 g	7.3 oz
hydrated lime	75 g	2.7 oz
sodium carbonate	75 g	2.7 oz

The procedure followed for light bulbs is as follows: The glass is washed with hot water. The etching mixture is then sprayed on or the glass is dipped into the solution and allowed to stand for about 20 seconds before further washing in hot water.

The process for producing decorative etching on glass usually involves the use of resists or stencils. The resists most commonly used are based on mixtures of beeswax and resin but there are many variations. One recipe for a brushing resist suggests the use of equal parts of paraffin wax and motor oil kept warm on a hot plate to maintain a consistency that allows the mixture to be brushed easily to a fine edge. The usual procedure is to dip heated glass into molten resist mixture and when this has set, to scrape away the wax to expose the glass surface where the etched area is required. Some cleaning of the exposed surface may be required and this can be carried out by the careful use of white spirit or similar solvent. Once this preparation is complete the glass is immersed in the hydrofluoric acid until the requisite amount of attack is achieved. The depth and type of finish would relate to the strength of the acid, the temperature, the type of glass and the length of the immersion. It is also common practice then to remove more of the resist, to repeat the procedure to produce varying depths and types of finish.

Many glass artists using acid are concerned with the process of etching through layers of underlaid or overlaid colour on bowls, bottles etc. When etching underlaid bowls (with the thin layer of the colour on the inside), it is simply a matter of filling up the bowl to the required level with the acid, leaving the acid to work for an appropriate time, removing the acid and rinsing off to ascertain the depth achieved and then repeating the process as necessary until the result is satisfactory. Overlaid pieces need to be placed in a plastic container and sealed as necessary to prevent the acid reaching the inside areas. Then the plastic container is filled with the acid to the necessary level, and the removing, rinsing, checking and repeating stages carried out as before.

The resists in general use are of three types: those based on wax, those based on liquid bitumen and those based on lead foil. The wax resist is normally a simple mixture of beeswax stiffened as necessary by adding some resin. Softer mixtures are achieved by adding tallow, lard or as suggested earlier, oil. Some artists have experimented successfully with painted PVA-type adhesive solutions and paints and there is an increasing use of the various types of cling film and fablon.

There are lots of old resist recipes about as the various workshops producing decorative etching all had their own distinct formulae. These almost always involved the use of various waxes, tallow, pitch and sometimes resin. Occasionally some pigment such as brunswick black would be included to make the work of scraping away

the resist clearer. Variations in the resist would exist in the same shop to allow for the nature of the application. Some glass would be dipped. Sometimes the resist would be brushed on and there would be a different recipe used simply for re-touching a resist. A typical recipe for a dipping resist is:

1.0 lb or 450 g	Russian tallow
1.0 lb or 450 g	Burgundy pitch
4.5 lb or 2.25 kg	Madagascar wax
4.5 lb or 2.25 kg	White wax

When a painted resist was required, it was normal to use a solution of bitumen which was brought to the desired consistency by adding sufficient solvent consisting of white spirit or turpentine to the thick and sticky material to make the bitumen sufficiently fluid for it to be applied as a paint. If used today some practice is needed in the application of this mixture. Good brushes are essential. The results from the freedom of expression which can be achieved by the skilled use of this method can be most rewarding.

Large-scale and very precise work was often carried out by adding a layer of thin lead foil. The procedure for using this is a little more complex and involves covering the glass with an even layer of bitumen. A piece of lead foil sufficient to cover the design is then coated with a layer of soft wax and placed wax side down on to the bitumen so that it can be rubbed down with a muller or smooth wooden block until it is completely and evenly attached. The design can then be transferred to the foil which can be cut and the waste lead removed as necessary and in appropriate sequences to achieve the required results. Again, some practice is necessary to produce an even layer which will adhere to the glass but which will allow parts to be peeled off cleanly after the design has been cut.

After cutting and when the pieces have been removed, it is usual to burnish the edges of the cuts slightly to prevent seepage and to clean the surface of the glass with white spirit to remove any residues of wax or bitumen on the surface to be attacked. Some degreasing can be carried out if necessary and when complete, the glass immersed in the acid.

Etching cream is much easier to use than the hydrofluoric acid mixtures for occasional work and with no free hydrofluoric acid involved, much safer. It is still a toxic material and requires careful handling but the viscosity is such that the dangers from splashing are unlikely. The use of this material produces what is known as 'White Etching' or 'French Embossing' and one popular formula is:

ammonium bifluoride	1 kg alternatively	2.25 lb
sugar	1 kg alternatively	2.25 lb
barium sulphate	125 g alternatively	4.5 oz
demineralised water	1 l alternatively	1.75 pt

The sugar in this recipe is included to increase the viscosity of the mixture. A common name for this mixture is

'Sugar Acid'. It is available commercially prepared as gel in tube form and, as it works slowly, it is fairly easy to control. Again, as the danger from splashing is negligible because of its viscosity, it is very much safer to use than the various etching acids based upon hydrofluoric acid.

A variation on sugar acid is a recipe which was commonly used for etching designs or names on to drinking glasses in the process known as badging. This involved preparing what was called 'Fluorine Liquid' by filling a plastic jar or bottle with ammonium bifluoride crystals and then pouring in hydrofluoric acid (40%) to a level just above the top of the crystals. This was shaken gently for a few minutes before being left to stand for about two days. A second mixture was then made, known as gum tragacanth mixture. This involved mixing together:

7 g	or	0.25 oz of charcoal or lamp black
170 g	or	6 oz of gum tragacanth
114 g	or	4 oz of ammonium hydroxide (specific gravity 0.880)
280 g	or	10 oz of water

This was put into a jacketed saucepan and simmered gently until reduced to about half its volume.

The badging paste was then made by putting into a wooden or plastic bowl two ounces of powdered rice starch and slowly adding two ounces of the fluorine liquid described above. This was mixed with a spatula until the whole was quite stiff and had a smooth surface. To this was then added one and a half ounces of the gum tragacanth mixture and the whole stirred again until it was smooth. One tenth of an ounce of magnesium oxide was added, stirred in well and left to stand for about an hour. Ten cubic centimetres of ammonium hydroxide was then added, stirred in and the whole mixture thoroughly stirred again before being stored for use.

This badging mixture was used by scraping it into a design engraved onto a copperplate and transferred by a thin piece of acid-free paper to the glass surface. This produced an etched design in about a minute. If the mixture became too stiff in storage it would be thinned by adding a jelly made by mixing together two ounces of sodium hydroxide (specific gravity 0.880), four ounces of water and one ounce of gum tragacanth, the whole being stirred thoroughly and stored for use. See also **Graal**.

Acid polishing. When glass is attacked by hydrofluoric acid, the surface is usually left fairly transparent whilst the various etching mixtures tend to produce some matting. Some variation in the finish on a piece of work can often be produced by matting a complete area, applying a suitable resist to the areas to be left matt and then immersing the piece in polishing acid to give a bright polished finish to the unprotected areas. The usual proportions for polishing acid in Britain are:

demineralised water	3 parts
sulphuric acid (95%)	2 parts
hydrofluoric acid (60%)	2 parts

Acid polishing became very popular with the producers of cut glass as its use meant that lots of time and effort previously spent on hand and mechanical polishing was saved. It is now the normal procedure in industry for polishing cut glassware and a few artists use it to soften a sandblasted surface. A very light application is usually all that is necessary to produce a fine matt finish which is easier to clean than an ordinary sandblasted surface.

In British industry the normal procedure is to use a short immersion in the strong polishing mixture as outlined above whereas in Continental Europe the usual practice has been to use a series of immersions gradually becoming more prolonged, in a much weaker solution. The initial immersion would be for about 5 seconds and followed by a 30 second rinse in a water bath kept about 10°C hotter than that of the acid. This would then be followed by further immersions, the last one being for about one and a half minutes; all the immersions being followed by the same 30 second rinse. The glass would be kept moving whilst in the acid and thoroughly washed on completion.

Polishing acid needs to be at a temperature of at least 40°C (104°F) to be effective.

There has recently been a move to use fluorosulphonic acid as a regenerating acid for the polishing of lead crystal. In industry where there is sufficient production to justify it, there has been a move to introducing lasers for polishing glass.

Acid stamping. The use of a stamp to produce a logo or trademark on glass by the use of etching acid.

Acidic oxides. In glassmaking these are usually considered as those which display acidic properties in the founding process. They are:

silica	(SiO_2)
phosphorous pentoxide	(P_2O_5)
boric oxide	(B_2O_3)
titania	(TiO_2)
tin oxide	(SnO_2)
zirconia	(ZrO_2)
ceria	(CeO_2)
vanadium oxide	(V_2O_5)
germania	(GeO_2)

others with weak acidic properties are:

antimony oxide	(Sb_2O_3)
arsenic oxide	(As_2O_5)
praseodymium oxide	(PrO_2)

Aciding. A term used by stained glass artists to describe the process of using hydrofluoric acid to eat through layers of flashed glass. The result is similar in effect to that of the 'Graal' technique used mostly on blown glass forms. In addition to the removal of whole areas of the flashed colour, it is also used to thin the layer sufficiently to produce variations in tone.

A leaflet *Hydrofluoric acid and you* is available free from:

H.S.E. Public Enquiry Point
Maynards House
1 Chepstow Place
London W2 4TF, UK

Adhesives. Opinions vary on the use of adhesives in producing studio glass pieces. The purists suggest that all work should be fused together rather than glued whereas others maintain that this is simply an unreasonable restriction on possibilities as both methods produce entirely different qualities. It would, of course, be virtually impossible to fuse glasses of widely differing expansions.

Glass provides its own problems in that the surface contains molecules which are not satisfied and as a result attract surface layers of moisture. When it is clean and dry, it can be wetted by both adhesives and unwanted grease and dirt. It is necessary to ensure before applying any adhesive that the glass is thoroughly degreased and cleaned. For many adhesives to work efficiently it may also be necessary to ensure that much of the water layer is removed in order to increase the area of contact. This applies particularly to some of the organic-based adhesives. The glass surface may still try to attract more moisture if it can; this could eventually result in a breakdown of the adhesion. The polymer-based adhesives are not completely waterproof and as the moisture penetrates through the skin, it can cause a reaction at the interface between the adhesive and the glass which again can reduce adhesion.

There are various adhesives available for glass, some of which have been in use for many years but as new materials from developments in polymer chemistry have emerged, more adhesives have come onto the market. There are several of these which are used by people who are involved in conservation work but those in most common use in small workshops at this time are:

Clear epoxy resins
Silicone sealants
UV curing glass adhesives

EPOXY RESIN. This is a two-mix adhesive comprising of resin and a hardener. Araldite AY 103 with hardener HY 951 is a popular, low-viscosity resin suitable for most purposes. Similar material is available from other manufacturers. It is often used for joining pieces of float glass together to form blocks which can then be ground and polished on all faces. When sufficient resin mix is applied to the centre of the pieces, they can be pressed firmly and carefully together until the resin spreads evenly to the edges to create a uniform layer which is not readily visible to the eye. This appears to be a very simple process but it does require great care to achieve complete success. Durk Valkema and Anna Carlgren from Holland are experts at this and at a demonstration of their technique, they took pieces of 10 mm glass, cut to size, cleaned them

An example of glass which has been glued together carefully in sections and then ground and polished. It is a technique which is very popular with artists from the Czech Republic.

all thoroughly three times with acetone and then placed the pieces between layers of paper to avoid any dust falling on to the surfaces.

They then placed the glass into a kiln to remove any residual moisture and to warm it so that as the adhesive was applied to the centre it would spread easily. Any bubbles were removed with a pin or a thin knife point. The next piece of glass was lowered on to the layer of adhesive from one end until it was flat and there were no bubbles. Pressure was then applied with a padded stick to press out any excess adhesive. The process was repeated with further layers until a block of sufficient size was formed. Durk studied at the Umprum in Prague and this precise use of adhesive to form blocks which are then meticulously ground and polished is a feature of the work of many artists working in the Czech Republic.

Even for general sculptural work where complete clarity is not essential, the glass must be degreased before the resin is applied and where there is a need to achieve maximum adhesion, some abrading of the surfaces is a considerable help.

In cold weather the resin can become too viscous to use easily and is best applied at temperatures above 30°C (86°F). It is also advisable to mix the resin in small quantities because there is a danger of generating an exothermic temperature rise from any mass of the mixture. This will certainly result in shortening the working life of the mixture and in sufficient quantity can create enough heat to produce noxious fumes.

Eye protection and rubber or plastic gloves are advisable. Good ventilation is essential. Suitable barrier and cleansing creams are available. Skin which has been in contact with the epoxy resin should be washed well with soap and warm water. Spatulas, brushes and any other tools can be cleaned with acetone or cellulose thinners before the resin has set.

Section of a large sculptural form by Matéi Negreanu. Pieces of window glass have been glued together and then heavily sandblasted. *Courtesy of Pilkington Glass Museum.*

For bonding pieces which need to be held in position whilst curing, rapid setting resins are available but setting of most resin can be accelerated by heating the glass. Curing of the AY103/HY951 mixture can take from 20 minutes to 24 hours depending on the temperature. Suitable schedules are available from the suppliers.

SILICONE SEALANTS. These are most suitable when gap filling and/or flexibility is required. It is usually supplied in pistol grip-type tubes and can be spread easily with a spatula or knife. The glass should be degreased with methylated spirits (alcohol) or acetone. The adhesive stops being tacky after about an hour but achieves maximum adhesion after about 12 hours. It is cheap, reasonably waterproof and easy to use but it contains acetic acid which is an irritant, so care is needed to ensure that it does not get onto the skin. Any excess material on the glass can be cleaned off immediately with methylated spirit or alternatively, left until it has just ceased to be tacky when it will usually pull away in strips. If it is left to cure, it can still be removed by cutting and scraping but will require much more work.

Silicone-based adhesives offer the advantage that they retain a considerable amount of flexibility which can often prevent damage in circumstances in which the glass comes under strain or physical attack.

The major difficulty with this material is that any adhesive left exposed on edges or faces will inevitably attract dirt. This will remain on the surface and may even penetrate into the material to leave a dark line or area which could be very difficult to remove.

Silicone is a term which relates to various compounds formed from silicon and organic radicals. They divide into two basic groups: the silanes which have excellent weatherproofing qualities but have less strength than the elastomers which form the other group. These are available as one-part silicones, usually provided in a sealed tube, and as two-mix silicones which are not as strong.

UV CURING GLASS ADHESIVE. This is a remarkably strong but relatively expensive material. An ultraviolet lamp is useful for curing but reasonably strong sunlight will work just as well. Close fitting surfaces are essential for good bonding and this material should not be used unless the surfaces fit together well.

The bonding action is very rapid so when the adhesive has been applied, it is essential to ensure that the glass is in exactly the right place before it is exposed to UV light. Setting can be completed within a few seconds. Degreasing of the surfaces with acetone or cellulose thinners is advisable. The same material can be used for cleaning off any excess adhesive immediately after setting as this will not cure as rapidly as that which is trapped between the layers of glass. If the excess is left to harden, it can be very difficult to remove and sometimes in the process of being scraped off will lift part of the surface of the glass. There have been reports of crizzling on

Sculptural form made from cast pieces cemented together with UV adhesive.

some glasses caused by the use of a UV light source and where there has been a pocket of adhesive left to fill a gap, there have been instances of the glass cracking.

The Carborundum Company who make the ceramic fibre insulation called Fibrefrax has brought out a range of adhesives suitable for high temperature applications. They are marketed under the trade name 'Fraxbond'. The first of these, number 702, is a powder which is mixed with water. When it is cured, it is claimed to have good adhesion to glass, ceramics and metals and will stand working temperatures up to 900°C (1650°F). The second and third, numbers 715 and 716, are both specifically intended for bonding ceramic fibre and are supplied as paste or liquid ready for use. They have a top continuous working temperature of 900°C (1650°F). Adhesive number 803 is a two-mix powder best used on nonporous surfaces and has a continuous working temperature of 1000°C (1830°F). It is recommended for bonding refractories. The last of the group, number 900, is a two-part mix of base and hardener recommended for glass bonding where high temperature usage is envisaged. It has a recommended top continuous working temperature of 900°C (1650°F).

The bonding of glass to glass can usually be achieved successfully by one means or another. Greater difficulties can arise if it becomes necessary to bond glass to other materials such as metals, rock etc., particularly when working on a large scale. The differences in expansion mean that any adhesive must have a degree of elasticity whilst retaining its bonding strength to both materials. Modern car design has produced a demand for such adhesives and much research is currently taking place to find suitable materials. No doubt the results will soon appear on the market and be available to glassmakers.

Adsorption. The process whereby the surface of a solid attracts moisture or vapour. It often involves a single layer of molecules, atoms or ions attached by chemical bonds to the adsorbent surface.

Agate. A form of natural silica characterised by its bands of concentrically arranged colour often of reddish browns and used to make various forms of jewellery. The material is slightly porous and is sometimes dyed to produce different colour effects. It became the inspiration for a form of glass known as 'Agate Glass' which was developed by Tiffany in the USA.

Agate glass. This type of glass, produced by Tiffany Glass of New York, was intended to reproduce the effects and colours found in natural agate, which was used as a semi-precious stone. It was made up of several layers of opaque coloured glass which were fused together and then ground and polished to give a laminated effect. It is suggested that the various colours were introduced into a pot, melted into the base glass and then stirred until the gathered material resembled the mineral. It was then worked into the required form.

Ageing. The process of maturing clay by storing it either in airtight bins or in plastic bags. This has the effect of gradually making the clay more plastic. It is a very useful process in the case of fireclay (not normally a very plastic form of clay) for making it more amenable when making glass pots.

Another variation of the process is known as 'Souring' and this refers to the use of the action of bacteria to break down any organic matter in order to release amino acids which flocculate the clay and increase its strength.

Aggregate (ballast). Materials used as solid additions to cement to produce concrete for enclosing stained glass, particularly dalle de verre.

Air compressors. Machines which draw in air at atmospheric pressure and then deliver it at a higher pressure.

Air compressors are now found in most small glass workshops. They are used for sandblasting, for cooling areas of work at the chair and for driving portable air tools used for grinding, drilling and polishing. Most of them are traditional piston-type machines, operated by single-phase electric motors which limit the capacity to approximately 14 cubic feet (400 litres) per minute at 100 psi (7 kg/cm²). For continuous sandblasting or for deep abrading, this is barely sufficient and the operator often has to stop to allow the pressure to build up again. If a three-phase system is available, then a compressor of somewhat larger capacity should be considered as this makes the work much easier and offers greater possibilities. The use of reciprocating piston-type compressors in studios is declining in favour of the rotary vane, screw and centrifugal types, which whilst being slightly less efficient, have the important quality of being relatively quiet.

A large reservoir is an advantage. A good quality filter/regulator and a good programme of maintenance is essential. Water must be regularly removed from the bot-

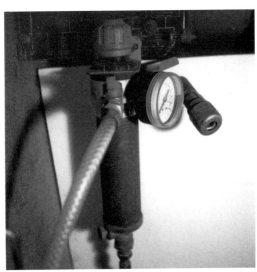

The combined controller and air filter fitted to most studio compressed systems.

tom of the reservoir. The filter needs to be checked and cleaned or replaced as necessary and in Britain it is mandatory that the reservoir is professionally pressure checked every year. A pressure relief valve must also be fitted.

Air gun. Used at the chair by the glassmaker to propel a jet of compressed air on to parts of the work which need to be cooled.

The simple type of air gun used by glassmakers at the chair to cool areas of the glass which is being worked.

Air traps. Bubbles deliberately introduced into glass and shaped or twisted as necessary. They are often found in the stems of drinking glasses. See **Air twists**.

Air twists. Air twist stems on goblets became very popular during the mid-18th century. They are thought to have developed from the habit of creating tears or small air bubbles in the glass. As these were twisted in the normal process of making goblets, they developed naturally into the air twists as we know them today. Initially, the bowl and stem were made from one piece, holes being pressed into the weight of glass at the base of the bowl and then sealed before the stem was drawn out with the pucellas in the normal way, but leaving the stem showing the twisted lines formed by the trapped air. The next progression was to put a knob of glass on to the base of the bowl, press holes into this and then draw out a stem as before, leaving a small length of plain stem at the base of the bowl. When many air twist stems were required, a large gather of glass, probably about 15 cm long by 10 cm in diameter was forced into a metal mould which was fitted with several steel spikes protruding from the base. This was drawn out into a long rod and cut into appropriate lengths for attaching to the bowl before being drawn into a stem.

The development of air twist stems in Britain probably reached its greatest heights with the production of the Newcastle light balusters. These were often made up of several 'bits' of glass, some containing air twists and some plain which were formed into various shapes or knops on the stem.

Opaque twist stems were formed in a similar way. A steel cylinder was lined with several rods of opaque glass, usually opal white, often alternating with coloured rods. A gather of glass on a punty iron was forced into the cylinder to enable it to pick up the rods. The gather

Air twists

Wooden bobbins fitted with small spikes and used for pressing into the base of a parison before it is drawn out into a stem.

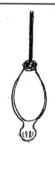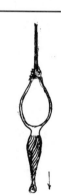

An alternative in which a knob of glass is formed with the pucellas before the spikes are inserted.

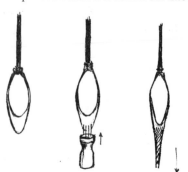

The bobbins being pressed into the base of the parison and the stem being twisted as it is pulled out.

The effect when lengths of cane containing air twists are attached to a parison to form a simple stem or to form one containing various sections, knops etc.

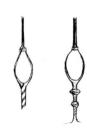

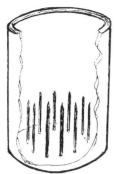

An alternative method of introducing spikes into a gather for pulling out into air twist canes.

with its rods would be marvered, covered with clear glass and marvered again into a slightly tapered form called a 'Carrot'. Several of these would be made for stock. In use, they would be reheated, picked up on a punty iron and heated again sufficiently to be attached to the base of the bowl. It would then be drawn out slowly

to form a narrow length suitable for making a stem and cut off as appropriate with the shears. The maker would form the stem and twists as necessary before forming the foot. Air twists and opaque twists were often incorporated into the same stem. Both air and opaque twists are made for incorporating into chandeliers. In this case the air twists are made by pressing two deep depressions into a large gather of glass and a large punty attached. The punty is then drawn slowly away from the gather at the same time being turned to form the twist. The long length of twist is then cut to length as appropriate and annealed before being shaped into elements of the chandeliers.

Opaque twists are made in a similar manner except that rods of opal or coloured rod are picked up and covered with clear glass. This is then marvered and drawn out as before.

(a) Pr of Spiral Tapes or Threads/Single Close Multi-ply Spiral Band: *also* 1, 3, 4, or 8 *do*. Threads: Pr of *do*. Bands: Pr of Solid Spiral Bands. (b) Multiple Spiral Twist

(c) Gauze/Pr of Corkscrews: *also* Gauze with Core: Twin Corkscrews. (d) Pr of Multi-ply Spiral Tapes/Pr of 2-5 ply Spiral Bands: *also* Four *do* Tapes: Four 2-3 ply Spiral Bands

(e) Lace Twist. (f) Pr of Spiral Gauzes: *also* Three Spiral Gauzes

(g) Spiral Gauze and a Single 2-ply Spiral Band: *also do* and a 3-, 4-, or 5-ply Spiral Band. (h) Spiral Gauze and a Corkscrew

Various profiles of threads. *Courtesy of Penguin Books Ltd.*

(a) Four Spiral Gauzes. (b) Lace Twist Outlined

(c) Multi-ply Corkscrew: *also* Pr of *do*. (d) Spiral Cable: *also* Pr of *do*: Vertical Cable

(e) Spiral Gauze with Core: *also* Pr of *do*. (f) Pair of Multi-ply Spiral 'U' Bands

 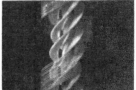

(g) Corkscrew/single 6-10 ply Spiral Band: *also* Pr of 6-10 ply Spiral Bands. (h) Vertical Column/Four Corkscrews/Single 10-20 ply Spiral Band: *also* Vertical Thread: Screwed Vertical Column

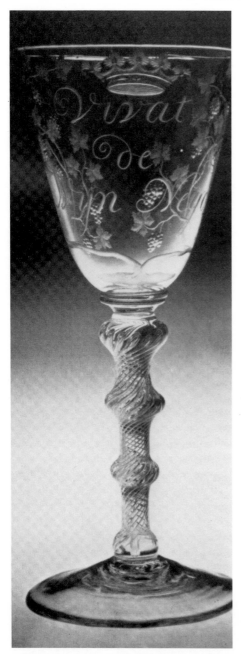

A Newcastle goblet with two knops, a multi-ply air twist stem and a conical foot. It was probably engraved in Holland. *Courtesy of Cinzano. Photograph by Peter Balmer.*

Alabaster. Calcium sulphate or gypsum. $CaSO_4.2H_2O$. The normal source mineral for the manufacture of plaster of Paris.

Alabaster glass. A slightly grey form of opal glass resembling gypsum which was often matted and then used as a base for decoration. It is thought to have originated in Bohemia in the 19th century but was developed further by Carter in the US who introduced an iridised surface.

Albite. Soda feldspar. $Na_2O.Al_2O_3.6SiO_2$. See **Feldspar** and **Batch**. It is occasionally used as a source of soda in a batch but its inclusion is restricted by the amount of alumina which can be accommodated in the batch. The formula shown is one which is generally accepted as a matter of convenience for batch calculations but in fact all the feldspars and feldspathoids vary considerably in content and each is likely to contain elements of others.

Alexandrit glass. This is a glass which produces the dichroic effect exhibited by the mineral alexandrite. It results from the addition of about 4% neodymium oxide to the batch. See **Dichroism**.

It is unfortunate that this glass is sometimes confused with a totally different coloured glass which was not dichroic but was produced by Thomas Webb and by Stevens and Williams in Stourbridge and named 'Alexandrite'.

Alexandrite glass. See **Alexandrit glass**.

Alkali. An alkali is directly opposite to an acid. To the glassmaker the fluxes, and in particular soda ash, are often called alkalis. When dissolved in water, alkalis release negatively-charged hydroxyl ions. In glassmaking, the strongest of the so-called alkalis, more accurately called fluxes, are soda which provides (Na_2O), potash (K_2O) and lithia (Li_2O). The latter is not used to the same extent as the other two because of expense but it is very useful in having a lower coefficient of expansion and being active at the lower melting range. Lithia is finding increasing use in the field of glass-ceramics. The alkaline earth glass modifiers are: magnesia providing (MgO), calcia (CaO), baria (BaO), lead oxide (PbO) and zinc oxide (ZnO).

Sodium oxide and sodium silicate are alkalis that are soluble in water and are used by potters to deflocculate clay slips. Both soda ash and potash have high coefficients of expansion and often have to be replaced in part in order to produce glass of specific and lower expansion.

Alkaline earths. Alkaline earth metal oxides. Beryllia, magnesia, calcia, strontia and baria. These oxides occupy the vertical Group IIA of the periodic table. They are all used to some degree in glassmaking, calcia and magnesia being particularly important in commercial soda-lime glasses and baria in the production of crystal-type glass as a replacement for lead oxide.

Alkali metals. The elements of the first group of the periodic table (Group IA): lithium, sodium, potassium, rubidium, caesium and francium. They all have one electron in the outer shell which they lose readily in the process of forming stable ions.

Alloy. A mixture of metals or of metal with another material in order to produce enhanced or different characteristics. Carbon and/or materials such as chromium and tungsten are added to iron to produce various types of steel. Brass is an alloy of copper and zinc often used

for the bearing surfaces of engraving lathes. Duralumin is only slightly heavier than aluminium but, because of its mixture of aluminium with small amounts of copper, magnesium and manganese, it is very much stronger and it is commonly used for the bodies of aircraft. Bronze is another popular alloy used for bearings. It is usually an alloy of copper and tin but can also contain aluminium.

Alternating current. An electric current which changes its direction with a constant frequency.

Alternator. A generator which produces alternating current. If necessary, this can be changed to direct current by use of a rectifier.

Alumina. (Al_2O_3). Aluminium oxide. Corundum. It is found naturally as the abrasives emery and corundum and as part of many gem stones. Large corundum crystals affected by traces of chromium, cobalt, copper and iron form the gem stones ruby and sapphire. It is also mined as bauxite, gibbsite or diaspore, which is a hydrated soft material easily ground down to be formed into a hard crystalline powder by calcining. It can then be ground into a form in which it can either be included in a batch or converted into metallic aluminium. It acts as a stabiliser in a glass, being particularly effective in resisting devitrification but is usually introduced in small proportions as larger amounts tend to stiffen the melt and to make the glass difficult to work.

It can be introduced into a glass as alumina hydrate, as calcined alumina or as part of one of the many feldspathic rocks. It is also used for the production of a wide range of abrasives. As a highly refractory material with a melting point of 2050°C (3722°F), it is used in this context as part of most natural and manufactured furnace materials. It is also used as a major constituent of ceramic fibre and as alumina bubbles in the production of various insulation materials. China clay and fireclays have the highest proportions of alumina of the various types of clay, but it is found combined with silica in all clay bodies where it helps to create the flat type of layered crystal which is instrumental in making the clay plastic. All clay was originally formed from decomposed feldspathic rocks which themselves contained alumina together with silica and various oxides. In fact, all the igneous rocks contain alumina but it is the feldspars and feldspathoids, which together with alumina in a calcined form, tend to be used in glassmaking.

Alumina is introduced into refractory clays used for making glass pots, often in the form of Molochite which is formed from calcined china clay, in order to reduce shrinkage and to improve the refractory quality of the fireclay. See **Batch** and **Abrasives**.

Alumina glass. High alumina glasses are often produced by melting alumina together with boric oxide, some fluxing material, a little calcia and a small quantity of silica. Some are used in situations which demand high resistivity to attack by alkali vapour such as in vapour discharge lamps. A batch for this type of application would have little or no soda. High alumina glasses are also used for situations in which there needs to be a high resistance to thermal shock.

A typical formula would be

	(Wt %)
SiO_2	7.5
Al_2O_3	24.5
B_2O_3	48.0
CaO	7.0
Na_2O	13.0

Aluminium. Al. A soft and light metallic element from Group III of the periodic table. It has high electrical conductivity. It is not found as a natural material but it is in abundant supply in the form of its oxide and as part of many silicates. It is a trivalent metal which forms many compounds. Its oxide, alumina, is found as the natural minerals emery and corundum but the metal is usually made from the mineral bauxite which is one of the major constituents of the earth's crust. The metal is non-magnetic and has a good resistance to oxidation which is partly the reason why suitable aluminium alloys have become so popular as a framing material for window glass. It is also popular as a casting material for forms associated with glass because of its low melting point. It can be formed into a considerable number of alloys of which duralumin is probably the best known. When suitably heat treated, it becomes almost as strong as mild steel but of course, is considerably lighter.

Aluminium oxide. See **Alumina**.

Amalgam. An alloy of mercury. Gold/mercury amalgam is used to decorate both ceramics and glass. Tin/mercury amalgam is used for backing mirrors.

Ambetti. Antique translucent glass containing minute opaque specks.

Amblygonite. ($Li.AlF.PO_4$). Lithium alumino-fluophosphate. A lithium ore with opacifying qualities which can also act as a strong flux.

Amethyst. The purple variety of quartz used as a gemstone.

Amorphous. Without a definite form. Glasses are amorphous because they have been unable to return to a crystalline state on cooling.

Crystalline solids have a specific melting point which defines the temperature at which they change rapidly from a solid state to becoming a liquid and vice versa. In contrast, amorphous solids such as glass go through stages of various softening, melting and maturing ranges.

Amphora, amphoriskos, arybalos, alabastron. The forms of early Greek vessels often used as designs for core-formed glass. An amphora was essentially a jar with two handles and an amphoriskos was a much smaller version of the same thing used to hold perfume etc. Arybalos and alabastron were also names for particular types of perfume jars.

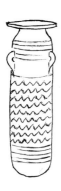 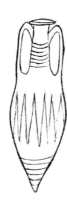

1. Amphoriskos. 2. Alabastron.

Typical Hellenistic shapes used as a basis for many of the core formed vessels.

Amphoteric. Can act either as an alkali or as an acid. Amphoterics often act as stabilisers and usually help to form the link between the glass formers and the alkaline fluxes. Alumina is one of the most important amphoterics in glassmaking. Other materials which act in this way are boric oxide, ferric oxide, chromic oxide and the three dioxides titania, zirconia and stannic oxide which also act as opacifiers.

Amplifier. Something which increases the voltage or strength of an electrical current. It is best known for increasing the strength of radio signals but can be found in various kinds of electrical control apparatus.

Amulet. A charm worn to protect the wearer or as a good luck token. These were often made from Egyptian paste or what was called Egyptian faience.

Analysis. The identification of a substance by separating it into its various components.

Chemical analysis gives information about whether or not something is present in a mixture or compound (qualitative analysis) or how much of each part is present (quantitative analysis).

Nuclear magnetic resonance recognises the individual natural frequency of the nucleus of each kind of atom. With the assistance of a strong magnetic field, this can be used to demonstrate, on an oscilloscope, the composition of a sampled material.

Spectroscopy dissects bands of coloured light and focuses them to indicate sharply defined lines of precise colour. Each substance has a unique spectrum and spec-troscopy is an established method of displaying this for purposes of identification.

Analysis is important in the consideration and use of the various glassmaking materials and suppliers often give a sample analysis to the buyer. This could be in the form of a chemical content, in the form of an analysis giving mineral content or as one which indicates the content of the material in terms of the oxides that it provides. The analysis of some materials may also be expressed in terms of their grain or particle sizes.

A typical chemical analysis of a potash feldspar is:

SiO_2	65.20 %
Al_2O_3	18.90
Fe_2O_3	0.06
CaO	0.53
Na_2O	3.35
K_2O	11.10

It can be seen that this is considerably different from the projected approximation of a potash feldspar which is often presented as containing one part of potash, one part of alumina and six parts of silica. If only a small quantity of this is being included in a batch, the approximation might suffice but most industrial glassmakers would use a sample chemical analysis as a basis for the necessary batch calculations.

A typical analysis of British limestone shows the following:
(not shown as a percentage)

SiO_2	0.48
Al_2O_3	0.10
Fe_2O_3	0.035
$CaCO_3$	98.60
$MgCO_3$	0.45
CaO	55.2
MgO	0.18
CoO	0.0014
ignition loss	43.50

This indicates that the quantity of iron is reasonably small but would still need to be totalled against that which might occur in the sand or other materials. The quantity of cobalt oxide will be seen as being negligible. The provision of CaO from the carbonate would need to be calculated using the appropriate conversion tables.

Another type of sample analysis from suppliers would offer information on the chemical content of a material together with the particle sizes as those remaining after each stage as the material was passed through a series of sieves. E.g.:

Aperture size (microns)	BS sieve no.	Fractional % remaining on	Passing through
1000	16	1.0	
500	30	13.5	
250	60	52.0	
125	120	30.0	
63	240	3.8	0.7

It would also tend to give details such as the bulk density of the material and its melting point etc.

Sometimes an analysis of batch materials will be presented as the effective oxides introduced, disregarding all the volatiles which will disappear during founding.

Anatase. TiO_2. One of the natural forms of titanium dioxide and usually preferred together with brookite as sources of white titanium dioxide rather than that of the minerals rutile and ilmenite which would normally have a higher iron content. Rutile and ilmenite are often used in stoneware ceramics because of the speckled colour introduced by the iron in addition to the opacifying effect of the titanium oxide.

Ancient glass. The origin of glass is still a matter of conjecture and much debate. It certainly existed in the form of a vitreous glaze on ceramics and stone, and as beads made from sintered material long before articles which could be called glass as we know it became evident.

There is a considerable amount of on-going research into early glass which eventually may offer more specific evidence but informed opinion at the moment suggests that it came into existence as an independent material about 3000 BC, the first objects consisting mainly of beads and solid forms.

The first vessels are thought to have appeared towards the end of the 16th century BC, the earliest coming from central Asia. These were followed very soon by similar pieces from Egypt. After this there was something of a lull until the 9th century BC when production revived in Mesopotamia. By the 4th century BC production was centred on Alexandria and it seems that it soon spread from there into Italy.

The first technique for making vessels seems to be that of winding or trailing hot glass around a core which was subsequently removed. See **Core techniques**. These core -formed vessels eventually became very sophisticated and, particularly in the 1st and 2nd centuries BC, the influence of Hellenistic shapes such as the amphoriskos, the alabastron and the aryballos became evident.

The composition of the core of these vessels has been the subject of much discussion and experiment. They were often described as 'sand core vessels' by many historians but after much research some were discovered which still had some of the original core intact. On analysis this revealed that the core of these particular vessels was formed with two layers, the outer consisting largely of fragments of limestone whilst the inner layers suggested a mixture of sand, clay and dung.

Dominick Labino in Ohio carried out a number of experiments to duplicate the sand cored vessels and two excellent examples of his results are in the Pilkington Glass Museum at St Helens. He published some of his findings in the *Journal of Glass Studies* in 1966 but omitted to reveal the nature of his cores because of some concern that it might lead to the production of fakes. See **Core techniques**.

In ancient times many objects were made from mosaics and a wide variety of these forms were made from rods of coloured cane which were cut into pieces and assembled before being fused together. See **Mosaics** and **Reticella bowls**. Other objects were laboriously cut from solid blocks of glass, various vessels and solid forms were made by casting or pressing into moulds.

Rosemarie Lierke in a recent paper in *Glastech* (Berlin, 1993) produced some highly imaginative thoughts on the possible production methods involved in what had previously been accepted as 'lathe turned' bowls. She suggests that many of these pieces were not turned in a lathe when cold as had been previously understood but were worked in a hot state on something which may have been or resembled a potter's wheel. On the basis of the evidence presented, she has a very convincing theory.

It was once thought that the glassmakers from times BC had sophisticated knowledge about the chemical nature and use of decolourisers such as antimony and arsenic, and of colour resulting from specific colouring oxides. Current opinion suggests that much of this material, whilst undoubtably being present in the glass, resulted because it happened to occur naturally in particular minerals from known sources or from slag from metal casting operations. A possible exception to this theory was that of copper oxide which was already in use on ceramic glazes.

A similar consideration related to the durability of some ancient glass. It was once thought that this resulted from specific knowledge of the role of calcia and alumina in stabilising glass. Again it seems likely that whilst much of the ancient glass which was not adequately stabilised has long since disappeared and that which remains shows an adequate content of calcia and/or alumina, this was almost certainly due to the fact that some of the natural materials used for glassmaking happened to contain the requisite quantities of these minerals.

Baked clay tablets from Assyria present valuable evidence about this controversy. A large number of these are available giving minute details of both the making of glass and glazes. Brill, a technologist from Corning, made a close study of these and established references to quartzite pebbles and to the ash of certain plants which could have provided all the calcia, magnesia and iron etc. found in subsequent analysis of the glasses. He also found references to the making of a frit which was ground up with copper salts to make blue and red glass.

Professor R. G. Newton in an article, 'Recent Views on ancient Glasses' vol. 21, no. 4 August 1980 of the *Journal of Glass Technology*, makes an interesting point to the effect that different methods of production existed on various sites, some concerned with the actual glassmaking and the others simply concerned with re-melting and forming glass. He suggests that the ancient Egyptians relied on imported fritted glass because they had not at that time discovered how to produce the frit or to make the glass themselves. There is evidence to suggest that there was a considerable trade in blocks of glass through-

out the Middle East at that time. A huge block of glass weighing eight tons was discovered in a cave at Beth She'arim, south of Haifa, and more blocks have been found at sites in Palestine. They were probably melted to be broken into blocks of cullet but how they managed to provide sufficient heat to melt such a large quantity of batch is still a complete mystery.

It is thought that glassblowing was discovered in or near Syria shortly before the beginnings of Christianity and was exploited by the Romans to change and extend the range of glassworking possibilities. The expansion and establishment of their empire also ensured that glassmaking and glassforming soon spread throughout Europe.

Andesine. A plagioclase feldspar containing both soda and lime feldspars.

Angström. Symbol A. A unit of length equivalent to one hundred millionth of a centimetre and mostly used to measure light waves. The waves of light which are visible to the naked eye range from 4,000 to 7,000 angströms per wave. It is named after the Swedish scientist A. J. Ångström. 1 angström = 0.1 nanometre.

Anhydrite. $CaSO_4$. Natural mineral form of calcium sulphate chemically similar to gypsum but harder and heavier. It is slightly soluble in water and hydrates slowly to form gypsum. It occurs naturally in white or greyish masses.

Anhydrous. Without water. Usually refers to a material from which chemically-held water has been removed.

Annagrun. Originally a type of uranium-coloured glass developed by Josef Riedel for his wife Anna in the mid-19th century. The name has been used more recently by Klaus Kugler to depict the colour of one of his production glass rods. The green colour produced from these rods does not replicate the original uranium-based colour.

Annealing. If a piece of glass is heated to a plastic or molten state and then left to cool naturally to a solid state and this is allowed to happen over a particular range of temperatures, the external surfaces will cool more quickly than the centre and the shrinkage will create residual stress. It is important that this stress is reduced to acceptable limits by the process of annealing. If this is not carried out it is likely that the glass will crack or, in the case of thick articles, the result could be much more dramatic. This will probably take place within a few days but it is quite common for it to occur years later. A badly annealed paperweight which explodes in a home, or on display, could create considerable damage, so it is important that the annealing cycle is adequate and appropriate to the type and thickness of glass. The process should never be taken too casually.

The stress is reduced by allowing the glass to cool to a temperature defined as its annealing point at which it is held for a length of time related to its thickness, the nature of the glass, its coefficient of expansion, the amount of surface exposed and the amount of residual stress required. The period of maintained temperature is followed by a controlled rate of cooling. The relief from stress happens because of a process of viscous flow. At the annealing point it can take place within a few minutes whilst at the lower annealing temperature, sometimes called the strain point, it can take a few hours. A small amount of residual stress is normal for most glass but for optical glass in particular it needs to be reduced to a minimum. This means that optical quality glass of some thickness such as that required for large astronomical telescopes may require several months of treatment.

A problem which often occurs in studio work results from the use of coloured and/or opaque glass in conjunction with clear glass. Even though both types of glass may have the same coefficient of expansion, coloured or opaque glass will tend to gain or release heat more slowly than clear glass and due allowance must be made when calculating an annealing cycle to allow for the differing cooling rates. When dense colour is used together with clear glass it is advisable to extend both the annealing time and the cooling cycle considerably.

It is a common fallacy that prolonged treatment will remove all kinds of stress. That which is caused by the incorporation of incompatible elements whether they are stones, cords or glass of different expansion etc., will never be relieved by any extension of the annealing cycle.

There is some latitude available in the process of annealing. Whilst stress will be removed most effectively at the annealing point it can also be relieved, though more slowly, when the glass is held within what is called the annealing range. In a typical soda-lime-silica glass this would probably extend between 480°C (900°F) and 550°C (1020°F) and for a high lead glass between 390°C (735°F) and 450°C (840°F). In practice this offers the advantage that a glass form, which, because of its size and shape might deform at a temperature only slightly above its annealing point, can be given a much longer soak at a rather lower temperature. It also means that the common studio practice of running the annealing kiln on the waste heat from the furnace becomes much more viable.

Many glassmakers are tempted to be casual about annealing because it is obvious that for thousands of years work was cracked off and placed in a compartment above or to the side of the furnace and moved away from the source of heat from time to time as new pieces were introduced. For much of this work the system must have been successful or the evidence would not be around. No doubt constant practice would develop a certain amount of awareness and expertise relating to both the heat and the placing though we can have no idea what proportion of the production simply did not survive.

Annealing in a small workshop tends to be different

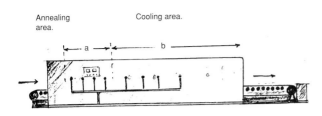

Annealing area. Cooling area.

The annealing lehr. It consists of a long tunnel fitted with a moving endless belt which passes through various zones where the temperature is controlled as required to provide annealing and cooling areas. The speed of the belt can also be regulated to accommodate various thicknesses of ware.

from that in a factory where work travels through various controlled zones of heat on a moving belt, moving at a speed regulated to suit the annealing requirement of the particular type of glass and production. This piece of equipment is called a 'Lehr'. In a studio it is the normal practice to use a kiln which is set to hold a particular temperature whilst work is being produced, this being followed by an appropriate programmed annealing and cooling cycle which usually takes place after the day's work is completed.

If batch, cullet or pellets are obtained from a particular supplier then it is always advisable to ask for the annealing schedules pertaining to the glass supplied and to extend these as necessary to make allowances for the nature of studio production which often contains coloured glass and may be of differing thicknesses.

A typical commercial annealing schedule for a glass with a coefficient of 90×10^{-7} is:

Thickness of glass	3	6	13 mm
Cooling to 5°C above annealing point	5	15	30 minutes
Cooling to 5°C below annealing point	4	1	0.3°C per minute
Cooling for the next 50°C	8	2	0.6°C per minute
Final cooling	50	11	3°C per minute

This is a fairly conservative schedule for clear industrial production glass but it would be prudent to adopt extended schedules for studio glass. Borosilicate glass with an expansion of 33×10^{-7} would require similar schedules to those above until they reach 5°C below the annealing point but cooling times could be decreased considerably after that. Another factor which affects annealing is the amount of surface area which is exposed. Blown ware for instance usually sits on a base in the kiln but both the exterior and interior surfaces of the remainder are exposed. On the other hand, work which has been fused together or slumped into a former will almost certainly have one side, likely to consist of almost 50% of the surface area, resting on a kiln shelf or mould. As work which is exposed only on one side needs about twice the annealing time of that which has both sides exposed, due allowance needs to be made for this. This problem can be even greater when dealing with castings. Those which are completely or almost completely enclosed within the mould are not particularly affected

as the mould material tends to insulate the glass to some extent and ensures that the glass surface does not cool much more rapidly than the interior. The type of casting in which the glass is cast into an open mould has the opposite effect in that much of the glass becomes insulated whilst the top surface is open and can cool more rapidly. A simple solution to this problem is to let the glass approach its annealing temperature but then to place a slab of insulation material such as ceramic fibre over the open area.

The effectiveness of annealing is normally checked by examining the article in a polariscope. Residual stress creates differences in the refractive index which show up as coloured patterns. The intensity and the nature of these patterns gives an indication of the amount of stress.

There is one particular situation in which a degree of evenly distributed stress is used to increase the strength of the glass. This is known as thermal toughening and results from a deliberate high rate of cooling which produces compression stresses on the surface.

Annealing granules. Granules of insulation material, usually vermiculite or ceramic fibre used in a tray or box by lampworkers to cover pieces of work whilst they cool slowly prior to putting them into an annealing kiln. Fine work in borosilicate with little mass will often anneal successfully in this medium without further need to resort to the annealing kiln.

Annealing kilns. Annealing kilns in studios are usually simple box constructions made from angle iron and insulating material and designed to operate at temperatures up to 600°C (1110°F). Most of them are heated by electric elements but can be gas operated or heated wholly or in part by the waste heat from the furnace. Ideally, they need good controls to maintain a specified temperature and to regulate the rate of cooling. Some glassmakers have a sensor fitted which opens the door automatically as one approaches to deposit the glass to be annealed and closes it again immediately afterwards. Apart from the convenience of this system, it also contributes to the retention of heat in the kiln and to a reduction in the use of fuel. A good modern programmable electronic controller is well worth the initial expense and provides a reliable method of producing an efficient annealing cycle. It also provides a much more flexible system than that of the old cam-type of controller.

Anorthite. Lime feldspar. $CaO.Al_2O_3.2SiO_2$. It is not often used as a batch material as calcia is readily available in more suitable and convenient forms but it can be used in circumstances where there is some advantage in introducing both calcia and alumina together. The proportions to be used would be unlikely to have a significant effect on the total amount of silica required.

Anorthoclase. $NaKO.Al_2O_3.6SiO_2$. A term which can be used to describe any of the feldspars which cannot be

considered to be a true soda or a true potash feldspar. Again, it is rarely used because of its variable composition. It is often simply calculated for convenience as being midway between albite and orthoclase.

Anorthosite. A combination of anorthite and albite feldspars. Plagioclase feldspar.

Antimony oxide. Sb_2O_3. A poisonous material introduced into batch as a refining and decolourising agent; often used in preference to or in combination with arsenic. It is sometimes also used to produce yellows in glass when introduced as antimonate of lead. Antimony behaves sometimes as a metal and sometimes as a non-metal. Its oxide is a glass former yet in some circumstances it also acts as an opacifier and as a glass modifier. It is mined as the mineral stibnite and is obtained mostly from China, Mexico and the USA. It is sometimes used in the formation of various lead alloys and as a paint pigment. See **Batch**.

Antique glass. This is a stained glass term which is used to describe the sheets of coloured glass produced by the cylinder method. They are usually uneven in thickness,

surfaces are often ridged and some of them have seeds deliberately introduced to give the appearance of medieval glass. It is still produced by Hartley Wood & Co of Sunderland and in similar specialist factories throughout the world. This glass has a very rich character and is appreciated by the artists who can often be seen searching through the racks to find sheets which will fit a particular design.

The sheets are quite small, usually about 50 cm (20 inches) square. The glassmaker produces these by first taking a large gather and onto this taking further gathers until there is a considerable weight of glass on the blowing iron. The gathers can be of different colours. This is blocked and then blown out into a large bulb which is swung and pulled out with the pucellas to elongate the form. The end is then cracked off and the form opened out. A large punty iron is prepared with another large gather flattened into a wide disc. This disc is then attached to the end of the blown form which is then cracked away from the blowing iron. The glass is re-heated in the glory hole and opened out to form a cylinder which is then taken from the punty and put into the lehr to be annealed.

After the annealing a glasscutter is run along the

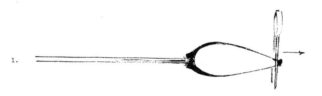

Figure 1. Sufficient gathers are taken to form a large bubble which is swung and blown further into a long pear shape. A blob is formed onto the end of this by cutting in with the pucellas which are then used to pull the shape out further.

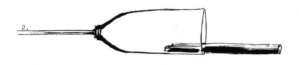

Figure 2. The end is knocked off and the glass opened out by inserting a length of wet wood and rotating the glass against this.

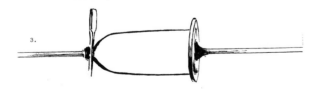

Figure 3. A large and heavy circle of glass is formed on the end of a punty iron and this is pressed against the open end of the glass. The other end of the glass is then cut in with the pucellas and cracked off the blowing iron.

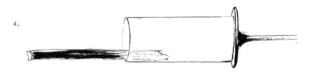

Figure 4. This end is now opened out in exactly the same way with the length of wet wood. It is then cracked off the punty iron and placed into the lehr to be annealed.

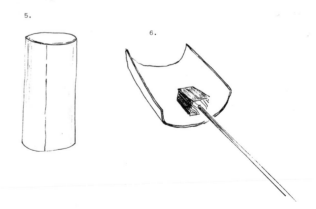

Figure 5. After annealing is completed, the cylinder is laid onto its side and cut along its length with a glasscutter, tapped along the inside to provide a dividing break and then placed onto another moving belt which runs through a kiln similar to a lehr to be re-heated.

Figure 6. When it reaches the appropriate point it is sufficiently soft to be opened out carefully and then flattened by the use of a block of poplar wood on a long iron rod. The glass sheet thus formed is then pushed into the next section of the kiln where it progresses through another annealing and cooling cycle.

Taking the initial gather.

Blowing out the large bubble.

Checking a cylinder prior to cutting.

An example of the streaky form of antique stained glass.

inside of the cylinder which is tapped to produce a crack along the cut. It is then placed on a moving belt to be re-heated until it is just malleable and then carefully opened out and flattened with a block of poplar wood on a long iron in the manner of somebody ironing cloth. It then continues along the moving belt to be re-annealed.

The colour range is very wide so the programme of founding needs to be carefully considered to ensure the successful progression from one colour to the next without the expense and trouble of having to change pots or to clean out a tank.

Some of the sheets of so-called stained glass contain two or three different colours. There are various titles for the different types. Some of them are: Venetian, Streaky, Reamy, Seedy Antique, Antique Gold Ruby, Antique Copper Ruby and Antique Flashed.

Apatite. $3Ca_3(PO_4)_2$, $Ca(ClF)_2$. Natural calcium phosphate of varied composition and the commonest of the phosphate minerals. It is the common source of phosphorous for making fertilisers but bone ash is usually the preferred source for introducing this material into glass as an opacifier.

Applied decoration. Any decorative addition such as prunts, trails etc. applied to a hot glass form.

Applique. Used in stained glass to refer to the practice of firing pieces of coloured glass on the surface of another sheet. It is important when considering this type of work to ensure that both the additions and basic sheet have approximately the same coefficient of expansion to avoid problems with cracking and that particular care is taken to ensure that the annealing is carried out properly.

The makers of stained glass sheet have never felt any necessity to attempt to make their various glasses compatible with each other so expansion can be a major problem for artists wishing to use the applique technique. Latterly, some artists have been fixing pieces in place by using either resin-based adhesives or with UV curing glass glue. To what extent such additions will survive long exposure to the weather remains to be seen.

Architectural glass. Whilst this refers generally to glass used in relation to buildings, it is also often used to describe what is commonly known as stained glass. Window glass is described under **Sheet Glass** and

Glass sculpture by Florian Lechner, 'Turmplastic', at the Kongresscentrum, Coburg.

Large six metres high architectural piece, 'Glasbrunnen', by Florian Lechner. It is situated in Munich.

Stained glass under that heading. A comprehensive book on the wider aspects of this subject is *Glass in Architecture and Decoration* by McGrath, Frost and Beckett, which was published by the Architectural Press of London.

Argentite. Silver sulphide. Ag_2S. A sulphide ore of silver which occurs sometimes in a cubic crystal system but is generally found as a dark grey mass. It shows a shiny surface when first cut. Usually found in conjunction with other silver ores.

Argonite. $CaCO_3$. A hard form of calcium carbonate which recrystallises into calcite.

Argy-Rousseau, Gabriel (1885-????). Gabriel Argy-Rousseau was one of the group of French artists who became involved in the making of pate de verre. He was a late entrant into the group which was started by Henry Cros. He did not produce pieces over any length of time so examples are comparatively rare but of very good quality and as a result are very costly. He is noted for his work in evolving his own technique which consisted of

constructing moulds made from a mixture of plaster, china clay and sand designed to withstand his firing temperature, believed to have been about 800°C (1470°F). He compacted ground glass paste against the sides of the mould and supported this with asbestos fibre prior to firing. It is now thought that the release of the pate de verre from the mould was assisted by water vapour released from the asbestos fibre. The results were a true pate de verre, being extremely fragile and resembling coarse sugar. The milky opacity of this kind of pate de verre resulted from the inclusion of tiny air bubbles. (Artists wishing to try this technique would be advised to use ceramic fibre rather than the asbestos.)

In addition to his delicate pieces Gabriel Argy-Rousseau later produced work of much thicker section. He also experimented with moulds made from fired ceramic material.

Armature. A metal, paper or wooden structure used as a support for modelling. It becomes particularly important when producing most three-dimensional models in clay which are intended for the production of moulds which are then to be used for casting glass. The clay usually

The simple type of armature which would be used for modelling a head in clay.

needs to be kept in a wet and reasonably plastic state whilst the model is being made as without the support of an armature it would tend to deform and could even collapse completely.

Armature also refers to the part of an electric motor or generator in which an electromotive force is generated. In DC motors it is usually the moving part. In alternators, it is usually the stationary part and in AC motors, it could be either.

Aromatic oil. A general term used to describe natural oils used as vehicles for powdered enamels when preparing the material for painting. See **Enamels.**

Arsenic. A metalloid element of Group V in the periodic table. It is found as impurities in over 150 minerals but the main sources are sulphide ores. It reacts with halogens, concentrated oxidising acids and hot alkalis.

Arsenic oxide. Arsenic trioxide. As_2O_3. A glass-forming oxide which is used mostly for decolourising and for refining glass in the founding process. Introduced in sufficient quantity it can form an opal glass. All the arsenic compounds are toxic. See **Batch materials.**

Art glass. A term used very loosely to describe much of the ornamental glass produced in the latter part of the 19th century.

Art Nouveau. (Jugenstil). A decorative style of art originating in France around 1880, embracing lots of curved lines and foliage. It was exploited by many glass artists including Galle in France and Tiffany in the USA. See **Tiffany** and **Gallé.**

Asbestos. This is a form of calcium-magnesium-silicate which is a very hazardous material often found in the insulation of old kilns. It is an irritant, tends to settle in the lungs and promotes pneumoconiosis (Silicosis) and cancer. Suitable safety masks **must** be worn when handling it.

It was commonly mixed with cement or plaster to form heat resistant slabs and boards which often formed the exterior containing layers of kilns and some small furnaces. It can be safely destroyed by feeding it into a glass furnace as part of the batch where, during the founding process, it ceases to be a dangerous crystalline material and becomes part of the glass.

There are essential regulations concerning the use and disposal of asbestos in existence in most countries. In Britain they can be obtained from the offices of the Health and Safety Executive.

Asbolite. A cobalt ore which usually contains manganese and iron impurities giving the resulting colour a muted and less garish effect than that produced by pure cobalt oxide. It is the safest of the cobalt ores to use as a colouring material as it does not contain arsenic.

Ashes. These usually comprise the solid matter left after combustion. Wood ashes and those resulting from the combustion of other plants were the source of much of the flux material used in glassmaking for many centuries.

Ash from differing sources usually contains various quantities of silica and other oxides in addition to the soluble potash. The burning of the wood removes much of the carbon, hydrogen and sulphur leaving a varied mixture of carbonates, oxides, sulphates, chlorides and phosphates etc. The variation between the proportions of these materials between one type of ash and another can be considerable. Because much of the potash is soluble it can be washed out if the ash is left open to the atmosphere for any length of time.

Wood ash has been exploited by potters for many years as a material which provides both colour, texture and some fluxing action in stoneware glazes. As a result several in-depth analyses have been made of the ashes from many wood and grass sources and even though these were taken after the soluble salts had been washed out, as would be the case when preparing them to be incorporated into ceramic glazes, they reveal wide-ranging differences. For example, some samples obtained from burned straw revealed 70% silica whilst those from apple wood produced as little as 10%. On the other hand, the calcia in the straw ash represented only about 12% whilst in the apple tree ash it was near to 50%.

Wood ash is little used in glassmaking nowadays though Oiva Toikka in Finland sometimes introduces it as a material to be picked up from the marver to provide unusual colour. Ed Iglehart from Scotland also uses it on the surface of some of his lampworked pieces to provide surface texture. This was not always the case, for in the past, wood and plant ash was the major source of flux materials in glass batch. As almost all of the furnaces

Mushrooms made in lampworked borosilicate by Ed Iglehart in which he has used wood ash to give a coloured textured surface.

were wood fired, a readily available supply was always at hand.

The difference in the chemical content of these ashes had a profound effect on the resultant glass. Some ashes, such as those from barilla became noted for their effectiveness whilst others created considerable difficulties. R. G. Newton in his article in *Glass Technology*, vol. 21. no. 4 of August 1980 refers to the fact that this happened, particularly in many parts of Europe around AD 800, when the furnace sites moved into the beech forests. This produced a glass which tended to have a rather high calcia-potash and low silica content resulting in medieval glass which is proving to be lacking in durability.

The ash produced from the burning of bones is mostly calcium phosphate and is a common source of this material for use as an opacifying agent.

An indication of the general content of ashes is:

Kelp, seaweed, marsh plants	Soda, magnesia, silica etc.
Wood and vegetables	Potash, calcia, magnesia, silica, phosphorous pentoxide, and alumina etc.
Bones	Calcia, phosphorous pentoxide etc.

At the fire. A term for re-heating glass at the glory hole in order to enable further work to be carried out.

At the flame. (At the lamp). Lampworking. The manipulation and working of glass by means of a lampworking torch. See **Lampworking**.

Atmosphere. The prevailing conditions within a furnace or glory hole. The term redox is often used to describe the processes of oxidation and reduction. It has particular

Oiva Toikka paperweights incorporating wood ash.

importance in the formation of various colours and surface patination. See **Firing**, **Oxidation** and **Reduction**.

The atmosphere around the flue areas of furnaces and that in factories is becoming increasingly a matter of public concern and there is constant provision of new legislation because of the toxicity and environmental implications of some of the volatiles released in the founding processes.

Atomic number. Atomic numbers are useful in that they can be arranged in a tabular form to indicate the likely properties of particular elements. The elements are arranged in groups showing a common electronic character which also indicates similarities in chemical and physical behaviour (see **Periodic table**). Whilst the atomic number indicates the number of electrons orbiting a nucleus it also refers to the number of protons in the nucleus.

Atomic structure. All atoms whether light and simple in structure as in hydrogen or heavy and complex as in lead consist of a positively-charged nucleus surrounded by a number of negatively-charged electrons. Practically all the mass of the atom is concentrated in the nucleus. This means that the electrons are extremely light and constitute only a small fraction of the mass. They are arranged around the nucleus in shells designated K, L, M, N, etc., the electrons in their respective shells being differentiated by their energies. Electrons in the innermost shell (K) have the lowest energy and the maximum number of electrons allowed in this shell is 2. The next higher energy shell is the L shell which can hold a maximum of eight electrons and surrounds the K shell. In a similar manner the next energy shells M and N etc. surround the K and L shells.

All the atoms in the universe can be imagined as having started to be built up from the hydrogen atom which has a positive charge of +1 and one electron with a negative charge of -1 in the K shell. By adding one electron after another whilst increasing the charge on the nucleus by +1 at each electron addition, the whole periodic table can be built up.

When the outermost shell of an atom has the maximum number of electrons appropriate to that shell, then the atom is very stable and shows very little tendency to combine with other atoms. Chemical combination of atoms is brought about by the re-arrangement of the electrons in their outer shells and this is more easily achieved in circumstances where there is a greater possibility of

The orbit arrangements for helium and neon.

The orbit arrangements for chlorine and sodium.

movement. Reaction may be spontaneous or may need to be stimulated as could occur because of changes in temperature or pressure.

The illustration of the helium atom shows a complete K shell and similarly the element neon has a complete L shell. The atoms of these elements are so stable that they do not combine with other atoms, not even with atoms of their own species. They normally exist as monatomic gases, each separate molecule consisting of one atom only. They are frequently referred to as inert gases. Their behaviour contrasts strongly with that of the gases hydrogen, oxygen and nitrogen which are much more reactive and exist at normal pressures and temperatures as the diatomic molecules, H_2, O_2 and N_2. The M shell can contain as many as 18 electrons and in fact all the elements from number 29 (copper) have a complete M shell of 18 electrons. When, however, the M shell reaches 8 electrons, with the gas argon, great stability is reached and so argon becomes another of the inert gases, the 8 electrons conferring great stability similar to that achieved by the 8 L electrons on the outside of the neon atom.

Atomic weight. The weight is expressed as the number of atomic mass units and represents the average weight of an atom of a specific element. Atomic weights are used to calculate molecular weights.

Atoms. An atom has a central nucleus which is positively charged and surrounded by negatively charged electrons which orbit around it. The nucleus always contains protons and neutrons with the exception of that of hydrogen which has no neutrons. Together these provide most of the weight of an atom. The protons have a positive charge whilst the neutrons are electrically neutral. This means that the nucleus has a positive charge which is balanced by the negative charge of the orbiting electrons.

The elements currently known are made up from these particles in a simple manner. For example, hydrogen (Element No.1) has a nucleus of one proton providing one positive charge and one orbiting electron which provides one balancing negative charge. Helium (Element No.2) has a nucleus with two protons and two neutrons giving a positive charge of two which is balanced by two negatively-charged electrons. The same process continues throughout the table of the elements. The number of positive charges in the nucleus always balances the number of orbiting electrons and it is this number which defines the atomic number of the element.

Electron orbits.

1. Hydrogen (H) Atomic number 1.
Hydrogen has a nucleus containing one proton and has one orbiting electron.

2. Helium (He) Atomic number 2.
Helium has a nucleus containing two protons and two neutrons. It has two orbiting electrons.

3. Lithium (Li) Atomic number 3.
Lithium has a nucleus containing three protons and three neutrons. It has an inner orbit containing two electrons. As this is then full the third electron is established in an outer orbit.

Whilst the electrons actually move in regions of space around the nucleus, for the purpose of establishing the relationship between these numbers and particular elements, it is convenient to consider the electrons as being arranged in well-defined orbits. Hydrogen (one electron) and helium (two electrons) have their electrons placed in the first orbit. Two electrons will fill this orbit. The subsequent elements move their extra electrons into a second orbit which will accommodate up to eight electrons. Elements 11 to 18 then need to use a third orbit to accept their increased number of electrons. This process develops similarly as the elements with higher numbers of electrons need further orbits to accommodate them.

When electrons are moving in a current, they provide electrical energy. When atoms and molecules join together or separate, they are involved in chemical energy. Chemical change involves heat energy and individual molecules moving at random also involve heat energy. To give an example, when oxygen combines with another element heat energy is released in the process known as oxidation.

In terms of basic physics, we know that atoms contain electrons, protons and neutrons and that whilst atoms were once thought to be indivisible, it is obvious that this is no longer the case. In the present age, all sorts of sub-atomic particles with strange names, each with its own anti-particle, continually appear on the scene suggesting the existence of smaller and smaller particles moving at incredible speeds and buzzing with frenetic energy like a colony of hyperactive bees and often with a very short life. The result of the particle accelerator which split the nuclei of various atoms has resulted in some 200 or so of these being identified. These have been classified in many ways.

For the practical considerations necessary for dealing with basic glass processes, an atom is generally accepted, perhaps rather simplistically, to be the smallest part of an element which is able to become part of a chemical reaction. However, as the understanding of the role of sub-atomic particles becomes clearer this concept may well change.

A symbol such as B_2O_3 would indicate that each molecule of boric oxide contains two atoms of boron and three of oxygen. The ability of an atom to combine with different atoms is called its valency.

Aventurine glass. Aventurine glass is reputed to have been developed by the Venetians. Early examples are yellowish with a metallic sparkle. The first French experiments produced aventurine glass as a result of adding iron and/or fine brass turnings to the hot glass which was then covered with ashes and the air to the furnace turned off. After very slow cooling, the pot was cracked open to leave blocks of aventurine glass. Similar material was made in the USA by supersaturating a high lead glass with chrome oxide. Copper has also been introduced in a similar manner. If an excess of metallic oxide is dissolved into the glass to the extent that it is unable to stay in solution, crystals can be formed which are large enough to reflect light and to give the characteristic aventurine appearance.

AZCS. Similar material to **AZS** below but with the inclusion of 26% Cr_2O_3.

AZS. Trade name for fusion-cast alumina-zirconia refractory blocks originated by the Corning Glass Works and since developed with subsequent increases in the proportion of zirconium. There has also been an introduction of chrome-magnesia into the range of products and more recently a high specification 94% fusion-cast zirconia refractory. **See Fusion cast refractories**.

Azurite. Natural form of copper carbonate which is a bright turquoise colour. The other common natural form is malachite which is green.

B

Baccarat. Cristalleries de Baccarat was founded in 1764 in Lorraine and produced crystal from 1819. In the 19th century it was famous for its production of opalines and pressed bowls. In the early part of the 20th century geometric ware was made and current production includes both reproduction ware and modern sculptural pieces designed by various noted artists.

Back painting. The process of painting the exterior surface of stained glass to reproduce the softening effect which would normally result from the natural development of a patina on the surface of old glass.

Badger. Blender. Type of brushes used by stained glass artists for blending colour on the glass. They are available in many shapes and sizes but are unique in having split or forked ends to the hairs. This has the effect of giving the brush a very firm base with a light and flexible tip. They are rather expensive but with careful usage should last a long time. They can be used to stipple or matt the enamel and also to smooth it out. They would normally be used dry but it is often necessary when stippling wet enamel to dry the brush on the hand or a piece of wood.

Badging. The marking of glassware to indicate capacity, ownership etc. See **Acid etching**.

Bag wall. The wall used in a gas- or oil-fired kiln to deflect the flame away from direct contact with the ware being fired.

Section through a kiln showing a bag wall which protects pieces being fired from having direct contact with the flames.

Ball mill. A traditional machine for grinding natural or synthetic materials into a fine powder. It comprises a horizontal steel cylinder which rotates about its axis at a fairly slow speed in order to tumble the material together with flint pebbles, porcelain or hardened steel balls. These pebbles or balls should take up about one-third, water about one-tenth and the material to be ground about one-sixth of the volume. Smaller types use a porcelain jar and are often known as jar mills. If the material to be ground is soluble in water, then the water should be omitted and the grinding process carried out dry.

Ballotini. These are small spheres of glass produced mainly for use in chemical filtering processes, shot blasting and as grinding media. They are also used in glass casting, particularly in lost wax casting and pate de verre production where they prove excellent material for filling moulds. They are made in a wide range of sizes up to about 1500 microns and are normally available in both lead and soda-lime glass.

Balusters. English goblets which had particular stems. These were of considerable variety, some having knops, tears, twists and inversions, all giving rise to the name which originates from the vertical pillars in wooden staircases. The Newcastle light baluster is often noted as

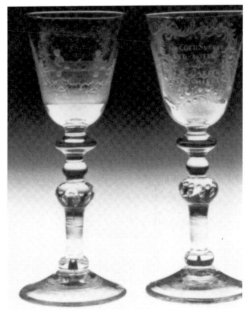

Two typical Newcastle baluster glasses with beaded knops and conical feet. *Courtesy of Cinzano. Photograph by Peter Balmer.*

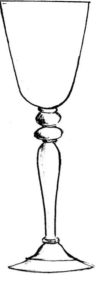

Newcastle-type balusters. These were goblets which were made mostly in and around the Newcastle area. The stems were shaped after the fashion of the wooden balusters found in staircases.

being the most elegant and beautiful drinking vessel ever designed. The bowls were often large, stems usually slim but with carefully contrived knops. Most of them were engraved with armorial or decorative designs, the engraving being of very high quality and frequently carried out in Holland.

Banding. There are two meanings to this. In decorating terms, it means the application of bands of enamel or lustre to blown forms. To the stained glass artist, it refers to the process of fixing copper wire to panels of glass.

Banding wheel. A steel wheel which is spun by hand and used for the application of bands of coloured enamels and lustres to glassware. It is often used for marking the horizontal bands to be used as a guide for engraving and cutting.

A banding wheel and indexing machine.

The rather more sophisticated version of the potter's banding wheel is known as a glass indexing machine and in addition to the turntable, it is fitted with a vertical slotted form which provides an accurate guide for the ruling pen. The indexing machine is really intended for use by the cutter or engraver but can also serve for the application of bands of lustre or enamel. See **Indexing machine**.

Bar. The name given to a rod made by fusing together several lengths of cane. A bar would be cut into sections for incorporation into paperweights or mosaics.

Baria. BaO. See **Barium oxide**.

Barilla. The ashes of a Mediterranean marsh plant which was burned to provide a high quality type of soda ash. It was exported to many countries for glassmaking. Many of the plants growing in the sea or in salt marsh conditions produce soda ash when burnt. Barilla was popular in Britain before the advent of lead glass which placed more emphasis on the use of potash as a secondary flux. Soda ash from barilla has now been almost entirely replaced by soda ash produced chemically.

Barium. Ba. A silvery element belonging to Group II of the periodic table. It is normally extracted from barytes (barium sulphate). The soluble salts of barium are extremely toxic.

Barium carbonate. $BaCO_3$. Used in batch as the major source of barium oxide. Occasionally mined as witherite but mostly produced from barytes (barium sulphate).

Barium oxide. BaO. Baria. A common flux, particularly in special glasses and latterly as a replacement for lead oxide when a similar refractive index is required. It is often used in optical glass. It is normally introduced to a batch in the form of barium carbonate as it does not exist as a natural mineral. It reacts readily with water and is unstable. Used on its own, it would only act as a high temperature flux but when used in combination with soda ash and potash as a frit, it is active over a wide range of temperatures.

Barytes. Barium sulphate. $BaSO_4$. This mineral is in plentiful supply and is the usual source of raw material for conversion to barium carbonate. It is often found in association with lead ores and with calcite and fluorspar. It became popular as a refining agent for a time but is rapidly being replaced by Calumite which is commercially prepared from iron furnace slag. It is extremely insoluble and as a result is not toxic as are most of the barium compounds.

Barytocalcite. $BaCO_3.CaCO_3$. A composite mineral containing both barytes and calcite. Like barytes, it is often found in association with lead.

Basalt. An igneous rock which contains about 50% silica as part of feldspars and similar materials. It is very dense and heavy and results from lava flow. It will melt into a glass which tends to be very dark because of its iron content and has found some limited use in coloured glasses. Some experimental work with this material has also been carried out in the field of glass-ceramics.

Base. A term often used in chemistry to refer to materials which are typically metal oxides, hydroxides or compounds which give hydroxide ions in aqueous solutions. A base will react to neutralise a protonic acid to form a salt and water. Bases are substances which accept or gain one or more protons.

Base ring. A separate glass ring added to the base of a glass vessel after the main part has been completed.

Basic furnace slag. This is a waste material from blast furnaces in the iron industry. It is re-cycled in many ways. It results from the flux introduced into a blast furnace to remove acid impurities in the ore. It usually contains some calcium silicate, phosphate and sulphate.

Perhaps its greatest use is in the making of cement and fertiliser but it has been used over many years in both the glass and ceramic industries.

Slag glass was made by the firm of Sowerby in Newcastle-upon-Tyne for many years but its major usage at the present time is not as a raw material or for the colouring properties resulting from its varied trace elements but as a fining agent which reduces the surface tension of molten glass because of the redox reactions of the sulphur. It is prepared commercially and is finding increasing use as Calumite. It has other valuable properties in that it can provide some alumina and calcia and it is claimed that it improves melting times. See **Batch**.

Bat wash. Material mostly used by potters over several thousands of years to stop glaze droppings from sticking to the kiln shelves. There are several materials used for this purpose; alumina hydrate mixed with a little china clay is the most common but many refractory materials mixed into a creamy liquid with a little clay to act as binder will suffice.

Glass workers using kiln shelves for casting and slumping tend to choose materials which will release cleanly from glass and leave a good surface. Materials such as whiting or dolomite are sometimes used in this context for glass forming, but it is important to realise that if the kiln shelves are then to be used for pottery production, particularly for stoneware, then whiting and dolomite are not suitable materials to use.

Batch. (The materials prepared for charging the furnace). The materials used as batch for making glass are of considerable variety. Those which are mentioned here are mostly those which might be used in a studio or small glasshouse.

Over several thousands of years, glass seems to have been made from sand, or ground siliceous rocks and natron (soda ash) or ashes from plants. The extent to which additions of lime, lead oxide, colouring materials etc. were added in ancient times is still a matter of debate. By the beginning of the 17th century, it is evident that batch composition was understood to the extent that such materials were deliberately introduced and that

there was a reasonably sound awareness of their function.

There are several glass formers (network formers) but the only ones likely to be used in normal glassmaking processes and even then not necessarily in the role of glass formers are: silicon dioxide (SiO_2), boric oxide (B_2O_3), and to a much lesser degree, phosphorous pentoxide (P_2O_5) and arsenic oxide (As_2O_3).

Silica is by far the most common of these. It is usually introduced as sand but can be included as part of a batch in the form of powdered feldspathic rock. It is normally used in proportions of between 50% and 80% of a batch. Sand for batch is now available to tight specification as it is important in most glass production that the supplies are relatively free from iron and chrome oxides. Whilst supplies of sand can be found which are sufficiently pure, much of it, particularly that found in Britain is now treated chemically in a hot acid leach process to bring it to the required standard. Boric oxide is the other common glass former but its quantitive role in the overall context of world glass production is minor when compared to that of silica. Its use is not strictly that of a glass former but it features very strongly in the production of specialist glasses, particularly those requiring high resistance to both chemical attack and to thermal shock.

Boric oxide, probably introduced in the form of borax, was used in glazes by the Romans, but was not used again to any extent in glassmaking until the mid-18th century when large deposits of suitable borax salts were discovered in California. It differs significantly from silica in that whilst it can form a glass on its own, it also acts as a flux and can be used to lower the melting temperature of a glass. Its main value lies in being a major constituent of most glasses with a low coefficient of expansion and whilst the normal soda-lime-silica type of glass will be likely to have an expansion of approximately 90×10^{-7}, the borosilicate type of glass used for scientific apparatus and for oven ware is more likely to be in the region of 30×10^{-7}. There are several sources of boric oxide. The most common are:

borax (hydrated borax)
borax (anhydrous)
boric acid
fused boric oxide

Hydrated borax contains approximately 36.5% boric oxide, 16.25% sodium oxide and 47.25% water. On heating, this soon turns to anhydrous borax which melts at 741°C (1365°F) to form a clear glass. Because of its high water content, it is bulky to store and to transport but it is sometimes introduced to a batch in this form because considerable amounts of steam are released during founding which are thought to assist with the stirring action in the melt.

Anhydrous borax (Dehybor, dehydrated borax, sodium biborate or sodium tetraborate) is generally preferred because its greatly reduced bulk makes for easier transport and storage. Both of the forms of borax contribute

boric oxide but also provide some sodium oxide to the melt.

Boric acid. This tends to be used when the alkali which is automatically introduced by using borax is not required.

Fused boric oxide. Used in similar circumstances as boric acid.

Arsenic oxide is a glass former but is almost always used in its capacity as a decolouriser and as a fining agent. Similarly, phosphorous pentoxide which is also a glass former is much more likely to be introduced for the production of opal glass.

FLUXES (NETWORK MODIFIERS). Fluxes are materials which react with other materials to reduce the melting temperature. Sodium oxide (Na_2O) is by far the most dominant fluxing material, particularly in the container and flat glass industry and is usually introduced as soda ash (sodium carbonate). It has been the traditional material to provide flux since earliest times being readily available over the years as the natural material natron and from the ashes of burnt seaweed. The ash from the Spanish plant barilla was a most popular source for several centuries and the term 'Barilla' is still used in some areas as the name for soda ash. It is now produced chemically, mostly from common salt (sodium chloride).

Natural soda ash from Wyoming has a small share of the UK market but it seems likely that material from the former East European states will soon appear on the market. It is a powerful flux which has a high coefficient of expansion.

Sodium sulphate (saltcake) was in common use in industry around the turn of the century both to provide sodium oxide and to act as a fining agent which would also help to remove silica scum. It was available cheaply from the manufacture of sulphuric acid but, though it survived for many years, its use declined for a time as a general preference for soda ash developed. It is now enjoying something of a comeback and is used as a refining agent in both the container and flat glass industries; its competitive price is now making it a serious competitor to soda ash as a source of sodium oxide. Caustic soda and borax are also used as sources of sodium oxide.

There are many plants throughout the world producing soda ash by the ammonia-soda process but there is still some mining of natural soda ash in various areas particularly in the USA and there are very large reserves available. As it is a relatively cheap material, it is usually introduced as sodium carbonate but it can also be introduced as part of one of the feldspars or combined with boric oxide as borax or other materials such as borocalcite.

Potassium oxide (K_2O) is the second most common flux and is normally used in conjunction with lead oxide in the crystal industry. It is also used in optical glass. It is normally introduced as potassium carbonate (potash), but sometimes potassium bicarbonate and potassium nitrate are used. Potash was produced traditionally from the ashes of plants but has recently been manufactured from potassium chloride which is available naturally in large quantities. It has a lower expansion coefficient than soda ash and is sometimes introduced into a batch as a replacement for some of the soda ash in order to modify the expansion of the resultant glass. It also produces some different colour reactions when used with particular colouring agents. It is available in both hydrated and calcined forms.

Potassium nitrate tends to be used as a refining agent rather than as a source of potash and is avoided in most production because of the creation of noxious fumes.

Lead oxide is a strong flux which had a very minor role in glassmaking until the early part of the 17th century when it was developed as a major flux for quality glassware by George Ravenscroft. It provided low melting and working temperatures, greater brilliance and density, a longer working time and a glass which could be readily cut and polished. In addition to its valuable qualities as a flux, it also acts as a stabiliser. Because of its resistance to radiation, it is used in proportions as high as 90% in glass produced for the nuclear industry. It was normally introduced as red lead (Pb_3O_4) or as litharge (PbO) but latterly, because of the growing concern about exposure to toxic materials, there has been a move towards the use of the various lead-silicate frits in making up batches for crystal production.

Lithium oxide (Li_2O) is often introduced to accelerate the melting process, usually taking the place of some of the soda ash. It is interesting to note that the total amount of flux required becomes reduced by incorporating lithia and that the actual melting and working temperature is also reduced. It is more expensive than most of the other fluxes so it tends to be used mostly for specialist glass production. It is often introduced as part of one or more of the lithium feldspars but latterly, because of the necessity for more exacting specifications, lithium carbonate is coming into greater use. It is also gaining increased use as a nucleating catalyst in the production of glass ceramics. Its principal source minerals are petalite ($Li_2O.Al_2O_3.8SiO_2$), spodumene ($Li_2O.Al_2O_3.4SiO_2$), lepidolite, aluminium fluosilicate and aluminium fluophosphate.

STABILISERS. Stabilisers have the effect of increasing the resistance of the glass to the actions of decay and to devitrification.

The principal stabilising network modifier is calcium oxide (CaO) and it is produced mainly from limestone or limespar. This is mostly calcium carbonate and is in plentiful supply though, as is the case with sand, much of it is contaminated with iron. Most of the calcium carbonate used in Britain comes from Derbyshire and this is high quality material.

It is commonly introduced into the batch as calcium carbonate but in some areas where long distance transport provides an element of concern with cost, it is calcined into CaO which is much less bulky. It can be used

in proportions as high as 10% in commercial glasses but in quantities over 5% it starts to shorten the working life of the metal so many studio glassmakers often replace it in part with zinc oxide to give a longer working time. In proportions above 10% it tends to promote devitrification. When the batch can accommodate some magnesium oxide, the calcia can be introduced as dolomite. Magnesium is also a stabiliser and if required without the calcia, it can be introduced as magnesium carbonate mined as magnesite or manufactured from sea water or as magnesium oxide. The additions of magnesia resulting from the use of dolomite as a source of calcia are very useful in inhibiting devitrification. High quality calcium carbonate is being produced as arragonite from the sea bed off the USA. It is also introduced with Calumite, made from blast furnace slag having a calcia content of some 35% to 40%.

Barium oxide (BaO), usually introduced as barium carbonate, is found naturally as the mineral witherite but it is normally produced from barytes (barium sulphate) which is available in greater quantities. It is used for optical and special glasses but is becoming popular as a replacement for lead oxide in cut glass, goblets and similar ware for which a high refractive index is required. When the dangers of using lead in both ceramics and glass production became an area of greater concern and legislation two or three decades ago, many glassmakers turned to barium carbonate as a substitute. In fact, barium carbonate is every bit as toxic as lead.

Strontium oxide has found a particular niche as a component in the manufacture of colour television tubes where it is rapidly replacing barium oxide.

INTERMEDIATES. From a technical point of view, these comprise alumina (Al_2O_3), zirconia (ZrO_2), titania (TiO_2) and stannic oxide (SnO_2). The only one of these which is relevant in this context is alumina as the others are more likely to be used in a studio situation for their opacifying qualities. Alumina can either be introduced as the powdered materials: hydrated or calcined alumina; as one or more of the many feldspathic or feldspathoid rocks of which it is a part, or latterly as one of the constituent materials of blast furnace slag and Calumite which is being used increasingly as a refining agent. Whilst the feldspars and feldspathoids contain alumina many of them unfortunately also have an iron content which is too high for them to be of practical use in most glasses. Those which have been found to be most suitable are appropriate samples of feldspar such as nepheline syenite, nepheline being the principal source of alumina in the British glass industry at the moment.

When the iron content is not critical, as in production of some coloured glass, alumina can be introduced as part of such materials as pegmatite, pumice, phonolith and petalite.

Alumina has many uses in a batch. It resists devitrification and added in small quantities reduces the melting point of soda-lime-silica glass. It can be present in quantities up to 7% in these glasses fulfilling a role as a stabiliser but over this proportion it has the disadvantage of beginning to increase the viscosity of the melt and making founding more difficult. It also has the effect of making the glass difficult to work. The normal proportion is likely to be in the range of 1-2%. It is used in conjunction with boric oxide to produce the high alumina glasses which are used in situations where a high resistivity to attack by alkali vapour is required.

REFINING AGENTS. Refining agents often perform dual roles as accelerators or as decolourisers. They provide increased homogeneity by providing a stirring action in the melt and reduce seed by producing large bubbles which collect the small ones on their way to the surface. Arsenic oxide has been the accepted refining agent for many years but it has now been replaced to some extent by antimony oxide, both of them being used in conjunction with nitre. Slag from blast furnaces processed and marketed as Calumite is also becoming very popular, particularly for sheet glass and similar applications where the iron content does not prove too much of a problem. It is often used in conjunction with anhydrite. Sodium sulphate (saltcake) and barium sulphate both enjoyed some popularity as refining agents in the past but saltcake is the only one used to any great extent today.

Perhaps the least likely batch material would seem to be water yet this has been added in various proportions to aid mixing and to prevent segregation. In Britain the sand has short haulage runs and is normally delivered with a water content of between 5% and 7% whereas in the USA, it tends to be delivered dry because of the longer distances and consequent higher costs. Some glassmakers aim to have a batch with a water content of 4% on mixing and ready for founding.

Batch and cullet melting. Most studio glassmakers melt their glass from cullet (pieces of broken glass) rather than by the normal commercial practice of using approximately 30% cullet to 70% batch. Whilst cullet melting is a relatively straightforward process, it is important to understand the various events involved in batch melting as many aspects of this relate to both methods and give a greater awareness of the nature and behaviour of the material.

The quality of the glass which the glassmaker usually seeks to achieve is one which:

1. Is free from cords, stones and seeds
2. Is clear, bright and stable.
3. Has long working properties.
4. Is compatible with the available sources of coloured glass.
5. Melts at a reasonably low temperature.

When melting batch or a cullet/batch mixture, the first essential is to select the necessary materials to achieve the qualities outlined above and to calculate the various

quantities required. The next step is to ensure that the materials are mixed very thoroughly. The importance of this cannot be overstressed. Even when dealing with the small quantities required for a small studio furnace, the materials need to be placed into a container which is sealed and rotated for at least an hour to ensure a homogenous mixture.

The particle size of the material, particularly that of the sand, is also important as it makes a considerable difference to the time taken to achieve a good founding. A high proportion of large-sized grains extends the time-temperature factor and can easily lead to the production of batch stones from unmelted material. Further improvement to this can be made if the batch is introduced in reasonably small quantities rather than in one large amount. The procedure in this case is to introduce a quantity of the batch/cullet mixture at an appropriate temperature, usually between 1000°C (1830°F) and 1200°C (2190°F) depending on the type of glass. When this has melted, produced an even surface and the furnace has recovered its temperature, the next charge is introduced. This may seem to be a time-consuming operation but it cuts down the overall founding time and is much more likely to produce good usable glass. Introducing the batch in one large amount often requires a higher temperature and a longer period of time at the end of the founding in order to achieve similar results.

REACTIONS WITHIN THE FURNACE. With a typical soda-lime-silica glass the sequence of events is as follows: At 100°C (212°F) any batch moisture begins to evaporate. Between 500°C (932°F) and 850°C (1560°F), the soda ash releases its carbon dioxide and forms a liquid which reacts with the grains of sand, gradually dissolving them into the liquid. About 900°C (1650°F) the calcium carbonate starts to decompose and at about 1200°C (2190°F) reacts with the liquid formed by the action of the soda ash on the sand. By 1300°C (2370°F) the glass should be well formed and the action complete but it could probably contain seed.

In a lead glass the events would be similar except that they would take place at relatively lower temperatures. Lead oxide and potash would take the place of the soda ash and calcia, if present, would be in much smaller quantities.

Seed occurs because various volatiles are released during the founding (see **Defects**). They are removed by a process of Fining (see **Fining**). The very small bubbles are the most difficult to remove so the process of fining is achieved by the combination of varying the temperature in order to increase and decrease the density and viscosity, and by providing a source of large bubbles which collect the small ones as they rise to the surface. Calcium fluoride added in small quantities (0.5%) as one of the fining agents helps the bubbles to come to the surface by reducing the viscosity of the melt. Unfortunately, it also releases a corrosive emission into the atmosphere.

An addition of 0.04% arsenous oxide plus 1% of nitre works by releasing quantities of oxygen late in the firing which makes the bubbles more readily absorbed into the melt. Arsenous oxide is a very poisonous material so it is usually introduced in the form of arsenic acid. As arsenic is a high temperature fining agent, many people use antimony as a replacement. One experienced studio glassmaker who is very conscious of the dangers of toxic dust mixes his batch complete with the nitre and then divides it into the amounts he intends to introduce at each charge. He estimates the amount that will melt down in about 30 minutes and then allows a further hour for the furnace to recover its temperature before the next charge, occasionally helping things along with a bit of mechanical stirring. He then introduces his antimony oxide with the last charge. By using this method he reckons to use much less antimony oxide, thus reducing the possible exposure to toxic dust and also maintains that he does not need to take his furnace to such a high temperature on completion.

There are various other fining agents described under **Batch materials**. The last part of the fining process is called conditioning and consists of reducing the temperature of the furnace to about 100°C (180°F) under the normal working temperature for about an hour before raising it again in order to start work. This helps to take any remaining seed into solution.

PELLETISED BATCH. This material has been in use for several years but is now available for small operations and is proving a popular replacement for cullet which has become difficult to obtain in consistent quality. Philips of Eindhoven have been responsible for marketing the pellets in the quantities which make this possible. It is simply batch which has been processed into pellet form and sold pre-packed in drums for easy transport and storage. There is considerable advantage to be gained as the material is consistent, there are no exposed toxic materials, there is no dust problem, the supply seems to be regular and secure and it is relatively easy to melt. Against this, it is undoubtably more expensive than cullet and batch but most people who have changed to its use seem to think that it is well worth the extra cost. The range of recipes available in these pellets has been gradually increased and Philips are willing to make up pellets to customer specification. They are also now producing them in a range of lead and cadmium-free coloured glasses.

CULLET MELTING. This is a much less complex process than melting batch but in addition to the obvious advantages there are also some difficulties. Firstly, the cullet must be of the same material as it is almost impossible to make a good homogenous glass from different kinds of cullet without adding sufficient batch to provide the necessary stirring and fining action.

The cullet must be clean. Bits of metal and rubbish must be removed. It is essential that the cullet is washed to remove dust and small particles which are likely to cause the formation of seed. As there is no in-built fining

action with cullet, it sometimes becomes necessary to resort to the old trick of introducing a large potato on the end of a bit of iron. This releases large quantities of steam which bubble up through the melt collecting the fine bubbles on the way. The advantages of cullet melting are that there is no involvement in handling toxic material, the melting temperatures are not so high and there is not the same problem of chemical attack on the furnace materials. The main drawback is that it is not always easy to achieve good glass.

Batch calculations. It will be evident from the notes on batch materials that whilst the various oxides affect the nature of the glass, most of them are introduced in the form of carbonates and some as nitrates and silicates. This means that there is a considerable release of gas, mostly of carbon dioxide, during the melting process. In order to arrive at a weight of raw material to provide a particular amount of oxide, it is necessary to refer to the appropriate conversion factors. These are listed in the appendix on tables (see page 224).

Materials such as silica are a straightforward conversion as one kg (2.2 lb) of sand provides one kg (2.2 lb) of silica whereas many of the other materials are rather more complex. Feldspar is an obvious example. For convenience it is often presented as containing one part of alumina, one part of sodium oxide and/or potassium oxide and six parts of silica. In fact, the material varies considerably from these approximations; small quantities of other materials are often involved and the iron content can be crucial if colour is an important factor. For the purpose of calculation, a potash feldspar would be seen as requiring 5.91 kg of raw material to provide 1 kg of K_2O, 5.46 kg of material to provide 1 kg of alumina and 1.544 kg of material to provide 1 kg of silica. Using the alternative conversion factors, i.e. material to oxide, it can be seen that 1 kg of potash feldspar would provide 0.169 kg of K_2O, 0.183 kg of alumina and 0.648 kg of silica.

The calculations are relatively straightforward but take a little practice and care. To use a simple example: A glass requiring 70% SiO_2, 23% Na_2O, 5% CaO and 2% Al_2O_3, could be converted to a batch recipe as follows:

70% of SiO_2 x conversion factor of 1.00 = 70.00 kg of sand
23% of Na_2O x conversion factor of 1.710 = 39.33 kg of soda ash
5% of CaO x conversion factor of 1.785 = 8.925 kg of limestone
2% of Al_2O_3 x conversion factor of 1.00 = 2,000 kg calcined alumina

To reverse the process, a glass batch composition would be converted to the oxide percentage by using the other conversation factor (batch to oxide):

70.000 kg of sand	x conversion factor of 1.00	= 70% SiO_2
39.330 kg of soda ash	x conversion factor of 0.585	= 23% Na_2O
8.925 kg of limestone	x conversion factor of 0.56	= 5% CaO
2.000 kg of calcined alumina	x conversion factor of 1.00	= 2% Al_2O_3

Unfortunately, most glass compositions are not as simple as those examples so two examples of calculations relating to current glass recipes are as follows:

Batch for full crystal

Sand	57.0 kg x conversion factor of 1.00	= 57.00% Si_2O
Soda ash	6.0 kg x conversion factor of 0.585	= 3.51% Na_2O
Potash	14.8 kg x conversion factor of 0.682	= 6.82% K_2O
Potassium nitrate	4.0 kg x conversion factor of 0.466	= 1.68% K_2O
Litharge	31.0 kg x conversion factor of 1.00	= 31% PbO

It can be seen from the example above that in the simple soda-lime-silica batch in the first example, much of the soda ash has been replaced by potash which is the normal practice in lead glass. There is no calcia as the lead oxide acts as both flux and stabiliser.

Batch for a 25% lead glass to fit Kugler-type colour is:

Sand	60.2 kg x factor of 1.00	= 60.20% SiO_2
Soda ash	4.0 kg x factor of 0.585	= 2.34% Na_2O
Potash	14.8 kg x factor of 0.682	= 10.09% K_2O
Sodium nitrate	2.0 kg x factor of 0.365	= 0.73% Na_2O
Limestone	1.8 kg x factor of 0.560	= 1.00% CaO
Antimony	0.3 kg x factor of 1.00	= 0.30% Sb_2O_3
Litharge	25.0 kg x factor of 1.00	= 25.90% PbO

A glass which is leadless, good for working and fits most of the Kugler-type colour is:

Sand	210 x factor of 1.00	= 210.00 SiO_2
Soda ash	88 x factor of 0.585	= 51.50 Na_2O
Limestone	10 x factor of 0.56	= 5.60 CaO
Barium carbonate	12 x factor of 0.777	= 9.32 BaO
Zinc oxide	12 x factor of 1.00	= 12.00 ZnO
Anhydrite	2 x factor of 0.41	= 0.82 CaO

The example above relates to a particular batch of 334 kg so to bring the formula figures to percentages it is necessary to total them and then divide each item by the total and multiply x 100. Thus, the amounts in the right hand column total 289.24. The percentage of silica in the recipe would be (210 divided by 289.24) x 100 = 72.6%. The percentage for Na_2O would be (51.5 divided by 289.24) x 100 = 17.8.

The example of the batch above is a useful one for modifying bottle cullet. When used in this context the limestone could be left out as this would have the effect of reducing the overall CaO content, the amount present in bottle cullet being too great for hand working.

In all the calculations given above kg are used as examples but as all the amounts are proportional they could just as easily be calculated as referring to pounds, cwts or tons.

Batch for modifying bottle cullet. The difficulties which trouble studio glassmakers seem to be largely those which relate to being paid for work, paying for and

maintaining working premises and equipment, the cost of fuel and obtaining good cullet at a reasonable price. There is little to suggest about the first except that perhaps there should be a system of putting persistent non-payers into orbit. The second seems to be one of those expenses endowed with a built-in capacity for steady increase. The third can be improved greatly by good design, efficient controls and very good insulation. The last one seems to be a permanent problem. If it is necessary to have cullet which has all the necessary qualities, then there is little alternative but to search around and to be prepared to pay for it.

Several glassmakers have turned from time to time to bottle cullet which at least is cheap and plentiful. The main problem is not, perhaps surprisingly, one of compatibility as most commercial bottle production seems to be within a reasonable range of expansion for Kugler-type colour, but with the fact that the basic glass is really designed for machine production and because of this, has a very short working life.

At a hot glass conference at the Royal College of Art some years ago, it was suggested that additions of between 3% and 6% of soda ash should be mixed with the cullet for at least half an hour before charging. A more likely solution comes from a French formula which suggests that for 40 kg of cullet, there should be an addition of 2.4 kg of borax, 3 kg of soda ash, 2.8 kg of feldspar, 1.2 kg of baryta, 100 g of manganese dioxide being added as decolouriser.

Most bottle cullet contains between 8% and 9% of calcia and this is very high for a hand-working glass so the real problem is to drop this to about 5%, replacing the calcia with zinc oxide or magnesium oxide if necessary. It should be obvious that to do this successfully, a much larger amount of batch must be added than that suggested by the previous two examples. In fact, the weight of batch would need to be at least that of the cullet which means that the whole exercise then becomes one of considering a batch/cullet founding. The batch could be a simple soda-lime-silica recipe with the limestone omitted and replaced by about 2% or 3% of either zinc oxide or magnesium oxide. A suitable batch is given under **Batch calculations**.

It must be evident that if bottle cullet is to be used, then it is largely a matter of deciding what is acceptable. The cheapest solution would be to use it as it comes and accept the difficulties of constant re-heating whilst working the glass. The French formula would certainly make a considerable difference but if a full modification of the working properties is essential then there is little alternative to making up an appropriate batch.

Bats. Refractory shelves used in kiln firing. They are normally made from pressed, high alumina clay but the better quality products are made from sillimanite or silicon carbide. The term is also used in a general sense to cover sheets of plywood, lengths of wood etc., which are used for bases for moulds.

Battledore. A rectangular wooden paddle with a handle used by the glassmaker at the chair for smoothing the bases or levelling the tops of glass vessels. Many glassmakers cover the face of the paddle with wet newspaper.

Bauxilite. Abrasive material made from fused bauxite, see **Abrasives**.

Bauxite. $Al_2O_3.2H_2O$. The major mineral source of aluminium oxide. This is a relatively soft form which is easily ground down to powder. It is also used for the production of aluminium. Similar minerals used for the same purpose are gibbsite and diaspore.

Beads. Beads were among the first objects made in glass and are thought to have appeared initially in the 3rd millenium BC. They almost certainly developed from the faience beads which had been produced throughout the Middle East over many earlier centuries. It seems likely that the faience beads evolved from the process of casting copper as the waste slag would inevitably contain similar material. The substance known to potters as 'Egyptian paste' would be similar to some of the waste slag. A controlled method of making faience developed in which the soluble glaze materials migrated to the surface during drying to turn into a thin glaze during firing. It is likely that this in turn led to the development of glaze as we know it today and many centuries later probably suggested the possibility of the production of glass as an independent material. It is interesting to note that in the Bronze Age very skilfully made faience beads made from sintered quartz were produced in Scotland.

When beads started to be produced in glass rather than as faience, they became very popular and for many years they were traded over a wide area. The early ones tended to be opaque but transparent pieces eventually appeared and a reasonable colour range emerged. Turquoise blue, bright violet, dark green, leaf green, bright yellow and sealing wax red were found from fairly early times.

The Egyptians produced some beautiful mosaic beads which were thought to have been made by using sections of mosaic rods which were ground and polished and then bored as necessary. Beads were also produced in China as early as 1120 BC and, much later, considerable quantities were produced by the Venetians.

Bearings. In terms of glassworking machinery, these can be critical. For most purposes, good quality ball or roller bearings work very well but for various types of glass lathes, solid bronze bearings coupled with hardened shafts are often preferred as even the slightest source of vibration is best avoided.

Bearings must always be kept clean and well-lubricated. Powdered glass or abrasive particles will soon wreak havoc if allowed to come into contact with bearing surfaces. Sealed bearings can be useful in this context but

it is still important to ensure good lubrication and to maintain cleanliness.

'Sealed for Life' bearings are available. These may appeal as a possible solution to the abrasive dust problem but some sceptics offer an opinion that the term is

Double row, cage-type, self-aligning ball bearings.

Cage-type thrust bearings.

Split plain bearings with replaceable inners.
Photographs of bearings by courtesy of Bearing Services Ltd.

also a recipe for short life and built-in redundancy. They are, however, usually fairly easy to change and are relatively inexpensive, so they are probably a better buy than those which are relatively open to contamination by the abrasive materials likely to be used in glass grinding and polishing operations.

There are several types of bearings. The most common of these are:

Cylindrical roller bearings. Suitable for high radial loads.

Taper roller bearings. To carry both radial and axial loads.

Spherical roller bearings. Suitable for high radial loads in situations where some flexibility in the shaft must be accommodated.

Single and double row ball bearings. These are the most popular form of bearing and take both radial and axial loads.

Self-aligning ball bearings. These are similar to the above but have a considerable advantage in being able to adjust automatically to minor variations in the shaft alignment.

Thrust bearings. These are essentially for taking an axial load and must not be used to accommodate radial loads.

Self-lubricating bearings. These are very popular and inexpensive and are available in a number of different designs. They are pre-lubricated with a low temperature grease but many of the designs are also provided with a grease nipple for further applications when necessary.

All of the above can be supplied with built-in seals to keep out dust and abrasives. Plummer blocks are available to accommodate the above bearings and most of them can be supplied pre-fitted into the blocks for ease of assembly.

Plain bearings, usually of impregnated bronze, are available for situations where an absolute minimum of vibration is required. They are usually used in conjunction with a hardened steel shaft to ensure that any wear will take place in the bearing which can easily be replaced rather than in the shaft which could be more difficult and more expensive.

Split bearings are forms of plummer blocks which can be split into two halves and which are fitted with split brass or bronze liner bearings. They are used in similar situations to the above but have the big advantage of being very easy to change because nothing else on the shaft needs to be disturbed.

Recent additions to the range of bearings are those made from various plastic materials. Nylon and polypropylene are common and PTFE (polytetrafluoroethylene) which offers particularly low friction is gradually becoming more popular.

Beeswax. Used in solid block form for lubricating pucellas and similar glassblowers' tools. Many glassmakers melt the beeswax together with a little resin and other materials such as carnauba wax to develop their own personal formula.

It is also used in many resist formulae and in the process known as waxing up which is when the sections of glass for a stained glass window are laid out on the table. They are joined by dropping heated beeswax from a copper- tipped tool into the small gaps between the pieces. This enables the joined sections to be held upright so that colour and design can be checked before proceeding further. See **Stained glass**.

Beilby. The Beilby family of Newcastle-upon-Tyne developed the art of enamelling on glass, uncommon in Britain until that time, to considerable heights.

William Beilby learned the art of enamelling at Bilston in the Midlands and started to produce his own work in about 1762. His father was a noted silversmith in Durham but as the family business collapsed, William had to give up his apprenticeship in Bilston and return to Durham. Together with his younger brother Ralph, he

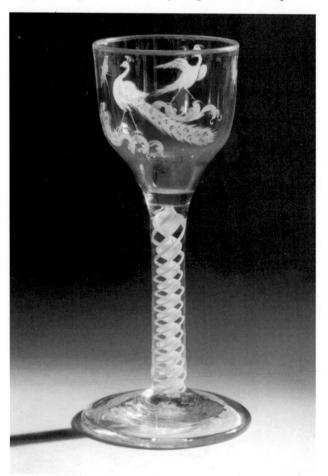

Wine glass produced by the Beilby family of Newcastle upon Tyne. It is decorated with white and pale blue enamel and has a double series opaque white twist stem, height 16 cm *c.* 1770. *Courtesy of Pilkington Glass Museum.*

eventually managed to set up an engraving business in Gateshead but his experience in enamelling and the development of the glass industry on Tyneside soon lead him into experiments with enamelling on glass. Much of his early work was in a thin white enamel and its success was a considerable achievement because he had to operate with a crude muffle constructed over the glory hole in one of the factories.

In addition to the work he carried out on glass, he also became a watercolour artist of some standing and much of the work that he produced in Fife and in Northumberland is still in evidence. He was a cultured person with an excellent command of both French and Latin.

When he established his glass enamelling business, he was joined by his young sister Mary whose early work consisted mostly of scrolls, floral work and pastoral scenes. Together they worked mainly on goblets. Later work expanded to include pastoral scenes, armorials and motifs commonly found on engraved ware and were perhaps, influenced to some extent by a brother, Thomas Beilby, who was experienced in heraldic engraving. The early work was often white or white with coloured tints but it gradually developed into the production of very well-controlled colour and gold. They were lucky because their movement into enamelling coincided with the emergence of the Newcastle light baluster, one of the most beautifully balanced goblets ever to have been produced. Many of their goblets had white twist stems. A late influence on the Beilbys was that of Thomas Bewick, an excellent draughtsman and engraver, who eventually took over the firm after the break up of the family in 1778.

For those interested in the work of the Beilby family, there is an excellent book *A Beilby Odyssey* by the late James Rush, published by Nelson and Saunders. He also wrote *The Ingenious Beilbys*. In addition to an interesting account of the life and work of the Beilby family, it also gives a graphic and fascinating picture of the early development of glassmaking on Tyneside.

Bentonite. This is extremely fine clay-like material formed from decomposed volcanic ash which can be added in small quantities to the fireclay used for making glass pots to improve its plasticity. It is really one of the montmorillonite group of minerals rather than a clay though it is often described as such.

Most of the available supply comes from North America but there are deposits in other parts of the world. Montmorillonites have a different molecular structure from that of kaolinite where the weak hydroxyl bonds join the layers of gibbsite to the layers of silica. There are no hydroxyl ions available on the outside of montmorillonites where all the outside surfaces are occupied by the oxygen atoms of the silica molecules. This results in very loosely bonded layers which slide easily and have a greasy nature which makes bentonite such an attractive lubricant for the oil drilling industry. The fact

that there are no hydroxyl bonds between the layers also means that bentonite can absorb large quantities of water without becoming a liquid, simply swelling to a mass of greasy material.

Beryl. A mineral form of beryllium aluminium silicate and the main source of beryllium. It is found as white, yellow, green or blue crystals, some of which are used as gemstones. Aquamarine is a popular form which, when stained with chromium, becomes the more valuable gemstone known as emerald.

Beryllium oxide. BeO. An alkaline oxide which acts as a high temperature flux but is rarely used in standard glassmaking processes because of the expense and its toxicity.

Bevelled glass. Glass which has been chamferred and polished along its edges. The effect is commonly used on mirrors.

Bi. The usual term to indicate a combination of two atoms or two molecules. It can also indicate an acid salt, e.g. sodium bicarbonate.

Bicheroux process. An intermittent process introduced at the end of the First World War in which the glass was poured from a pot and passed through rollers to produce a long ribbon of glass which was cut by guillotine into sheets suitable for grinding and polishing into plate after they had been annealed. It offered the advantage that much smoother plate was produced than was previously available and much less grinding and polishing was required.

Binders. These are numerous and varied. They are used as vehicles to bind together the painting and matting materials used in stained glass. The most common is gum arabic but others which are often used are: casein, Venice turpentine, emulsion, methyl cellulose and even sugar solution. They all have their own characteristics in use and most stained glass artists experiment until they find something which best fits their own personal type of work and method of working. Binders are also used in enamels and lustres but tend to be of aromatic oils and/or resins.

Biotite. Mica. The name for a number of alumino-silicates related to the montmorillonites. They have a large crystalline structure which allows them to be cleaved into fine and often almost transparent sheets. Such sheets were used as windows before glass sheets became available.

Biscuit. This refers to the firing of ceramic material to a state where it is solid but remains porous. For the potter it is material which is prepared to a condition in which it will accept a glaze. Moulds made from clay which are to be used for glass casting or slumping are often fired to a similar temperature.

Bismuth. Bi. A white crystalline metal often tinged with pink and belonging to the Group V of the periodic table. Often used to form low-melting metal alloys.

Bismuth oxide. Bi_2O_3. Rarely used as a flux but is commonly used in the manufacture of lustres where it gives a 'Mother-of-Pearl' effect. It is also used as a carrier for other lustre-forming materials. The metal is usually produced from ores associated with lead, tin and copper. When polished, it resembles silver. It is sometimes used in metal alloys. It is currently being investigated as a substitute for lead in crystal glasses.

Bit gatherer. The glassworker whose job as part of a team is that of gathering the small bits of glass for attaching to work in progress.

Bit irons. Lengths of steel rod used to gather small amounts of glass from the furnace to attach to work in progress. Glass for the stems and feet of goblets, handles etc. would be gathered by using a bit iron.

Bits. Small gathers of glass used to attach to the parison to make prunts, stems, knops, handles etc.

Bitumen paint. Used as a resist for acid etching techniques. See **Acid etching**.

Black bottles. These were reputed to have been first made in Britain in the 17th century and were actually dark green or dark brown. The dark colour was intended to protect the contents.

Blacks. The glass removed from a blowing iron or pontil often has iron particles or even flakes of iron oxide in it. The pieces are known as 'Blacks' or 'Black Moils' and when cullet is bought from a factory, these pieces need to be separated from the clean cullet to avoid contaminating the melt. If it is found to be necessary to use them, they can be immersed in hydrochloric acid which has the effect of separating the iron from the glass.

Blanks. (1) Any piece of glass prepared for further working.
(2) A parison or preliminary gather shaped ready for finishing.

Blast furnace slag. Blast furnace slag is material of considerable variation but can be used in several ways in glassmaking processes. It can provide a number of major constituents and it can act as a colourant but its major use is as a fining agent which reduces the surface tension of the molten glass by the redox reaction involving the sulphur in the slag. It is processed commercially and sold to the industry as Calumite. See under **Basic furnace slag**.

Blaze. The name for a pattern of parallel lines in cut glass.

Blister. Any large, gas-filled bubble in glass. They are often created during kiln-forming processes when material releases gas in the firing which then becomes trapped between layers of glass. They can also be formed as air pockets when pieces of glass have been fused together. The air tends to expand into the soft glass to form blisters.

Large blisters formed in glass because of the action of expanding trapped air.

Bloating. A fault which tends to occur in clay-based refractories and bricks in the initial firing. It takes the form of blisters often opening out into cracks which develop because of the expansion of air pockets or by the formation and expansion of gases which cannot escape.

Blobbing. The action of dropping blobs of molten glass onto the surface of vessels to provide a decorative effect.

Blocks. Hollowed wooden blocks with a hemispherical recess fitted with a handle and kept wet, and used by the glassmaker for producing a uniformly centred gob of

Blocks. These are wooden blocks carved out to a hemispherical shape and used by glassmakers at the chair to shape gathers into a central, suitable shape for blowing. Many glassmakers use a handful of wet newspaper instead of the wooden blocks.

glass from which to form a parison. Many glassmakers use a wad of wet newspaper held in the hand as a substitute for the blocks. They are usually made from fine grained hardwood which will burn to a fine charcoal finish. Glassmakers in industry who blow most of their glass into moulds often use blocks rather than the marver.

Bloom. The dulling of the glass surface when it is affected by smoke or fume.

Blowing. The process of introducing air into glass for the purpose of forming hollow ware.

Some historians place the discovery of blown glass between 27 BC, and AD 14 in the region in or near Syria. It then developed quickly into Rome where factories became established and into Greece and other lands bordering the Mediterranean. From there it spread throughout Europe.

In industry this has become largely a complex automated process whilst what is known as the 'handmade' sector has faded rapidly because of the expense and is now almost wholly confined to the production of quality crystal or of products which need to be made in smaller quantities than would merit the setting up of suitable mechanical processes. In the studio or small workshop situation, all the pieces tend to be made individually and are 'free-blown'. A more common term for this is 'off hand working'. Articles can be formed completely at the glass maker's chair or they can be made largely by blowing the molten glass into moulds and by then completing them at the chair.

It is a craft which has its own demands which do not relate easily to any other activity. For the beginner, perhaps the greatest difficulty is one of developing a constant awareness of the condition of the glass on the end of the blowing or punty iron. It is easy to become frustrated by trying to blow or work the glass when it is too hot and soft or by allowing the glass to become so cool that it simply will not work or shatters when it is re-introduced into the furnace for a subsequent gather. It is essential to form a habit of constantly rotating the iron with the fingers so that however the glass is formed on the end of the iron, its form is retained and truly centred. With this in mind, it is a good idea for the beginner to have a short length of rod constantly available and to practice rotating this whenever possible so that the movement becomes completely natural.

The first part of the actual process is to heat up the end of the blowing iron to a dull red heat prior to introducing it to the glass in the furnace. This can be done at the furnace mouth if a special area is not provided. If the iron is of plain steel, it should not be heated to a red heat or it will tend to form scale which could drop into the molten glass. Most modern blowing irons have chronite ends and can be safely taken to red heat without creating scale.

Glassmakers tend to have differing concepts about collecting a 'gather' or 'gob' on the end of the iron. The

popular method of making the initial gather is to rest the iron on a pig or on the edge of the gathering port and to place the tip on to the surface of the molten glass, commonly called 'Metal'. It is then dipped slightly into the glass and whilst rotating it slowly, drawn back towards the furnace mouth so that the glass tends to be picked up with the major part of the material away from the end of the iron. The theory behind this is that by working this way there is less likelihood of glass entering the tube and causing some difficulty in forming an initial bubble. On the other hand, many glassmakers working in a factory simply plunge the iron in to the required depth and rotate it to gather sufficient glass for the size of the initial gather needed and proceed from there.

When the iron is lifted out of the metal, the iron should still be turning slowly and the trail should come from the end of the gather rather than from the side. It must be rotated constantly and pointed slightly downwards as it is taken towards the marver. Initially, a gather will almost certainly be uneven but with practice it becomes possible to control this process to the extent that the gather will be suitably round and even everytime.

The next step is to 'marver' the glass on a marver plate which consists of a flat and polished slab of cast steel. The gather is rolled on to this plate to make it symmetrical, to shape the gob of glass so that it is largely off the end of the iron and to chill the surface of the gather slightly to give some resistance when blowing. Rolling needs to be slow but long and without undue pressure using the full extent of a flat hand on the iron. Beginners tend to think that they only need to roll the iron back and forward in short jerky movements but this only results in producing a series of flat faces on the glass.

It is important that the surface of the marver is kept scrupulously clean. Any dust collecting on it and picked

A glassmaker using blocks to centre and form the gather.

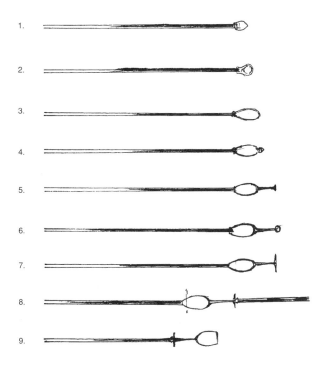

Blowing processes. The stages in making a goblet. In a studio or small workshop these stages are normally carried out by the glassmaker alone or with an assistant. In an industry, the operation would be carried out by a team or 'chair' with different workers being responsible for various stages.

The servitor takes a gather of glass (Figure 1) and blows a small bubble into it (Figure 2). By swinging the glass and with further blowing he forms the glass to the right shape and size (Figure 3). The bit gatherer then gathers a small amount of glass to attach to the base (Figure 4) which the servitor pulls out with the pucellas to form a stem (Figure 5). The bit gatherer gathers another blob of glass which is attached to the base of the stem (Figure 6) and the servitor then uses a hinged wooden tool called a footboard or clapper to shape the foot (Figure 7). The bit gatherer gathers a small piece of glass on the end of a punty iron and attaches this to the base of the foot (Figure 8). The servitor then touches the glass at the appropriate place with the wet ends of his pucellas and gives the blowing iron a tap to crack it from the glass which is left on the end of the punty iron.

The glass is then re-heated and handed to the gaffer who uses his pucellas to open out and shape the bowl, shearing the rim level as necessary, and completing the goblet (Figure 9) which is then taken to the lehr for annealing.

up on the surface of the glass can affect the finish quite badly. Some makers centre the gather of glass in hollowed out wooden blocks or with a thick block of wet newspaper held in the hand rather than use the marver.

The next step is to turn the marvered gob of glass into a parison by introducing a bubble into it. This is a process which some people find very difficult and it often requires considerable patience to master. One of the difficulties is that whilst the experienced glassmaker can take a gather and marver it into the correct shape reasonably quickly, a beginner often finds that in doing this the glass has become too cool and needs to be re-heated before a bubble can be formed. The technique is to put either a finger or thumb into the mouth at the same time as the blowing iron, to give a puff of air into the tube and immediately seal the end with the thumb or finger. Whilst keeping the end sealed tightly, the iron can be tipped up and held vertically so that the bubble can be seen as it forms, and to prevent the glass gob from becoming elongated. Some practice is necessary to be able to keep the end sealed whilst rotating the blowing iron until the heat expands the air and forms a bubble in the glass. It is possible for the bubble to expand quite rapidly and at this stage, it is essential that the glass is not allowed to become too thin to allow further operations to proceed, or to take further gathers.

For some forms it is possible to collect sufficient glass in one gather, but it is normal practice to allow the parison to cool somewhat before putting it back into the molten metal in order to take a further gather. For large forms it might be necessary to take subsequent gathers until there is sufficient glass on the iron to produce the required piece. Before each of these extra gathers, the mass of glass on the iron must be allowed to cool until it

Various tools used at the chair by a glassmaker.
Courtesy of the Centre del Vidre de Barcelona.

is stiff enough to collect the new gather without falling into the melt. When the bubble has been blown out into a parison it is usual to start work at the glassmaker's chair.

Again, it may be necessary to shape and centre the gather by using hollowed wooden blocks or a thick layer of wet paper held in the hand. Before progressing further, it is necessary to 'neck' the glass. This involves rolling the iron along the arms of the chair whilst gently squeezing the glass just off the end of the iron with the blades of the pucellas. Further heating and blowing followed by some final shaping may be necessary to achieve the required form. The parison can be elongated by swinging the iron. It can be shaped into a squat form by holding the iron vertically with the glass at the top until the parison assumes the required form.

There are many things which can be done with the parison before it is transferred to a punty iron. Colour can be picked up from the marver, clear or coloured glass can be trailed around the form, pieces can be added as prunts, stems and feet can be formed and the parison blown into a mould. These processes are described later but once the work on the parison is completed, it is transferred to a punty iron and cracked off the blowing iron.

The punty is prepared by taking a small gather on to the end of the punty iron and marvering this into a shallow cylindrical shape. At the same time the glassmaker must keep the base of the form on the blowing iron hot, whilst somebody else is preparing the punty, in order that the base of the glass on the blowing iron and of that on the punty iron are as near as possible to being the same temperature. Once the punty is attached, the glassmaker dips the ends of his pucellas into cold water, touches the glass form at the point where it was previously necked and gives the blowing iron a tap which releases the form to the punty iron. This must be rotated to keep the form centred until it is cooled sufficiently to hold the glass firmly in place. The glass is then heated at the glory hole and the bowl trimmed and opened out and shaped as necessary before being released from the punty iron by tapping the iron. The completed form can then be taken to the annealing kiln.

Forming a stem for a goblet is started either by leaving a weight of glass on the base, or by a second person taking a small gather and dropping a small amount onto the base of the parison. This is formed into a small knob with the pucellas and extended into a stem by pulling outwards whilst the iron is rolled on the arms of the chair. If the knob is sufficiently large, it can be used to make the foot but it is often necessary to add a little more glass. This is centred and then flattened into a foot by using footboards. These are made from two strips of fruit wood hinged together along one edge, one piece being perfectly flat whilst the other has a section taken out to accommodate the stem. These are used wet and squeezed together gently whilst the glass is being rotated to form the foot. It may be necessary to finish the foot with a paddle or with the back of the pucellas.

Blowing into moulds is general practice in much of the

Jenny Antonio pulling out a stem with pucellas.

Glass being blown into an industrial mould.

Shaping the foot with pucellas.

Footboards (clappers).

Industrial-type blowing moulds.

handmade sector of industry and mostly the moulds are either of fine cast steel or graphite though in some countries and particularly in Eastern Europe wooden moulds are still made and used. These wooden moulds are soaked when not in use and, in common with the other moulds, are dipped into water after each article is blown. The steam caused by the hot glass acts to some degree as a separator and creates a very good finish on the ware. Some studios have achieved considerable success for small numbers of articles with moulds made from resin bonded casting sands used by the metal casting industry.

In the Czech and Slovakian Republics where wooden moulds are in common use a composite mould material has been developed which, it is claimed has a much longer working life than wood. It is based on a cement binder called Pecol and the resulting mould material is marketed under the trade name Penoform.

Blowing mould made from square section tubing.

Shoes produced by blowing into a plaster mould.

In a small workshop moulds are often made up quickly out of all sorts of materials to suit a requirement which might be for only a few pieces. Moulds for square or rectangular forms can easily be made from flat pieces of wood simply tackled together or from lengths cut from metal sections. Cylinder moulds made from pieces of piping are common. Complex moulds are often made from plaster-grog-silica or from alumina, cement and grog. Lengths of rod welded vertically into a steel base can be found in many studios to provide a mould which will give a corrugated effect. Even crude moulds from various kinds of wire mesh have been used to produce irregular shapes. Sometimes the metal moulds need to be prepared by coating the interior surface with linseed oil and dusting this well with cork granules or with sawdust. This is fired in an oven or annealing kiln to produce a carbon layer which will lubricate the glass.

Handles are usually attached whilst the vessels are still on the punty iron. An assistant takes a gather on a bit iron or a punty iron and marvers it into a cylindrical shape. He re-heats it if necessary and takes it to the chair where the glassmaker grasps the iron with a pair of notched shears and lowers the end of the marvered cylinder to attach it to the vessel. He then lifts the iron to stretch the cylinder before cutting it to an appropriate length with the shears. The vessel is then rotated quickly so that the length of attached glass hangs down centrally. He allows this to stiffen slightly before rotating the vessel again so that the attached glass is now on the top. At the same time he lifts up the end of his iron so that it is sloping downwards and the piece of glass tilts towards the top of the vessel and can be attached. A piece of wood is then used to shape the handle as necessary and to press the end on to the vessel.

Blowing irons. Hollow rods formerly made from ordinary fine steel are nowadays more commonly made of stainless steel and fitted with chronite ends. They are used for gathering glass which is to be blown into shape. Some factories use mild steel noses as they can be easily repaired by the factory blacksmith in what is termed 'knocking up'.

Blowpipe. The length of thin tubing used by a lampworker for working glass.

Body. Another name for the clay used for making any kind of pot including the fireclay used for making glass pots.

Bohemian glass. Early Bohemian glass suffered from the necessity of using ground rocks of variable composition and other crude batch materials. This resulted in considerable amounts of poor glass in which much of the colour came from the various metallic oxides occurring naturally in these materials. Later, as glass quality improved, the existing expertise in grinding and cutting semi-precious stones was applied to glass and Bohemia became

the world leader in engraving, cutting and carving. In the 16th century, Bohemia became more important in enamelling than Venice but at this time the designs were generally more robust than refined.

During the 19th century, glass production began to be centred on N.W. Bohemia where both technology and experimental design developed very rapidly. Louis Llobmeyr from Vienna founded a studio at Kamenicky Senov in Bohemia where he gathered together a team of the best glassmakers, designers and craftsmen that he could find. He generated much interest in the revival of art glass and became noted for the production of fine iridescent pieces.

In Bohemia today there is still a considerable tradition and expertise in glass production. The various glass schools train a steady supply of excellent craftsmen who are well able to produce high quality work of both traditional and modern design. There is also a considerable group of artists producing individual studio work of remarkable standard. It is interesting to note that the system of working in Czechoslovakia produced a completely different approach from that in the West where much of the studio glass impetus came from the enthusiasm of making blown glass from small furnaces. In Czechoslovakia blown work and much of the cast work was designed by the artists, but carried out by the glassworkers in factories and then returned to the artists for any cutting, decoration and finishing which might be required. This has resulted in a majority of artists who specialise in grinding, cutting and polishing.

The other relevant influence was that of a considerable dependancy on state-funded projects which meant that the glass department at the University in Prague under Stanislav Libensky specialised in the design of works, often large, for municipal and state buildings. Again, the same system operated of designing work, making moulds etc. and then having the work carried out at a factory and returned ready for finishing by the artist.

The political system has undergone a complete change and the move away from state-funded projects will certainly instigate a change in the nature of studio work. The Czech and Slovak artists are mostly very imaginative and display a great deal of creative energy so there is little doubt that their high standard of work will continue.

Boiling point. Normally accepted in general terms as referring to the boiling point of water (100°C or 212°F), but all liquids have their own boiling point including the molten glass in a furnace.

Boracite. Stassfurtite. A borate and chlorate of magnesium. It is variable in content and is used occasionally for the production of frits.

Borates. Boric oxide is normally found in combination with a wide variety of other elements. The most common of these are: borax, in which it is in combination with soda, hydrogen and oxygen; sassoline or boric acid, pandermite and colemanite which have a calcia content rather than soda and boracite which has magnesium chloride instead of soda.

Borax. $Na_2O.B_2O_3.10H_2O$ – sometimes presented as $Na_2.B_4O_7.10H_2O$. The common source of both boric oxide and sodium oxide as one material. See **Batch materials**. It is found as a natural precipitate in California and in many other forms throughout the world. It contains 36.52% boric oxide, 16.25% sodium oxide and 47% water of crystallisation. It has an approximate density of 50 lb per cubic foot. When heated it releases its water of crystallisation at various stages until what remains is anhydrous borax which melts to a clear glass at 741°C (1365°F). This then consists of 68.65% boric oxide and the remainder of sodium oxide and has a bulk density of approximately 80 lb per cubic foot, or 1.28 kg per litre.

Many manufacturers favour the use of the hydrated form as, in the process of releasing its water vapour at various stages, it promotes an early fluxing action with other batch materials and produces the necessary stirring action to help in attaining homogeneity. It does however, have an unfortunate tendency to generate foam which can lead to losses of material into the flues.

Boric acid. H_3BO_3. Refers to a number of acids containing boron and oxygen but generally it refers to that known as orthoboric acid with the formula H_3BO_3. This is used to provide boric oxide in a glass batch when the soda which is automatically introduced with borax would be more than that required for the particular batch. See **Batch materials**. It is also used in the manufacture of paper, adhesives and explosives and, particularly in the USA, of detergents. Because fused boric acid has the ability to dissolve other metal oxides, it is used as a flux for welding and brazing.

Boric oxide. B_2O_3. Glass former which also acts as a strong flux. See **Batch materials**. Fused boric oxide is a vitreous form which becomes pourable at about 500°C (930°F) with the viscosity decreasing as the temperature rises. It is only rarely introduced into a batch in this form except for some special glasses.

Borocalcite. See also **Calcium borate** and **Colemanite**. Sometimes used when both calcia and boric oxide are required. It is subject to wide variation in content and often presents difficulties because of this. It also has a very high H_2O content which is released during founding.

Boron carbide. A very hard black solid made by heating coke with boric oxide in an electric furnace and subsequently used as an abrasive.

Borosilicate glass. A glass made from both silica and boric oxide usually manufactured for laboratory ware, domestic cooking ware and for many kinds of technical

purposes where a relatively high resistance to both heat and thermal shock is required. It is also used for low expansion-type glasses required to bond to metals and for glasses with a high degree of chemical resistance.

Borsella. A type of glassmaker's tool rather like a pair of tongs but with flattened untextured areas at the mouth which are used to provide a form of impressed decoration.

Bottle cullet. See **Batch for modifying bottle cullet.** There has been a considerable increase in the recycling of cullet, particularly in the container industry. There is environmental pressure to do so and it has gradually become a good economic proposition now that the quantities available have made its collection viable and that highly sophisticated selection machines have been introduced to remove unwanted material.

Bottle glass. Green or brown glass produced by using batch materials, particularly sand, which has an iron content and therefore much more readily available than the low iron sands required for making clear glass.

Boxes. Boxes are a comparative rarity in glass but they have emerged from time to time. The Romans produced glass boxes of which there are some good examples in the British Museum. In more modern times Fujita in Japan has specialised in making remarkably refined versions with beautifully worked gold and silver inclusions.

Brass. An alloy of copper and zinc used to make the framework and occasionally the bearings of traditional copper wheel engraving lathes. It is relatively soft, easily worked and takes a good polish. Brass filings were once introduced into a batch to make aventurine glasses. See **Aventurine glass**.

Brazing. The process of joining two pieces of metal by using a mixture of brass and zinc as a type of solder. It is commonly used in jewellery making and occasionally for joining copper calme.

Brilliant cutting. A decorative process involving the use of abrasive and polishing wheels to produce designs on flat glass.

The process of decoration on architectural glass is certainly not new as it was used considerably in the 18th century for the edges of mirrors. However, it was developed, as we now know it in Britain, by Mark Bowden in Bristol in 1850 and it became extremely popular in Victorian times.

It is still evident in some old pub windows, grand houses and on old mirrors. A certain amount of it is still produced today by specialist firms. Unfortunately, in England, a great deal of beautiful work was lost when the brewery chains embarked on a campaign of what was called modernisation and many pubs of great char-

acter suddenly became anonymous replicas of each other. Fortunately, the trend has now been reversed and many pubs which still have some character are being preserved.

Much of the actual cutting of what was often very exuberant decoration was initially similar in technique to that employed on cut glass vessels, except that the lathe used was a larger version of the normal cutting lathe. The major difference was that larger and larger surfaces were decorated and it became necessary to apply the glass to the cutting stones from above rather than from below.

The design would have been cut on natural sandstone wheels sometimes up to 36 inches or 1 metre in diameter and up to $1^1/_2$ inches (38 mm) thick, with grades ranging from about 120 to 240 and with several varying profiles. They were smoothed with a wooden wheel fed with pumice and water and then polished with rouge and water on a bristle brush. The process is still much the same today except that natural sandstones have been largely superseded by manufactured stones, the wooden wheels by composite fabric and the polishing bristle wheels by felt wheels or by soft silicone rubber wheels impregnated with polishing compounds. The speeds of the wheels would be fairly slow and unlikely to be more than about 300 r.p.m.

The move to large sheets of glass meant that it became necessary to develop a method of suspending them so that they could be decorated without the strain of the operator having to carry the weight. It became normal to use a system including a counterweight which could be moved along a bar to balance the weights of different sizes of glass. This allowed for the possibility of a much greater delicacy of touch whilst cutting. Most curves could be made with 'V' and edge cuts on fairly large stones but sharp curves of small radius needed small stones. Much of the later work also involved sandblasting, acid etching and embossing. Perhaps sadly, much of the handcrafted brilliant cutting is now being superseded by computer-controlled and laser-guided machinery.

Brilliant cutting lathe showing the counterweight arrangement to reduce the weight of the glass held by the operator.

Bristol blue. This deep blue glass, often attributed to the various Bristol glasshouses, was also made in Stourbridge, Newcastle-upon-Tyne and London. There is no specific definition of the glass but there seems to be some general agreement that it is a deep blue with a slight tendency towards purple in thick sections. Some authorities express the opinion that the Bristol connection is really to William Cooksworthy who supplied various materials to both glasshouses and potteries including a blue smaltz from his factory in that town. There is some conjecture that the blue smaltz came from his mining interests in Cornwall but there is also a possibility that he imported the material as zaffre from Germany. The colourant is obviously based on a natural ore of cobalt oxide which may have been modified by natural impurities.

British thermal unit. A measure of the heat required to raise one pound of water through one degree Fahrenheit. It is equal to 252 calories, or 1055.66 joules. 100,000 British thermal units (BTUs) = One therm.

Bronze. A metal alloy usually composed of a mixture of copper and tin. It is very popular for use in cast sculpture but is also sometimes used by stained glass artists for re-inforcing bars and armatures in stained glass windows. It is a popular material for the manufacture of solid bearings used together with hardened steel shafts in order to produce glass lathes with little or no vibration.

Brookite. TiO_2. A natural mineral ore of titanium dioxide. Others are anatase, rutile and ilmenite.

Brunswick black. A paint pigment used by sculptors to coat metal re-inforcing bars in casts and introduced into resists for acid etching processes to enable the resist to be seen more clearly.

Brushes. Brushes are very personal tools. Every painter seems to develop his or her individual preference and what suits one artist often only proves to be totally unsuitable to another.

For stained glass painting, good quality tradesman's broad hog brushes with long bristles are very popular because of their ability to hold sufficient paint to carry out long brush strokes. Artist's regular hog oil brushes are useful for some purposes but have the disadvantage of not holding much paint. The soft hair oil brushes with a good length of hair are sensitive to work with and can be most useful. Expensive sable and sable mix watercolour brushes are very good for applying lustre but in general do not find much favour for stained glass painting. The long-haired liners and riggers, on the other hand, are excellent for producing a spontaneous and vital type of drawing and painting. Large and medium-sized Chinese goat hair brushes have similar qualities and again will usually find favour with the artist who likes a lively and vigorous, rather than a slow studied,

Various types of brushes used by artists working with stained glass

1 and 2. Round hog bristle brushes.

3. Flat hog bristle brush.

4 and 5. Short stubby hog brushes often made from old and worn hogs and used for stippling etc.

6. The typical soft hair brush used for delicate lining and for work with lustres.

7 and 8. Flat and round badgers.

approach. Probably the most important brush for the stained glass artist is the badger. It is used for matting and for moving the paint around on the glass so only the tips tend to be used. A good badger will be expensive but with care should last many years. See **Badger**.

Bullions. Crowns. Discs of glass made by spinning out a blown bowl. The term is also used to describe the centre part of such a disc where the glassmaker's punty iron has been attached. Bullions were the major source of window glass for centuries before the cylinder method emerged and became popular because of the larger panes which resulted. They are now not often used except for restoration work and for the production of antique types of glass panes.

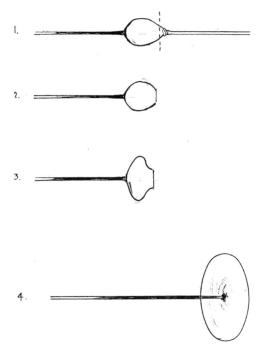

Bullions. Stages in the making of a bullion.

1. A large bubble is blown and transferred to a punty iron.

2. The bubble is opened out and the rim levelled.

3. The bubble is heated and raised so that it becomes a little wider and shallower.

4. It is then spun rapidly until the centrifugal force forms the glass into the typical wide and circular bullion.

Bullion marked out for cutting into panes.

Bull's eyes. Often used as an alternative name for a bullion but more usually refers to the central pane cut from a bullion which contains the raised part where the punty was attached.

Bung. A stopper in a kiln. Sometimes fitted in the door for viewing purposes and sometimes in the roof to

release any fume which might occur from firing lustres, enamels etc.

Burgee. The waste material consisting of abrasives and ground glass resulting from the glass grinding process. It is essential to ensure that it is not allowed to settle in drains as it tends to set into a hard mass which can be difficult to remove.

Burner block. The refractory block through which the flame is projected into the furnace.

Burner control and safety systems. Most countries have statutory regulations relating to gas safety equipment and it is essential that any operator should become acquainted with these before establishing any gas system.

Gas-fired furnaces need adequate safety controls. As they tend to be operated continuously, they need to operate safely when there is nobody in attendance. The main source of danger occurs when a volume of gas/air mixture is allowed to develop before the introduction of a source of ignition. Statistics show that most explosions in gas appliances occur in the ignition process. Others tend to occur when there has been a flame failure and the furnace has not been hot enough to provide automatic ignition of any gas/air which has been subsequently admitted.

In a fully automatic system, any flame failure should result in the fuel supply being cut off immediately, this being followed by an air purge (usually equivalent to five times the volume of the kiln or furnace) and, after a suitable time, a programmed sequence of re-ignition. In a semi-automatic system, the flame failure again results in the fuel being cut off but manual attention is then necessary before the supply can be re-established.

For efficient ignition, it is essential to ensure that the gas/air mixture enters the combustion area in such a condition that it will ignite immediately and burn properly. Ideally, it should not be possible for the gas/air mixture to enter the combustion chamber unless there is a suitable source of ignition present to provide immediate ignition. The volume of fuel entering a combustion chamber during the ignition period is usually restricted to a set volume and specific time. It is also important that adequate ventilation and extraction facilities are available so that once the fuel is ignited, it will burn completely and that the products of the combustion are removed efficiently. Incomplete combustion could result in an explosion in the flue system. Burners should be stable under all operating conditions. If they are not, then there is always a possibility of flame failure. A stable burner is essential for more efficient and therefore more economic firing.

It is important to ensure that there is very little deviation in the gas/air ratio as this is a major cause of flame failure. Hazardous situations can develop if there is incomplete combustion or loss of flame due to reduction

of the air supply or if there is a formation of flammable gas/air mixture in the gas supply line and/or in the air line and centrifugal fan. To control these possibilities, automatic air/gas proportional devices, air flow monitors and air pressure switches can be installed to ensure that the gas is cut off when the air flow is reduced. Non-return valves must also be fitted in both lines to ensure that gas, air or gas/air mixture cannot flow back. Controls must be placed so that they are easily accessible. It is advisable to have clear operating instructions, particularly those appertaining to emergency shut down procedures, readily and obviously available.

Burners. Burners come in all sorts of shapes and varieties. Some of the most common are:

 Atmospheric or venturi,
 Air-assisted,
 Forced air,
 Pre-mix and
 Self-recuperating.

The atmospheric or venturi burner is very basic and works by virtue of the gas being forced under pressure through a small jet which has the effect of inducing primary air proportional to the gas flow into a tube or burner head where the gas and air mix prior to combustion. It is the simplest type of burner and is easily adjusted by balancing the gas pressure against the air flow which is regulated by a disc or other simple mechanism. If the pressure is too low, it becomes possible for the gas to burn inside the burner pipe producing a loud popping noise. If this is allowed to continue, the pipe can become sufficiently hot to cause a hazardous situation. Conversely, if the pressure or flow is too high, then the flame can start to move away from the end of the burner block with a subsequent loss of efficiency. There is often a gradual widening of the venturi tube towards the burner head to produce a static pressure in the gas/air mixture. It provides a relatively efficient method of combustion particularly when used with propane and other liquid petroleum gases (LPGs) which are under high pressure. It is not so suitable for use with low pressure natural gas and it is common practice in this case that provision must be made for a supply of secondary air to aid efficient combustion.

Air-assisted burners are basically similar to an atmospheric burner but they have the addition of a fanned air supply. Even with this arrangement a supply of secondary air may still be needed with some fuels. A variation of this type of burner is that in which the air from a

blower is used to induce gas from an atmospheric regulator into the air stream through an adjustable orifice. These burners are more likely to be used with natural gas than with bottled gas because of the relatively large proportions of air to gas required by the latter.

Forced air burners have been standard equipment for small glass furnaces for many years. They are a little more expensive than the basic venturi types but they are very efficient, can be used with either natural gas or LPG, lend themselves to being used in conjunction with sophisticated control systems and provide a wider range of efficient thermal input.

Pre-mixed burners are similar to the forced air burners but the air and gas are mixed prior to entry into the nozzle rather than in the nozzle itself.

Package burners are small units comprising a control system, a built-in blower and a burner. They are portable and easily connected to a mains electricity supply and to a source of gas. They are available for both natural gas and for LPG and are ideal for use with small, temporary furnaces and glory holes.

Self-recuperative burners are mostly used in industrial situations but small versions are appearing and offer considerable advantages in fuel economy. They may seem to be expensive but should soon regain the initial outlay. They work by circulating some of the hot flue gases around the air intake. This pre-heats the air and increases the efficiency of the combustion. Savings of up to 40% are often claimed by manufacturers. Less sophisticated recuperative systems are relatively easy to conceive and install as it does not take a great deal of ingenuity to channel the air intake to the burners around or through part of the flue.

Even the most basic and simple device can have a considerable beneficial effect. One established studio in London was using fuel which cost just under £700 per month to run the furnace and glory hole. When the furnace was replaced, improved and fitted with a new energy-saving recuperative system, the costs dropped to approximately £140 per month. With the current environmental pressure to reduce the amount of fossil fuel being burned, there is an additional benefit in this respect as well as the purely economic gain in reduced costs.

Burners.

1. A venturi burner.

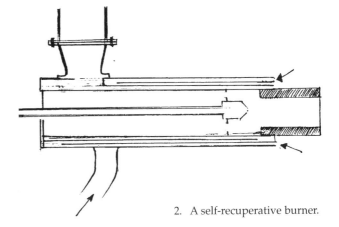

2. A self-recuperative burner.

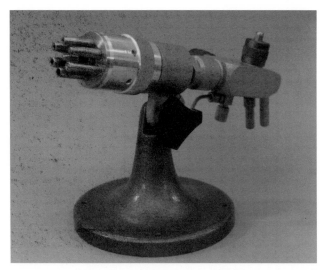

A turret-type lampworking burner designed and manufactured by a lampworker. The head can be rotated quickly to give different sizes of flame as required. *Courtesy of J. Young, Scientific Glassware Ltd.*

There is also a considerable advantage to be acquired in the nature of improved working conditions.

The process of pre-heating the air intake into the burner system is also employed effectively in industrial furnaces by the use of a regenerator system. This is usually located underneath the furnace and makes use of the heat accumulated in the refractories of the furnace. In most cases, heavy refractories are located in a space through which the air proceeding to the burners is passed. Another advantage of this system is that some of the exhaust gases can be re-circulated through the system to reduce the nitrox emissions. Regenerators do not seem to have appeared in studio furnaces as yet but there is no reason why a small and suitable unit could not be devised.

Lampworking torches or burners use a mixture of oxygen or air with gas (usually propane or natural gas) and whilst some of them are very simple units similar to those used for brazing or welding metals, there are very sophisticated torches available with multiple heads which swivel into place as required. Fingertip controls to provide fine adjustments to the flame are also provided. Some workers use a foot control so that when the burner is not in use it will remain ignited with a small, luminous and rich flame while not actually operating but by pressure on the control can be changed immediately to a suitable flame for the work in hand. See **Lampworking**.

The use of oxygen to supplement or replace air is gradually gaining some popularity in industrial glass furnace fuel systems. The costs of the oxygen in industrial quantities have been reduced to an acceptable level and fuel efficiency has risen accordingly. One of the great benefits of this system is that fuel is not wasted in heating the huge quantities of nitrogen which enters the system in the air. Another important environmental benefit is a reduction in the amounts of nitrogen monoxide and

nitrogen dioxide released into the atmosphere. It is unfortunate but it is almost certain that even with all the resulting advantages, it will be a long time before oxygen can be introduced into a studio furnace fuel system because of its cost when bought in relatively small quantities. Some authorities are beginning to question the value of introducing oxygen as an air supplement into furnace burner systems and suggest that better reductions in nitrox emissions are more likely to be obtained from specially designed burners. There is one aspect of the use of oxygen that may not be apparent and that it conveys its own particular dangers. Whilst it does not burn, it reacts with many other materials, including some that would not normally burn in air and appropriate precautions must be taken. These are described under **Safety and bottled gas**.

Burning off. Separating a piece of work from its moil by rotating the glass against a ring of burners fitted with fine jets until the glass parts. This is a common commercial practice and the results show a rounded and slightly thickened edge. It also is a source of possible damage unless the glass is annealed after the process. Goblets and drinking glasses which have been burned off will often show a layer of strain when seen in a strain viewer. This strain can develop small vertical cracks under the rim. As with the cracking off process, glass which has not been re-annealed can also separate cleanly just under the rim to produce a ring of glass and a sharp edge. See **Cracking off**.

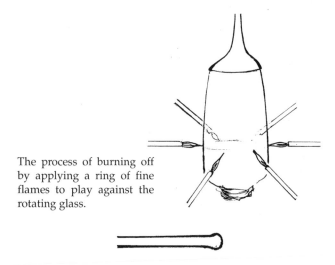

The process of burning off by applying a ring of fine flames to play against the rotating glass.

The rounded edge found on glass which has been burned off.

Burning out. The stage in the firing of glass pots or refractories which ensures the safe removal of both water of plasticity and chemically-held water. It is a term also used to describe the process of melting the wax out of a mould in the lost wax process. See **Lost wax process**.

Burn-out oven or kiln. The low temperature kiln or oven used for melting wax out of moulds.

C

Cable decoration. Applied twisted threads or canes of glass replicating strands of rope.

Cadmium. Cd. A white metallic element belonging to Group I of the periodic table and used as a protective coating on other metals. It is also used as a colouring agent in the form of its sulphide for glass and enamel, often together with selenium. It produces a brilliant yellow colour in glass when introduced as the sulphide, or as many now prefer, with small additions of sulphur, and strong reds when used with selenium. Many of the colours need to be 'Struck'. In other words, the glass often has to be re-heated for the colours to become apparent. (These strong yellows and reds have been the basis for many of the glasses produced for signal lamps for several years.) Another problem is that if they are used for slumping or fusing, the colour can change completely.

Cadmium is also the basis of many of the colouring pigments used for paint, plastics etc. It is used in nickel-cadmium batteries and in the manufacture of low temperature solders. Because of its high toxicity there is considerable environmental pressure for more suitable and less dangerous alternatives to be found.

Cadmium sulphide. CdS. This is found as the mineral greenockite and is used as a painting pigment, in photo-electric cells and in fluorescent materials. It is used in glassmaking in conjunction with selenium to produce strong reds and yellows. Most of the modern signal reds and yellows are based on these materials.

Caesium. Cs. An alkaline metallic element in the first group of the periodic table.

Cafferata. A form of fine casting plaster often used by sculptors.

Cage cups. Diatreta. These cups are remarkable for the considerable amount of care and fine craftsmanship that must have been involved in their manufacture. They are cut and ground from a thick bowl to produce a fine lattice, often of circular forms joined together which stand out from the cup surface on short stalks. There has been much conjecture about their method of manufacture as many similar cups were obviously formed by some method of attaching and trailing cane. The most famous of the diatreta glasses is in the Roman-Germanic Museum in Cologne and another fine example is in the Corning Museum of Glass in the USA.

In the early 1960s, Josef Welzel at the Hadamar State Glass School in Bavaria, Germany, decided to prove the grinding theory by producing a replica. The work took several weeks but he was successful in his attempt. An article on his achievement was published in the Schotts magazine and is of so much obvious interest to people working in glass that, with the kind permission of Schotts, it is reproduced here.

In 1960, excavation work in Cologne uncovered a Roman coffin. When the archeologists opened it they came face to face with one of the most beautiful, most valuable and yet most puzzling treasures ever to be found in Germany. It was a glass with a delicate lattice work apparently floating around it without any support.

'Diatreta' as these glasses are called, were famous in ancient times but only nineteen of them have been discovered up to now. To art connoisseurs they have been a delight, but the feeling they arouse in glass experts is more one of helpless amazement, since for several hundred years they have been trying to work out how these marvels of glassworking technique were made.

One suggestion was that the Roman glassworkers towards the end of the Roman Empire were able to cut the cage out of the glass body by grinding, and indeed, all diatreta bear grinding marks. The old description of this craft also lends support to this view, since the word 'Diatretum' is of Greek origin and means 'broken through' or 'drilled'. Yet it seemed impossible to experts that during weeks of laborious work the delicate glass lattice would stay intact. A slip of the hand, say a slight misplacement of the grinding wheel, and the glass would easily be broken. Glass is hard and brittle and impossible to repair. It gives no second chances. In the twenties, Professor Wilhelm von Eiff, probably the leading glass expert of his time put it thus, 'You can't take chances with Glass'. Moreover, examples of Roman glass cutting and engraving are not, from a point of view of craftsmanship, of a particularly high standard, so it was difficult to believe that craftsmen of the time would have had the skills to produce diatreta glasses.

Glass experts therefore assumed that the glass lattice work had been achieved by some form of primary glass forming, since it is a well known fact that hot glass is easy to bend, shape, press and pull out into fibres. Glassmakers in the ancient world made other glasses, similar to the diatreta whose ornate decorations were attached to the main body by the tiniest of glass rods. Although these glasses bear none of the grinding marks,

they also lack the geometric precision of the diatreta lattice work.

During a discussion in the early sixties, Josef Welzel, a teacher at the Hadamar State Glass School was the only supporter for the grinding theory. As he was unable to convince his colleagues with words he decided to grind a diatretum glass himself. He began by experimenting with different techniques until he found those which would enable him, by grinding, to reproduce the precision of the diatreta lattice work. The techniques used by the Roman precious stone and cameo cutters were found to be the best. The art of decoratively engraving vessels of agate was nothing new to these ancient craftsmen. Precious stone engravers of the time were already using rotating metal grinding wheels with diamond or corundum as the grinding medium. Many Roman intaglios and cameos are deeply undercut so that the relief stands out from the different coloured background. Their delicateness and accuracy are quite exquisite. Welzel decided that it must have been possible for precious stone cutters, who were used to working with hard agate, to have cut the lattice work by grinding, so he attempted to reproduce a Roman Diatretum using the tools and methods of the ancient precious stone cutters.

Schott Zwiesel produced the blank for his replica of what is probably the finest example of its type, the tricoloured diatretum found in Cologne Braunsfield in 1960. The blank was bell-shaped, with bands of green, yellow and red glass overlaid on it. It is vital for the grinder to work with completely unstressed glass. When there is a change in temperature the different layers of glass must expand or contract to the same extent. The glass experts at Schott Zwiesel pooled their collective experience to fulfill these requirements with new glass mixtures and particularly careful processing. Grinding and polishing the structure of the lattice work took several weeks even though Josef Welzel had been able to test out and perfect his technique in earlier experiments.

The first step is to gouge out the hollows, using grinding paste and a tool that was widely used in the ancient world – a rotating shaft with small grinding wheels made either from copper or iron. After this stage in the process, the coloured glass lattice work is in relief to the transparent inner body of the vessel. Relief grinding is the next step. With the exception of the slender glass supporting rods, which hold the two together, this process completely frees the lattice from the inner part of the vessel. Next the face of the grinding wheel is placed onto the glass and gradually moved all over it, work that demands the highest level of concentration. One false move, even a defect in the glass, and work that has taken weeks will be ruined in a matter of seconds. In the third stage, the curves of the lattice are ground clean with a wedge-shaped wheel. Each stage of the work requires grinding, first with a coarse, then a medium and then finally a very fine grinding paste. The final polishing is a particularly time-consuming task.

The final result was a successful reproduction of the Roman diatretum glass, true to the original in all respects. It confirmed that the Roman craftsmen owed their success, as in other areas of their work, firstly to their great patience, unimaginable to us living in the 20th century, and secondly to their manual dexterity perfected through decades of work. Klaus Dissel, Schott Information. issue 2. 1987.

Since the production at Zwiesel, the process has been repeated several times by George Scott in Edinburgh.

Caithness. There are two factories producing a range of cut crystal and engraved glass but Caithness is particularly famed for its paperweights which are very collectable articles. The famous specialist paperweight maker, Paul Ysart, was associated with Caithness for many years.

Cake. The name for the slabs of clay which come from a filter press. In order to produce clay which is as homogeneous as possible for making glass pots, it sometimes becomes necessary to add sufficient water for the clay to be turned into a slip. The slip is then thoroughly mixed and sieved before being put through a filter press to be turned into cakes of usable clay. It would most probably be put through a de-airing pugmill before actually being used to make the pots.

Calcareous. Containing compounds of calcium particularly in reference to minerals.

Calcia. Lime. CaO. Commonly used as a stabiliser in amounts between 5% and 10% mol. of a batch. It also acts as a flux at temperatures above about 1100°C. It is normally introduced as calcium carbonate.

CaO is commonly known as quicklime. It readily reacts with water to form slaked lime $Ca(OH)_2$. Chemically-prepared calcium carbonate free from iron oxide is used for making some optical glasses but most of the world's deposits contain some iron. Its most common source is limestone and a relatively pure source is mined in Derbyshire. There are many other sources (see **Calcium carbonate** and **Calumite**) but one which is finding increasing use in the glass industry is the commercial product Calumite which is prepared from blast furnace slag and provides approximately 35% to 40% calcia. See **Batch**.

Calcine. This actually refers to the burning of lime but it is a term commonly used to mean the burning of material to clean or change its composition. For instance, 'Calcined Alumina' would simply mean alumina which had been heated to remove extraneous material. Calcined china clay becomes Molochite which is often used as a source of grog for inclusion in refractory bodies. The term is also used to describe material which has its water of crystallisation or hydration removed.

Calcite. Calcspar. Crystalline calcium carbonate. $CaCO_3$. One of the most common minerals. It is found in both igneous and sedimentary rocks. It often forms clean white crystals in limestone but is also found in less obviously crystalline forms such as marble, chalk and stalactites etc.

Calcium borate. $Ca(BO_2)_2$. Used to introduce both calcia and boric oxide into a batch. See also **Colemanite**, theoretically $2CaO.3B_2O_3.5H_2O$, but extremely variable in content and occasionally used in this context. Anhydrous borocalcite.

Calcium carbonate. $CaCO_3$. The common material used for the introduction of calcia into a batch. See **Batch materials**. It decomposes at about 850°C (1560°F) to release carbon dioxide leaving the calcia to incorporate into the batch. The release of carbon dioxide during founding can help with the fining process. Limestone is the most common source but chalk, arragonite from the sea bed, limespar and dolomite, which includes magnesium carbonate, are also used. Calcium carbonate is a plentiful material and in some areas of the world where mineral deposits are not readily available sea shells and coral are ground down to provide it.

Calcium fluoride. CaF_2. Fluorspar. Blue John. A very attractive mineral once used as a source of fluorine for the production of opal glasses. It was used as a flux in the steel industry but in Derbyshire where most of the British supply is available it is now mostly exploited as a material which is turned and carved into decorative forms. See **Fluorspar**.

Calcium oxide. Lime. Calcia. CaO. See **Calcia**.

Calcium phosphate. $Ca_3(PO_4)_2$. A source material for the inclusion of both calcia and phosphorous pentoxide into a batch. It is used as an opacifier and the common material used is bone ash but other similar source materials are apatite and phosphorite.

Calcium sulphate. $CaSO_4$. Anhydrite. The material from which plaster of Paris is made. See **Gypsum**. It is also used as a refining agent, particularly in conjunction with Calumite.

Calculations. Most of the calculations that a glassmaker needs to make are, apart from the various financial considerations, concerned with batch. There are various conversion tables which are relevant and these are noted under the heading 'Tables' at the back of the book. The method of actually calculating the amounts and proportions of the materials used in batch are given under the heading **Batch calculations**.

Calme. (Came in the USA.) The strips of I-shaped material used to contain and support areas of glass in stained glass windows. It is usually made from lead but can be of copper, brass or zinc and is readily obtainable from commercial sources in various profiles and sizes. Lead is the original material used for joining the sections of coloured glass in stained glass windows and is still the most common form of calme in use today. Once *in situ* it oxidises rapidly to produce a surface which stops further deterioration. It is soft, pliable, easy to work around complex shapes and is simple to solder. Early lead calme used to be made by casting molten lead around lengths of reed which burned away to leave tubes in a block which was then cut along the centre of each tube to produce a crude lead calme. Nowadays, the lead is cast into a thick I-shape which is then pulled and extended in a simple machine called a lead mill until a strip of calme is extruded and ready for use.

Various sections of lead calme. (Figure 1) shows the medieval type which was probably cast around willow canes. (Figures 2 to 6) stock calme sections. (Figure 7) Edge calme.

The lead mill presses the lead between two rollers through a suitably shaped die which determines the outside shape. Various sizes of milled rollers are available to provide differing capacities of calme. Calme is also produced industrially by a continuous extrusion process. The presence of a lead mill in a studio has its own advantage as scrap lead can easily and cheaply be converted into usable calme.

Calorie. The amount of heat required to raise 1 g of water through 1°C. The calorie unit has now been largely replaced by the joule. One calorie = 4.1868 joules.

Calumite. This is blast furnace slag which has been processed for use as batch material for large production situations where colour resulting from its iron content is not critical. It is described as a calcium aluminate/calcium silicate with some combined sulphur and a variable iron content. It produces a good refining action in conjunction with anhydrite.

Cameo glass. Cased forms of glass, usually with an opaque white over a colour, in which the outer layer is carved to leave a translucent white relief design or figure in contrast against the layer or layers of base colour.

It seems likely that cameo glass developed from the lapidary techniques used on layered precious stones and

was well-known in Roman times as is evident from the examples available. Many of these came from their glasshouses in Alexandria. The Portland Vase is probably the best known piece of ancient cameo glass but the technique has been revived in various places over the centuries. It is often suggested that the technique was lost until it emerged again in the 19th century but cameo work was produced in Egypt and in Persia in the 9th and 10th centuries AD and was also produced in China in the 18th century.

Considerable amounts of fine work were produced in the Stourbridge area where John Northwood, who was born in 1837, was responsible for many of the innovative ideas produced in the area during the latter part of the 19th century. He became noted for cameo work of particularly high quality and was followed by several other excellent designer glassmaker/engravers including his son John. Much of the design was either floral or of Grecian figures. Colonel R. G. Williams Thomas in his book *The Crystal Years* gives an excellent account of this cameo production with the advantage of being able to quote from the records of the company, Stevens and Williams, who employed John Northwood and many of the other artists at that time.

The technique which Northwood used resulted from a considerable knowledge of the process of acid etching. It seems that he first dipped the glass to be carved in a potassium fluoride bath to produce a matted surface which was suitable for drawing in the initial outlines. These were then protected by being painted with a resist. The edges were given a coat of a mixture of tar, pitch, red lead oxide and lamp black whilst the rest of the design was painted with bitumen paint. The glass was then put into an acid bath which was kept agitated and the surface of the glass mopped with some cotton wool fastened to a wooden stick to keep the effect even. When the work of the acid was completed, the area for carving stood out from a smooth matt and coloured surface. The carving of the cameos was then carried out by hand carving with a rod of square, hard steel sharpened to a triangular point and by work on the intaglio lathe.

Most of the best English cameo ware was produced between 1870 and 1890 and was destined for the American market where it fetched very high prices. Some of the cameo workers left Stourbridge for America and started to produce pieces in various factories but by this time other glass factories in the US had started to produce cheap imitation cameo ware in which the images were built up in white enamel. This soon ruined the market for the much more labour-intensive and expensive cameo work and production in both Britain and America declined rapidly. See **Cased glass** and **Portland Vase**.

Canada balsam. A slightly yellow liquid obtained from the balsam fir. It is used in a suitable solvent as an adhesive for lenses and optical instruments because its refractive index is similar to that of many optical glasses. It is commonly used as an adhesive to stick samples to slides when preparing thin sections of stones.

Cane. Rods of glass usually formed by drawing out long lengths of glass from large gathers on a punty iron. Bundles of canes are often fused together and drawn out again to a suitable diameter before being cut into small decorative pieces such as millefiori for picking up into paperweights. They are also cut into lengths and placed against the side of an open mould for picking up onto a gather which is marvered and pulled out to make rods used for opaque twists and filigree work.

Capacitor. Capacitance. See **Electrical terms**.

Caposil. The trade name for a form of slab insulation material made from calcium silicate and often used in kiln construction as a back up material because it has greater rigidity and more physical strength than that of most of the ceramic fibre-based slabs.

Carbon. C. A non-metallic element in the fourth row of the periodic table. Its natural forms are as diamond, graphite etc. It is commonly used as charcoal, coke and as a black pigment. It forms the basis for all organic chemistry.

It is used in the form of graphite to make moulds for blowing purposes and by lampworkers in various profiles as tools for shaping glass. In its diamond form it is used as an abrasive and for cutting. It is also introduced into a batch to produce carbon amber glass and to act as a reducing agent. See **Colour**.

Carbon amber glass. This has been the subject of much debate over the years and for a long time it was thought that the colour came essentially from carbon. It has now been proven that the rich amber colour is due to iron oxide and sulphur in a soda-lime-silica base melted in a strongly reducing atmosphere. Carbon is the usual reducing agent used. The quality of the colour is notoriously difficult to control due to both variations in the nature of the raw materials and maintaining the strongly reducing conditions. This glass has a tendency to re-boil and create seed if the sulphur content is too high.

The big advantage of carbon amber glass is that it is very cheap to produce. A basic soda-lime-silica glass using a high iron sand (0.1 to 0.4%), iron oxide (Fe_2O_3) and additions of sulphur and carbon can give an acceptable amber colour. Commercial producers of amber glass for beer and wine bottles use the carbon/sulphur amber system.

One of the anomalies of glassmaking terminology is that much of what artists would refer to as being yellow is often called 'amber' by glassmakers. The so-called amber glass used for technical and decorative purposes is usually coloured by mixtures of cadmium, selenium and sulphur and would be considered distinctly yellow by most people. These raw materials tend to be very

expensive. It may be that this combined with the restrictions that are gradually building against cadmium and similar materials will stimulate more research into the possibilities of carbon amber glass.

Carbon dioxide. CO_2. Produced by the efficient burning of fossil fuels in firing and released from many of the batch materials during the founding process where it bubbles through the molten glass and helps with the fining and the stirring of the melt.

Carbon monoxide. CO. This is produced when fuel is burned without sufficient air being readily available to provide enough oxygen to form carbon dioxide. The gas searches for more oxygen and takes it from any metal oxides which happen to be available and thus reduces them either to the metal or to a lower form of oxide. See **Reduction**. Chemically, it is a combination of a carbon atom with an oxygen atom and it is a highly poisonous gas which is particularly dangerous in confined areas because it is both colourless and odourless and not easily detected. Amounts as little as 1% in the air can prove fatal.

Carbon rods and flats. Various shapes of hand tools, usually made of graphite, used by lampworkers for shaping hot glass.

Carbonate. A compound containing the acid radical of carbonic acid. Various carbonates are used to provide oxides in a batch. The changes involved release gases which contribute to the homogeneity and fining of the glass.

Carborundum. A proprietary name for an abrasive material made by heating sand, coke, sawdust and a little salt to high temperatures. See **Abrasives**.

Carder, Frederick. Frederick Carder was born in England in 1863 and was apprenticed to Stevens and Williams in Stourbridge at the age of seventeen. He became one of the foremost designers and technologists of his age. He was fascinated by the Art Nouveau movement (see **Art Nouveau**) and studied with Emile Gallé in order to understand the philosophy and methods of the school of Nancy. He was famous for his development of various cameo techniques and was persuaded to go to America with his family. There, together with the Hawkes brothers, he founded the famous Steuben glass works and was directly responsible for many of the innovative techniques and the high quality glass for which Steuben became famous. In cooperation with John Northwood at Stourbridge, he produced a glass known as moss agate (see **Moss agate**) for Stevens and Williams. This was made by gathering a layer of lead glass over a gather of soda-lime glass. Powdered colour was then picked up from the marver and covered with another gather of lead glass. When the vessel was formed, some cold water was introduced to crackle the interior soda glass surface and then it was re-heated. Whilst the cracks were rejoined, the evidence of them remained to give the characteristic appearance of the 'Moss Agate' glass. In America he maintained his interest in making glass which replicated the effects of precious stones and he developed what he called his 'Jade' glass (see **Jade glass**). This was basically a translucent white glass modified with additions of various colouring oxides. He died in 1963.

Carnauba wax. This is a form of leaf wax from the Brazilian carnauba tree. It is often used together with beeswax and resin for lubricating glassmaking tools.

Carrot. Rods of glass, mostly containing twists of various kinds, for forming the stems of goblets.

Cartoon. The design, usually full-sized, for a stained glass window. This is usually made on wide paper, joined as necessary to produce the required size. It is almost always a drawing, perhaps with tones added but rarely coloured. Compressed charcoal is the normal material for drawing lines and areas which need to be softened and a 2B pencil is used to produce harder lines.

Carved glass. A term commonly used to describe glass which has been cut and/or abraded into shape from a solid block. It is also one which can be used to refer to blown or cast glass which has been further shaped by cutting and/or grinding.

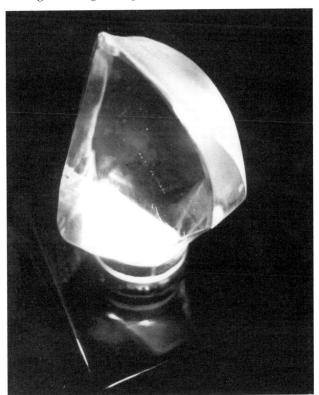

Carved glass. Such pieces are usually carved from blocks removed from the bottom of a cold tank or pot.

Cullet blocks saved for carving.

It was one of the earliest techniques to be used and utilised the skills already established by the gem cutters of the Middle East. Many figurines were produced by a process of rough casting followed by laborious carving and polishing procedures. There are examples of alabastron from Assyria which were carved from solid blocks. There is a particularly fine example in the British Museum carrying the name of Sargon II Nimrud, (Assyria. 722–705 BC). The Roman cameo glasses and cage cups showed considerable carving skills. It was also common in early glass to copy forms which would normally be produced in other materials. Rather than using the manipulative possibilities of hot glass, handles were often carved out of solid glass. This sometimes resulted in stiff forms which now seem uncommonly cumbersome.

The process of cold cutting as a method of decoration on vessels is well known. See **Cutting**. Abrading by sandblasting is described under **Sandblasting**.

A more recent development has been to return to the original concepts and to produce sculptural forms by carving solid blocks. Some blocks of reasonable size can be bought from producers of optical glass but some glassmakers have been successful in using large pieces of cullet removed from a furnace which has been allowed to cool down naturally. These can be very large blocks and because of their size and the fact that a furnace cools very slowly will often prove to have been self-annealing. These are usually carved by the normal methods of cutting with diamond saws and/or abrasive wheels but some artists have turned to the use of high pressure sandblasting and achieved results which would have been difficult to achieve by other means. The late Jutta Cuny produced some spectacular pieces by such a technique. Commercial producers of thick float glass now use very high pressure water jets to cut the glass to size. It would seem reasonable to expect that artists with access to the necessary equipment would seek to develop the possibilities of this. Many artists in the Czech Republic, Slovenia and in Germany where there is a rich tradition of cutting and polishing have become famous for their work in producing carved forms in optical glass.

Cased glass. This usually refers to blown glass which has two or more layers, one of which is either coloured and/or opaque. It was well-known in Roman times as is evident from the various examples available. It became a common technique in Bohemia and spread throughout Europe, becoming particularly popular in England and the USA during the 19th century.

The layers of colour are usually etched, engraved or cut through to reveal the clear glass underneath. Latterly, sandblasting has become a popular method for removing some of the colour. Normally the technique was to develop the layer of colour on the outside of a form (overlay) but it has been developed on the inside of bowls, particularly in Scandinavia, by artists wishing to explore the graal technique. See **Graal**. To produce the overlay, the normal practice when a pot of coloured glass is available is to take a gather of clear glass from one furnace and shape it into a suitable form, then cover it with a final gather from a pot of colour before blowing out and working into the required piece.

The more common technique in a small studio where a separate pot of colour is unlikely to be available is for the glassmaker to form a cup of coloured glass and then to introduce a gather of the clear glass into it (cup casing). After casing, the glass is blown out further and shaped in the normal way. The cup is formed by picking up a length of concentrated coloured rod (usually between a third and half a stick) onto a punty iron, shaping this into a rounded form which is then transferred to a blowing iron to be re-heated and blown into a fairly thin parison. A blob is formed on the end to enable the shape to be pulled out before cracking the glass off a little way in from the blob. The glass is opened out into a cup shape

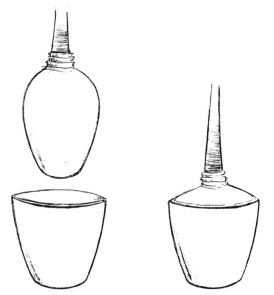

Outside or cup casing is carried out by lowering a gather of glass into a thin, pre-formed and heated cup of coloured glass. The gather is blown gently into the cup until the two are sealed together. It is then blown out and worked as necessary.

with the sides tapering in towards the bottom. It is then cut in close to the end of the iron to seal any air gap and cracked off from the iron. It is kept hot until a full gather of clear glass is made. At this stage the coloured cup, heated to approximately 80°C (175°F) above its annealing point, is placed in a suitable container and the gob of clear glass lowered into it so that it spreads from the base of the cup and avoids trapping air bubbles. Further outside layers can be made by repeating the process. The whole is then marvered and/or blocked, blown out as necessary and worked into the required shape. If the glass used for each layer is fully compatible, then the procedure is relatively simple but the margins can be tight. It is advisable to use the same basic glass composition for all the layers and to ensure that there is no more than plus or minus 2% in expansion between them. The annealing point for each layer must also be reasonably the same. Cadmium-based reds and yellow opaque glasses often prove difficult.

The procedure for putting a layer of colour on the inside is considerably more simple. In this case, the piece of coloured rod is picked up and shaped as before, transferred to a blowing iron and then covered with clear glass as necessary before blowing out and working to the required shape.

The Portland Vase is probably the most famous of the early examples of this technique. Casing is the basis of cameo glass and a considerable amount of decorative cut glass produced over the years. See **Portland Vase** and **Cage cups**.

Casein. A milk-derived adhesive material occasionally used as a binder for the materials used for painting stained glass.

Cassiterite. SnO_2. The crude ore of tin oxide often containing impurities such as arsenic, bismuth, iron and zinc.

Cast. Work which has been produced by forming the glass in a mould.

Casting. In a small workshop casting is usually carried out either by ladling hot glass from a furnace into a pre-heated mould, by melting glass in a crucible from which it is poured into a mould, or by heating both mould and glass together in a kiln until the glass assumes the form defined by the mould. Industrial moulds are usually made of fine steel or bronze; they are intended for repetition blown or pressed ware and are very expensive to produce. They are rarely used in a studio where the glassmaker is unlikely to need continuous production of the same form. As a cheaper and more practical alternative, moulds for studio use tend to be made from simple and readily available materials such as fine plaster or aluminous cement together with appropriate granular refractory materials. The various properties required of such moulds are:

- The mould should give good reproduction of detail.
- It should release from the glass cleanly in order to cut down the time which would need to be spent on cutting and polishing.
- The mould should be able to stand the necessary temperature without disintegrating.
- For casting from the furnace or crucible it must also be able to withstand thermal shock.

Glassmakers usually work out their own recipes for mould making to suit their particular type of work and vary this to suit the number of casts required.

The most popular mixture for a mould suitable for a single cast is a simple mixture of 50% dental plaster and 50% ground flint or quartz. Another which seems to be used successfully is 40% plaster, 30% ground flint and 30% pre-fired plaster which has been ground down. This is said to reduce the likelihood of cracking during the casting process.

Casting process showing a piece-mould complete with its risers and filled with grains of glass. Some extra glass is situated in a funnel shape above the runner to take up any space created by the release of air through the risers.

Alternative casting process again showing a piece mould with risers but in this case the glass is placed in a container such as a ceramic plant pot and when sufficiently molten allowed to run into the mould.

Another popular variation is to introduce crushed, high temperature insulation brick in place of the pre-fired plaster. The proportion of water to the plaster/silica mixture is approximately 1 pint of water to 2 lb (or 1 litre of water to 1.6 kg) of the mixture. This 1 pint of water to 2 lb of mixture should make approximately 40 cubic inches or 655 cc of solid investment. With practice, the weighing out process becomes unnecessary and the amounts can readily be estimated by eye. Some artists prefer to use warm water for mixing in order to speed up the process.

The mixing process is important to the results. The plaster and silica need to be well mixed, preferably in a sealed plastic bag in order to avoid the possibility of breathing siliceous dust. The plaster/silica mixture is added to the water carefully to avoid introducing air and left for a minute or two to soak, then mixed into a slurry, preferably by plunging the hand into the mixture and gently shaking it from one side to the other. Taking the hands in and out tends to introduce air. It is left to settle to allow any bubbles to come to the surface. These should be skimmed off carefully and any excess water poured away. At this stage the material should be ready for pouring into the cottle.

Before any casting can take place, it is necessary to ensure that the original model will release from the set plaster. Damp clay will present no problem but models made from wood or porous materials will need the application of some kind of sealant or separating agent. There are several of these available and suppliers of casting

To calculate the amount of glass that will be required for a particular casting, the mould should first be filled with water and this poured into a suitable glass or plastic container as shown. The amount of water should be measured as (a) and noted. More water should be added to the container to ensure that there will be sufficient to accommodate the glass. This level should also be noted.

Broken glass for the casting should then be added until the level of the water rises equivalent to the measurement (a). This amount should then be enough to form the cast but it is always a good idea to add more to make sure that there will be sufficient. If a similar form to that required is available, then all that may be necessary is to weigh the existing piece and to use this weight to estimate that required for the new form.

equipment and materials will supply a range of suitable products. Porous materials can be coated with either a couple of coats of shellac or quick drying lacquer.

Separators are also used to prevent the cast from sticking to the mould, to lubricate the surface, and to form a very thin, uniform film between the mould and the cast. Potters soap is a very common separator. It needs to be thinned down with water and it is usual to brush on several coats before giving a final wash after which the surface of the mould should feel slippery to the touch. Another separator is made by mixing warmed flakes of stearic acid with paraffin (kerosene), 1 lb of stearic acid to 1 quart of paraffin. When completely mixed, it is applied to the mould with a soft brush. Similarly, petroleum jelly thinned with paraffin can be used. Other separators in the form of coats of thin machine oil, warm olive oil or spirits of camphor can be sprayed on to a metal model.

Another rather more complex mould recipe which has been highly recommended is:

2.25 lb	or	1 kg of plaster
2.25 lb	or	1 kg of flint
7.0 oz	or	200 g of china clay
0.7 oz	or	20 g of alumina fibre
0.7 oz	or	20 g of heavy paper such as paper towels
3.0 pints	or	1700 cc of water

The process is to liquidise the fibre and paper to a pulp with some water in a domestic blender. The pulp is then washed and drained. The rest of the ingredients are introduced to the water and after they have been absorbed, the pulp is added and the whole stirred lightly by hand before being stirred vigorously either in a blender or with a paint stirrer in an electric drill for a few seconds. The mixture sets very quickly so it needs to be poured on to the model soon after stirring.

The use of suitable wetting agents is recommended to allow the mixture to flow and to allow the rather fragile mould to release from the model when it has set. The mould needs to be shaken gently after pouring to move any bubbles away from the contact surface. When a plaster-based mould has dried, it is essential to pre-fire it gently to about 300°C (570°F) to remove any moisture before actually using it for the casting process.

Bert Van Loo uses a two-layer mould consisting of an inner layer made with 60% plaster and 40% talc backed up with an outer layer of 50% plaster and 50% grog. He maintains that this produces a mould that can be used several times if treated carefully.

More permanent moulds could be made by using 'Ciment Fondu' or 'Secar' together with similar aggregate materials to those used with plaster. These moulds would need to be pre-fired to the manufacturer's recommended temperatures and would also need a dusting of a suitable separator such as talc or whiting before use.

It is again an advantage to make double skin moulds, an inner one of the alumina cement with fine powdered flint or talc and an outer layer with the cement and grog.

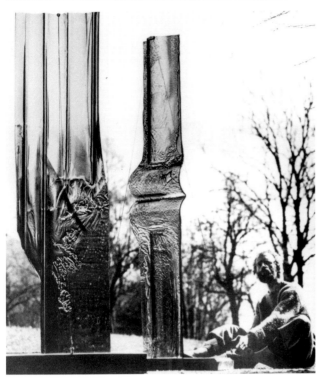

Large cast sculptural forms, 'Flugel und Stele', by Florian Lechner.

'Kosmische Schreibe', cast glass, 400 cm x 173 cm by Florian Lechner.

Relief cast mask in black glass, 40 cm high.

Other mould mixtures are:

40% dental plaster
30% silica
30% previously fired mould material

50% plaster
25% silica
25% Molochite

50% plaster
25% silver sand
25% Investrite

100% Investrite

60% plaster
40% talc

50% plaster
50% silica – used as an inner mould and surrounded by an outer mould of 20% Ciment Fondu and 80% grog.

40% plaster
20% Ciment Fondu
40% silica

40% plaster
10% Ciment Fondu
40% silica
10% ceramic fibre

20% Ciment Fondu
80% grog

Moulds made from plaster mixtures need to be dried thoroughly before being placed into a kiln for the actual casting process. Many craftsmen often leave them in a warm oven overnight to remove any excess moisture before the start of the kiln firing processes.

There are many casting techniques. For full three-dimensional forms to be produced in a kiln, the 'Cire Perdue' process, commonly used for casting metals, but using the plaster mixtures previously described, is probably the most popular. For casting from the furnace or from a crucible, resin-bonded sands, which again are

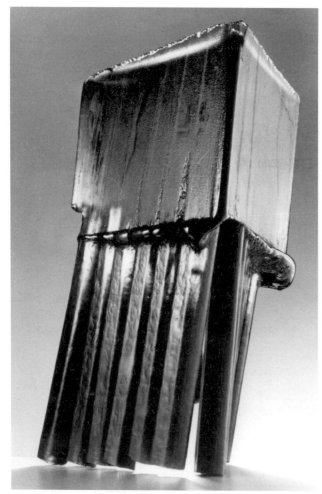

Slabs of kiln shelf arranged for casting.

Heavy cast piece by Gisela Sabokova. Now in the Museum of Glass, Brno, Czech Republic.

used for metals, are available. Small quantities of these can usually be obtained from a metal foundry.

An alternative to this is to use solid blocks of graphite which can easily be worked with appropriate wood-working tools. The only difficulty is that this can create an incredible amount of black dust which must be carefully and completely removed as it appears. Graphite is expensive but is a very good material for moulds as it withstands the thermal shock of hot glass very well. Even so, it helps to drop some hot glass into the mould and to remove it before the actual cast is made so that the surface of the mould is hot enough to avoid cooling the surface of the glass too rapidly.

Relief casts are usually made by taking a mould directly from the original model which will probably be made from soft clay, modelling wax, or vinyl-type material.

The casting of slabs of glass of simple form in a kiln is possible without the necessity of making moulds. A kiln shelf can be prepared by ensuring that it is perfectly flat – if necessary, first running it over with a diamond abrasive pad to remove any material which may have become fused to the surface. A sheet of ceramic fibre is laid on the

Ceramic fibre laid onto the slabs of kiln shelf to act as a separator.

The completed mould ready for the pieces of cullet to be placed in prior to firing.

Cast form by Michele Perozeni. This form has been sandblasted and treated with acid after casting.

Cast block by Colin Read showing misty swirl effects similar to those obtained by the inclusion of fine sand.

shelf and cut at the corners so that it can be turned up along the edges to form a box. These edges are then supported by narrow strips cut from kiln shelf material. Deep box forms made in this way will probably need further pieces of refractory placed along the strips to ensure that they do not spring apart when the glass melts into the form.

When casting glass into open moulds, most makers simply lay in sufficient cullet and then melt it into the form. If the glass needs to flow into the form, the cullet can be placed into a suitable ceramic plant pot which is placed so that when heated, the molten glass will run through the hole in the bottom of the pot and into the mould.

Some makers deliberately introduce small amounts of

fine glassmaking sand into casts of clear glass to give some internal movement or flow which often emerges as a fine cloud effect. This can be done quite haphazardly by sprinkling the sand amongst the cullet or by making half the cast, putting a small amount of fine sand on to the surface, spreading this with the fingers or a brush into a pattern as necessary and then casting the remainder of the glass on top of this. It must be emphasised that the amounts of sand used must be very small.

Catalyst. A material with special properties which even in minute quantities helps a physical or chemical change to take place without producing any change in itself.

Perhaps the best known catalysts are platinum, rhodium and palladium for their role in changing the carbon monoxide, hydrocarbons and nitrogen oxide emitted through car exhaust systems into relatively safe compounds. A car catalyst can last up to 80,000 miles on two grammes of platinum. The hardening compounds of accelerators used for setting various epoxy and polyester resins are often sold as catalysts but, strictly speaking, they are not.

Catenary arch. This is a form which derives from the shape which a chain assumes when it is allowed to hang from two fixed points. It provides a shape which is often used to form the arch of a pottery kiln as there is a natural strength inherent in its design. It can be used to provide the top part of a small furnace as it is a relatively simple form to cast in one piece and apart from its structural strength, it reflects the heat back on to the surface of the glass. An egg-shaped furnace based on this concept was constructed by Heikki Kallio in Finland.

The catenary arch is a shape which reflects the shape that a chain takes up when it is allowed to hang between two fixed points. It results in an arch of considerable strength and has long been used for kiln construction.

Cathedral glass. A form of rolled, translucent glass which often has a highly textured surface.

Celestine. $SrSO_4$. Strontium sulphate. Formerly used as a constituent of lustres but it is a material which now tends to be avoided for this purpose because of its inherent toxicity. It is a source of strontium oxide which is finding increasing use in the manufacturing of television tubes.

Cellosolve. Hydroxy-ether. Glycol-monoethyl-ether. A colourless liquid used as a solvent in the plastics indus-

try and as a binder used for painting in stained glass work.

Celsian. $BaO.Al_2O_3.2SiO_2$. Barium feldspar. The mineral is too rare to be of any significance as a source of baria for glassmaking.

Celsius. °C. Centigrade. Degrees Celsius are simply degrees centigrade. Originally named after the Swedish scientist Anders Celsius, they are units on a scale where 0 represents the freezing point and 100 represents the boiling point of water. It was later extended by Lord Kelvin. See **Kelvin**.

Cement. Any material used to bind together suitable aggregates is a cement. It is commonly used to join together refractory bricks and blocks or to form concrete for holding blocks of dalle de verre in place in stained glass windows.

Common cement is made from various siliceous minerals but special alumina cements are available for high temperature work. The most common of these is 'Ciment Fondu', a dark powder producing a black or near black refractory concrete and 'Secar', a white powder used for higher temperature work. The cast blocks made from either of these alumina cements need to be pre-fired before use.

To the stained glass worker, cement refers to a mixture of boiled linseed oil, whiting and a little turpentine or turpentine substitute, somewhat similar to a material which used to be termed 'Mastic' in the building trade. Sometimes a small amount of paint drier is introduced to speed up the drying process. Vegetable black stain can be added to bring the colour more in line with that of lead calme.

There are various cement mixtures and stained glass artists often develop ones to suit their particular requirements. One common mixture consists of:

 40 parts of whiting
 20 parts of plaster of Paris
 4 parts of vegetable black
 1 part red lead
 Equal parts of turpentine and boiled linseed oil
 sufficient to mix the whole into a sticky mixture.

The cement is applied generously and scrubbed into the lead calme on both sides with a stiff brush to ensure that the final window is waterproof. If wide calme has been used, then it is generally advisable to lift its edges and to brush the cement underneath before flattening them back onto the cement. After the surplus cement has been removed, it is common practice to spread a mixture of sawdust and whiting onto the panel and to use this to remove any remaining cement and to give the glass and the lead a final polish.

Cemented. Sintered. Various materials such as carbides, tungsten, titanium etc. can be mixed with other materials and heated until they form a solid mass. They can then be used to provide very hard working surfaces on cutting and grinding tools. When glass particles are heated to fuse in this way, the term used tends to be 'sintered' rather than 'cemented'. See **Sintering**.

There are many materials which do not require heat to effect a join to other materials to form a solid mass. The most usual is that of the cement used in the building industry but there are also special high temperature aluminous cements used together with suitable refractory or insulation aggregates to make cast forms for furnace buildings.

Centrifuge. Apparatus which can shape hot glass by using the force achieved by high speed rotation to spread glass against the inside surface of a special mould.

Ceramic fibre. Fibre manufactured from various alumino-silicate materials and made into a wide range of forms for use as lightweight, high temperature insulation. It is available in a number of grades, shapes and qualities to suit the particular specifications required. Specially high temperature material is made which incorporates zirconium silicate used increasingly in burner blocks and forehearth applications. See **Insulation materials**.

Ceramic paper. Ceramic fibre insulation material pressed into a paper form and usually sold in 1 mm and 2 mm thicknesses. It is particularly useful for separating glass from a kiln shelf during slumping and fusing processes. Its other major use is as a sandwich layer between insulation refractories.

Ceramic welding. This is a system which has been developed for repairing glass furnaces. It is mostly used on large production tank furnaces and has the advantage of making it possible to carry out repairs whilst the furnace is still in operation. This prolongs the life of the furnace considerably and saves costs by postponing the need for a furnace re-build.

The method is as follows: A water-cooled thermic lance is used to penetrate the furnace. Then dry, appropriate refractory powders and fine metallic particles are projected in oxygen onto the area of the furnace refractories to be welded. The metallic particles oxidise, which creates a very high localised temperature which in turn melts the refractory face and causes the incoming refractory powders to fuse onto the surface.

Ceria. CeO_2. Cerium dioxide. An oxidising agent and decolouriser which can be introduced together with manganese dioxide into a batch. It was extensively used in the container industry (the makers of glass jars and bottles etc.) to replace arsenic. It is sometimes used as a refining agent in lead and other glasses. It also cuts off UV transmission in glass.

The studio glassmaker will know it more for its gen-

eral use as a polishing material both on its own and as part of many commercially-prepared polishing powders. It is one of the lanthanide oxides. It can be used together with titanium to produce yellow colours.

Cerium. Ce. A rare earth element belonging to the lanthanide group which is finding increasing use as a constituent of many alloys. Its oxide is used as a polishing material both on its own and together with other materials.

Chain. A line of atoms of the same type in a molecule.

Chair. A bench fitted with two arms in which the glassblower (gaffer) sits whilst working the glass; the blowing iron or the punty iron being rolled along the arms to ensure that the glass remains central to the iron whilst it is being cut or shaped.

The term is also used to refer to the team of glassworkers operating around a chair.

The glassmaker's chair is basically a firm seat stretched between two frames fitted with arms which slope slightly downwards.

Chalk. Calcium carbonate. $CaCO_3$. Chalk is the softest of the minerals providing calcium carbonate and is easily ground and reduced to a fine powder. It suffers from the disadvantage that it tends to have a higher iron content than that of the harder limestones. As a result, whilst it can be readily used for glasses where the colour resulting from the iron content is not important, it is rarely used for good quality clear glass as iron-free limestone is usually readily available.

Chamotte. Grog. Usually consists of fireclay which has been fired and ground to suitable grain sizes to act as reinforcing material in clay and in plaster mixtures for making moulds. Grog for glass pots is often made from Molochite.

Chance Brothers. The Chance brothers made a substantial contribution to the production of sheet glass in Britain. Robert Lucas Chance introduced the broad or cylinder method of making sheet glass from the Continent. He improved the process by making much larger cylinders. These were annealed and allowed to

cool before being split, re-heated and flattened into sheets. They were then re-annealed as they cooled. He supplied almost a million square feet of sheet glass for the Crystal Palace in 1851. James Chance invented a method of producing improved plate glass which made sheet of such quality that it was in great demand for mirrors and coach windows.

Chandeliers. Branched, hanging supports for several lights. Glass chandeliers have been produced in various locations over the centuries. Perhaps the earliest notable examples were the floral chandeliers which appeared in Venice in the early 17th century. They were often made from the opalescent glass of Murano. When Ravenscroft introduced his lead crystal glass, it proved to be an excellent material for the accurate cutting and polishing required for facetted pendant drops. As a result, various shapes, ground, cut and polished in the manner of the Louis XIV rock crystal chandeliers became very popular and began to be produced by many other glassmakers in

Lampworked chandelier by Tom Iglehart.

Britain and later in continental Europe. In more recent times, Orrefors in Sweden became noted for its chandeliers but most production today seems to be centred on Llobmeyrs in Austria and in various factories in the Czech Republic and Slovakia.

Charging. The process of loading batch into a furnace.

Check. A crack in the surface of a glass object. It is often caused by contact of the hot glass with a cold surface.

Chemical analysis. This operates in two forms.

(1)*Qualitative analysis* which provides the determination of an element or elements present in the substance being analysed.

(2)*Quantitative analysis* which provides a determination of the amount of an element or elements in a substance.

The chemical analysis of glass is usually expressed as the oxide e.g. SiO_2, Al_2O_3 etc. See **Analysis**.

Chemical bonds. The unit of force joining two or more atoms together to make a compound. The main types affecting glassmaking are: *Ionic bonds* which are formed when ions of positive and negative charges attract each other to create a strong bond and *covalent bonds* which are formed between atoms when they share a pair of electrons. This creates a weak bond.

The bonds which form molecules must result from a situation in which the process is favourable in terms of energy. The inert gases are the most stable of the elements because they have a complete outer shell of electrons. They do not react with other elements because in their case, their energy cannot be improved by the process of forming compounds.

The electrons in the outer shells of atoms are those most likely to be concerned with the formation of compounds. Molecules are only formed if in the process each atom moves towards a more stable configuration of electrons. There are some electropositive elements with atoms which release one or more electrons easily. There are electronegative elements which gain electrons and there are elements which tend neither to gain or lose electrons. These variables produce a situation in which various types of bond are possible.

- Firstly, that of an electropositive element with an electronegative element and called an ionic bond.
- Secondly, that of an electronegative element with an electronegative element and called a covalent bond.
- Lastly, that of an electropositive element with another electropositive element and called a metallic bond.

An example of an ionic bond is that of sodium with chlorine. The sodium atom has only one electron in its outer shell. It can achieve stability by losing that electron. It then becomes known as a sodium ion and has a charge of +1, because it now has a positive nucleus charge of 11 and only 10 negative electrons. On the other hand, a chlorine atom has an outer shell which only needs the addition of one electron to make it complete. In gaining this electron it becomes known as a chlorine ion and has a net charge of -1. When the sodium and chlorine react together, the outer electron of the sodium transfers to the chlorine to produce sodium and chlorine ions which are held together by the attraction of opposite charges. In this case both kinds of atoms become more stable, being more favourable in terms of energy, and sodium chloride is formed.

Any concern with materials used to provide batch means having to deal with bonds which, though not all, are largely ionic. There are some bonds which could be better considered as being covalent or metallic. They are cations if they have lost electrons and as a result have gained a positive charge and anions if they have gained electrons and obtained a negative charge. The electronic charge depends on the number of electrons that have been gained or lost in forming the ion. Compounds with ionic bonding are made up of positive and negative ions arranged together in a lattice. The electrostatic attraction is non-directional and extends in all directions equally.

This means that to break ionic bonds requires an input of considerable amounts of energy. Such compounds as these are usually very hard and have high melting points. As the size of the atom depends in part on the electrostatic attraction between the positive nucleus of the atom and the negative electron field around it, any change in the number of electrons changes the size of the particle. The size of an ion is important in relation to its ability to fit into a crystalline compound. The size of an ion is also important in its effects on a material when there is an ion exchange.

Chemical symbol. Standardised symbols used to describe the various chemical elements. See **Tables**.

Chequers. Firebricks or other suitable refractories arranged across each other in layers with spaces between each brick to allow the flue gases to flow through them so that they can store the heat. Once hot, the flue gases are switched to a different set of chequers and the air for the burners passed through the hot ones to collect the heat and produce more efficient combustion. See **Regeneration**.

Chert. See **Flint**.

China clay. Kaolin. A pure form of clay formed from decomposed granite. It has a high alumina content and because of this, it is highly refractory. The calcined china clay, Molochite, is often the grog input for refractory clays used for making glass pots because of its low iron content and its high melting point.

It is known in China as Kao-ling. Good workable deposits have been found in France, in the former Czechoslovakia and in Britain.

Chromite. $FeO.Cr_2O_3$. An ore found in igneous rocks; it is the common source of chromium oxide. As iron chromate it is used as a colourant in ceramics. It is also used as a pigment to provide various colours in paints. Chromium salts have a corrosive action on the skin and on the nasal cavities. There is also some evidence of increased incidence of lung cancer amongst people working with chromite ore.

Chromium. Cr. A hard transition metal with excellent corrosion resistance; used to help form the stainless steels commonly used for making various tools, particularly blowing irons.

Chromium oxide. Cr_2O_3. A refractory colouring oxide

used indirectly in small quantities mainly to provide greens and yellow-greens. See **Colour**. It is not very soluble in glass and tends to produce black specks so it is normally introduced in the form of sodium or potassium chromate or dichromate.

Chronite. A heat resistant form of stainless steel used for the ends of blowing irons to prevent the contamination of the glass by flakes of iron oxide.

Chunk glass. A common name for slabs of glass. See **Dalle de verre**.

Ciment Fondu. A trade name for a high temperature aluminous cement made by heating lime and alumina together. It is used with suitable aggregates for many types of cast forms for furnace applications and for making moulds for glass casting. Particular care needs to be taken to pre-fire the casts slowly before putting them into operation. A similar material for higher temperature use is 'Secar'.

Circuit breaker. A device which provides the same result as a fuse without destroying itself. Usually introduced as a safety device. It is now a legal requirement in many European countries to fit these in workshops. See **Electrical terms**.

Cire perdue. Refers to the lost wax process of metal and glass casting. See **Casting** and **Lost wax process**.

Clam. The action of spreading wet clay to seal the bricks used to brick up the front of a pot furnace.

Clapper. A glassmaking tool comprising two wooden arms joined at one end with a hinge usually made from leather. Used to squeeze a blob of molten glass when forming a foot on a goblet.

Claw beakers. Beakers that have a distinctive claw decoration on their outer surface. They vary in shape and are often large. They may have been added partially as decoration and/or to provide a better grip.

The Romans knew of prunts and claws though they never seemed to exploit them to any extent. It was in the 5th century AD that claw beakers started to appear in the Seine-Rhine area and in England. They have been found in considerable numbers. Some from the 8th century have been found in Scandinavia.

There is some conjecture that the vessels were blown into moulds containing holes through which the claw pieces emerged. It seems much more likely that blobs of hot glass were attached to a blown form whilst it was still on the iron. This is the standard method of attaching prunts today. On blowing into the vessel these blobs would soften the parent glass sufficiently to allow the blob to extend to the extent that it could be grasped and pulled with pincers into a hollow claw shape. The end of this would then be attached to the blown form towards the base. Solid claws would be produced in a similar manner except that as they would not need to be blown out they could be attached when the vessel was on the punty iron. Claw beakers were usually made from typical green waldglas (forest glass) and they often incorporated trails towards the rim. One of the finest examples of these from the 5th or 6th century was found at Castle Eden in County Durham and can be seen in the British Museum. See **Prunts**.

Clay. Clay consists mostly of alumina and silica but it is a material of considerable variation both in content, form and characteristics. Primary clay, also known as residual clay, is formed from decomposed feldspathic rocks and at this stage is usually relatively pure, as in china clay. Chemically, it can be described as a hydrated silicate of aluminium. It is a mineral with an extremely fine crystalline structure but the primary clays tend to have a larger particle size than the secondary clays which makes them less plastic. As clay is washed down from its place of origin, carried away by rivers and redeposited, it gathers a wide range of other minerals and forms secondary or sedimentary clays; usually becoming more plastic in the process. If sufficient iron is picked up, the clay becomes red, yellow or brown.

Fireclays, the refractory clays used for making glass pots and for some refractories used in furnace construction, are secondary clays but they tend to be those with a higher than normal alumina content. Those selected for this purpose are also those which prove to be low in iron as this tends to move into the glass and acts as an unwanted colourant.

Clays are thought to have originated as hot magma pushed up to the Earth's surface, where it cooled into domes of igneous or metamorphic rock. Various hot gases reacted with the rock whilst it was cooling to break it down into mixtures of feldspar, mica and softer materials including clay. The various types of granitic rock so formed have been subjected to the gradual process of chemical and physical erosion by ice, wind and water resulting in the formation of many fine grained materials. These, in turn, have been subjected to further varied and complex chemical action, the most obvious of these being that of acidic attack by water containing carbon dioxide. One of the most common minerals concerned would be feldspar and as an example, this would break down as follows: Assuming an approximated formula for feldspar of K_2O, Al_2O_3, $6SiO_2$, this would separate into clay (approximately Al_2O_3, $2SiO_2$, $2H_2O$) quartz ($4SiO_2$) and potassium carbonate (K_2CO_3). In practice the reaction would be most unlikely to be so simple and other minerals such as iron oxide, mica, unaffected particles of feldspar etc. would almost certainly be present.

As clays become eroded from their original formation and re-deposited, they pick up further minerals and organic material and what may be generally accepted as a simple material really describes something which

varies enormously in content. The actual clay present in one of these materials can constitute as little as 25% of the body. The only common characteristic of them is that when wet they are plastic, hard when dried out, and readily re-constituted to a plastic state when water is added.

The particles of clay in the plastic state have often been likened to a pack of cards, each of them surrounded by water. The flat plates will slide freely whilst separated by water but hold together to form a stiff, brittle material as the clay dries. The water which creates the plasticity can represent between 20% and 30% of a wet clay but this is by no means the total amount. The theoretical formula of the clay crystal is $Al_2O_3.2\ SiO_2.\ 2H_2O$. This means that another 14% is tied up in the chemical structure. In addition to this, another 9% is held by the pores. As all this water is lost in the processes of drying and firing, it accounts for the considerable shrinkage which occurs between the movement from wet clay to the finished product.

The clay crystal is composed of thousands of sheets of aluminium silicate layered one on top of the other to form a reasonably flat and vaguely hexagonal crystal. The primary clays such as china clay and the fireclays generally have large crystals which accounts for their tendency to be far less plastic than the secondary clays such as the ball clays which have very fine crystals.

The sheets forming the crystal are formed in distinct alternate layers comprising a layer of silica and a layer of gibbsite joined both together and to the next pairing by oxygen atoms.

Clichy. One of the major French glass factories. Founded in 1848 and famous for its production of paperweights and a colour 'Clichy Rose' which was soon copied by many other glasshouses.

Cobalt. Co. A light grey transition element used in specialised alloys. Used for stainless steels and to produce resistance to corrosion at high temperatures.

Cobalt carbonate. $CoCO_3$. A compound of cobalt; it can be used to introduce cobalt oxide into a batch. However, it is used more in glazes where its fine particle size contributes to even colour distribution.

Cobalt oxide. CoO, CoO_2, Co_2O_3 or Co_3O_4. The most powerful and most persistent of the colouring oxides. It produces a very strong blue from small quantities and unlike many of the other colouring oxides is only slightly modified by the particular batch being used. It is often deliberately muted by additions of iron oxide or manganese dioxide. The colour is blue in most batches but it changes towards mauve in the presence of magnesium and towards turquoise with titanium.

It is also a strong flux and spreads easily and evenly through a batch. It was often used in the past as the natural mineral zaffre from Germany in which case the colour was softened somewhat by the presence of other oxides. It is mined as an ore which is usually combined with arsenic, sulphur, manganese and nickel. Most of it is imported from South Africa and Canada.

Cobaltiferous wad. An impure hydrated form of manganese oxide containing up to 30% cobalt oxide. It is sometimes used to produce a softer blue with a purple hue.

Coefficient of expansion. A numerical expression of the increase in size of materials in relation to temperature change. In glass materials, this usually refers to the increase over a specific range of temperature rise. See **Expansion**.

Coffins. The boxes used in a stained glass studio for the storage of lead calme.

Coil base. A ring on the base of a glass vessel; formed by trailing a coil to form a base on which the vessel will stand.

Coiling. This is a common method of making pottery. Coils of clay are rolled out, laid one on top of another and then thumbed or scraped together. Glass pots (the pots which are made to contain glass which is being melted or worked) are made in a similar way. Rods of clay, as they emerge from the pugmill, are first wedged and then used in pieces joined and pressed together in the same way as that used by potters in making coiled pottery.

Because of the thickness and weight of clay being used, it is usually necessary to make the glass pots in various steps by coiling together just sufficient clay to ensure that it will not sag and then smoothing the coils on both sides (some pots may have to hold up to a ton of glass). The top layer is then covered so that it will remain sufficiently soft to enable further layers to be added whilst the lower coils are left to harden sufficiently to carry the added weight. The process then carries on in a similar manner until the pot is completed.

Cold painting. This is the tradition of applying artist's ordinary oil or polymer paint to provide decoration on glass. Recently, there have been developed several commercial preparations specially prepared for painting on to glass in order to provide a cheap substitute for stained glass panels.

Cold working. An all-embracing term for the various techniques such as engraving, grinding, carving, cutting etc. carried out when the glass is cold.

Colemanite. Borocalcite. Hydrated calcium borate. Priceite. Pandermite. Approximately $2CaO.3B_2O_3.5H_2O$ but variable. Occasionally used to introduce both boric oxide and calcium oxide into a batch where it acts as a powerful flux. It is extremely variable in composition

and tends to be used more as a glaze material rather than for glass batch. It is the only mineral which contains boric oxide in an insoluble form. It also tends to be bulky in relation to the oxides it would contribute to a batch because all the various forms of colemanite have a very high content of H_2O. It should be noted that the name borocalcite is also used to describe calcium borate.

Collage. Used to describe the practice of cutting up and applying pieces of coloured paper to a stained glass cartoon.

Collar. A band of glass applied around the rim of a bottle or open vessel.

Colloids. Finely divided particles of material dispersed in another substance, often showing different characteristics as a result. Halfway between a suspension and a solution. Such fine particles are known as a dispersed phase whilst the materials in which they are suspended become the dispersion medium. Both together form a colloid.

Colloids are classified in various ways. *Sols* are small solid particles dispersed in a liquid. *Emulsions* are colloidal systems in which both the dispersed and continuous phases are liquids. *Gels* are colloids in which both dispersed and continuous phases have a three-dimensional network which forms a kind of jelly.

Colloidal dispersions in glass can be responsible for many colours. Sometimes this colour results from the actual colour of the colloidal material but it often results from the fact that the particles are so tiny that they interfere with the waves of light bending them to produce an opaque effect rather than one of transparency or of reflecting and/or transmitting light to affect the colour.

Perhaps the most famous example of colloidal dispersion in glass is that provided by the Lycurgis cup in the British Museum. It appears opaque green in reflected light but becomes wine-red in transmitted light. See **Lycurgis cup** and **Diachroism**.

Several heavier metals go into a dispersed phase to produce colour. Gold and copper will each produce ruby, silver will produce yellow. Some non-metals can also become colloidal suspensions. Carbon and sulphur will each produce amber. Selenium, particularly in association with cadmium, is widely used to produce a range of yellows and reds.

Colour. Colour is a phenomenon which is perceived when light of different wavelengths is received on the human eye. There is a visible spectrum ranging from approximately 390 nm to 740 nm running from violet through indigo, blue, green, yellow and orange to red. A total mixture of all these found in normal daylight produces white light. Other colours can be produced either by omitting some components or by varying the proportions.

A colour has three qualities: its hue which depends on the wavelength, its saturation which depends on the degree in which it moves away from white light, and its luminosity. In looking at a painting or a solid coloured object, the colour we see usually results from the pigment. A blue sky in a painting seen in a white light results from the fact that the pigment absorbs all the other colour elements except the blue. Glass presents problems because it not only gives the colour sensation in a similar way to that in paintings but it also deals with light which is transmitted through the material or reflected from small particles in it. As a result, a very thin layer of copper lustre will register as being the colour of copper metal when we see the reflection of light from the surface of the glass but will appear as being blue when light actually comes through the glass.

Much old glass is coloured naturally by virtue of the impure batch materials and the nature of the firing processes used at the time. Most modern glass is now coloured either by the effect of small quantities of the oxides of transition metals in solution, in colloidal dispersions of insoluble particles, or by the introduction of previously coloured material. The colour is rarely a constant produced by a particular oxide in isolation. The nature of the remainder of the batch can have a considerable effect as different glasses have differing refractive indices. For example, when nickel oxide is used with a soda glass (soda-lime-silica glass), a brown colour of some sort will result even if it is in association with other materials such as barium, boron, calcium or lead. If, however, the soda in the batch is replaced by potash the colour becomes violet and remains so with the same materials in association.

The oxidising or reducing atmosphere in the furnace also has a significant effect as some colours can exist in the glass in more than one valency state. The obvious example is that of iron oxide. It can reduce to ferrous oxide (FeO) and produce a blue colour. It can also become ferric oxide (Fe_2O_3) to produce the green and browns of bottle glass. Copper oxide will be blue-green in a normally oxidised alkaline glass, green in a lead glass but it can also be reduced to produce reds within the glass or to produce a thin layer of metallic copper on the surface. Colour such as that from cobalt ions tends to remain similar in both oxidising and reducing atmospheres. In an oxidising atmosphere, most of the colour results from the effect of coloured silicates or coloured salts whereas in a reducing atmosphere the colour tends to arise from the scattering of light from the particles of the metals. See **Oxidation** and **Reduction**.

When a metal is not dissolved into the glass but remains dispersed as small particles, the size and shape of the colloidal dispersion affects the colour. Silver, copper and gold are commonly used in this way to produce yellow, red and orange colours. Very often these dispersions give very different colours according to whether they are viewed in a transmitted or in a reflected light. See **Colloids**.

Glasses coloured by copper, gold, selenium and silver

usually need to be re-heated to enable the colour to strike.

The effect of aventurine glasses results from the presence of large particles which have not been able to be incorporated into the glass structure because of saturation. See **Aventurine glass**.

Some of the colours produced by oxides which have dissolved into the glass are:

CHROME In very small quantities (up to 2%), it can be used to produce yellow greens in lead glass and green in soda- lime glass. Chrome oxide is a very refractory material and is sometimes introduced as potassium dichromate because of its low solubility. All chromium glasses have a high transmission in the red part of the spectrum. Chrome was used for the production of aventurine glass by the formation of large crystalline plates of Cr_2O_3 in the melt. See **Aventurine glass**.

COBALT The strongest of the colouring oxides, giving a range of blues in most glasses. As little as 0.5% will produce a strong blue. It is often deliberately muted by adding iron oxide or manganese dioxide. Glasses containing magnesium move the colour towards pink. Together with copper, it was used to produce the earliest known blue colours. One blue vessel from Mesopotamia has been dated at about 2000 BC and the Egyptians often used cobalt and copper in their blue glass.

Dark blue glass resulting from the use of cobalt became very popular in Europe after AD 600 but it really developed in Venice from whence it moved to Germany and England. In Britain, it reached its greatest popularity with the introduction of Bristol blue glass (see **Bristol blue**). It is still produced in considerable quantities today in most parts of the world as it is one of the easiest colours to make and to use because of the tendency of cobalt to be constant in its colouring effects.

COPPER In a soda-lime glass made in an oxidising atmosphere, it produces a blue-green colour and in a lead glass, a green colour. In a reducing atmosphere, it can be used to produce a ruby colour and in high proportions (about 10%), it can make an aventurine glass by saturation.

It was probably one of the first materials used to produce a ruby colour and there is some evidence of it being produced and melted in a reducing atmosphere in the 7th century AD. It was not however made with any real degree of consistency until the 17th century.

IRON Used in proportions from 0.5% to 10% to give a range of greens from very pale to a green bordering on black. Strong reduction will move the colour towards blue. It was responsible for most of the green-coloured glass which has been in evidence from the beginnings of glassmaking and was characteristic of the forest or Waldglas in Germany and in Britain. See **Waldglas**.

It is still used in the production of wine and beer bottles where the colour results naturally from the iron content of the sand and other batch materials. It is often used together with manganese to produce shades of amber.

MANGANESE Used in proportions 1% to 10% to give a range of colour from pale purple to black in a potash glass; tending to pink shades in a soda glass. It also has a strong tendency towards stiffening the glass and making it difficult to work. It was often used to produce a pale rose pink colour but perhaps its major use has been as a decolouriser to counter the colour resulting from iron in the batch materials. It is very sensitive to variations in the furnace atmosphere.

NICKEL Used in proportions from 0.5% to 4%. In lead-potash glass it produces purple-red colour and in soda-lime glass a grey-brown. Proportions above 4% are used to produce black.

SELENIUM Produces golden browns in lead glass and pink in soda-lime glass but it is mostly used in conjunction with cadmium sulphide to produce a range of strong reds and yellows.

The colours produced above are very basic and wide ranges of colours are produced commercially by the inclusion of more than one colouring oxide into a melt. Combinations of materials are often used to produce specific colours.

The range of amber colours is a case in point. They are traditionally produced by the introduction of various sulphur compounds in conjunction with carbon and are essentially reduction colours but iron oxide with manganese dioxide will also produce an amber glass as will selenium in a lead crystal glass, both in an oxidising atmosphere.

Ruby glasses are almost wholly produced at the present time by the use of cadmium and selenium together. The traditional materials of copper and gold are now only used for art and prestigious ware but antimony together with some sulphur and carbon can also produce a ruby with a similar transmission to that of the selenium ruby. With the strong environmental lobby against cadmium compounds, it seems that copper as a source of ruby glass is likely to make something of a comeback.

The harsh colour produced by cobalt oxide is often modified with copper to give a different range of blues or by small quantities of iron or manganese simply to mute the colour. Turkish blue is produced by the additions to the cobalt of chrome, iron and copper oxides.

A wide range of greens can be produced by mixtures of copper, chrome and iron in an appropriate batch.

Silver is the traditional source of most yellows but a bright clear yellow for signal glasses i.e. glasses made for traffic and railway signal purposes, is now made with cadmium and sulphur. Titanium with cerium also makes a very attractive yellow. Iron with manganese can give a range of softer, olive yellows.

Glassmakers who wish to pursue the possibilities in depth should read the comprehensive book on coloured glasses by W. A. Weyl published by the Society of Glass Technology (see the Bibliography at the end of the book). See also **Colloids, Oxidation, Reduction** and **Aventurine glass**.

Combing. An extension of the process of threading. Fine threads of coloured glass are trailed around a parison and then combed across to form wavy or feathered patterns which can then be marvered in to the surface. See **Threading**.

Combustion. This occurs when a substance reacts with oxygen to produce heat and light. This is often a free radical chain reaction.

Compatibility. The problems of compatibility are of major concern to glassmakers. Whenever glasses of different origins and different composition are fused together, there is a distinct possibility that they will prove to be incompatible. It is generally assumed that the cause of this will be differences in coefficients of expansion and certainly this is the most likely culprit. If it is possible to obtain expansion details from manufacturers or to make thread tests then much of the difficulty may be avoided but there are other factors which can affect the issue. One of these is that whilst glasses might well be defined as having similar expansions, they might easily have different annealing points and, though there is generally a reasonable temperature range within which glasses can be annealed, some strain can be created, particularly in thick sections. Another and less obvious factor is that dense, opaque glass gains and releases heat at a different rate from clear glass. When the concern is with a thin layer of one on the surface of another there is a much better

chance of success than when one is layered between the other or when dealing with thick sections which may be fused or cast together.

Compensating cable. Cable used in pyrometry and manufactured to have a specific resistance to ensure the correct transmission of data from the thermocouple to the temperature indicator or controller. See **Pyrometers**.

Composition. The chemical nature of the elements in a substance expressed as a list based on the elements it contains.

Compounds. Two or more elements chemically combined in fixed proportions and producing a totally different substance. The formation of a compound requires a chemical reaction which produces a change in the arrangement of the valence electrons in the atoms. The difference between mixtures and compounds is that the compounds cannot be separated simply by physical means.

Compressed air tools. These are becoming increasingly popular for use with glass. Most of them are various forms of drills, angle grinders etc., for use with abrasive discs and pads. They have the great advantage over elec-

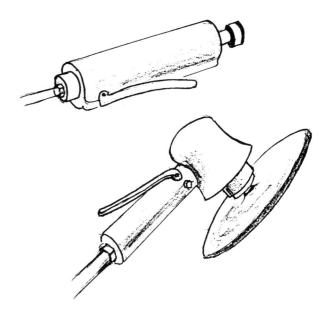

Small air driven hand grinder. This type is usually fitted with interchangeable collets designed to hold a range of dental burrs and small shanked abrasive wheels. The larger version of this fitted with a three jaw chuck is slightly more bulky but is far more versatile as it can accommodate various sizes of shanks and a much wider range of equipment.

The type of cracking which occurs when two pieces of glass that are not compatible are fused together.

Air-driven disc sander. The lever at the side controls the speed by varying the air supply. These can either be fitted with rubber pads to which standard diamond or abrasive discs can be fitted or they can be supplied with pads in which the abrasive material is an integral part.

tric hand tools in that they are safe to use with water. Air grinding and sawing tools are often fitted with a water facility. Small-diameter diamond saw blades may also be fitted. These offer the advantage of providing the flexibility of use away from the restrictions imposed by a fixed saw bench and, apart from their obvious use in cutting out difficult sections, they can be used to produce the vigorous type of engraving normally produced with abrasive wheels on a heavy duty flexible drive.

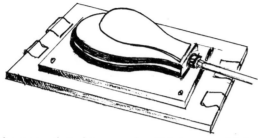

Another type of air-driven sander. This has an orbital movement and black rubber finger grips. The speed is regulated by the palm pressure on the top. As with disc sanders, diamond or abrasive sheets are available.

All these machines can be supplied with fittings to provide a facility for introducing water to the grinding face.

Compressors. See **Air compressors**.

Conduction (Thermal). The process of transferring heat through a substance from an area of higher temperature to one of a lower temperature. In a liquid or a gas, the energy tends to be transferred by the collision between atoms and molecules whereas in a solid it is transferred mostly by the migration of fast-moving electrons. The calculation of the amount of conduction taking place through a material is vitally important in calculating the amount and the nature of both the refractories and insulation materials required in furnace and kiln construction.

Conduction (Electrical). The movement of an electrical charge through a substance.

Cones. To the potter these are three-sided pyramidal forms of clay-based material designed and made to be placed in kilns to measure heat work. With heat they soften and bend over. There are several makers of these and each has its own numbering system to indicate a temperature at which a particular cone will begin to bend. They are rarely used by studio glassmakers as the necessity to control both firing and cooling cycles in a glassforming kiln means that electronic controllers are rapidly becoming the normal type of installation.

To the glassmaker, a cone is the huge brick construction in which the furnace used to be located. The furnace was set into the centre with several gathering ports around its circumference. The cone acted both as a workplace and as a chimney which removed the volatiles and the products of combustion.

Configuration. (1) The arrangement of atoms or groups in a molecule or (2) the arrangement of the electrons around the nucleus.

Conical foot. The foot of a goblet which had been shaped into a cone with the pucellas rather than being left flat as would be the normal result after using the foot boards or clappers.

Constructions. The possibilities in this area are enormous, and they often contain elements of glass together with other materials. These can be fused, glued or simply bolted together. It is impossible to describe all the variations in approach but the so-called 'Toys' of John Smith are excellent examples of the incorporation of some simple engineering to produce glass structures which also involve movement.

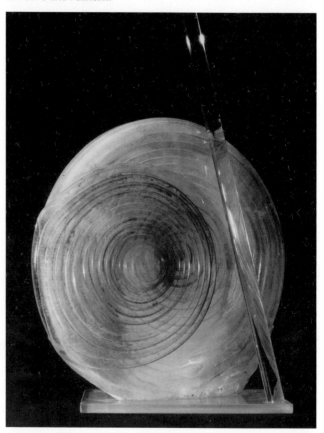

Construction of fused borosilicate circles and borosilicate rod. *Photograph by City Repro, City of Newcastle-upon-Tyne.*

Contactor. A power-operated switch suitable for making and breaking an electric circuit.

Control equipment. Modern control equipment for kilns and furnaces tends to be electronic and possesses much greater scope for accuracy and programming possibilities than used to be the case. Suitable thermocouples are still used to monitor the actual heat but thereafter the system relies on appropriate electronic components to register and control any necessary heat input.

The common type of programmer-controller usually arrives with established parameters built in. Some of these can be modified before installation so it is essential to ensure that they are understood and amended as necessary. The parameters can be as simple as those establishing limits on total time and temperature or those which make such choices as whether a programme becomes aborted altogether when there is a power failure or whether it will continue when power is restored. Once installed there are still various parameters which can be established from the control panel. Once these have been decided, the business of programming becomes relatively simple. A programme will probably consist of three or four stages, each consisting of a ramp which is designed to reach a specified temperature in a particular time. This is followed by a 'dwell' period, formerly often described as a 'soak' period, in which the temperature is maintained for a set time before proceeding to the next stage.

On completion of the stages, the controller will probably indicate that cycle 1 has ended. If the cycle parameter has been set to 1, the programme will then end but if by chance this has not been done, the whole programme will simply re-start. The controls on the panel are usually touch contact and signalled by various light emitting diodes. A typical control panel is:

The face of a standard controller/programmer.

Diagram showing a typical series of three stages in a controller/programmer.

The first stage in programming in a standard programmer is to touch the label PROG and then FUNC whereupon a sign TEMP will appear. There are two arrows one of which points up and the other points down. Touching the 'UP' arrow will start a sequence of numbers moving and a small light will show at the bottom of a sloping line to indicate a ramp. When the numbers indicate the temperature required, touching FUNC again will bring up the sign TIME and the arrows can then be used again until the time required is shown. Touching FUNC again will then indicate DWELL, and a small light will move from the sloping line to a horizontal line and the arrows can be used to define the time required for the amount of dwell. This will programme the first stage. Pressing FUNC again will start the next stage and the required data can be programmed in as before. This will continue until all the stages are complete. Pressing RUN will then start the programme.

Convection. The process of transferring heat through a liquid or gas by movement in the fluid itself.

Conversion tables. Various tables used for the conversion of data from one set of values to another. See **Tables**.

Cooling curve. Curves shown by plotting the temperature against time in an annealing cycle. This used to be controlled in most small annealing kilns by the use of interchangeable cams which had to be pre-cut to give a particular cooling curve. These have now been almost wholly replaced by programmable electronic controllers.

Copper. Cu. A reddish-brown, malleable and ductile transition metal often used for electroplating glass. See **Electroplating**. It can also be produced on the surface of a glass containing copper oxide by the use of a reducing flame or as flecks in a supersaturated aventurine glass. See **Aventurine glass**. It may be successfully incorporated as thin copper wire into fused panels of glass both to provide linear elements of design and areas of texture. It can be found as a metallic ore. However, it is more likely to be obtained from several different ores and it may be found combined with sulphur, carbon and oxygen and with other metals such as iron, tin, lead and zinc.

As a metal it is used considerably as an excellent conductor of both heat and electricity and as tubing in central heating and plumbing work. It was also once a popular form of roofing material but it is only likely to be used in this context nowadays in replacement work on buildings such as cathedrals. It is also an essential component part of many important alloys such as brass and bronze which are used in the manufacture of bearings. Small copper wheels are used for the process of copper wheel engraving.

Copper carbonate. $CuCO_3$. Found naturally as the ores malachite and azurite and sometimes used in a batch or enamel as a source of copper oxide.

Copper foil. Used to replace lead calme in stained glass work where finer lines and lighter weights of glass are involved. It is used largely for lamp shades and for making terrariums.

Copper oxides. Cupric oxide (CuO) or cuprous oxide (Cu_2O). These are strong colouring oxides, used mostly to produce greens. In an alkaline glass, they produce a turquoise blue and in a lead glass, green. It can, by process of reduction, be made to produce strong reds. Before the introduction of cadmium-selenium reds, copper and gold oxides were the most common colouring materials used to achieve a wide range of so-called ruby red coloured glasses. It is also used in excess to make aventurine glass. See **Colours**, **Colloids** and **Aventurine glass**.

Copper wheel engraving. This is a form of engraving carried out by holding the glass against a small copper wheel which is running in a lathe and fed with a mixture of oil and abrasive powder. Some confusion can arise because copper wheel engraving is often known as 'Intaglio' engraving whilst many collectors and some engravers see intaglio as referring specifically to the type of engraving carried out by using small abrasive wheels on a slightly larger type of lathe known as an 'Intaglio', or more often, as a 'Tag' lathe. Matcham and Dreiser in their book on glass engraving give a more specific definition of 'Intaglio' as meaning the type of work giving the illusion of standing relief rather than the effect produced by actual positive relief. See **Engraving** and **Intaglio**.

The various spindles used for the copper wheels.

The machine for copper wheel engraving is known as an 'Engraving lathe' and uses spindles fitted with various sizes and profiles of copper discs. The slightly larger tag lathe is basically a small edition of a cutting lathe and is used with small diameter grinding wheels which fit directly on to the lathe shaft.

The discs of copper are riveted to the end of a spindle which has been turned slightly to produce a rebate against which the riveting can take place and with about two millimetres of spindle protruding through the disc. After making sure that the copper wheel is completely flat, it should be fitted onto the protruding part of the spindle which should then be carefully hit in the centre either with pin hammer or with a small ball pein hammer.

The initial blows should be enough to secure the disc to the spindle but the rivetting is then completed by shaping the rivet head into the normal dome. The disc will probably need to be centred and this is carried out by

Copper wheel engraving lathe. *Photograph by courtesy of Gernot Merker.*

Example of a traditional copper wheel engraving lathe.

The copper wheel being rivetted onto the spindle using a small cross pein hammer.

Spindles need to be turned or filed to produce a small rebate on the end to accommodate thin copper wheels.

The bending iron is used to straighten spindles.

The abrasive and oil mixture being fed on to a copper wheel via a small leather tongue.

running the spindle in the lathe with a chalk held against the side of the wheel to show any deviation. The dome of the rivet is then hit with the hammer on the side where the chalk mark has been made. This process is repeated until the wheel runs true in a vertical plane. If the edge of the wheel is out of centre then this is usually corrected by using a sharp knife or chisel in the manner of a wood turning tool to shave it to the correct profile. It can then be finished by applying a piece of pumice or soft stone.

Various types of abrasives have been used for the actual engraving but currently the most common is 320 grade carborundum (silicon carbide) though some engravers prefer a similar grade of alumina. It is made into a paste by mixing the grit with about half its volume of paraffin (kerosene) and then adding a similar amount of thin machine oil and allowing the whole mixture to stand until the surplus oil separates into a pool and can then be poured away.

A tongue of soft leather which has been soaked in oil is clipped between two pieces of springy brass so that the tip of the tongue rests on the copper wheel. This is fed with the abrasive by dipping the end of a finger into the surface of the paste and applying it to the wheel. As engraving progresses, this action takes place every few seconds and a lot of practice is required to pick up just the right amount of abrasive. If the grade of grit needs to be changed, a different leather tongue kept specially for that grade must be inserted. Whenever work or grit is changed, it is most important that everything including the bench and the machine be cleaned very carefully.

Cordierite. Magnesium alumino-silicate. This occurs naturally as a mineral in the USA but is usually made synthetically for the ceramic industry for the production of flameproof ware. If finds occasional use in glassmaking.

Cords. Striata formed in or on the surface of glass. These striata are usually made of glass which has formed with a different viscosity to that of the remainder of the melt. See **Defects**.

Core. Investment material used to fill a cavity in a mould in order to produce a hollow casting.

Core techniques. Core-formed vessels. A method of making hollow forms, which is said to have been developed in ancient Egypt about 1500 years before glassblowing was discovered. They eventually became very sophisticated, beautifully trailed and combed, copying various Hellenistic forms.

There have been many theories on how these were made. One suggests that hot glass was trailed around a form composed of a core of sand or mixture of sand, clay and camel dung. Another, and far less likely, suggests that a similar core was dipped into hot glass and rotated in a similar manner to that used at the glass furnace of taking a gather of glass and marvering it into shape. A third suggests that a tapered metal rod was coated with a mixture of frit and binder over a layer of sand. This was heated until the binder burned off and the glassy layer formed. The sand core then being removed from the inside after cooling. The dipping of a core into molten glass is considered to be most unlikely as there seems little chance that the Egyptians would have been able to produce a core which would have been able to stand being dipped into a crucible of hot glass whilst remaining sufficiently friable to be removed later. One aspect of this theory which is often quoted is that it would not have been possible because the Egyptians did not make their own glass. Whilst this seems likely to be true, they certainly re-melted imported glass chunks in small crucibles and in the unlikely event of a suitable core and larger crucibles than those which have been found being available it would have been possible to dip a core into hot glass. It is thought that the Egyptians at that time relied on re-working imported chunks and frits from

what is now the state of Israel or from areas in or around Syria. There is certainly plenty of evidence of trade in blocks of glass with upper Syria. As any practising glass-worker will know, it is a standard operation whereby small pieces of coloured glass are heated sufficiently to be picked up on a punty iron and after further heating in a glory hole, used for trailing around another form. As this method would need nothing more sophisticated than an open fire, possibly with some kind of enhanced draught, it seems the most likely method of trailing glass around a suitable core in ancient Egypt.

As a result of a comprehensive search for a core-formed vessel with sufficient of the core intact to provide an analysis, one was found which revealed a two-layer system: the outer layer being largely composed of lime-stone fragments and the inner of what seemed to be a mixture of sand, clay and vegetable matter which probably came from dung. It is possible that a variety of techniques were employed in different locations over many years to make cored vessels but on current evidence the most probable method was that of trailing hot glass around a core. As the outer surface of these vessels is usually smooth, it is also likely that after trailing, they were combed and then smoothed on a flat stone or on a wet wooden paddle. There have been several recent attempts to reproduce core-formed vessels but Dominick Labino in Ohio has been the most successful and two excellent examples of his results are on exhibition at the Pilkington Glass Museum in St Helens. He eventually published the results of his researches and experiments in *The Journal of Glass Studies*, Corning, 1966 but decided to keep the composition of his core secret to avoid the possibility of the production of fakes.

Cork belts. Endless belts of re-inforced paper or cloth which are faced with cork granules for use with polishing powders on a linisher.

Cork wheels. These were originally made from sections of bark from the cork oak tree but latterly they have been made of ground cork bound together with suitable adhesives and used together with pumice or fine abrasive powders for polishing glass. See **Abrasives**.

Corning. Small town in New York State which is the home of the Steuben glass works and the Corning Museum. Corning Incorporated is a worldwide glass-making organisation.

The Corning Glass Museum is arguably the finest specialist glass museum in the world. It developed considerably under the direction of Tom Buechner and has established a remarkable collection of both modern and historical glass.

The factory in Corning has a viewing balcony from which the glassworkers can be seen demonstrating their skills.

The Corning factories in many parts of the world have long been associated with products made in borosilicate glass, particularly their ovenware under the trade name of Pyrex. They also produce a range of optical glass and the Steuben factory is famous for its production of high quality articles in crystal.

Cornish stone. Petuntze. An igneous rock of variable content which can be used as a feldspar in glass batch. It usually contains feldspar, quartz kaolinite, mica and a little fluorspar.

Cottle. Cottling. A containing wall usually made of wood, cardboard or plastic film, to hold poured plaster around a model until the plaster has set.

Figure 1. Cottles. Shows the most common type of cottle made from a length of cardboard or thick plastic bent to form a circle and held tight with string or elastic bands.
Figure 2 shows the type of cottle made from lengths of wood fitted with an angle bracket screwed as shown into one end. The brackets slide over the adjacent length of wood as in the illustration. This offers the advantage of being easily modified into various rectangular shapes.

The base of the cottle is normally sealed with wet clay before the plaster is poured.

Covalent bonds. Where two atoms share a pair of electrons, each atom contributing one electron to the bond.

Covalent crystal. Crystals in which the atoms are held together by covalent bonds producing very hard substances such as diamonds and boron nitride.

Cracking off.
(1) The process for releasing glass forms from the blowing iron. This is usually achieved by the glassmaker rotating the glass against the blades of the pucellas to produce a cut line at the point where a crack is required. The tips of the pucellas are then dipped into water and applied to the line. The resulting thermal shock of the wet tips against the hot glass produces a crack. The blowing iron on being given a sharp tap will then release the glass. The process is also sometimes known as 'wetting off'.

The glass being rotated firstly against a diamond or tungsten point and then against a fine flame in the cracking off process. The glass eventually cracks along the line and the two pieces can then be separated.

(2) A process used in industry particularly for forms which have been blown into moulds. The annealed glass is rotated against a diamond or tungsten point to provide a scored line. It then continues to rotate and a fine flame is played against this line until the glass cracks around its circumference.

Craquelle. Crackle. The process of producing a crazed layer on a glass form, usually by plunging the gather or parison at some stage into cold water. See **Ice glass**.

Crimper. A tool used to produce a crimped or wavy edge as a form of decoration.

Cristallo. An early Venetian soda-type glass made with barilla. It was soft, either clear or pale yellow, and easy to work. It was often used for diamond point engraving.

Cristobalite. Silica. SiO_2. One of the primary forms of silica, chemically similar to the others but with a different molecular structure. It is a crystalline solid which experiences a sudden expansion at 226°C (440°F) of approximately 3%. Similarly, there is a contraction of the same amount at the same temperature in a cooling cycle which can create cracking and dunting in many ceramic forms.

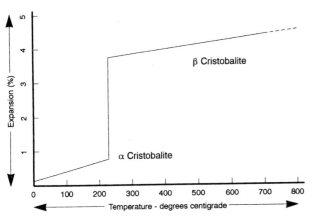

Diagram to show the cristobalite phases as they change because of temperature movement.

The presence of cristobalite in refractories can contribute to spalling. Fortunately, glass pots are rarely fired to biscuit stage before being put into a furnace. They tend to be fired directly from a dry raw state in the furnace or heated in a pot arch and transferred to the furnace when well over red heat where they usually stay until they have completed their useful life. As they are not normally cooled down for further use the expansion difficulties with cristobalite are unlikely to arise.

This sudden expansion is caused by the fact that cristobalite is capable of achieving variations in its silica lattice whilst keeping its valency. It can have a slightly collapsed arrangement and an extended straightened version. The common silica tetrahedron is usually portrayed as a silicon atom joined to four oxygen atoms with considerable space in between. In fact, whilst they are closely packed, the silicon atom is just too large to allow the oxygen atoms to pack immediately next to each other and it actually pushes them apart. This then produces just sufficient opportunity for minor adjustments to take place. It is one of these adjustments which creates the sudden expansion at 226°C (440°F).

Cristobalite can be formed in certain insulation materials when held at temperatures above 900°C (1650°F) and any dust arising from this, which occurs during repairs or dismantling, could be hazardous and appropriate dust masks should be worn.

Crizzling. Fine cracks which develop in glass as a result of poorly calculated batch or poorly founded glass. It usually occurs because of an excess of alkali and/or insufficient stabilising material. If not properly maintained, the glass will eventually decompose. See **Defects**.

Crocus martis. $FeSO_4$. Calcined ferrous sulphate. Once used for colouring enamels.

Cros, Henry (1840–1907). One of the first of the group of French artists who became involved in the revival of pate de verre. He was a painter and sculptor who worked in many different media and it was because of an interest in reproducing coloured statues from ancient Greece and Rome that he became aware of the possibilities of pate de verre. His first experiments around 1884 were not very successful and he even resorted to including fine strands of copper wire to re-inforce the pieces. It was not until 1894 that his pate de verre was considered good enough to exhibit. He was given a place to work at the Sèvres factory and eventually made masks, large panels and groups made from composite sections.

Crown glass. Sheets of glass produced by spinning bullions (see **Bullions**) and then, after annealing, cutting out the sizes required. The bullions were produced by taking a heavy gather and blowing this into a large globular shape. This was transferred to a punty iron and opened out with the pucellas into a 'U' shape. After re-heating, the iron was rotated rapidly causing the glass to extend

Model of man making a crown of glass. *Courtesy of the Pilkington Glass Museum.*

into a flat disc by centrifugal force. The early crowns were used in pairs and were only sufficiently large to produce one sheet of glass from each disc. Therefore, each contained what is often called a bulls-eye in the centre. As larger crowns began to be produced, it became possible to cut several panes from the same disc. The resultant glass was still favoured for many purposes when other methods of making flat glass were developed because it was fire polished, was often quite brilliant, and the ridges almost inevitably produced in the bullions gave this glass an individual character.

Crucibles. These are often used for melting tests and for making small amounts of colour. There are no defined differences in what might be described as a 'pot' and what should be a 'crucible' except for the matter of size and then a large crucible could just as easily be a small pot. They are readily available from suppliers of refractories. Crucibles made from platinum find regular use in laboratories and occasional use in industry to avoid the contamination of tests or special glasses by the invasion of material from the refractories.

Small crucibles for melting studio tests or for making small quantities of colour easily be made by coiling or by throwing a good pot-making clay. There are many recipes available which have been found to be satisfactory over the years. Here are a few:

1. Iron-free fire clay 60
 Molochite grog 40

2. China clay (kaolin) 35
 Ball clay 10
 Molochite grog 55

3. China clay 30
 Ball clay 15
 Calcined alumina 10
 Grog 45

Zirconium silicate can be used in place of part of the grog.

Cryolite. Na_3AlF_6 or AlF_3 3NaF. A natural mineral found in Greenland and used occasionally as an opacifier.

Crystal. A term used to refer to glass made with lead oxide as a major flux. Under current European standards, 'Full Crystal' refers to glass with at least 30% lead oxide and 'Half Crystal' 24% lead oxide. The lead oxide provides brilliance, stability, good cutting quality and long hot working.

The term is often abused as glass with similar brilliance can now be produced without the lead content and glass often sold as 'Crystal' can have as little as 1% lead oxide. The current terminology was established in 1963 but translation of terms can lead to some confusion particularly with reference to glasses with low lead content or with glasses specially formulated to have similar qualities.

Crystal lattice. A regular pattern of atoms, ions or molecules in a crystalline material.

Cullet. The broken or scrap glass introduced into a furnace for re-melting. In studios it is often used on its own but in industry it is normally combined together with an appropriate proportion of batch. With the growing environmental emphasis on re-cycling, increased proportions of cullet from many sources are now being used in industry. Complex sorting machinery is appearing on the market which will automatically select cullet of different colours and densities and which will remove any unwanted materials, particularly metals.

Cup casing. See **Cased glass.** A method of producing cased glass by a process of making a cup of coloured glass, usually from a piece of Kugler-type colour, into which the glassmaker introduces a gather of clear glass. The whole is then re-heated before being worked in the normal way. Cup casing is often used when the glassmaker does not have ready access to separate melts of coloured and clear glass.

Cupric oxide. CuO. Black copper oxide. See **Copper oxide.**

Cuprous oxide. Cu_2O. Red copper oxide. See **Copper oxide**.

Cusping. Small protruding pieces of stone in Gothic tracery.

Cut glass. Cut glass is simply a name for a variety of the wheel-cut designs embracing high relief and intaglio work and as such cannot always be defined precisely. It usually consists of geometric arrangements of facets, printies, olives, mitre cuts and line. The various types of abrasive wheels used for producing cut glass have already been described (see **Abrasives** and **Abrasive wheels**).

There has been a gradual change from the natural sandstone wheel to the modern synthetic wheel which has been trimmed to the appropriate profile and to diamond wheels which are bought from the manufacturers to the specific grades and profiles required. In use, sufficient water is fed to the wheel so that the whole of the cutting surface is kept wet and to ensure that any debris is washed away. The glass is held against the wheel towards the top in such a position that the operator can see the cut clearly through the glass. The normal procedure is to move the glass gently from the top to the bottom of the proposed cut and to then reverse the direction, repeating the sequence until the appropriate depth and width of cut is achieved.

Smoothing is carried out by a similar process but by using a wheel of fine grit, and ideally, slightly greater diameter. It is essential that whenever a change to a wheel of finer grit or polishing medium is made, both glass and hands must be washed thoroughly. When using the fine wheel, the glass needs to be moved gently but held firmly as sometimes it will seem to be 'snatched' by the wheel. It is normal to aim to produce a uniform, silky finish from a fine wheel before proceeding to the polishing process. Polishing is often still carried out by using wooden wheels turned to a similar profile as that of abrasive wheels and fed with a slurry of pumice powder. This process is normally completed by using a bristle brush fed with a slurry of tripoli powder. Cork wheels for the pumice and felt wheels fed with cerium oxide-based polishing powders have largely replaced the wooden wheels and bristle brushes over the years but because of a considerable recent movement towards the use of diamond wheels, much greater use of the acid polishing process is now the normal procedure.

Decorative glass cutting played a strong part in the glassmaking production in Bohemia in the 16th and 17th centuries and became popular in Britain in the 18th century when the brilliance and excellent working qualities of British lead crystal proved ideal for this process. There was a considerable amount of exuberant rococco design produced which became even more evident in Victorian times. Unfortunately, just as glass design remained repetitive in Venice for a long time because the standard production of traditional Venetian and latticino work was in sufficient demand to make innovation and development unnecessary, the development of innovative design in cut glass ware has stood still in most of Western Europe over the last century, most of it being extremely boring and overdone. One eminent technologist in Sheffield described it aptly as glass which has suffered the death of

Bowl cut and handpainted by Gunnar Lyren. *Courtesy of Orrefors.*

Champagne flute with printies.

An example of a cut glass.

a thousand cuts. The industry maintains that there is insufficient demand for new design to be economically viable but it is now evident that demand for traditional ware is decreasing every year.

The number of firms which produce their own forms is also dwindling rapidly and most of the cut glass now on the market is being produced by firms who buy cheap mass produced machine-made blanks and then simply cut their designs on to these. Very often, this results in simple, one-cut effects made on a diamond wheel, sometimes automatically, after which the glass is treated by immersion in acid to produce a polished finish. It seems likely that two distinct products will emerge, one composed of mass-produced and largely traditional ware and the other from small workshops producing high quality handmade and hand-cut glass.

There are some bright spots however. Glass schools in the Czech Republic and to a lesser extent in Germany encourage a considerable amount of excellent and innovative cutting. Some of the factories in these areas and in Scandinavia also produce designer pieces of excellent quality so perhaps there will be some eventual influence on the ware which appears on the mass market. There are also a few individual artists who produce exhibition pieces.

Computerised cutting is also on the increase and whilst it is likely that the major intention of this will be to lower production costs, if it is used creatively then again it could have a beneficial effect by extending the possibilities for new design.

Cutters. Glass cutters are currently available in a wide range of types and shapes. It usually takes a little time to establish exactly which is right for the kind of work and which feels comfortable in use. Diamond cutters are very

good for cutting straight lines on plate glass but are not generally favoured for cutting stained glass because of their lack of manoeuverability. It may be necessary to turn to them when a particularly hard glass is encountered which will not respond to the ordinary steel wheel cutter.

Tungsten wheels are popular because they tend to keep their edge for a long time. Sometimes the mounting will wear before the wheel. Unfortunately they tend to produce a ragged line on the glass so more use then is made of the ordinary single steel wheel which, whilst it will wear more quickly, will produce a very effective fine line which can hardly be seen. Steel wheels also have an advantage in that they can easily be sharpened by running them at an appropriate angle on a fine oilstone. The single wheel glasscutter with a steel handle usually has a series of three varying sizes of grooves in it which can be

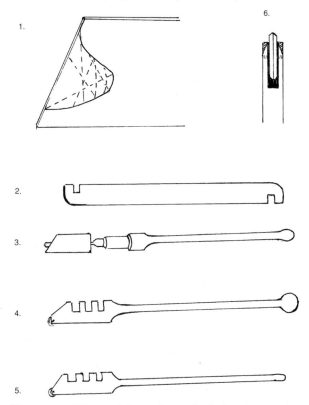

Glasscutters. *Diagram 1* shows the method of cutting an internal curve. The first cut is made along the line where the curve is to be completed but then a series of small cuts are made across the area to be removed as shown in the diagram. These can be tapped carefully from underneath. They may well come away easily but if not can be removed by using a pair of grozing pliers or a grozing tool.
Diagram 2. The standard type of grozing bar simply made from a length of mild steel with a slot ground into each end as shown.
Diagram 3. A typical diamond glass cutter with a swivel head.
Diagram 4. Wheel cutter fitted with a ball end for tapping along the underside of a cut.
Diagram 5. The standard cheap but effective wheel cutter.
Diagram 6. The removal of the metal shoulder to enable the wheel to be sharpened.

used for grozing. See **Grozing**. Some of them are also fitted with a ball end which is used to tap the underside of a cut. Occasionally an ordinary steel wheel will develop a flat spot. When this happens it should be thrown away as to continue trying to use it will probably result in the glass cracking away from the cut line.

The cutter should be held between the first and second fingers with the first finger resting on the flattened area and the cutter forming an extension of the pointing direction of the same finger. The wheel should rest on the glass with the body of the cutter almost perpendicular to the surface. The common mistake with any kind of cutter is to apply too much pressure. A light application with a smooth continuous stroke is all that is usually necessary. With practice it becomes natural to sense the amount of pressure required for a particular piece of glass as there is some difference in hardness from one piece to another.

Flashed glass is usually very hard on the flashed side and it is almost always necessary to cut on the reverse side. Selenium reds and yellows also tend to be very hard and often a cut cannot be seen. It cannot be taken for granted that the cut is not there and it is worth giving the glass a tap as it will often fracture where it is intended. When too much pressure is applied, glass splinters tend to come away and a groove appears in the glass which almost inevitably results in the glass cracking in any direction but the one required. The splinters can also collect around the wheel and if they are not rinsed away can cause it to jam and create a flat spot. When the cut has been made, most stained glass will usually break simply by applying pressure between the thumbs and fingers but often thick pieces of glass need a sharp accurate tap on the underside to the cut at one end. Once the fracture has started and the cut is a straight one, a little pressure will usually cause the fracture to run along the glass.

Curved cuts are much more difficult and usually need to be tapped at various places. Some artists recommend that the tapping should start at one end, moving to the other end before tapping towards the middle. Others recommend starting at the middle and moving towards each end. It is usually necessary to experiment to find the method which proves most effective. Deep curves need even more complex attention. They usually need several cuts as shown in the illustration so that the small sections can be nibbled out with a grozing tool or a pair of grozing pliers.

The common steel wheel is fairly easily sharpened. At the end of the normal cutter there is a flat section and the ends of this need to be ground or filed back at an angle to allow access to the bevel of the wheel. Once this is done, a fine oilstone should be anointed with a little thin lubricating oil and the cutter rested on the stone so that the bevel of the wheel is in contact. The cutter is then moved up and down the stone so that the wheel turns but at the same time is being cut by the stone. This takes a little practice. If the wheel is turning but there is no feel of cutting then nothing is happening. On the other hand, if there is cutting action but the wheel is not turning it will

create a flat area on the wheel. If this happens the wheel should be discarded. After sharpening, the wheel should be rinsed in paraffin (kerosene) to remove any remnants of oily abrasive which may have been picked up. It is a good idea to keep a selection of cutters in reserve, to get into the habit of rinsing them after use and keeping them in a jar with sufficient of a mixture of paraffin and thin lubricating oil just to cover the wheels.

Cylinder glass. This is the method of making sheet glass which has largely replaced the production of crown glass in many countries, though which process actually evolved first is a matter of some debate. It is still used to produce the sheets of coloured glass used by many stained glass artists. It is also interesting to note that the first known production in Britain was at Sunderland when Benedict Biscop in AD 675 brought glassmakers across the Channel to help to glaze the monastery being constructed at Monkwearmouth. Rosemary Cramp of Durham University excavated the site and found evidence that the glass was actually made there. This site is only a few hundred yards from Hartley Wood and Co. who still produce stained glass by the same cylinder method today.

Cylinder glass is produced by taking sufficient gathers to make a large globular form and pulling out one end to stretch it. The end is knocked off and opened out with a length of wet wood until the piece is roughly cylindrical except where it nears the blowing iron. A punty is then made from a thick disc of glass wider than the diameter of the cylinder on a heavy punty iron and attached to the open end of the glass. The blowing iron is then cracked off and the glass opened out using the length of wet wood.

The cylinder is rotated in a shallow metal half cylinder containing some sawdust and then put into the annealing lehr. After annealing, a glass cutter is run along its length and the cylinder tapped so that the glass cracks along the cut. It is then put onto a moving belt so that it travels along a heated chamber until it reaches a point where it has softened sufficiently to be opened out and flattened by the use of a block of wet poplar wood on a long iron. It then travels on to be re-annealed before emerging at the end as a flat sheet.

The cylinders gradually became so big that the glassblowers had to blow them over a pit in order to be able to produce the length required. The system eventually developed further in America when a process was evolved for producing window glass in which hot glass was poured into a heated pot and a steel ring lowered into the glass. This cooled onto the ring which was then gradually raised as cold air was blown into the forming cylinder. The size of the cylinders produced by this method far exceeded anything that could be blown and when the cylinders were cut and flattened, the resulting sheets of glass were in considerable demand because of their greater size and because they were fire polished. See **Antique glass** and **Sheet glass**.

D

Dalle de verre. The technique of using thick slabs of coloured glass in some modern stained windows. These slabs are often used in three-dimensional constructions and set into either resin or concrete.

The system was developed in the early 1930s by two French stained glass artists, A. Labouret and Pierre Chaudiere. Early installations were often attacked by the alkaline material in the concrete, particularly where damp conditions prevailed. Similarly, other faults developed in areas of wide climatic variation because no provision for possible differences in expansion were made. Leger used dalle de verre in the church at Audincourt and Ralph Bergholz has used it in several churches in Sweden. Good examples of its use in windows are to be found in the cathedral designed by Corbusier at Royan.

The slabs are roughly similar wherever they are made and vary between two and four centimetres thick. European slabs are usually about 30 cm x 20 cm (12" x 8") whilst those in the USA are normally about 20 cm (8") square. They are cut roughly to size by the usual practice of scoring with an ordinary glass cutter but then either need to be tapped on the other side with a cross pein hammer or brought down sharply on to a length of steel bar, preferably one which has been ground to an edge. The edges of the slabs are then chipped away with a mason's hammer, preferably one with hardened tips, against a lead-faced wooden block until they are the correct profile to fit their places in the pattern. As each slab has uniform colour and is not suited to the subtleties of shading, painting and enamelling common to other forms of stained glass techniques, design needs to be bold and vigorous.

Resin is becoming used much more for holding pieces of dalle de verre. It is almost always coloured and textured to produce a representation of concrete. There has been little attempt to make use of any possibilities which might be available if resin were to be considered as a material with its own visual characteristics.

It is the normal practice to make up a shallow wooden frame the size of the finished section of the window to enclose the resin and the cut pieces of dalle de verre. Sometimes the pieces are laid onto a bed of moist clay and occasionally onto a sheet of polyurethane foam, which means that the design has to be drawn into the moist clay or on to the sheet of foam. This can be avoided if a sheet of clear plastic is used and laid directly over the cartoon or design. This can be coated with rubber or latex cement and the pieces of dalle de verre laid onto this. Alternatively, the cement can be applied directly onto the

pieces before they are placed down. This is to ensure that when the resin is poured it does not creep under the flat surfaces.

It is important that the pieces are cleaned thoroughly and wiped with either acetone or cellulose thinners to ensure that they have no greasy surfaces which could resist the adhesion of the resin. If any facets are required to remain clear of resin, it helps to paint some kind of resist such as a PVA glue or wax which will peel off easily once the resin has set.

Before the resin is mixed and poured, a thin layer of sand, coloured to the required finish if necessary, is spread thinly between the pieces and around the edges to give a stony texture to the final casting.

If different colours are required for the interior and exterior faces the resin can be poured in two stages, one with one colour and then the remainder with the other. It is important to remember that when resin is mixed with its hardener and left as a mass, it can soon generate a lot of heat. It should be poured as soon as possible after mixing. Any excess left in the mixing container should be poured out onto a scrap piece of polythene sheet where it can spread and set without creating any hazard before being thrown away.

Damper. This is usually a slab of refractory material which can be pushed into or out of a flue to control the amount of exhaust fumes entering the chimney. It is more likely to be used in a gas- or oil-fired kiln rather than a furnace. When the damper is applied, it causes pressure to build up in the kiln chamber and reduces the amount of air being drawn in at the burner end. It is a common device used to control the furnace atmosphere.

Daum. Jean Daum established his firm in Nancy in France in 1875. He was joined by his two sons who were strongly influenced by the work of Emile Gallé. Initially they produced some excellent pieces in the Art Nouveau style but their later work was much less successful. See **Gallé** and **Art Nouveau**.

Day tank. This is a term which is somewhat elastic in its use and there is no precise definition.

Most small tank furnaces are made for handworking and tend to be used during the day rather than continuously, hence they are often called 'day tanks'. Sometimes when work is completed, the furnaces need to be topped up with batch and/or cullet which is re-melted overnight. In a studio or small workshop, it is more usual

to continue working the furnace until the glass level becomes low and then to recharge it.

De-airing. The process of removing air from the fireclay being prepared for making glass pots. Most of the air is usually removed in what is known as a de-airing pugmill. This is fitted with a chamber into which a vacuum is being constantly created by a suitable pump. It has the effect of drawing the air out of the fireclay as it travels through the pugmill.

De-Airing Pugmill

← Hopper

Vacuum chamber ────→

The de-airing pug showing the hopper where the clay is introduced, the upper chamber where the clay is mixed and pushed into the vacuum chamber and the final mixing chamber from which the clay should emerge ready for wedging and for use.

Decals. The name used in the USA for colour transfers.

Decay. Glass rot. Crizzling. Sick glass. This has always been a major problem for curators, conservators and collectors and unfortunately, it does not only happen to ancient or medieval glass. Some work of recent origin is displaying exactly the same symptoms and this is particularly causing great concern to museum authorities who hold such glass in their collections.

The theory often expounded that ancient glass was more durable than much of that which followed is certainly not valid. Much of it has simply disintegrated and disappeared whilst those pieces which just happened to have had the right constituent materials, were well made and were well annealed have survived.

There are several contributing factors affecting decay, the major ones being those of glass composition, poor founding practice and environment. Others are exposure to aggressive solutions, time and temperature. The usual symptoms are weeping, layers of crazing, formation of weathering crusts and occasionally, the existence of plugs. Weeping is often caused by an excess of alkali and the lack of sufficient lime and/or other stabilising material in the batch.

The chemical nature of decay is both complex and varied. Usually, the surface of the glass reacts with water and the process continues further into the glass, though there are many other factors involved. A glass surface lends itself to this because the surface ions are not com-

pletely coordinated, allowing a certain amount of replacement by other ions. This then allows further reaction with molecules of water, oxygen, etc. to the microporous substructure. Alkali ions are commonly leached from the glass to be replaced by protons of smaller volume, causing shrinkage to take place and the creation of crizzled layers which give access to further attack. This is a most complex study which cannot possibly be considered adequately here. There is still a great deal of ongoing research but the excellent book on *Conservation of Glass* by Roy Newton and Sandra Davison is currently the finest source of reference available. Restoration is rarely possible for much of the material and containment seems to be the aim of most conservators. Protective coatings and careful storage appear to be the basic essentials. Some further research is being carried out jointly by Imperial College London and the Victoria and Albert Museum and the results of this will appear in the book about conservation by Victoria Oakley and Susan Buys of the Victoria & Albert Museum (London) which should be published soon.

Decolourising. The process of introducing a mineral into the batch which neutralises the colouring effect of other materials. Traditionally, the decolourising agent used over many years was manganese dioxide. This countered the colour produced by iron oxide which often occurred in glass from the sand, other batch materials, or from the pot or tank in which the glass was melted. In the process, the manganese and the iron each absorb the light which the other transmits. Selenium and a mixture of selenium and cobalt have also been used in a similar context. Neodymium has been used occasionally and erbium has also been tried.

Decorchement, Francois Emile. He worked with enamel until 1903 when he became involved in the development of pate de verre. He started to use powdered glass from the Cristalleries de St Denis and produced many vessels with a range of mixed colour and also produced sculptural forms by using the cire perdue technique. He is reputed to have experimented in producing his own coloured glass which he crushed to appropriately sized particles. The decoration of his forms is noted for the quality of its detail.

Defects. In chemical terms this refers to a discontinuity in a crystal lattice. In normal terms, it refers to a fault which may have arisen during or as a result of a failure in a method of manufacture. The defects which arise most commonly and obviously from the process of glassmaking are cords, stones and seeds. To a lesser extent there are also problems of decay which do not become evident until much later. Stones, cords and seeds represent some of the major frustrations for the glassmaker. In the molten stage they may be removed with some difficulty but in the finished articles they tend to represent work which qualifies for the scrap or the cullet bin.

STONES. There are typically three types:

1. Those which arise during founding.
2. Those which form from the molten glass.
3. Those which come from attack on the furnace refractories.

Founding stones are caused by the incomplete melting of batch materials and can derive from:

- Wrong particle size of materials (sand too coarse etc.).
- Poor batch mixing.
- Poor founding practice – principally too low a founding temperature or too short a founding time.
- Rubbish in the batch or cullet.
- Insufficient stirring action in the melt.

The resulting stones are usually siliceous in character but often have materials in close association in either a crystalline or part-crystalline form. Stones which form within the glass after founding tend to be refractory stones or devitrification stones. In a studio, devitrification stones often occur because the furnace has been left idling at too low a temperature when the glass is not being worked. This allows devitrification to take place and siliceous crystalline material begins to form in the melt. This material may remain as isolated stones or may form threads or masses. Some glasses are much more prone to this than others but even with a very stable glass it is not worth the risk of idling the furnace at too low a temperature. Refractory stones are sometimes found when the surface of the pot or tank starts to disintegrate and they are a sure indiction that some remedial action will be necessary in the near future.

CORDS. Cords are caused by:

- Insufficient stirring action in the melting process to achieve complete homogeneity.
- Volatilisation from the glass surface.
- The continuing reaction between the glass and the furnace refractories.
- The re-melting of stones.

As glass is fined the rising bubbles produce a stirring action within the melt which, together with the natural convection in the furnace due to temperature differences, have the effect of helping to remove variations in the glass. Incomplete melting or insufficient fining can produce cords which can be seen as striata on a gather or on completed articles. See **Fining**. Most glasses contain elements which volatilise. When this happens, a silica rich layer forms on the surface which creates cords when the glass is gathered. Refractories suffer constant attack both from the batch materials and from the molten glass. This often creates a viscous layer within the glass. Stones can re-dissolve into the glass and change into cords. The cords caused by droppings from the furnace roof can often be identified by their tendency to be pear- or worm-shaped.

In some kinds of glass, cords can be considered to be little more than an unsightly nuisance but in fact they can constitute something of a hazard. A cord will inevitably be of a slightly different composition from that of the rest of the melt. Its viscosity and its coefficient of expansion will probably also differ, creating an element of strain which cannot be removed by annealing.

SEEDS. Most seeds are formed in the founding process. They consist of small bubbles of gas and usually occur because the fining process has not been sufficiently effective. It is essential that the bubbles are encouraged to rise to the surface. Large bubbles tend to rise quickly and whilst a bubble of $1/8$ in diameter would probably rise in minutes, much smaller bubbles could take weeks.

Seeds in glass.

Because of this, it is important to create sufficient quantities of large bubbles to enable them to collect the smaller ones en route to the surface. This fining process is caused by chemical action and various fining agents are introduced into the batch materials for this purpose. (See **Batch melting** and **Batch materials**.) Most studio glassmakers melt cullet rather than batch so there is no chemical fining involved and it becomes very important to ensure that the cullet is thoroughly washed and cleaned to remove any dust or rubbish which would be likely to cause seed.

The traditional method of producing large bubbles other than by chemical action is to introduce a large potato on the end of an iron into the melt. This releases quantities of steam in large bubbles which rises quickly and collects much of the small bubbles which might be in the glass. If on completion of the founding, the temperature of the melt is reduced about 100°C (180°F) below the working temperature for about an hour, it will help the glass to absorb the fine bubbles.

STAINING DEFECTS. A problem which is often presented to glassmakers is that of cleaning the interior of a vessel, typically a decanter in which liquid has been left standing. There is no doubt that if the vessel does not clean with a normal application of water and detergent with a soft brush then the problem is probably best avoided and

the owner referred to a trained conservator. Some stains will disappear by appropriate soaking overnight. For instance, lime stain can be removed by soaking in a weak acid solution. Compared with most materials, glass has a good resistance to attack by acidic and alkaline solutions but there is no doubt that quite a lot of glass when left over a long period in contact with either type of solution can suffer surface deterioration which will cause some form of matting effect or discolouration.

Interior defects which occur as a result of the manufacturing processes present problems which are best avoided. On an exterior surface it would almost certainly be possible to remove such defects with the aid of some careful abrading and polishing but on an interior surface any application of abrasives would only be likely to worsen the problem. Similar problems arise occasionally in engraving. It is remarkably easy to make a slip in lettering or even to make the mistake of putting in the wrong letter or of leaving one out. This is likely to need something rather more than a mere cleaning of a surface. It is probable that a sequence of grinding and polishing will need to be pursued. The diamond-faced flexible belts on a rubber wheel are most useful here as they can quickly remove the majority of the glass to be taken down and a change to a finer belt can take the surface to a stage where it is ready for the pumice and finally the cerium polishing. The process is not really as easy as it would seem. After grinding down the surface to a stage where the glass appears to be ready for polishing, it is almost certain that there will be small areas which will turn out to be either flat or slightly hollowed.

It is nearly always the case that some careful handlapping will be necessary before the polishing can safely take place. See **Handlapping.**

Another common cry for help often comes from the friend or acquaintance with a goblet which has a chip either on the rim or on the foot. Again, it is not difficult to grind down the rim of a goblet or to make the diameter of the foot smaller to erase the effect of a chipped edge but is all too easy to upset the balance of the form or to make it evidently different from what might be the remainder of a set. After doing this carefully to ensure that the form has not been changed too drastically, the polishing follows the same pattern as that of dealing with the engraving fault except that the work may have to be carried out on a fine edge rather than on a surface. The original edges would have almost certainly have been fire polished and a ground and abrasive polished edge could easily look obviously wrong. Another problem is that a chip on a fine goblet can easily mean that there is also a fine crack present which may not be easily detected so the goblet must be examined meticulously to ensure that it is sound before any remedial action is contemplated.

When the studio glassmaker makes a goblet it is blown, formed, cracked off the blowing iron and transferred to a punty iron, re-heated and the rim cut with shears before finishing. This involves a process of re-heating before the goblet is put into the annealing kiln. On the other hand, much commercial glass is often cracked or burned off after it has been annealed. Cracking off involves the rotating of the glass against a tungsten or diamond point followed by a fine flame until the resultant line cracks and the glass separates into two parts. Burning off involves rotating the glass within a ring of fine flames which soften the glass until the waste falls away. Both processes can leave a fire polished and rounded rim. If, as is normally the case, the glass is not then re-annealed it can create small, faint vertical lines running down from the rim. Fortunately these would probably be noticed during routine inspection. There is not much that can be done about these except perhaps to re-anneal the piece, during which the cracks could develop further, and then grind the rim down below the level of the cracks. It would almost certainly be a cheaper solution to buy or make a replacement.

Another likely difficulty to occur is one where the heat involved in the burning or cracking off leaves an area of strain below the rim. This can easily be seen by using a polariscope or by using polaroid spectacles together with a piece of polaroid film. When the glass is held between the film and the light source the piece of film can be rotated. If there is strain present it will show up as a dark or coloured band a few millimetres below the rim when the film reaches it. With this kind of fault the glass will usually crack cleanly along the fault line in which case, it should be re-annealed and the rim ground down and polished as described earlier. The proportion will obviously be badly affected but at least it will be usable.

Deflocculation. The dispersion of particles of clay in a slip in order to make the material more fluid. This is often needed when slipcasting refractory crucibles for melting small quantities of coloured glass or small batch mixtures for testing.

 Clay platelike particles under normal conditions

 Clay particles after the addition of a deflocculant

Clay particles before and after adding deflocculant.

Deflocculated slips have a higher proportion of clay materials whilst still remaining sufficiently fluid to be poured. This is achieved by adding to the water suitable alkaline materials which exchange their ions with the clay particles to the extent that the clay particles begin to repel each other. As they no longer tend to pack tightly together, they slide against each other and try to avoid contact. This means that the amount of water required to

make the water-clay mixture fluid can be reduced to about 15% of that normally required. The amount of deflocculant required can only be achieved by a process of trial and error because of the varied nature of the clay likely to be used but a rough guide which could be used as a starting point is:

Clay	20 kg (44 lb)
Water	2 litres (3.5 UK pt)
Sodium carbonate	50 g (1.75 oz.)
Sodium silicate (75 TW)	75 cc (2.6 fl.oz.)

To ascertain the quantity required, small amounts of deflocculant are added to samples until the process of developing greater fluidity begins to reverse at which stage it will become obvious that the ideal proportion has been passed. Deflocculants only act if they are able to go into solution so sufficient water for this is necessary to allow their ions to exchange. See **Twaddell**.

Dehydration. The process of removing water, usually referring to water which is chemically combined.

Delcalcomania. The use of blotting or other absorbent paper by stained glass artists to produce a random pattern in glass enamel or glass paint. The paper is pressed onto the wet paint and then lifted to remove some of the paint from the surface of the glass.

Density. (Mass per unit volume). This is often used to identify glass objects. A lead crystal type glass will have a much greater density than that of a common soda-lime-silica glass. The relative density of a high lead glass will be likely to be over 3.0 whilst that of the soda-lime-silica glass will be below 2.4.

Dental burrs. These are available with tungsten, diamond or composite abrasives and are used in conjunction with small power drills, specialist flexible drive engraving machines, or with an actual dental machine, for a wide range of engraving or carving applications. The modern dental machine has the advantage of also providing a water supply to the drill point and to the glass surface. Dental burrs are particularly suitable for fine engraving work which cannot be carried out conveniently on a copper wheel. The equipment necessary has the advantage of being much less costly to set up than an engraving lathe with all its associated spindles. Small diamond wheels which are replicas of larger cutting and

sawing wheels are now commonly used and various abrasive-impregnated rubber polishing burrs, together with fine felt wheels to be used with polishing pastes, are also available for the polishing processes. (See **Flexible drives**.)

Devitrification. Glass is a material with a randomly distributed structure which, on cooling from a molten state, tries to regain a more regular crystalline lattice. It is restricted from doing so because of the viscosity of the material. If, however, the glass is held at its liquidus temperature for any length of time, the network modifiers can help to form crystals, of, for instance, devitrite. These localised crystals have a changed composition from that of the glass resulting in a different coefficient of expansion. This creates areas of strain and tends to promote cracks. For those people responsible for large-scale production, devitrification is something of a nightmare and as far as is reasonably possible, both glass composition and the cooling rates are designed to avoid it happening. Because of this, the normal procedure is to cool the glass as quickly as possible to a temperature at which it can be annealed.

A glass which has a high lime content tends to devitrify easily. An increase in the lime content also reduces the working time so a manufacturer who wishes to produce a glass which hardens quickly to suit his forming processes may decide to increase the amount of calcia in the batch. If he overdoes this he increases the risk of producing crystals of devitrite. Devitrification can occur in the furnace, particularly if there are parts of the tank or pot which remain cool. This can cause the production of devitrification stones and/or cords and create a subsequent loss of material.

The danger of devitrification in studio glass is exactly the same as in the factory. It often occurs in kiln-cast glass where the cooling of the material in a mould tends to be slow. If the result is one in which there is uniform translucency or opacity then this may well be caused by some other factor such as glass to glass phase separation or simply the effect of dust on the pieces being fused or cast. The studio glassmaker has always taken a rather wide, and often incorrect, interpretation of devitrification and anything which in the process of creating cast or kiln-formed work has become opaque or translucent tends to be labelled as being affected by this. Experience would suggest that anything which has developed individual patches of what could possibly be crystalline material is likely to be suspect and should be discarded whilst glass which has become evenly opaque or translucent throughout will probably be safe provided that there has been adequate annealing and if all the pieces of glass involved are compatible.

Studio glassmakers producing kiln-formed pieces need to be particularly careful when trying to re-melt or fuse together glass which contains areas of devitrification with glass which is clear. The devitrified areas of glass will not melt as readily as the normal glass and as a result

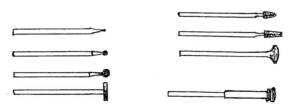

The common range of dental burrs used in flexible drive equipment for engraving purposes.

will not move into the required form. Even if the two materials become incorporated to any extent the result will inevitably be unstable and will probably crack or simply fall into pieces.

Diamond. A form of carbon currently considered to be the hardest substance known and used in various forms to cut and to abrade glass. It is a form of pure carbon which has crystallised in the cubic system under great pressure. Industrial diamonds have usually been naturally formed but are not of sufficient quality for the jewellery trade. Man-made diamonds are now becoming much more common and are finding increased usage in industry.

Diamond drills. These consist of hollow steel tubes with diamonds attached to the outer and end surfaces. They screw into a special chuck which is attached to a suitable electric or pneumatic drilling machine which allows a flow of water to run through the tube of the diamond drill to act as a coolant. The drilling machine must be solid and free from vibration and fitted with a spindle which is running true.

There are three kinds of diamond surface available. In one, the diamonds are formed into a matrix which is bonded to the steel core. In another, the diamonds are plated onto a steel shank in a single layer but in rather greater concentration than in the first example. The last is where diamonds are attached in layers by electroplating onto a drill with a thinner wall. The disadvantage of the single layer type of drill is that in comparison with other types, it will have a relatively short life. For the craftsman who does not envisage a lot of repetitive work, it may well suffice. The speed of the drills depends on the type of drill and the nature of the work but, in general, impregnated drills can be used at much higher speeds than the plated types. Diamond coated taper drills are available for drilling and finishing tapers for stoppers or for stop-cock keys.

Manufacturers will usually give tables to indicate rec-

Diamond drills showing the tube area coated with diamonds. Water under suitable pressure is fed down the centre of the drill.

The chuck used to hold the diamond drills and to feed the water to the centre of the drill.

A pedestal drilling machine designed to take diamond drills with a built in facility for water to run down the centre of the machine. *Photograph by Heathway Engineering.*

ommended speeds for their products and there seems to be some disparity in those that they recommend. As a rough indication, drills up to $^1/_2$ in (13 mm) can be used at speeds between 3500 and 4000 rpm, and between $^1/_2$ in and 1 in (25 mm) 2000 rpm. Drills up to 2 in (50 mm) 1000 rpm and up to 4 in (100 mm) 500 rpm.

Diamond (and tungsten) point engraving. Despite some rather crude work from earlier times, the use of diamond point for linear work of any standard on glass did not really appear until the mid-16th century. The Venetian Verzelini, was credited with bringing the technique to Britain. However, much of the work accredited to him is now thought to have been produced by a Frenchman, Anthony de Lysle.

One school of thought suggests that the use of a diamond point for stipple engraving seems to have originated in Holland and developed from the similar technique used on copperplate for printing. Others suggest that the use of a hard point to produce areas of shallow and deep stippling progressed naturally from linear work. One difficulty which arises from this technique is that whilst diamonds are hard, they are also brittle so many engravers wishing to use the stipple method turn to tungsten points. There is no doubt that stipple engraving can produce very subtle variations of tone and much admirable work has been produced using stipple alone or in conjunction with line. See **Stippling**.

The beginner needs a lot of practice to achieve the correct wrist action to make the rapid but controlled sequence of impacts to produce the necessary variation. Vibratory tools are available which purport to make the process easier but often they are clumsy and lack control. Diamond points for engraving differ from those used by the glazier as they are set firmly on the end of a steel rod and are turned to a conical point rather than being directional and set into a swivel head. The angle of the cone usually approaches 90° but points can be obtained turned to various angles between 60° and 90°. The 90° angle has the disadvantage that it tends to obscure vision of the point of contact with the glass. A 60° angle is much better in this respect but means that the tool needs a little more care in its general treatment.

Tools with tungsten points are much cheaper than those with diamond points and offer the great advantage that they can easily be sharpened against a diamond wheel. Tile cutters are readily and cheaply available with tungsten points, some of which are already sharpened to a cone and these are easily fashioned to the required shape. Some engravers simply re-profile worn out dental burrs and use them similarly. The quality of line produced by a diamond or tungsten point is often governed by the nature of the glass which is being engraved. A soft lead glass is usually the most sympathetic and soda lime glass the more likely to produce the fine flakes which make for a slightly ragged edge. Tungsten points are generally considered to be better than diamonds for very fine work. See **Stippling**.

Diamond tools. These have become very popular with glassworkers as a replacement for traditional metal or abrasive tools. Because it is brittle and reacts to local sources of heat, glass is a difficult material to machine. Chipping and cracking are common faults which occur when machinery is not running smoothly and when insufficient care has been taken to ensure adequate cooling.

The introduction of diamond tools has resulted in much higher cutting rates than were possible with more traditional materials but this has placed an even greater emphasis on the precision of the equipment. Diamond points for engraving and diamond glasscutters have been with us for many years but diamond saws, diamond drills, cutting wheels, abrasive discs and belts are relatively new. They need a constant flow of water and/or specific coolant to operate efficiently but are generally much quicker and cleaner in use than traditional or manufactured stones. The introduction of a recommended coolant has a considerable effect in reducing high temperatures at the cutting face and helping to eliminate the problem of burning out the diamonds. The development of diamond tools has promoted the development of new high speed and high precision machinery to obtain the greatest advantage from the cutting efficiency of diamonds.

Both natural and synthetic diamonds are used and are bonded to the cutting face of an appropriate steel form. In some circumstances the diamonds are in a matrix, in

A typical diamond saw. Most diamond saws are simple but extremely rigid and precise machines. They are usually fitted with a moving tray to hold the glass, a water and/or coolant supply to the saw blade and the possibility of adjusting the height of the saw.

Diamond saw blades for cutting glass can either be fitted with a continuous strip of metal with diamonds embedded into a matrix in its rim (1) or a similar rim can be arranged ion segments to allow greater facility for clearing away debris (2).

others they can be composed of a plated layer of single diamond particles and in others they can be built up in layers by an electroplating process. Whilst cutting, the diamond points are easily clogged by particles of glass which reduces the efficiency considerably. It is therefore essential that a constant and generous flow of coolant is provided. This can be water but it is advisable to include an appropriate oil concentrate in the ratio of 1 to 25. This has the effect of reducing the surface tension of the water and thereby increasing the efficiency considerably.

The diamond grit used for glass varies from 60s to 400s mesh and the choice relates both to the cutting speed and to the finish required. The tools are also available in amounts of diamond concentration. The higher the concentration, the more expensive and usually the greater cutting power but this is not necessarily so. The makers of diamond tools are always ready to advise on what mesh and what concentration will best suit a particular requirement.

The various wheels are engraved with an identification system. The first figure indicates the grade of diamond. The second indicates the bond type, the next gives the concentration and for glass the number has a suffix of a letter G and the last gives the depth of diamonds in millimetres.

Standard depths of diamond impregnation are 1.5 mm, 3 mm and 6.5 mm. The greater depth is likely to be more economical in the long run as replacing wheels of shallow impregnation as they wear out is likely to prove more costly.

There is an international standard code to indicate the number of carats of diamond per cm^3 of bonding material.

A diamond-faced flexible belt on a rubber wheel fitted to a glass lathe.

Concentration	50	=	2.2 carats per cc
Concentration	75	=	3.3 carats per cc
Concentration	100	=	4.4 carats per cc
Concentration	125	=	5.5 carats per cc

The availability of various flexible pads impregnated with diamonds has given rise to several hand-held tools, both pneumatically and electrically driven, which have been adapted to allow a water supply to be directed to the working surface. These are becoming very popular with artists dealing with large sculptural casts or carvings as it is usually much easier to manipulate these tools rather than having to hold what could be very heavy pieces of glass against abrasive wheels on a fixed lathe.

The following diamond grain sizes as per FEPA standard are those commonly used for glass engraving.

D151	125–150μ	The coarsest material likely
D126	106–125μ	to be used.
D107	90–106μ	Medium coarse grain. Usually
D91	75–90μ	in bronze and used for
D76	63–75μ	preliminary work.
D64	53–63μ	Granular medium grain.
D54	45–53μ	

Napkin rings cut from a blown form with a diamond saw.

D46	38–45μ	Popular medium grain used for general purpose work.
D35	32–38μ	Fine grain used on narrow sintered wheels.
D25	25–32μ	Very fine grain used mostly for
D20	20–25μ	drawing.

Diaspore. $Al_2O_3.H_2O$. A particularly pure, white and hard form of alumina hydrate.

Diatoms. Plankton with cell walls composed entirely of silica. Their bodies are formed into reefs of pure silica which can be cut to make into insulation bricks.

Diatreta. Cage cups. Vessels in which an outer layer has been carved away to leave an open network which is joined to the inner layer by fine glass struts. See **Cage cups** and **Lycurgis Cup**.

Dichroic glass. Dichroism. Dichroism to the mineralogist refers to crystals which exhibit two or more colours according to the nature of polarised light passing through them. As glass is not normally a crystalline material the dichroic effects are achieved in other ways. Exceptions can occur when glass becomes partially devitrified and the crystals so formed within the glass produce a dichroic effect.

Dichroic (literally – two colours) glass can result from various chemicals being incorporated into it, but usually it refers commercially to a clear glass which has been coated with various chemicals to give specific properties in relation to transmission or reflection of light. The system works because the chemicals, for example, zinc sulphate and magnesium fluoride, are deposited on the glass in alternate layers so that each layer interacts with the other, allowing the transmission of certain wavelengths of light and the reflection of others.

The effect is easily seen in the small tungsten halogen light bulbs used for spotlights and display lighting. The reflector is coated to give a silvery finish on the reflecting surface. This sends the light forward as in a conventional mirror. However the coating is transparent to infrared and the heat given off by the bulb tends to pass through the reflector and is not projected from its surface. When applied to glass in specific ways, these chemicals can produce primary colours when viewed in transmitted light, a second colour when viewed at an angle of 45° and a third colour in reflected light.

Flat glass for windows and architectural use is often coated to produce decorative and/or solar control effects. This product is traditionally referred to as 'coated' but more complex varieties with as many as twenty layers are essentially dichroic glass. Many materials are used including gold, copper, nickel, cobalt oxide, iron oxide, chromium oxide and titania depending on the properties and finish required. The coating can be applied by hot spraying with an organo-metallic compound, by electrical deposition in the float bath and by vacuum deposition.

One typical commercial product is Pilkington 'K' low emissivity glass. This glass, used in windows, has a coating which will allow light and short wave infrared into a room whilst reflecting the long infrared wavelengths from internal sources back into the room, thus conserving energy. The makers of this glass have been remarkably successful in controlling dichroic effects. Apart from in exceptional circumstances as might occur in polarised light, the glass appears to be normally transparent and colourless. There are many variations from both Pilkington and other manufacturers, some of which deliberately exploit the possibilities of dichroic colour.

Dichroic effects from materials within the glass have been evident over a considerable period. Perhaps the most famous of the early examples is that of the Lycurgis Cup from the 4th century AD which is normally coloured an opaque dull pea-green with a few parts showing as a more yellowish green. In transmitted light, however, this changes to transparent wine colour whilst the yellowish green parts become a transparent purple. See **Lycurgis Cup**.

Another example of dichroism is that of Alexandrit Glass produced by Kolo Moser in Bohemia in the early 1900s. This contained about 4% neodymium oxide and was famous for its property of changing colour according to the nature of its lighting. In daylight it tended to produce a blue colour whilst in artificial light, which tends to have little short wave radiation, it was predominently red. This effect is evident in the mineral Alexandrite, hence the name given to the glass.

It seems reasonable that artists will seek to exploit the colour possibilities offered by the use of dichroic coatings but at this time there is little evidence of much creative activity in this field. One student at Sunderland University is currently exploring the possibilities and has already installed a window which exploits these effects at a Sunderland technical college.

Dichromatic glasses. Glass which shows different colours when seen with either transmitted or reflected light.

Didymium glass. A commercial form of neodymium glass. It is used for the lenses of safety spectacles which are needed for both borosilicate and soft glass working.

Die sinker. The name given to the craftsman who makes metal moulds.

Diffusing sheet. A sheet of translucent perspex or similar material used to diffuse artificial light when exhibiting or examining stained glass.

Digital. With reference to counting or measuring by using distinct units (**Electrical terms**).

Dioxide. An oxide which has two atoms of oxygen combined with one atom of another element.

Dip mould. The simplest of the moulds used for blowing. It comprises an open cylinder into which the parison is lowered and then blown.

Divalent oxides. Used in glassmaking as alkaline fluxes. They are the oxides of those elements in Group II of the periodic table, namely:

Beryllia	(BeO)
Magnesia	(MgO)
Calcia	(CaO)
Zinc oxide	(ZnO)
Strontia	(SrO)
Baria	(BaO)

Dolomite. $CaCO_3$. $MgCO_3$. Magnesian limestone. Used as a high temperature flux and stabiliser. It is used when both calcia and magnesia need to be introduced into a batch.

Drafting tape. Black tape used to indicate a glazing bar in a stained glass cartoon.

Drawn stem. This refers to a stem which is drawn out of the body of the glass rather than one which is formed from a 'bit' of glass attached to the base of the bowl.

Dust. Solid particles which tend to be airborne. Many of these arise during the batch mixing and founding processes. Some of them are toxic, many of them are irritative and some may even be carcinogenic so it is always prudent to use appropriate dust masks during these processes.

Many of the older type electric kilns have asbestos in their insulation and it is important to take particular care when dismantling, renovating or re-building these kilns as the dust can be very dangerous.

Occupational exposure standards are applicable in most countries. In Britain they are given in Guidance Notes EH40/91, Occupational Exposure Limits 1991, Health and Safety Executive. They are based on time weighted averages (TWA) for limits of concentration of dust of various materials. An example (8 hour TWA reference period) is:

Silica (amorphous) – total inhalable dust – 6 mg/cubic metre.

Dwell. Formerly known as 'Soak'.

E

Earth leakage circuit breaker. A device introduced into a circuit to give protection from electric shock. See **ELCB**.

Easel. A device for holding sheets of glass in a vertical or near vertical plane. The traditional easel used by stained glass artists works rather like a sash window as it is fitted with counterweights so that the height of the sheets of glass can be readily adjusted. It is usually placed in front of a source of natural light so that the colour can be viewed effectively.

Efflorescence. The process whereby a crystalline hydrated material loses water, usually leaving a white deposit.

Eglomise. A method of decorating glass by the application of gold leaf which is then engraved with a fine point. The resulting decoration is not fired on to the glass so it is normally protected by a layer of varnish or by another layer of glass.

Egyptian paste. Used in ancient Egypt to make beads, amulets and other small objects. A mixture of clay, alkaline salts and small amounts of copper oxide is mixed with water and modelled into various forms. As the mixture dries, the salts and copper migrate to the surface and when fired produce a thin glassy turquoise surface layer similar to a ceramic glaze.

A typical modern recipe for this material is:

Ball clay (or china clay with some 2% bentonite)	2 parts
Soda feldspar	3.5 parts
Flint	3.5 parts
Soda ash	1 part

The proportions are not critical. Coarse sand can be included to give a more open texture. The only likely difficulty occurs when too much flux is added or if the mixture is overfired as this can lead to a complete collapse of the forms. The models are normally placed onto refractory powder, placing sand or a thin sheet of ceramic fibre for firing. It became very popular in schools a few years ago as a method of producing modelled objects which did not need a second firing to produce a glazed surface, thus saving precious kiln space.

The traditional turquoise colour will result from an addition of about 2% to 4% copper oxide but other colouring oxides can be used successfully.

0.5% to 2% of cobalt oxide will give a range of blues.
2% to 4% manganese dioxide will give browns and purples.
1% chrome oxide will give a pale yellow-green.

There are numerous variations in this material. One form, rather inappropriately known as Egyptian Faience is thought to have contained a larger proportion of silica than the mixture suggested for Egyptian paste and may have been glazed in a second firing.

ELCB. Earth leakage circuit breaker. A device introduced into a circuit to give protection from electric shock. It is usually situated between the meter and the fuse box and reacts to any leak which might occur between the live current and the earth. Similar but smaller switching devices can be fitted to individual pieces of equipment. The fitting of these devices in workshops is mandatory in many countries.

Electric elements. To the glassmaker, an electrical element is a length of material with a specific resistance which can be used to heat a kiln or furnace.

Elements are usually made from coils of suitable alloys of wire which are formed to provide a conducting material with a calculated amount of resistance so generating radiated heat when an appropriate current is applied. The same material can be obtained in the form of a tape.

The most common of these alloys are:

- Nichrome which is normally approximately 80% nickel and 20% chromium and suitable for temperatures up to about 1100°C (2000°F) in general use.
- Kanthal of which there is now a range of grades using variable alloys of chromium, aluminium and iron suitable for temperatures up to 1350°C (2460°F).

The current range of both types available in either ready-made elements or as wire and tape for those who may wish to coil their own is:

Type	Maximum element temperature	
Nikrothol 80 plus	1200°C	2200°F
Nikrothal 60 plus	1150°C	2100°F
Nikrothal 40 plus	1100°C	2000°F
Kanthol APM	1400°C	2550°F
Kanthol A-1	1400°C	2550°F
Kanthal AF	1400°C	2550°F
Kanthal D	1300°C	2370°F

Cast blue glass with laminated soda-lime piece by Charles
Bray. Height 30 inches (75cm). Photograph by Roger Lee.

Left: 'Pendulum' construction by John Smith.

Right: 'Mixteque', pate de verre piece by Yves Jumeau.

Below: Golden Pavillion and Shining of Fall by Koyhei Fujita. Courtesy of the Ebeltoft Glasmuseum.

Cast bowl by Tessa Clegg.

Section of a stained glass panel showing the use of leading by Sarah Richardson.

Right: 'Vortex', fused borosilicate form by Charles Bray.

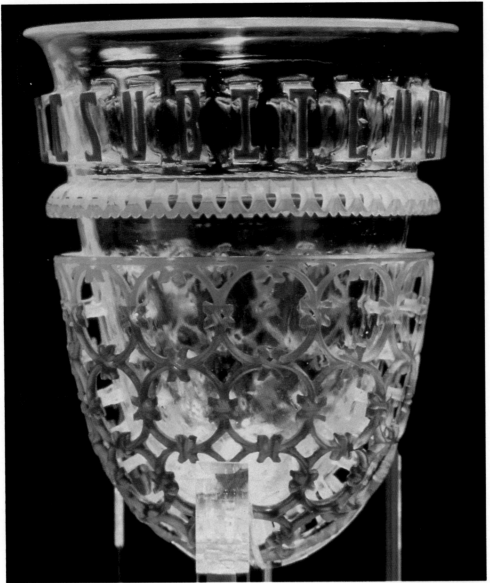

The Diatretum (cage cup) found near Cologne. It is currently in the Romanic-Germanische Museum near Cologne.

The blank made by Schott Glass at Zwiesel.

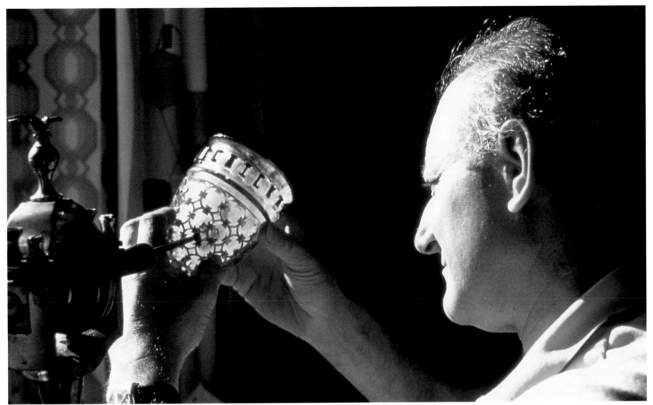
Joseph Welzel at work on the cup.

The cup partly completed.

The completed replica.

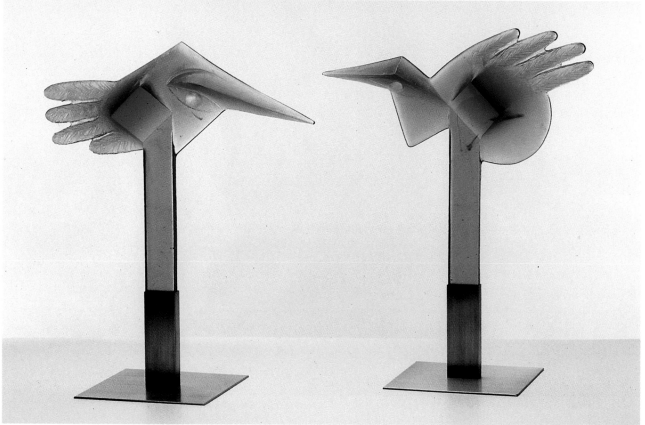

'The Magic Birds' by Blanka Adensamova.

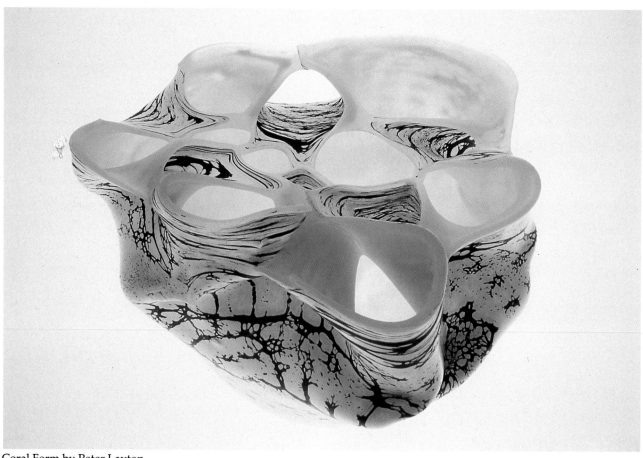

Coral Form by Peter Layton.

It must be stressed that the temperatures quoted are maximum element temperatures for continuous running. This will be 50°C (120°F) above the recommended running temperature of the furnace.

Complete assemblies of Kanthal super elements are available for higher temperatures such as those required for glass melting furnaces. The range currently available is:

Kanthal Super 1700	1700°C	3100°F
Kanthal Super 1800	1800°C	3270°F
Kanthal Super 1900	1900°C	3450°F

The other elements for high temperature applications are Silicon Carbide Hot Rod and Crusilite. They are used at temperatures up to

| Kanthal Hot Rod | 1625°C | 2960°F |
| Kanthal Crusilite | 1575°C | 2870°F |

All metallic elements need to be used as far as possible in a normal oxidising atmosphere as they tend to be attacked by reduction. They can also burn out suddenly. Temporary repairs made by overlapping the burned out areas of coil are usually effective for a short time until replacements can be made.

Silicon carbide used in solid or hollow rod form will achieve higher temperatures. These elements have the added advantage of being resistant to the action of reducing atmospheres but are much more expensive than the other types. They are not commonly used for glassforming kilns as the temperatures required for casting, fusing and slumping techniques are easily attainable by using Nichrome or Kanthal elements. They are used, however, in some glass furnaces where the requirement for the attainment of higher temperatures is essential. In this case Kanthal Super elements are also available for the high temperatures necessary for glass founding. They can be supplied as complete element assemblies, as 'Hot Rod' straight or multi-leg elements, or as straight or tubular silicon carbide (Crusilite) elements. These elements have a high surface loading and a particularly long life in a continuous running situation.

The most likely cause of any damage which might occur is breakage as they can become brittle when cooled after a long period of continuous running. Because of this, particular care is needed during furnace repairs or re-builds.

The use of electric elements for glass pot furnaces seems to have a beneficial effect on the life both of the pot and the furnace refractories. Other benefits arise from the fact that loss from volatiles is reduced considerably thus contributing to the current search for more environmentally friendly ways of producing glass.

By far the most popular element wire for glass-forming kilns and enamelling kilns not likely to be required for operating above 1000°C is Kanthal AF. This is marketed as a replacement for nichrome and tends to be lower in cost, has low density and will withstand high surface loads. For those who wish to have a kiln which may also be used for higher temperatures such as those likely to be necessary for ceramics, then Kanthal A-1 is a better alternative. For those who wish to make their own elements, the wire is normally supplied to a standard wire gauge (swg). 0 gauge at 0.324 in diameter is the thickest and 47 swg at 0.002 in diameter the thinnest. There is a difference between the British and American systems but as a guide to the common thicknesses in use, 13 swg is approximately equivalent to 11 awg, 14 swg to 12 awg, and 15 swg to 13 awg. The most common forms for ready-made elements are known as straight or hairpin.

Elements can also be supplied ready-fitted into a variety of either insulation or ceramic modules. These make kiln re-building a very simple process and may well be worth investigating for anybody contemplating a kiln re-build.

Almost all materials have some resistance to electricity and it is the current flowing against this resistance which generates heat. A material which has little resistance is known as a conductor and one which is totally resistant is an insulator. The amount of resistance is calculated in ohms and elements are manufactured to a specific resistance. It means that if one needs to provide the current for a six kilowatt kiln to operate on single-phase supply, then the number of amps required would be $^{6000}/_{240} = 25$. If the elements are to be in one circuit, the resistance required will be 240 divided by 25 which is 9.6 ohms. If, as would be more normal, the elements are in two circuits, each of them would need 25 divided by two which would be 12.5 amps and therefore the resistance in each circuit would be 240 divided by 12.5 which is 19.2 ohms. The resistance of standard Kanthal A1 wire is:

SWG	Ohms per metre	Per foot
11	0.019	0.065
12	0.025	0.081
13	0.031	0.103
14	0.041	0.136
15	0.051	0.168
16	0.065	0.213
17	0.085	0.278
18	0.116	0.379

Similarly for American Wire Gauge.

AWG	Ohms per metre	Per foot
9	0.020	0.067
10	0.026	0.084
11	0.032	0.106
12	0.040	0.133
13	0.051	0.168
14	0.065	0.212
15	0.082	0.268
16	0.103	0.338

To calculate the length of wire required for a particular circuit, divide the total ohms value of the circuit by the

figure in the table representing the wire gauge to be used. For example:

Assuming a small kiln rated at 30 amps on a supply of 240 volts,

$$\text{Resistance} = \frac{\text{Volts}}{\text{Amps}} = \frac{240}{30} = 8 \text{ ohms}$$

Using 13 swg wire which is calculated at 0.1 ohms per foot, the length needed would be:

$$\frac{8}{0.1} = 80 \text{ feet of wire.}$$

Unfortunately, this is not the whole picture and it is necessary to consider another factor. It is possible for an element to generate more heat than it can dissipate and if this happens the element becomes too hot and burns. This causes a breakdown and whilst temporary repairs might allow a firing to be completed, the same situation would arise very soon afterwards. As a result, the element provision would need to be re-calculated and different elements or wiring system would need to be installed.

The heat relates to the number of watts of energy applied to the material so the process is known as 'Watt Loss'. In order to bring this factor into consideration, it is necessary to calculate the surface area of the wire. This is done by multiplying the diameter of the wire by π (3.14) and then by its length.

The following table gives surface areas of kanthal wires in square inches per foot and by square centimetres per metre.

Gauge No.	Sq In/Ft	Sq Cm/Metre
SWG 11	4.37	91
SWG 12	3.92	83
SWG 13	3.47	73
SWG 14	3.02	63
SWG 15	2.71	57
SWG 16	2.14	51
SWG 17	2.11	44
AWG 9	4.31	90
AWG 10	3.84	81
AWG 11	3.42	72
AWG 12	3.05	63
AWG 13	2.71	57
AWG 14	2.42	51
AWG 15	2.15	45
AWG 16	1.92	40

To arrive at the watts per square inch or per square centimetre it is simply a matter of dividing the total wattage of the circuit by the length of wire used and then dividing the result by the appropriate figure in the table above. Fortunately, the temperatures likely to be needed for glass-forming are unlikely to create any problems if the wire used is Kanthal A1 but it is possible to have difficulties if Kanthal A is used as this does not dissipate the heat as well as A1. A temperature of 1000°C (1830°F) on Kanthal A would need to be within a limit of 19 watts per square inch whereas the limit on Kanthal A1 would be 21.2.

The power needed for a kiln relates to its cubic capacity, the nature of the insulation and the maximum temperature at which it is required to operate. Commercial kilns made in Britain tend to demand a higher power than comparative commercially-made kilns in the USA. This is probably due in part to the greater use of ceramic fibre as a hot face material in the USA whereas in Britain many manufacturers still insist on a brick interior. For example, an 8 cu ft capacity kiln in Britain would normally be calculated to need about 15 kW. Most commercial kilns are designed for ceramics to be fired to stoneware temperatures whereas a glass-forming kiln is unlikely to need to be taken to anything above 1000°C (1830°F). With the full use of micropore and fibre to replace insulation brick and the lower temperature requirement 10 kW would probably suffice whilst 12 kW would give a very good margin to cope with special occasions.

Electric motors. Machines for changing electrical energy into rotary mechanical energy. Their efficiency can be very high – typically up to 95%. The principle on which they work is that current passing through a coil within a magnetic field will generate energy to rotate the coil. There are several variations. Those running on direct current offer the advantage of being relatively easy to operate on an electronic speed controller. Their main disadvantage is one of size as they often tend to be considerably bigger than alternating current motors with the same energy output. AC motors are presently available in Britain to run on either single-phase 220/240 volts 50 cycles and on three-phase at 415/230 volts. In continental Europe this has been: single-phase 220 volts 50 cycles, three-phase 380 volts 50 cycles. The voltages throughout the European Community have now been standardised and the single-phase will be designated as being 230 volts 50 cycles and the three-phase supply as being 400/230 volts. As these voltages fall within the permitted variation permitted in Britain and in the rest of Europe, there should be no difficulty with using existing equipment. In the USA the standard supply is 115 volts, 60 cycles.

To the glassmaker, the smooth running of an electric motor is very important particularly when it is being used to power an engraving or cutting lathe. In this respect, the three-phase motor is considerably better than the single-phase equivalent and it also offers the advantage of tending to be smaller in size. Over the years we have been accustomed to being supplied with electric motors from reputable makers which have been well-made and extremely reliable. Recently there have been some cheap motors arriving on the market, some of which have proved to be excellent but many others have tended to be badly balanced. This creates a lot of vibration and a considerable strain on the bearings which in

turn results in a short life. Smooth running is so important to most glassworking machinery that it is essential to check that a motor is well-balanced before fitting it to a machine.

Types of motor regularly available are:

Induction motors. In these, the AC current is passed through a stationary coil to create a rotating magnetic field which induces a current in the rotor. The advantage of this type of motor is that the current does not need to pass through a commutator to the rotating part of the motor.

Synchronous motors. AC current fed to a coil produces a magnetic field which rotates and locks into the field of the rotor, this being an independent magnet, with the result that both the coil and the rotor turn at the same speed. The rotor can be a permanent magnet or one fed with DC current through slip rings.

Universal motors. (AC or DC). Current is fed to the coil and through a commutator to the rotor. These motors divide into two types, in the first of which, the series wound motor, the two are in series and in the second, the shunt wound motor, in which they are in parallel.

Electrical and electronic terms. With the increased usage of sophisticated control systems a considerable number of terms is appearing. Whilst it would be difficult to cover all these comprehensively, there are many which it may be beneficial to define.

ELECTRICAL SYMBOLS.

E.	Electromotive force	measured in volts V.
I.	Current	measured in amperes A.
P.	Power	measured in watts W.
R.	Resistance	measured in ohms O.
L.	Line (Live)	
N.	Neutral	

ALTERNATING CURRENT. (AC). A flow of electrons in which the direction of movement reverses periodically. The number of cycles completed in a second denotes the frequency.

In Europe single-phase supply is 220–230 volts and three-phase supply is 400/230 volts. Both operate at 50 cycles per second. In the USA, the single phase is 110 volts 60 cycles and three-phase 220 volts 60 cycles.

It is most important that any instrumentation matches the supply.

AMPERES. (Amps). The amount of current that one volt sends through one ohm of resistance.

ANODE. The positive of an electronic device.

BI-METAL STRIP. Strips of two different metals welded together and used to open or close contacts on some relays and thermostats.

CYCLE. This normally refers to the wave length of an alternating current but in terms of controllers it refers to the total sequence of planned events.

CIRCUIT DIAGRAM. A representation of the connections and functions in line and symbols of an electrical device.

CONDUCTOR. A material which offers little resistance to electrical current.

DIRECT CURRENT. (DC). Current which does not have a specific direction and which has negligible changes in value. The current from a battery is normally of direct current. That from many old-type generators also tends to be DC. Electric motors running on direct current tended to be rather large but recent developments in materials have enabled most forms of electric motors to be made much smaller than formerly. They were used for many occasions when variable speed control was required as they were initially easier than the AC motors to fit with electronic speed controls. Direct current is also more dangerous than AC. It is easier to receive a severe shock from a DC supply.

DWELL. The second part of a controller stage in which a particular temperature is held for a set period.

HOLD. The command which is entered when it becomes necessary to maintain part of a programme for longer than that previously entered.

KILOWATT-HOUR. A practical unit to indicate the energy defined by a power of 1000 watts in one hour. It is commonly used when referring to the energy that a kiln will use when on full power. A 6 kW kiln would theoretically use 6000 watts in one hour and calculations of cost, the necessary supply, fuses, switchgear etc. would be based on this figure.

LIGHT EMITTING DIODE. (LED). The small device used to provide an illuminated display of information or controls on a control panel.

OHMS. A measure of resistance. A constant of one volt across a resistance of one ohm produces a current of one ampere.

RAMP. In a controller this refers to the programmed movement from one temperature to another within a set time.

RESISTANCE. The ability of a material to resist the passage of electrical current. It is commonly used as a method of generating heat as in the case of electric elements. The amount of resistance is measured in ohms.

RHEOSTAT. A type of variable resistor occasionally used to provide speed control on electric motors. It is not a very efficient method of speed control because by virtue of

providing increased resistance to slow down a motor, it also reduces the power which is provided.

SINGLE PHASE. A supply in which there is a single alternating current. In the European Community it represents the common 230 volt supply used domestically.

SOLID STATE RELAY. (SSR). An electronic relay in which all the components are solid and do not rely on physical movement.

STAGE. A controller term used to define a set sequence of events which usually includes a ramp and a period of dwell. Most controllers have three or four set stages in a cycle.

THREE PHASE. A circuit in which the alternating voltages differ in phase by one third of a cycle. Three phase differs from single phase supply in that power is delivered by three live wires instead of a line and a neutral as used in a single phase supply. In the European Community it is the usual 380–400/230 volt supply used for power. It is the normal supply required for kilns of more than about 30 amp capacity. It offers an advantage when used with electric motors driving glass lathes as much less vibration is produced than from a motor running on single phase.

TRANSFORMER. A device used to change the voltage of a supply.

VOLTS. The unit of electromotive force.

WATT. The amount of energy per second expended by a current of one ampere under a voltage of one volt (one joule per second).

Electroplating. Electroforming. This is a relatively simple method of applying a thin coat of metal to a glass surface. Cold glass is a non-conductive material so the surface needs to be treated in order that it will conduct an electric current. The bonding of the metal will be improved if the surface of the glass is first lightly sandblasted. There are three common methods of providing a

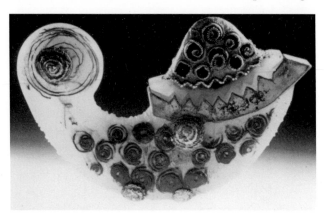

Electroplated form by Keith Cummings.

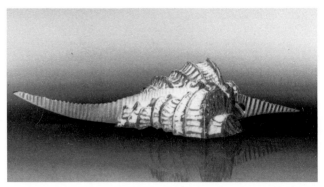

Electroplated form by Keith Cummings.

conductive surface. The first consists of rubbing the surface with some form of graphite such as a soft lead pencil, graphite powder or paste. The second method is to fire onto the surface some metallic lustre. The third is to coat the surface with a layer of shellac or similar quick-drying lacquer and then to dust it with metallic powder.

The actual plating process consists of preparing a bath of plating solution into which the glass is immersed and attached to the negative terminal whilst a piece of the plating metal is also immersed and connected to the positive terminal. There are many recipes for plating solutions and manuals on the subject are readily available in most public libraries.

Copper is the favourite metal for use on glass and a suitable solution is made by mixing 200 millilitres of strong sulphuric acid into four litres of distilled water (the acid must be introduced slowly into the water and never the other way round). Into this stir 850 g of copper sulphate until it becomes dissolved. Commercially-made plating tanks are available but for occasional use a photographer's developing tray or even a strong plastic bucket will suffice.

A piece of copper sheet can form the anode and be connected to the positive terminal of a 12 volt DC supply. The glass to be plated needs to be connected to the negative terminal of the same supply. It is essential that a good contact is made between the connecting wire and the area to be plated without leaving more of the wire exposed than is reasonably possible. The glass must be immersed in the solution so that all the area to be plated is covered. On the other hand, the copper plate need only to be suspended into the solution and the connection to this need not be immersed. The supply from a car battery charger will be sufficient to carry out small plating projects but if more plating work is to be done then it would be better to make up a suitable rectifier system. It is useful to have a reasonable amount of control in such a system; the introduction of a variable resistor into the positive input line of the transformer will do this. An ammeter is also useful in the circuit as it will give some indication of what is happening and notes can be made to help with future repetitions or modifications.

The resulting surface can be changed in many ways. The most obvious of these being:

1. Varying the voltage and/or amperage.
2. Changing the solution strength.
3. Changing the solution temperature.

(It is suggested that a temperature of 80°C should be maintained by using a small immersion heater.)

A suitable rectifier unit should ideally provide a range of between 3 and 12 volts at between 25 and 50 amps. The lower the amperage, the longer the plating time. Fumes from electrolytic solutions can be dangerous so adequate ventilation and fume extraction is advisable. Rubber gloves, a suitable apron and face protection should be used.

Elements. (Chemical). A substance which contains only atoms of the same atomic number. Elements used in glassmaking are as follows:

Element	Symbol	Atomic weight	Valency
Aluminium	Al	26.970	3
Antimony	Sb	121.770	3
Arsenic	As	74.920	3
Barium	Ba	137.370	2
Beryllium	Be	9.012	2
Bismuth	Bi	209.000	3
Boron	Bo	10.820	3
Cadmium	Cd	112.400	2
Calcium	Ca	40.070	2
Carbon	C	12.010	2 and 4
Cerium	Ce	140.100	4
Chlorine	Cl	35.450	1
Chromium	Cr	52.000	3
Cobalt	Co	58.940	2 and 3
Copper	Cu	63.570	1 and 2
Fluorine	F	19.000	1
Germanium	Ge	72.590	4
Gold	Au	197.200	-
Hydrogen	H	1.008	1
Iron	Fe	55.840	2 and 3
Lead	Pb	207.200	2 and 4
Lithium	Li	6.939	1
Magnesium	Mg	24.310	2
Manganese	Mn	54.940	2, 3 and 4
Nickel	Ni	58.710	2 and 4
Nitrogen	N	14.010	3
Oxygen	O	16.000	2
Phosphorous	P	30.990	3 and 5
Platinum	Pt	195.100	-
Potassium	K	39.096	1
Praseodymium	Pr	140.900	4
Selenium	Se	78.960	2, 4 and 6
Silicon	Si	28.060	4
Silver	Ag	107.880	1
Sodium	Na	22.897	1
Strontium	Sr	87.620	2
Sulphur	S	32.060	2 and 4
Tin	Sn	118.700	4
Titanium	Ti	47.900	4

Element	Symbol	Atomic weight	Valency
Uranium	U	238.000	3, 4 and 5
Vanadium	V	50.940	2, 3, 4 and 5
Zinc	Zn	65.370	2
Zirconium	Zr	91.220	4

Elements. (Electrical). See **Electrical elements.**

Embossing. A process of producing matt surfaces by the use of various mixtures of chemicals based on hydrofluoric acid. See **Acid etching**.

Emery. A naturally occurring impure form of alumina used both as an abrasive and as a polishing material. See **Abrasives**.

EMF. An abbreviation for electro motive force.

Enamel glass. This is something of a misnomer and refers to some opaque white glass produced in the 18th century and given this name because of its similarity to tin-glazed ceramics. Some of the colour rods used by glassworkers are specified as 'Enamel White'. The term probably comes from the same source. These rods are a dense opaque white as distinct from those specified as 'Opal White' which are a translucent white.

Enamels. The use of enamels on precious metals emerged from the tradition of incorporating coloured and precious stones into jewellery and dates back to pre-Christian times. Over the years it has spread to cover a wide range of applications for the decoration of various other metals, ceramics and glass. Eventually, enamels came to be used for purely practical purposes such as providing a non-rusting surface on iron pans and for coatings on baths, cookers etc. Much early enamel was made by grinding together particles of glass with suitable colourants and fluxes. Nowadays they are fritted together from a wide variety of materials to suit specific requirements. The resulting prepared powders or grains are readily available from several commercial sources and those prepared specifically for use with glass can be supplied as:

- 'Roll on' or 'Pick up' enamels – designed for picking up directly on to a parison from the marver.
- Painting or spraying enamels designed for firing onto the glass at temperatures usually between 550°C (1022°F) and 650°C (1200°F).
- Low temperature stoving enamels designed for firing onto glass at about 200°C (390°F).

The first two are available in a wide range of transparent or opaque colours. Stoving enamels are usually opaque.

Roll on enamels are not difficult to make in the studio. Coloured glass similar in expansion to the glass in use from the furnace can be ground down and used as roll on

enamel. Most suppliers of colour rods supply similar material in powder or grain form and this can be used in the same way. Enamels for painting or spraying need rather more preparation. As they need to melt at a lower temperature than the softening point of the glass to which they are applied, appropriate fluxes must be introduced to the powdered glass. Lead frits, soda ash, lithia, borax etc. can be used and ground together with the coloured glass powder and further colouring oxides and opacifiers as required. The resultant enamel needs to approximate to the expansion of the glass to which it is to be applied so it is essential that this is considered in deciding which particular frits to use. Small quantities can be ground in a pestle and mortar together with a little glycerine or aromatic oil but larger quantities are best prepared by grinding the ingredients together in a ball mill until a fine, consistent powder is produced.

There is no doubt that after this stage a great deal of elbow grease expended on mulling the results on a glass plate into a fine, smooth paste pays dividends and produces enamel which is a delight to use. Even the commercially-prepared enamels benefit from some care and work with a muller. Turpentine or white spirit is used for thinning but this must be introduced with care. Too much will cause the enamel to run if it is applied to a vertical surface. The commercial enamels that are readily available in small quantities are usually made to approximate in terms of expansion bottle glass as industrial container production presents the greatest source of demand. There is usually sufficient flexibility for this to fit most stained glass and studio glass applications. The people who miss out on this are the lampworkers using borosilicate glass as the expansion difference is far too great for the standard enamels to fit. Special low expansion enamels are made for borosilicate glass but whilst the manufacturers supply these in quantity to industry, they are not very interested in supplying the small quantities that a solitary lampworker might require. The demand is also insufficient for the retail outlets to be

interested so the lampworker is almost inevitably faced with the necessity of making his or her own colour. There is a little light emerging on the problem as a company in the U.S. has seen the market and has started to produce coloured borosilicate glass rod and powders with the standard expansions to suit the needs of the lampworker. Schotts in Germany now also produce coloured rods and tube in their Duran range to match their clear borosilicate glass. Fortunately, in lampworking the colour is melted in the flame so it can be made to melt at a fairly high temperature. This offers the possibility to experiment with mixtures of borax frit, ceramic glaze and colouring oxides in order to make colour which can be rolled on to a heated rod or tube in a similar manner to that in which roll on enamels are marvered on to a parison for blown glass processes.

Perhaps the pinnacle of hand painting with enamels in Britain was achieved by the Beilby family in Newcastle-upon-Tyne in the late 18th century. Since then the art has declined as lithograph transfers and screen printing have catered for the demands of the production line. Hand painting has survived to a greater extent in the ceramics industry but highly skilled hand painting on glass, apart from some small specialist firms such as James Rush & Co of Newcastle-upon-Tyne, seems to have become the province of the glass industry in the Czech Republic. There, various schools give a most thorough training in the technique and the factories allow considerable space and personnel to be devoted to the achievement of a high standard of work.

The following formulae are from an old, handwritten list which came from Hartley Wood and Sons of Sunderland. From the language it would appear that they originated sometime in the 19th century. They are shown here to indicate the nature of the materials in general use and made on the premises of individual factories before we had access to the sophisticated frits which are readily available from commercial sources today.

The use of a muller to prepare enamel.

Enamel and medium being mixed further with a spatula after being ground with the muller.

Enamel flux No 1	8 red lead
	6 flint glass
	3 borax
	3 flint
Enamel flux No 2	7 red lead
	4 borax
	2 flint
Enamel flux No 3	4 borax
	3 red lead
	3 flint glass
	2 flint
Enamel flux No 4	3 red lead
	1 flint glass
	1 flint
Gold flux	11 borax
	6.5 litharge
	1 oxide of silver

'The materials are to be made very fine especially the flint and mixed well together so that the particles may be more easily concrete when in a state of fusion. Calcine in a glost oven when the whole mass will be changed into a brittle resplendant mass.'

Fortunately, we do not need to make such frits in the studio today as frits of similar character are readily available from the suppliers.

Colour made industrially is initially produced in the form of inorganic pigment which is then used for a variety of purposes, the largest usage being for paint, plastics, ceramics and glass. For use on both ceramics and glass this pigment is milled together with an appropriate frit for several hours to produce a fine powder. In a commercial operation concerned with repeat production, much of the enamel is applied by various processes such as screening, spraying and transfer and a quick-drying medium based on wax or resin is the normal vehicle. Hand painting requires something rather more sympathetic and flexible so one of the aromatic oils is normally used as a medium.

The firing of enamels rarely poses problems. Most of the artists who use enamels apply them to flat panels and the fine control of temperature necessary to avoid ware collapsing is not critical in this case. Care is needed when firing enamels onto blown ware as it becomes necessary to take firing to a temperature at which the softened enamel will bond by a process of ion exchange with the surface of the ware. In order for this to happen effectively the ware must approach its own softening point and with many forms any over-firing would be likely to result in collapse. It often becomes necessary to provide some means of support, particularly when enamelling wide, shallow bowls. The medium burns away fairly early in a firing and particularly where there is a full kiln, some ventilation should be provided up to about 400°C (750°F) in order to avoid a reducing atmosphere.

The colour industry is currently encountering problems with legislation relating to metal release. Much of this is concerned with standards for tableware and perhaps surprisingly, with waste packaging materials. The European Community seems intent on following the American lead in this respect and whilst at this time it does not directly affect people painting stained glass windows or art ware not used for food, most of the enamel we use is actually made in quantity for commercial purposes and any restriction on the materials in this context could result in a much more restricted range of colour being available to the artist.

Many glass technologists feel that whilst there was considerable justification in the initial concern with metal release from tableware, much of the danger was caused by poorly formulated and fired glazes and decoration on ceramics, often made in primitive conditions. Standards have now been established and there can be no doubt that in the majority of countries they will be achieved. If they are raised even higher then we may find that we have to accept limits to the range of colour available for the decoration of tableware as it will then be impossible to use certain materials. It seems perfectly reasonable, however, that some degree of legislation and tests to establish permissible levels of metal release from containers or tableware should be enforced. The criteria for architectural glass is different from that for tableware and it is to be hoped that any new legislation reflects this. The matter of metal release from waste packaging where it concerns the enamel labelling of glass bottles seems to be highly debatable. Any metal or metal oxide taken from the earth and then returned to it incorporated into a properly formulated glass is surely likely to be in a state where it is much more environmentally safe than it was in its original form.

Encased glass. Objects made from coloured glass which are covered with an outer layer of clear glass e.g. paperweights.

Encrusted glass. Glass which has been marvered or blocked and then rolled over small pieces of glass, often coloured, which remain as a coarse texture after the glass has been blown out.

Energy. A measure of a system's ability to do work. It is normally measured in joules but much of the information currently available is still given in foot/pounds (ft/lb).

Energy and work are interchangeable terms and are measured in the same units. Work is done whenever the point of application of a force is moved in the direction of the force. The amount of work carried out is measured by the product of the force and the distance of movement in the direction of the force. For example, if a weight of 5 pounds is lying on a table and is lifted to a shelf 10 feet above the table the amount of work done is 50 ft lb. This work is not lost. It could be used to operate a machine whilst it falls back to its original height on the table. As

even such a simple machine would not be completely efficient, some of the work (energy) recovered would be somewhat less than the original 50 ft lb, some of it inevitably being lost as heat in overcoming friction and noise. The same amount of work would be carried out in raising a 1 lb weight 50 feet or by raising a 25 lb weight 2 feet. This means of storing energy for future use is known as increasing the potential energy of a body.

The same principle is used in some electrical power supply situations in which water is pumped up to a high level reservoir during the night when electricity is available at a cheap rate and allowed to flow down to a lower level to generate electricity at times of maximum demand.

Engraving. Design produced by cutting into the surface of the glass. The principal methods include copper wheel engraving, intaglio work and diamond or tungsten point engraving. Flexible drive work, acid etching and sandblasting are also common methods of producing variations to these techniques. They are discussed further under their respective headings.

The Romans were skilled engravers and produced some excellent examples of both linear and low relief work but the activity seems to have declined until it re-emerged towards the end of the 15th century. Diamond and tungsten point engraving has been the province of the artist for many years whereas wheel engraving has traditionally been carried out by craftsmen trained in industry. Despite this, there has been a gradual but constant development of wheel engraving by artist engravers. Nowadays, there is an abundance of really exciting engraved work being produced from both individual artists, studios and from designer craftsmen working in factories.

Engraved and sandblasted bullion, 'The glassmaker'.

Two views of a wheel engraved work 'Stagnation' by Peter Dreiser.

There has been a dearth of information on the subject with the only book of note dealing with the techniques being a German manual produced in 1920. However, an excellent book by Jonathan Matcham and Peter Dreiser has recently been published by Batsford.

Enstatite. MgO.SiO$_3$. Magnesium silicate. A pure form of pyroxene mineral found in igneous rocks.

Epoxy resin. A synthetic resin. Produced by co-polymerising epoxide compounds with phenols. They can be hardened either by the addition of agents such as the polyamines or by the use of catalysts which produce further polymerisation of the resin. For most studio glassmakers it is an adhesive usually comprising a two mix (adhesive and catalyst) which is used for bonding glass in sculptural constructions, laminated forms and for setting dalle de verre in stained glass windows. It is particularly resistant to chemical attack. See **Adhesives** and **Dalle de Verre**.

Equation. A symbolic or formulaic expression of a chemical action. Both sides of an equation should be equal in terms of the number of atoms represented. The term thermal equation is used to describe the situation in which there is no net heat exchange within a substance or between it and its surroundings. It is also sometimes used to describe the position when the exterior surface of a furnace or kiln has reached a stable temperature.

Equivalent weight. The mass of an element or compound which in a chemical reaction could combine with, or replace, one gram of hydrogen or eight grams of oxygen or 35.5 grams of chlorine. For an element, it represents the relative atomic mass divided by its valency.

Etching. A process of matting or removing a surface of glass by exposure to hydrofluoric acid or its derivatives. See **Acid Etching**.

Eutectics. The mixing of two or more materials together in order to produce melting at the optimum lowest temperature. The minimum freezing point for particular mixtures is called the eutectic point. Alloys which melt at low temperatures are usually eutectic mixtures. A common example of this effect in glassmaking with particular reference to the behaviour of refractories is that of mixtures of alumina and silica. These materials melt at

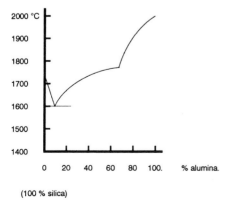

(100 % silica)

Eutectic scale showing the effects on melting temperature by differing proportions of silica and alumina.

2050°C (3720°F) and 1710°C (3110°F) respectively. The eutectic mixture of these materials at 10% alumina and 90% silica melts at 1545°C (2810°F) which is considerably lower than the individual melting points of either of them.

Eutectic mixtures in the actual glassmaking process are common because all the alkaline oxides react with silica to provide a lower melting point. As all the oxides become excited by the effect of heat and in the presence of other oxides, the excitement is increased and the intermolecular activity creates the effect of melting. This becomes something of a continuous process in that the materials forming the lowest eutectic temperature will melt first to mingle with the other materials and stimulate further eutectics to lead to more molecular activity until the founding is complete.

Expansion, coefficient of linear. In glassmaking this refers to the amount of linear expansion and contraction of materials per unit specified temperature gradient. Tables for these were calculated by Winkelmann and Schott and are in general use for approximating the compatibility of different glasses. Most glasses fall into a range of 3 to 10 x 10^{-6}. This can be measured actually or relatively, or calculated within limited parameters from the oxide composition of the glass.

Much bottle and window glass, and much of that used for studio glass production, is around the 8.8 x 10^{-6} figure whilst the borosilicate glass used for laboratory and ovenware is around 3 x 10^{-6}. As a general rule, glasses within a range of 5 at the top end of the scale will probably be compatible but this range will be considerably decreased at the lower end. The compatibility of various types of glass is very important to the glassmaker working in a small workshop for whilst the basic glass may well be made on the premises, the coloured glass to be used with it will almost always be bought in a concentrated form. If there is sufficient disparity in the coefficients of expansion, the resulting production is bound to fail.

When a material is heated, the vibration of the molecules increases in amplitude. If there is plenty of space between them for this to happen as in vitreous silica then the material needs to expand very little to accommodate the larger vibrations. As a result vitreous silica has a very low coefficient of expansion and is very good at withstanding thermal shock. On the other hand, in the case of soda-lime-silica glass the molecules become packed much more tightly and any space available is much smaller. As the size of the vibrations increase, the glass has to expand to allow them to do so and as a result a soda-lime-silica has a high coefficient of expansion and is much more readily affected by thermal shock.

Extrusion. The forcing of hot glass through a die to produce tubing or rods of specific shape and dimension. Gobs of glass are often extruded in automatic pressing and blowing operations.

F

Faceted glass. Glass, usually round in section rather than flat, which has been ground and polished to produce flat areas on the surface.

Façon de Venise, A La. Glass in the Venetian style. Glassmaking in Venice suddenly blossomed during the 15th century from being somewhat nondescript to extremely skilful, imaginative and often very delicate. Together with the development of cristallo, a fine clear glass, this made Venetian glass both famous and in considerable demand all over Europe. The glassware often contained ornate and complex stems. The Venetians guarded their skills by putting heavy restrictions on their glassmakers. This was intended to stop them practising anywhere else. However, eventually some of them did leave and work 'as made in Venice' began to be produced in many other areas. This became known as 'A la Façon de Venise'.

Fahrenheit. A scale of temperature measurement which has the freezing point of water located at 32° and the boiling point at 212°. It was invented by a German scientist G. D. Fahrenheit in 1714. The scale is no longer in use for scientific purposes and in most other instances it has been replaced by the Celsius scale.

Faience. An erroneous name given to a sintered siliceous material used for making small objects such as amulets in ancient Egypt and covered with a thin glaze. True faience refers to a tin-glazed ceramic ware originating in Faenza in Italy.

Farriers' nails. The soft tapered nails used for fixing lead calme temporarily in place when forming stained glass windows.

Favrile glass. A Tiffany glass with an iridescent surface resembling that of ancient glass which has been buried and retrieved.

Feathering. A type of decoration in which applied bands of colour have been pulled out with a tool bent at the end to produce a fine pointed hook. It was commonly used on the ancient core glasses and resembles the similar type of effect found in some cake decoration.

Feldspar. Felspar. A group of silicate minerals forming the most abundant minerals in the earth's crust. They are found widely distributed in igneous, metamorphic and sedimentary rocks and are sometimes introduced into a batch to provide alkali (usually sodium and/or potassium oxide), together with silica and alumina. They tend to be variable in content and each of them is likely to contain elements of one or more of the others. See **Batch materials**. Orthoclase or potash feldspar is the most common and albite or soda feldspar is the next. The 'Clase' ending of some of the names refers to the property of the feldspars in having two cleavage directions or planes in which they are most easily broken. These cleavages are approximately 90° to each other and result in the formation of regular tablet-shaped particles when they are ground.

Feldspathoids. Materials similar to feldspar as they are crystalline, alumino-silicates and have various alkaline oxides. They cannot be considered to be true minerals because they do not have a unified chemical formula. Their lattices link in a random manner. The most common feldspathoids used in glassmaking are: nepheline, nepheline syenite, petalite, lepidolite and spodumene. They tend to have less silica and more alkalis than the true feldspars.

A double handled mug by George Elliot showing the use of the feathering technique.

Felt wheels. Wheels made up of compressed felt which are used in conjunction with a suitable shaft and motor, and very fine abrasive powders for polishing glass. They are of two basic types. One is brown and of long coarse hair and the other of white wool. Early wheels used with tripoli powder and tin oxide were soft, but when the polishing powders based on cerium oxide became the norm, much harder wheels were made to suit these materials. See **Abrasives**.

Ferric oxide. Fe_2O_3. The most common form of iron oxide and used both as a colouring material and as a polishing powder. It is occasionally introduced in excess of the proportion which will enter into solution in a glass in order to provide aventurine effects.

Ferriferous. Ores which are capable of producing iron or iron oxide.

Ferrous oxide. FeO. Black iron oxide. A stronger fluxing material than ferric oxide but not so commonly used as a colouring oxide.

Fibreglass. There is nothing new about glass fibre. Threads have been drawn from hot glass from very early times and natural glass fibre known as 'Goddesses' hair' and as Pele's hair was produced by high winds blowing across molten lava. It is used in the form of glass wool for insulation, as glass fibre for matting etc. and as continuous thread for re-inforcing plastics, textiles and electronics.

Glass fibre is made by several different processes. Large-scale production of glass wool is made by blowing powerful jets of steam or air onto molten glass emerging through platinum nozzles from a large, continuous tank furnace. On a smaller scale, glass marbles are melted in a small platinum furnace but then treated as above.

Flame blowing is a similar process except that coarse fibres emerge into a chamber where they meet a high velocity flame. This softens them and stretches them into very fine fibres.

There is a spinning process in which the molten glass runs into a rapidly revolving container which spins out glass through a series of small holes near to the base. This is then hit by a high velocity air blast to produce the fibre.

Continuous filaments are drawn from a furnace in which suitable glass marbles are melted. They often consist of several fibres which are spun into a continuous filament and rolled directly on to a winding tube.

The glass used for the production of most fibres usually has a high boric oxide and alumina, and a low alkali, content. Special alkali resistant fibres have been produced for use as re-inforcing material in concrete. The fibres are usually chopped up and mixed with the concrete which is then sprayed or cast into position.

Files. Files are used by the glassmaker to cut into the surface of a glass form which is about to be cracked off the blowing iron. The most common type is a fine cut triangular file but flat, half round and even square files can be used. The file can be applied wet and a gentle tap onto the iron is usually enough to release the form.

Filigrana. This is a general term used to cover a range of products originally made in Murano as early as the 16th century. It embraces the inclusion in a clear glass of threads of white and, occasionally of coloured, opaque glass known as lattimo.

It has come to be accepted as a term which now covers all kinds of decoration on clear glass which has been produced by similar methods. It includes the parallel threaded glass ware known as 'Vetro a Fili' and the network of threads known as 'Vetro a Reticello'. Filigrana glass is thought to have originated in the middle of the 16th century in Venice and has remained an aspect of Venetian production today though it is rare to find work of such fine delicacy as that produced when filigrana was in great demand.

One of the methods of producing filigrana consists of making several long lengths of cane with opaque white and occasionally with opaque coloured twists using the technique described under **Lattimo**. These are cut into suitable lengths and are then placed together and heated on a warm metal plate. A gather of clear glass is formed into a flat disc (Figure 1) which is rolled along the end of the line of rods to pick them up (Figure 2) so that they can

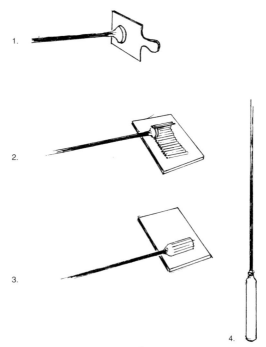

The making of filigrana vessels.
1 and 2. The cylinder is rolled along the end of heated cane or lattimo.
3. A gather is marvered into a shallow cylinder.
4. The resulting cylinder is marvered, trimmed and swung to an appropriate length before blowing etc.

be marvered into the shape of a cylinder (Figure 3). This is heated so that it can be extended by swinging (Figure 4) and the end cut level and closed. The result is then blown out and worked on the chair into whatever form is required.

The process of making reticello is described under **Reticello**.

Fillers. These are solid and inert materials introduced into a resin, paint, plaster etc. to add bulk or strength and sometimes simply to make the final material cheaper to produce.

Filligree cane. See **Lattimo**.

Fining. The final part of a founding in which the large bubbles released from the batch materials or which are induced by the introduction of fining agents rise through the glass to create convection currents and provide a stirring action which helps to produce a homogenous glass. At the same time the large bubbles collect the small ones on their way to the surface and reduce the possibility of seed. See **Defects** and **Batch**.

Fins. Thin ridges of glass which can appear on a cast when the molten glass has managed to run between two or more joints in the mould.

Fire polishing. The process of introducing glass into a flame or source of sufficient heat such as a kiln in order to fuse the surface of the glass into a bright, polished finish. Objects which have been worked at the bench are often given a final finish by heating them in the glory hole before removing them from the iron and placing them into the annealing kiln. Cast slabs and sculptural forms are often re-heated in a kiln to produce a fire polished finish.

Fireclay. Fireclays are usually associated with coal seams but some are laid down in deposits similar to those of china clay. They have provided the basis of many of the refractories used in the glass industry over the centuries though their use has been considerably reduced in recent times. It is thought that the fireclays found under coal seams were affected by the fact that they originally underlay the forests. The trees and vegetation covering the clay removed much of the soluble salts and mineral material including some of the silica. This left clays which were relatively high in alumina which accounts for their refractory properties.

Fireclays vary considerably both in composition and in behaviour but those used for making pots for pot furnaces or for any refractories which are likely to be in contact with molten glass must be as free of iron as possible and have a high vitrifying temperature. In Britain most suitable clays tend to be in the north which suggests that those in the south collected various impurities during a process of migration. The Scottish fireclays are high in alumina which accounts for their excellent refractory properties. Those found in the south on the other hand usually have a higher proportion of silica.

Fireclays and the primary china clays tend to have a larger particle size and as a result are not as plastic as the other secondary clays. They often contain particles of quartz, calcite and carbon. Sulphur also tends to be included in the form of iron pyrites. Carbon and sulphur when trapped often create difficulties in firing and their presence in even small amounts demands the need for slow and careful control.

Firing. (1) The process of taking a glass furnace to temperature and then maintaining that temperature as necessary.

(2) The process of converting clay materials to a hard ceramic by the use of heat.

There are various changes during the firing process. Organic matter needs to be safely burned away but water is released in two stages. The pore water which reflects the atmospheric humidity is removed between room temperature and about 120°C (250°F) and this temperature must be reached slowly to allow the steam to escape. Most organic matter starts to burn out at about 200°C (390°F). The chemically-held water starts to be released at about 350°C (660°F) and continues to about 600°C (1110°F), when it slows down to be completed by about 700°C (1290°F). The carbon and the sulphur then begin to burn out, the carbon usually being removed by about 900°C (1650°F) and the sulphur taking somewhat longer and often not being clear until about 1150°C (2100°F). The rate of firing relates strongly to both the nature of the clay and to its thickness. The firing of firebricks is usually done over a period of several days and a glass pot which may be up to 2 inches thick normally takes at least five days in a pot arch to achieve a temperature at which it could be safely transferred to the pot furnace.

Flame. A luminous mixture of gases in combustion. The chemical reactions in a flame are usually chain reactions of free radicals and the luminosity occurs either because of the fluorescence of excited molecules or ions or from the incandescence of small solid particles.

Flame detection systems. The three main flame detection and safeguard systems are: Flame conduction, Flame rectification and radiation detection.

FLAME CONDUCTION. The ionising envelope of a flame will conduct electricity. If an electrical potential is applied to an electrode in the area where fuel is ignited, the current passing between the electrode and the burner can be amplified to operate valves in the fuel lines.

FLAME RECTIFICATION. In addition to being able to conduct electricity, a flame is also able to rectify an alternating current passing through it.

If an alternating current is applied to an electrode located in the flame envelope, the circuits can be designed to respond when that potential is rectified. In the case of flame failure, there would be an immediate change in the signal which would result in the closure of the appropriate valves. This is a relatively cheap method of control and whereas until recently it was not popular because the electrodes had a short life, the introduction of more durable materials has made this system much more viable.

RADIATION DETECTION. This system operates by detecting the ultraviolet oscillations in the flame. If the photocell is situated properly, this system is very reliable and provides an immediate response to flame failure. It is however sensitive both to heat and to mechanical shock. Care must be taken to ensure that the photocell is situated so that it cannot be overheated and as an ultraviolet cell is sensitive to electric sparks, it should be placed so that it cannot view the sparks or the reflections of sparks from automatic ignition systems.

Flame polishing. See **Fire polishing**.

Flameworking. See **Lampworking**.

Flashed glass. Glass which has a thin layer of another glass, usually coloured or opaque, applied to one side. This is usually produced by dipping the final gather into coloured glass before it is blown out.

Flat glass. Sheet glass. A term which covers a wide range of glass produced in sheet form. See **Sheet glass**.

Flexible drive engraving. The use of flexible drive equipment has become increasingly popular over the last few years, perhaps because of its low initial cost and because it is not seen as requiring the depth of skill required for the use of the copper wheel. There is also a wide range of equipment readily available to suit the requirements of the particular engraver.

Many engravers used and still use dental drills which they have bought or scrounged from the local dental practice as they have been replaced by more modern equipment. These usually consist of a motor unit with a foot operated speed control, either a flexible drive or a series of small pulleys and a long drive cord, and a suitable handpiece to hold the various dental burrs which can be used for engraving.

Similar equipment based on a small motor which is either hung over the work surface or mounted nearby is now specially-made for engraving purposes and available in various sizes. Handpieces are made to fit this equipment but unfortunately they do not have a standard fitting and may not be interchangeable. The chucks on various engravers' handpieces are also not standard.

Most of them are provided with sets of collets. Often these sets contain the standard $^5/_{64}$in collets, 2.35 mm

($^7/_{64}$in) collets and sometimes additional 3 mm collets ($^1/_8$in) which will not take the popular size of dental burr. Other handpieces may be fitted with a variable chuck which is a smaller version of that normally fitted to larger electric drills used for wood and metal. This has the advantage of taking all the sizes of burrs available. It is certainly advantageous to ensure that any handpiece will fit the remainder of the equipment and that it will take a wide range of burrs.

Most modern dental drills are driven by compressed air and have a water system built in. Unfortunately, these also operate at very high speeds and need a very delicate touch on the speed control to enable them to be used at the right rpm.

Ideally, the drill should operate smoothly from very low speeds to at least 8000 rpm, though some are available which have top speeds up to 60,000 rpm. The range

Some of the types of flexible drive units available for engraving.
Figure 1 shows a drive fitted to a bench fitting motor.
Figures 2 and 3 show models in which the motor unit is suspended on an appropriate bracket.
All of the above are commonly fitted with a foot operated speed control.
Figure 4 shows a unit which is not, strictly speaking, a flexible drive unit but an engraving tool which comprises a small electric motor fitted with a chuck and attached to a transformer.
Figure 5 is a much larger industrial machine fitted with a heavy chuck which will hold grinding wheels suitable for engraving large areas.

of speed is usually achieved by the use of a simple variable transformer but as the initial difficulties of smooth response at low speeds from electronic controllers have been ironed out, these are becoming much more common. One of the problems of high speed working is that a fine mist can be created which contains fine glass particles and the use of a face mask is advisable.

There are also small hand-held units available in which the motor is incorporated into the handle. These are suitable for light work and though perhaps not so comfortable to handle as the ordinary dental handpiece, they do not have the restriction imposed by the flexible drive.

Large-scale work such as the panels made by John Hutton for Coventry Cathedral etc., are made possible by the use of a much larger flexible drive unit driven by a motor of approximately 3/4 H.P. able to take grinding stones up to 5 inches in diameter. One of the minor problems with using this kind of equipment is the necessity of ensuring that a regular supply of water is provided at the working point. Some engravers use a trickle feed from the mains supply but many also simply use a plastic container with a suitably controlled outlet.

The flexible drive has some advantages over the copper wheel. When using a copper wheel, the work is held by the operator in both hands. This creates some difficulty because the arms need to be held in a solid and fairly rigid position. As a result some parts of the glass may be not easily applied to the wheel. The flexible drive on the other hand is much more adaptable. Almost any table or bench surface can be used. The engraver can sit in comfort and work with the glasswork in one hand and the handpiece in the other. Many engravers consider the dust problem so negligible that they ignore it but finely ground particles of glass could accumulate in the lungs and it is advisable to avoid the problem and to provide a small water drip to keep the work wet.

The burrs to fit flexible drive equipment are mostly the standard types used for dental work. They are usually composed of steel shanks with diamond particles embedded at the tip. They are available in a variety of profiles and three grades, coarse, medium and fine. The fine grade gives the best quality of cut for engraving. As the diamonds are only embedded in the steel, they will not last long if they are treated roughly. They need water lubrication and should be applied gently if they are to last.

Larger dental burrs fitted with synthetic abrasive wheels can also be used to good effect. These tend to be

Left.
A typical collet fitted to many flexible drive handpieces.

Right.
The standard type of Jacobs chuck fitted to some flexible drive units.

either of green carborundum (silicon carbide) or corundum (aluminium oxide) which can be either white or pink. Again, they are available in the three grades of coarse, medium and fine but engravers tend to use medium carborundum for coarse and medium work and fine white corundum for finer finishing work.

Small diamond wheels similar to the larger types used for sawing and cutting are available. They are different from burrs in that the diamonds are sintered into a brass or phosphor bronze matrix on the edge of a steel disc. When treated properly, they will last much longer than the burrs because, as they wear, the softer metal matrix will erode more quickly than the diamonds and reveal further diamond points. They need to run at high speed with a constant water supply and very little pressure.

Polishing is again similar to the process used in dental work and burrs are fitted with profiles of rubber impregnated with abrasives. The firmer types are best for glass polishing and need to be used in exactly the same way as larger felt wheels. They can be applied wet or dry. When wet, more glass tends to be removed but the wheels wear rapidly. When used dry, there is a better polish but some dust can be created. Any bloom which might be created by the wheels straying off the etched area onto the surrounding glass can be removed with a small felt wheel treated with a paste of cerium oxide or commercial polishing powder.

Flint. SiO_2. Flint pebbles were often used as a source of silica. The modern powdered material can replace sand as a batch material but it is much more expensive and therefore it is only used rarely and for specific purposes. It is often mixed together with plaster of Paris to create moulds for forming or casting glass in a kiln. See **Casting**. It is usually sold with sufficient added water to prevent the hazard of breathing the fine dust particles known to cause pneumoconiosis. See **Silicosis**. Flint also tends to contain about 3% of calcium carbonate and about 3% of trapped water. In the natural state, it is extremely hard and grey or grey-brown. Because of its hardness, it is very difficult to grind so it is normally calcined which has the effect of softening it sufficiently to produce a white powder after grinding.

Flint glass. The name flint glass originates from the attemps of George Ravenscroft to reproduce Venetian Cristallo. In early experiments he used calcined English flints and potash but this was not very successful. Later he introduced lead oxide to replace some of the potash and gradually replaced the flints with sand. The name 'Flint glass' remained.

Float glass. Sheet glass which has been manufactured by floating a ribbon of hot glass on a bath of heated liquid, usually molten tin. The process originated with Pilkingtons of St Helens and is now the standard method of producing good quality sheet glass which is clear, flat, with parallel and fire polished sides.

Flotation. A process of separating material according to its density. The material is usually mixed with water, stirred and allowed to settle so that the heavier particles drop to the bottom and the lighter particles either remain at a higher level or actually float. Fine particles can be separated from a material which is agitated together with suitable chemicals to form a foam on which the fine particles float and can be carried away.

Flotation process showing the separation of particles.

Fluidity. When referring to molten glass, it is usual to use the term 'viscosity' rather than 'fluidity' which has a meaning directly opposite. An increase in viscosity implies that a liquid becomes thicker and less likely to flow whereas an increase in fluidity means that a liquid will flow more readily.

Fluorine. A very poisonous, pale yellow gaseous element belonging to Group VII of the periodic table. It causes severe burning on the skin. It is obtained from fluorspar and cryolite. Chemically, it is the most reactive and electronegative of the elements.

Fluorspar. CaF_2. Calcium fluoride. Fluorite. Greatly admired as the mineral, 'Blue John'; it is generally purple in colour though some samples can be yellow or brown. It has been used in the past as a strong flux in the steel industry and as both flux and opacifier in glass manufacture. It has also been used as a source of fluorine and hydrofluoric acid. It is rarely used now in the glass industry because of current concern with the release of dangerous fluorine volatiles into the atmosphere during the founding process. It is mined in Derbyshire where it is carved and turned into a wide range of ornaments because of its attractive colour and translucency.

Flutes. The term originally referred to the tall, slender, conical and often elegant drinking glasses used for drinking ale or champagne. The use of this name is obvious from the flute-like shape of these glasses. Nowadays, the term tends to be used more commonly to refer to the glasses with a rather narrow bowl used for drinking champagne.

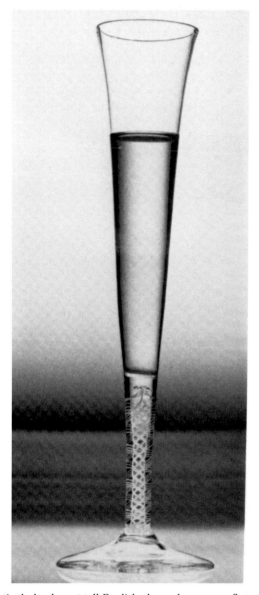

A particularly elegant tall English ale or champagne flute with a multiple air twist stem. *Courtesy of Cinzano. Photograph by Peter Balmer.*

Fluting. Narrow vertical grooves used as a form of decoration.

Flux. In glassmaking this refers to an oxide which interacts with other oxides to promote fusion. See **Batch materials**.

It also refers to the materials such as oleic and hydrochloric acids or commercially-prepared materials which are used in the soldering of lead calme in stained glass windows.

Foot ring. A ring of glass added to the base of a vessel whilst it is being formed.

Forceps. These are the lampworker's equivalent of a glassmaker's pucellas and are often made by the craftsman from an ordinary pair of engineers spring dividers.

Forest glass. Waldglas. Free-blown medieval glass usually green-yellow or brown in colour as a result of the crude materials and firing processes used at the time. The term is thought to originate from the Bohmer Wald on the Bavarian side of Bohemia where there were many glasshouses and nomadic glassworkers. Similar ware was made throughout Europe and many examples of bottles in forest glass were made in England.

Formulae. A formula is simply a convenient way of expressing principles, procedures or relative values. For example: in converting temperatures from Fahrenheit to Centigrade the formula would be:

$$C = (F - 32) \times {}^5/_9$$

and conversely the formula for converting Centigrade to Fahrenheit would be:

$$F = (C \times {}^9/_5) + 32$$

A batch formula for a particular glass could be:

SiO_2	66.0%
B_2O_3	22.7%
Al_2O_3	4.5%
Na_2O	6.8%

A chemical formula is a convenient way of expressing the nature of a chemical compound by using appropriate symbols for the various elements. For example, common borax would be expressed as:

$$Na_2O.2B_2O_3.10H_2O.$$

This would indicate that there are 2 molecules of boric oxide and 10 molecules of water to every molecule of sodium oxide. (Hydrated borax is now more commonly presented as being $Na_2. B_4O_7.10H_2O$.)

Founding. The process of charging and melting glass in a furnace. See **Batch melting**.

Fourcault process. Process for drawing sheet glass vertically from furnace. See **Sheet glass.**

Fraille. A framework specially designed for carrying glass.

Free blowing. This refers to glass which is blown and shaped directly by the glassmaker without resort to moulds and mechanical aids.

Free radical. An atom or group of atoms with an unpaired valency electron. Because of this free valency, most free radicals are very reactive.

Free silica. This occurs in clays and in many insulation and abrasive materials. It can be dangerous when inhaled in the form of fine dust and could be a cause of the development of silicosis or pneumoconiosis.

French embossing. A process of exposing the glass to mixtures of salts of hydrofluoric acid in order to produce a white acid etch. It is then given further sequences of treatment with various acid mixtures to produce a variety of shades to suit the particular design and then often taken back sufficiently to produce areas of clear glass.

Friggers. (Whimsies in the USA, Whigmeleeries in Scotland). Articles made by factory workers either in their spare time with permission or illegally when no supervision happened to be available to restrict their activities. They have been produced ever since any semblance of organised glassmaking appeared and are still

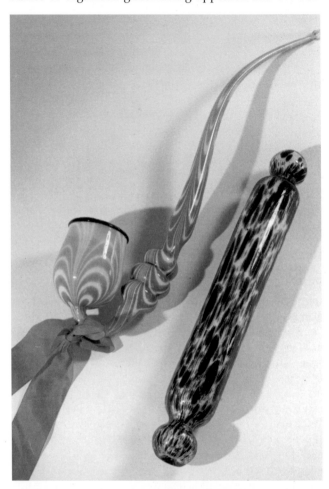

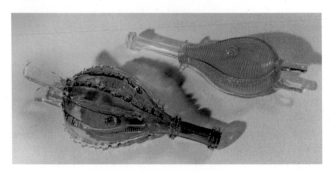

Photographs of friggers from Broadfield House Glass Museum.
Courtesy Broadfield House Glass Museum.

Friggers. A photograph of some of the popular types of friggers.
Courtesy of Pilkington Glass Museum.

made in most factories today. It is interesting to note that all over the world it is possible to see exactly the same fish, swans, ash trays, pipes, walking sticks and rolling pins etc. In Scandinavia musical instruments are often produced and played. The Orrefors factory has its own band. In the North East of England glass snooker cues and yards of ale seem to be the most popular friggers. In the 19th and in the early part of the 20th century very elaborate constructions with birds, plants and even ships were made and were often presented complete with a turned wooden stand and glass dome. A very good example of one of these can be seen in the Pilkington Museum at St. Helens.

The term has an altogether different connotation in the USA where it is used as a rather rude expression. It is suggested in some quarters that it derived from the god of marriage, 'Frigga' in Norse mythology but how this developed into a reference to spare time glass objects or into the American version provokes some imaginative speculation. Another theory holds that the name derives from the old English 'Frician' meaning 'To dance'.

Frit. A batch material which has previously been melted and then ground. For instance, lead oxide has traditionally been mixed directly into a batch for charging the furnace but there are many instances when the lead oxide has previously been melted with silica and then ground down to form one of the lead silicates thus reducing the exposure of the furnace men to toxic dust from the lead oxide.

Frosting. This is a general term used for a variety of matt finishes. On moulded ware it can result simply from the mould material becoming embedded into the surface of the glass. It is also produced by sandblasting and by some of the acid etching processes. See **Acid etching**.

Fuel. The source material used to provide the energy for firing furnaces, kilns etc. In early times this was wood which offered the added advantage of providing ashes for use as flux. In the Middle Ages it also had a devastat-

ing effect on the forests. After coal started to replace wood, it became the dominant fuel for many years. Nowadays gas is the most popular fuel in both factory and studio production with oil taking second place.

Mikko Merikallio announced that he was running his furnace in Finland on solar power. What he meant was that he had used a crop of rape from the family farm and turned it into rape seed oil which he then used to fire the furnace. He will probably be turning the farm manure into methane for his next project. No doubt solar power and wind power will soon emerge as contenders, if only indirectly, as a means of generation of electricity.

The use of electricity as a fuel is on the increase and offers many advantages over oil and gas. It is clean, quiet, easy to control and in some countries, very cheap. The major disadvantage is the cost of the large transformer system which it needs and the disastrous results which can occur with a furnace if there happens to be a prolonged power cut.

Heavy fuel oil is often used in industry but the popular grade of oil used for firing studio furnaces is what is usually termed '28 second oil'. It is the same as that used for most domestic heating systems. It is pressurised through fine jets into a mist which tends to give a long flame. It has a small sulphur content which can create slight difficulties with a tank or open pot and needs a constant and adequate forced air system to avoid reduction problems.

The types of burner used for domestic central heating systems can be converted to operate reasonably provided that the size is suitable for the purpose. These come provided with a balanced fuel to air ratio, a pump to provide oil at the right pressure to atomise the oil at the orifice and usually have the necessary safety system built in. The amount of possible turn down is limited as in their normal usage in a central heating situation these burners operate by a system of turning off and on which is hardly suitable for firing glass furnaces. Some modification is possible by changing jet sizes and the air intake aperture to suit. It is also possible to achieve some turn down by using either an electronic speed control or a variable transformer on the motor system. The only advantage of this type of burner is that they can be picked up for practically no cost as most central heating engineers would rather supply a new unit than repair a fault which is rarely located in the burner itself. It is certainly not recommended to introduce one of these burners as a long-term facility as burners designed specifically for furnace use will inevitably perform much better.

So-called town or coal gas is still used in some locations but natural gas is the fuel which has become the norm in studios throughout Europe. It has a relatively high calorific value, is reasonably cheap and excellent burner systems have been developed to suit it. It usually provides about 1000 BTUs per cubic foot and has an advantage in being lighter than air and any leaks which might occur can often disperse into the atmosphere without creating a hazard.

Oil, coal gas, and natural gas tend to have fairly long flames and usually need air under pressure to achieve efficient combustion.

Where natural gas is not available, on-tap propane or LPG is the usual replacement. It is supplied as a pressurised liquid. It is much more expensive but works very well. It has a higher calorific value than natural gas at about 2500 BTUs per cubic foot. It is heavier than air and any leaks will build up at floor level and particularly with its high calorific value and low flash point can soon generate a very dangerous situation.

It requires about 24 cubic feet of air to a cubic foot of propane for efficient combustion and whilst unlike coal gas and natural gas it will work well on an ordinary venturi burner the provision of some secondary air will often be required to ensure maximum efficiency. Both butane and propane have a short, hot flame and the position of the burners will need to be considered in relation to this.

Fugitive. A term often used to describe colours that are difficult either to form or to strike. It is also used to describe colours which change because of the release of volatiles whilst glass is standing or being worked.

Fumes. The release of fumes, particularly during the founding process, has been the subject of a great deal of consideration in recent times as a result of the much greater awareness and legislation relating to the nature of emissions from a wide range of industrial activities. Much of that coming from glass furnaces is simply water vapour and carbon dioxide which comes mainly from the conversion of the various carbonates in the batch and from the burning of gas or oil. There are many chemical changes in melting batch and a wide range of volatile materials can be involved. Some of these continue to release fume after the glass has been founded and is being used. See **Faults – Cords**. Some of the major elements concerned are:

- Sulphur dioxide – from saltcake, barytes and from oil. Together with water vapour can form sulphurous and/or sulphuric acid.
- Nitrogen monoxide and nitrogen dioxide – from combustion processes.
- Fluorine – from making fluorine opals – a highly corrosive and toxic gas which becomes evident from its matting effect on windows in the vicinity.
- Cadmium – from making red and yellow glasses – a cumulative poison which attacks the kidneys.
- Lead – from making lead crystal – also a cumulative poison which is causing a considerable amount of concern at the moment.

Fume is also released during the firing of lustres and, perhaps obviously, during the process of producing iridescent surfaces by fuming.

There is a great deal of statutory legislation emerging throughout the world. Most of it is directed at industry but much of it is also applicable to the operator in small workshops. It may well appear to be of little concern but the implications of both the legislation and the hazards involved should be taken into account.

Fuming. This is a method of exposing hot glass to fumes, usually of tin chloride or silver nitrate, to produce a thin interference layer on the glass. This results in an effect of iridescence. In the past, it was common practice to place some of the metallic salt in a tin at the mouth of the furnace and to drop a small piece of hot glass from a bit iron into the tin to create the fumes. The glass being worked would then be held in the fumes to create the iridescence. The normal practice today is to mix the metallic salts together with distilled water or with alcohol and to put this mixture into a small plastic hand garden spray. The mixture is then sprayed directly onto the hot glass in an extraction chamber until the required amount of iridescence is achieved. The hot glass is then reheated in the glory hole before being cracked off to be annealed. See **Iridescence**.

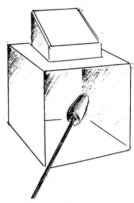

A typical, simple fuming cabinet used when spraying tin chloride onto hot glass.

Furnace refractories. The types of refractories available to furnace builders are varied and numerous. Some of the more common ones are: silica, high alumina firebrick, fireclay, sillimanite, mullite, bauxite, corundum, zirconal and a considerable variety of fusion cast materials.

A general classification is indicative of the proportion of alumina present so a firebrick 52 would indicate that it had a 52% alumina content. Normally, the higher the alumina, the higher the operating temperature and, perhaps unfortunately, it also tends to signify greater cost.

The choice of refractory depends on several factors. Some of these are:

- The design of the furnace.
- Whether it will be used to melt batch, pellets or cullet.
- The type of glass to be melted.
- The type of fuel to be used.
- Whether the refractory is to be used above the glass level.
- Whether the refractory will be in contact with the glass.
- Initial cost/life/rebuild/cost ratio.

In industry it is common practice to use silica refractories above the glass line (the highest level of the molten glass in the tank). However, in a small furnace which is likely to be heated and cooled more quickly than a large industrial furnace, these may provide problems with spalling as silica refractories have a low resistance to thermal shock below 600°C (1110°F). As most studio glassmakers melt either cullet or pellets and are likely to run a furnace down more often than in industry, it is common practice to use high temperature insulation refractories in this context.

Now that chemically-bonded refractories can be cast to such fine measurement and finish and have both bubble and fibre insulation cast into the same block, purpose built base, side and roof blocks for small furnaces are gradually becoming available.

In reference to a pot furnace, it is relatively simple to gather information on the refractory qualities of a popular type of pot. Once a particular make has proved its worth, word soon spreads around and most glassmakers gravitate towards it. In these circumstances, collecting the necessary data is not a problem. Tank refractories somehow seem to avoid generating this amount of discussion so there is a much greater tendency towards individual preference in deciding which glass contact refractories to use in tank furnaces.

Furnaces. The furnace is such a basic essential for any hot glass studio that its design and construction has been a constant topic for discussion and debate whenever groups of studio glassmakers have met. This discussion has often centred on such subjects as 'Tank or Pot', types of burner system, types of refractories, gas, oil or electricity, automatic operation and safety.

Much has been made of the myth that the emergence of the small furnace has been the major element in the development of studio glass. In fact, small furnaces are certainly not new and they have been used for centuries in various situations all over the world. They have always been used in factories, particularly for the production of small quantities of coloured or special glasses. Another myth has emerged to the effect that the heating of annealing kilns from the waste heat from the furnace also came about because of the emergence of studio glass activity. Similar systems have operated from ancient times and at the beginning of the 15th century, furnaces were commonly constructed in tiers with the annealing chamber sitting on the top level.

The beginnings of studio glass as we know it today happened because the possibility of using small furnaces in modern individual studio operations was suddenly seen as offering an extension to the activities of some ceramicists. There is no doubt, however, that this move, attributed to Dominick Labino and Harvey Littleton in the USA, has stimulated considerable development and interest over the last 20 or 30 years.

In the early days of studio glass, most furnaces were simple, small rectangular day tanks with a venturi-type burner firing directly onto the surface of the glass. Whilst this type of furnace has practically disappeared, it still finds some favour with the occasional glassmaker who needs something which he can operate spasmodically and which he can dismantle and re-build easily when it becomes necessary.

Section through a small tank furnace showing the refractories of the furnace forming the container for the molten glass.

Perhaps the first radical move away from the concept of the rectangular day tank came from Heikki Kallio in Finland. He developed the idea of a furnace based on the shape of an egg. He considered that this would offer many advantages over the cube form. The top of the egg would be similar to a catenary arch in three dimensions and would thus provide considerable structural strength and at the same time reflect radiant heat directly down to the surface of the glass. The hemispherical container meant that the glass could still be gathered from the centre but it would be much easier to empty than the rectangular box and there would be less likelihood of cold spots forming in the glass to create cords.

Another innovative and imaginative furnace builder is Mikko Merikallio, also from Finland. As he often built furnaces in such places as East Africa where mains electricity was rarely available, he became adept at making the most of whatever fuel was available. Over the years he has used, with considerable success, mixtures of paraffin and old diesel oil, rape seed oil, and he has built multi-fuel furnaces for use with gas, oil and electricity.

Just as the small furnace in a factory is likely to be something which has been built quickly, used for a short time and then dismantled, most studio furnaces reflect their intended use. A small furnace which is only to be used very occasionally will not be seen as meriting considerable expense and will be likely to be something very basic which can be taken up to temperature quickly and can be dismantled and re-built in two or three hours. On the other hand, a furnace which is to have more or less

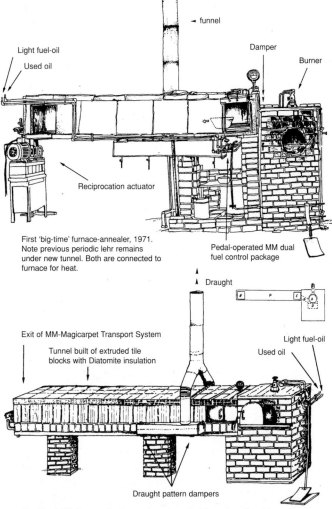

First 'big-time' furnace-annealer, 1971. Note previous periodic lehr remains under new tunnel. Both are connected to furnace for heat.

Combined MM-Furnace Continuous Annealer unit of Harambee Glass-blower, Kenya

Early furnaces constructed by Mikko Merrikallio in Africa to suit the types of fuel and materials available. *Courtesy of Mikko Merrikallio and the Crafts Council.*

Section through a pot furnace showing the glass container as a separate pot resting on the floor of the furnace.

continuous use will almost certainly be much more sophisticated.

As the increasing cost of fuel became an important factor, efficiency became of greater concern. Burners were moved to the side. Their function, efficiency and lack of noise became matters of considerable examination. Insulation was increased and improved.

The old system of using waste heat for heating annealing kilns was re-introduced and became commonplace. Recuperative systems became popular and some people have gone to great lengths in establishing the use of sensors to open gathering ports, lighting glory holes and opening annealing kilns as the operator approaches.

The early furnaces were often crude, wasteful of fuel, noisy and costly. The latest recuperative furnaces to be installed in many studios are so efficient that it is common to find that they are running at something like a quarter of the cost of the older types. The other benefits to the operator are that there is now much less noise and

as a result the studio atmosphere is much more comfortable.

As legislation and the resultant pressure to decrease nitrox emissions reaches the studio operator, the introduction of oxygen/fuel burners and even small regenerator systems to re-circulate the exhaust gases through heavy refractories to provide a source of heated air to the burners etc. may have to be considered. Either way there is a likelihood of problems with the cost of oxygen especially if it has to be bought in relatively small quantities. The efforts to reduce nitrox (more commonly Nox or No_x) emissions are causing considerable concern at the moment and whilst some advocate the addition of oxygen into air/fuel systems, others see this as not being a successful answer and that a better approach might be through specially designed low NO_2 burners. It is considered that whilst it is obvious that oxy-fuel burners which do not use air would produce little or no NO_2 as this could only come from the fuel, when the system is simply oxygen enhanced then the greater heat of the flame actually increases the possibility of the production of NO_2. Other possibilities being explored include the injection of ammonia into the exhaust gases to neutralise the NO_2.

It is a matter of some concern to the small workshop operators that legislation on such matters as acceptable standards of nitrox emissions will be negotiated with the large flat glass and container industries and as a result what might be reasonably achieved in large plants may provide a virtually impossible target if they are then applied to small studio furnaces.

As much better refractory pots have become available there has been a move towards small pot furnaces as the standard equipment in studios rather than the small tank. Whereas at one time most people built their own furnaces, a few specialists have now emerged, particu-

The small studio pot furnace made by Sismey and Linforth. It takes a pot 60 cm (24 in) wide by 40 cm (16 in) high and holding approximately 120 kg of glass. Pot setting is through a rear hinged door for easy access.

The studio type tank furnace built by Sismey and Linforth. It holds approximately 200 kg and will easily melt 100 kg of batch overnight.

larly in Europe, and the standard Heath Robinson-type of furnace which looked as if it might have been thrown together from a great distance has given way to state of the art professional production. Unfortunately, the commercial furnace manufacturers did not respond to the need and for many years tended to provide small versions of factory furnaces with massive refractories which were not really suitable to the studio glassmaker. Despite what the industrial suppliers may say to the contrary, studio furnaces are now much more environmentally and energy efficient than comparative small furnaces to be found in industry where any savings to be gained are likely to be insignificant in relation to the overall expenditure in the plant. It appears however, the furnace manufacturers have suddenly discovered the market possibilities and Sismey and Linforth who normally concentrate on building large industrial systems have produced specially designed small pot furnace and small tank furnace units completely suitable for small workshops. These should certainly fill a gap in the market.

Both furnaces are fitted with compact, modular, and programmable control equipment and the pot furnace is fitted with automatic flame ignition and flame failure equipment which is also available as an option to the tank furnace.

Furnaces (Electric). Although natural gas has been, and still is, the most commonly used fuel as it has a high calorific value, there are no problems from contamination and in comparison with other fuels it is cheap, there has been an increasing use of electricity. This is particularly so in countries where it is not expensive. It is becoming much more popular in industry and there are several advantages which might outweigh the possibility of higher operating costs in small workshops. It is completely quiet. No fan buzzing away and no burner noise. There is no scouring action on the surface of the glass to pick up potentially volatile materials. In one factory a change over to electrical operation is reputed to have resulted in a drop of over 80% in the loss of lead oxide from a lead crystal melt. In a studio the furnace would be unlikely to be used for more than about eight hours a day. With well-designed insulation the electricity required to maintain the temperature whilst the furnace was not being used would be negligible compared with that of a gas or oil firing where even in a tick over situation the continuing heat loss up the flue could be considerable.

There are two types of electric furnace in common use. One uses high temperature elements, usually dispersed vertically around a pot, whilst the other uses blocks of tin oxide built into the opposing walls of a tank. In the latter system, sufficient cullet is heated in the tank, either by a gas burner or by radiant heat from rod elements, until it is soft enough to allow the passage of an electric current. Then, acting in a similar way to an electric element, it provides a resistance to the current. A low voltage high amperage current is passed from the transformer to the tin oxide block on one side of the tank, through the semi-molten glass and back through the tin oxide block on the other side. The resistance of the glass causes it to heat sufficiently to melt completely and more batch and/or cullet is added until the founding is complete. There is some advantage in having the source of the heat in the glass itself rather than from an external source. It creates a natural system of convection to help keep the glass homogeneous. There is a reduced tendency for attack on the refractories and, particularly where there is good insulation, there is efficient use of the energy input. Unfortunately, blocks of tin oxide tend to be very expensive.

The main drawbacks of installing an electric furnace are the initial expense of providing a suitably large transformer to reduce the voltage to an appropriate and safe level and the high cost of electricity in most countries. It may be, however, that if the regulations relating to nitrox (No_x) emissions become too stringent, electric furnaces may well provide the only reasonable answer.

Furniture. The types of kiln shelves, props, shelf supports of various kinds used in both slumping kilns and in annealing kilns. They are usually made from high alumina refractories such as sillimanite, mullite and fluxed alumina but zircon-rich shelves are also made. For high temperature applications, silicon carbide shelves are available. Cordierite shelves are made from mixtures of mullite and talc and have a high resistance to thermal shock but should not be used for temperatures over 1260°C (2300°F).

Fuse. The deliberately introduced weak link in the chain. It usually consists of a strip of metal which, because of its low melting point, is designed to fail if a current flows through the circuit which is stronger than that for which it is designed. Without the fuse the wires in a circuit could become hot and create a fire. Alternatively, a piece of electrical equipment could be badly damaged.

Fusiform. Cigar-shaped. Tapering in at each end.

Fusing. The process of heating pieces of glass until they fuse together. This can be carried out in various stages. Works which are made up from pieces of window glass

Form fused and assembled, borosilicate glass.

Fused glass forms, 70 cm high, incorporating opaque white and clear glass.

Fused glass form, 'Stellae', 70 cm high. In this example the glass has been heated until the pieces fused together but without becoming fully melted.

Fused glass pieces by Frank van den Ham from Holland.

such as many of those of Mattéi Négréanu can either be glued or fused together. Those which are fused tend to have a totally different character from those which are glued, largely because they usually have curled and softened edges.

Similarly thick blocks of glass are often made up in the same way. It is quite common practice for slabs of optical glass to be fused together by artists needing larger blocks of clear material. In this case, it is perfectly feasible to control the fusing temperature so that the slabs do not deform in the process. It is important to ensure that the surfaces to be fused are clean and free from dust. It is also possible that when a more fluid result is required, the glass can be heated to a state at which it will change its shape and may even begin to flow.

Some difficulty can arise when attempting to fuse hard glasses to soft ones. A lead glass will start to become soft at a lower temperature than a soda-lime glass and they both require different annealing schedules.

Work which has previously been enamelled can often be successfully fused and colour can be applied deliberately in the form of enamel, lustre or threads. Very thin swirls of fine sand are also commonly trapped between layers. Another common technique is to engrave one or more of the trapped surfaces before fusing, though some

The effect of fusing grooved or cut pieces together.

covered with a layer of ceramic fibre paper. The degree to which the glass will pick up some of the separator or some of the surface fibre will depend on the temperature and the type of glass being used. Some glasses tend to release cleanly under most circumstances whilst others tend to pick up other materials readily. When a very smooth finish is required, it often helps to run a steam iron over the ceramic fibre before putting on to it the glass to be fused.

It is also essential to ensure that the glasses to be fused are of similar expansion. Particular care may be needed in annealing if clear glass is to be fused with dense coloured and opaque glasses even when theoretically they should be compatible.

Fusion. Melting. The creation of a homogeneous liquid mass by the melting together of different materials. The fusion processes in glass melting involve heat but also depend on the interaction of the various batch materials. They are aided by the release of bubbles which rise to the surface and provide a stirring action which brings more of the particles together.

Fusion cast refractories. Refractories made by melting a refractory batch to a viscous liquid in an electric furnace which is tapped to allow the liquid to run into special moulds. The furnace is taken to very high temperatures (up to 2500°C, 4530°F). Whilst there were earlier experiments into the process, it was Corning Glass Works in the USA which succeeded in producing fusion cast blocks of 72% alumina in 1925. It provided immediate improvements both to the life of glass furnaces and to the quality of the glass. There have been continuing developments in the range of fusion cast refractories. ZAC (AZS) which is based on alumina-zirconia, and Monofrax which is based on pure alumina became the most popular for many years. The zirconia content was increased from a standard 32%, first to 41% and eventually reached a high specification casting containing 94% zirconia which is used for the production of fluorine opals, special borosilicate glasses, lead crystal and TV glass. Other fusion cast blocks containing 26% Cr_2O_3 have been produced which are used mostly in the glass fibre industry. AZS refractories are commonly used for chequers in regenerators.

care is needed to ensure that the glass does not become too fluid as fine detail could be lost. If engraved or even coloured pieces are separated by layers of clear glass then very interesting illusions of space can be created. It is also possible to sandblast or cut through layers of flashed glass before fusing them to clear glass. A problem which might be encountered in this case, is that any air which becomes trapped can well produce bubbles, particularly if the temperature is taken higher than that needed.

Fusing is usually carried out on kiln shelves which have either been coated with a separator or have been

G

Gadjet. A device which clips around the foot of a vessel and avoids the necessity for the use of a punty iron.

Gadjet. This is a device which clamps around the foot of a goblet or similar form whilst the bowl is being worked and finished. Glassmakers use it to replace a punty iron. Small versions of this tool are often used by lampworkers.

Gaffer. The leader of a chair or team of glassblowers.

Galena. PbS. Lead ore. Lead sulphide. A lead ore which is dark blue-grey in colour and usually found as cubic crystals. This is the most common source of lead. The lead is recovered from the ore by a process of roasting followed by reduction. Potters used to make a glazed surface by dusting powdered galena from a cloth bag on to the wet pot. It was once thought to be less toxic than the various oxides of lead but it is poisonous and suitable precautions must be taken when it is used.

Gallé, Emile. (1846–1904) Nancy, France. Emile Gallé took over the artistic direction of the ceramic and glass factories of his father in 1874. He developed an interest in Japanese and Islamic art and became a prominent member of the Art Nouveau movement. He was very inventive and became noted for his development of the process for making ware containing layers of differing coloured glass, often with gold inclusions, which he cut through in areas to reveal the colours below. He also experimented successfully with enamels and with cameo glass.

Gamboge. A yellow pigment often mixed with the yellow silver stains for application to pieces of glass to be fired and used in stained glass windows.

Gathering. The process of collecting a gob of molten glass from the furnace on to a blowing iron, a punty iron or a bit iron. The iron is heated until the end is a dull red colour and then introduced into the surface of the molten glass where it is turned until the metal builds up on the tip. When sufficient glass has been gathered, the iron is lifted slightly and turned more slowly so that the gather leaves the surface. The iron is then drawn back towards the gathering port, still rotating sufficiently to keep the gather in place and leaving a trail from the end rather than from the side. See **Blowing.**

Gathering irons. The long iron rods used to collect molten glass from a furnace.

Gelatine. A material made from bones and used to make flexible moulds.

Georgian wired glass. Glass with a regular square pattern of wire incorporated into the glass.

Germania. GeO$_2$. Germanium dioxide. A glass-forming oxide which finds occasional use in special glasses but tends to be too expensive for normal use.

Gerstley borate. (variable content). A type of colemanite which also contains soda. It is mined in the USA.

Gibbsite. Al$_2$O$_3$.3H$_2$O. A white form of aluminium hydrate, easier to grind than the other two forms, diaspore and bauxite. They are all used to provide alumina for abrasives and batch but they are also the source of the metal aluminium. Gibbsite is the name given to the aluminium-hydroxyl layer in crystals of kaolinite.

Gilding. The application of gold on to glass. This has been practised since Roman times with fairly wide-ranging techniques, some more successful than others. Powdered gold or a precipitate of gold was mixed with suitable enamel and painted on, or mixed with honey or aromatic oil and applied on top of enamel and re-fired. Gold leaf was often used in preference to powder but the firing needed careful judgement on the part of the operator to ensure success.

Gilding was a very popular method of decoration throughout the Middle East and some very fine examples of work which was gilded and then engraved were produced. It became popular in Britain in association with 'Bristol Blue' ware and it was used both for lettering which indicated the nature of the purpose for which the vessel was intended and for the fine decorative linear work used to embellish it. Occasionally the gold leaf

would be trapped between two layers of glass. This is a technique much exploited by some studio glassmakers today. They pick up the gold leaf from the marver on to a gather of glass and then cover this with another gather before blowing out the form. Early gold sandwich glass in which the gold was trapped between two layers was produced in the third century BC and became very popular about the 4th century AD.

Gold leaf was also applied cold by mixing chalk, red lead and linseed oil and by using various varnishes painted on to the surface of the glass. The gold leaf was applied as required and when dried, burnished to a bright finish. As this was not fired onto the glass, the result was not entirely satisfactory and tended to disappear over the years as a result of cleaning and abrading. A common method of applying gold at the present time is to use gold lustre.

Glass ceramics. Glass ceramics are materials that are produced from glass which has been deliberately modified into a polycrystalline structure under controlled conditions. The range of these materials has increased considerably over recent years and they are now specially formulated to fit the needs of domestic, high technology engineering and many other processes. Perhaps the most well-known to the general public are the so-called ceramic hobs on cookers and opaque glassy oven ware. Most of the glass ceramics offer advantages of low thermal expansion which makes them particularly resistant to thermal shock. They can also be produced from such basic materials as basalt, furnace slag and fly ash from power stations. They are finding increased use in medical circles as materials for bone replacement and in dentistry for fillings to replace the mercury amalgam which is rapidly falling out of favour because of a growing reputation as a potential health hazard.

The normal method of manufacture is to melt a suitable glass, form it into shape as a glassy material and to then hold it at a suitable temperature for the polycrystalline structure of a glass ceramic to form. The process has not shown any sign of being exploited by artist craftsmen as yet, largely because it is seen as a highly technical process needing specially formulated glasses with suitable microfine nucleating agents evenly distributed throughout.

Glass constituents. Glass is made by the fusion under heat of a mixture of mineral oxides, at least one of which must be what is known as a 'glass former'. The number of glass forming minerals is very limited. The best known are silica (SiO_2), boric oxide (boron trioxide B_2O_3), arsenic trioxide (As_2O_3), and phosphorous pentoxide (P_2O_5). Of these silica is by far the commonest and most widely used.

In all glass in large-scale commercial production (e.g. bottle glass, window glass etc.), silica is almost always the major constituent in quantity and is frequently the only glass former present. After silica, the next most used

glass former is boric oxide. It is used to facilitate the melting operations and to confer upon the finished glass certain desired characteristics such as chemical resistance and resistance to thermal shock. Arsenic trioxide and phosphorous pentoxide are rarely used as major glass formers. A small quantity of arsenic trioxide is often used, not as a glass former, but as a refining agent helping to clear the glass of small bubbles and as an oxidising agent to reduce the blue-green colour resulting from traces of iron in the batch materials.

Small quantities of arsenic trioxide and phosphorous pentoxide as glass formers dispersed in the melt of what is largely silica tend to separate during cooling into small discrete particles which scatter incident light, giving the glass a white opalescent appearance.

The glass formers are sometimes called network formers because they have the property of being able to link their atoms together very strongly to form a continuous three-dimensional network.

Glasses contain certain other minerals which are not network formers (they are not, in the absence of a glass former, able to make a glass). They are included either because they expedite the melting process, acting as fluxes, or because they have beneficial effects on the properties of the finished glass. Other oxides are called intermediates because, whilst they cannot form glasses independently, their atoms can enter into the glass network and become an integral part of it.

The chief fluxes are the alkalis: soda (Na_2O), potash (K_2O) and occasionally lithia (Li_2O). They are usually used in conjunction with the alkaline earths, the most used being lime (CaO) and magnesia (MgO). Zinc oxide (ZnO) is also used occasionally. Alkaline earths increase the chemical stability of the glass.

The chief intermediates are lead oxide (PbO) and alumina (Al_2O_3). Lead oxide opens up the network, acting as a flux and increasing the optical refractivity and reflectivity of the glass. Alumina is used to suppress devitrification and to raise the viscosity of the glass with the object of reducing the tendency to deform at high temperatures.

Glass structure. Glass is obviously different from most solid bodies in both its physical and chemical nature. Many glassmakers melt their glass from well-tried formulae, often with continuing success, but when problems occur the reasons are often very difficult to find. Meaningful explanations of glassmaking processes can only be given in terms of the atomic characteristics of the elements involved and the reactions between them.

When we say that the chemical formula for silica is SiO_2 it simply indicates that silica is a compound of the elements silicon (Si) and oxygen (O) and that there are twice as many oxygens as silicons. It does not tell us anything about its structure. In fact, within a piece of silica such as sand containing many millions of atoms, each silicon atom is bonded to four oxygen atoms and each oxygen atom is bonded to two silicon atoms.

The four bonds emanating from the Si atom are directed symmetrically outward so that the four bonded Os lie at the corners of a regular tetrahedron with the Si atom at the centre.

Glass structure. Figure 1.

In the diagram, each Si-O bond is represented as a straight line from the centre of the Si atom to the centre of an O atom. The line has been continued outward through the O atom to indicate that each O is in fact bonded to a second Si. Each of these Sis is in turn tetrahedrally bonded to four more Os. Thus each O is situated at the corner of a tetrahedon and serves to bond adjacent tetrahedra. This connecting or bridging function of an O is shown in Figure 2 indicating two tetrahedra bonded by a common O. The O in this case is said to be bridging.

Glass structure. Figure 2.

From this figure it is possible to visualise a three-dimensional structure reaching out into space and consisting of silica tetrahedra joined together at corners by the common O atoms. The ability to form a network in this manner is connected with the fact that the silicon element is 4-valent (able to bond simultaneously with 4 Os) while the bivalent Os link the individual tetrahedra together. In the growth of the silica network, the 4 valence of the silicon atom permits the surrounding space to be filled uniformly. When the material becomes hot the structure is allowed to become mobile, in the sense that the tetrahedra can rotate relatively to one another whilst the Si-O bonds are continually breaking and re-joining, always maintaining enough bridging Os to keep the physical continuity of the network. This characteristic is seen in the drawing of very fine fibres. The ability to form fine fibres from the hot fluid material is one of the distinguishing characteristics of a glass former.

There is a contrast between the oxides of mid valence

elements and those of elements with high or low valence due to the different types of bonding which pertain in the respective cases. The explanation is to be found in the distribution of electrons in the outer shell of the various atoms involved. Briefly, elements of low valence when chemically combined tend to lose one or more electrons by near permanent transfer to the partnering atom, and thus behave as electrically positively charged atoms termed '+ ions'. The atom receiving the electron or electrons becomes negatively charged and is termed a '–ion'. The two oppositely charged ions attract each other strongly. When elements of high valence take part in chemical combination they act as receivers and become – ions whilst the partnering atoms act as donors and become + ions. Any process of chemical combination which involves high or low valence elements produces compounds in which the bonding is predominantly ionic i.e. by the mutual attraction of oppositely charged atoms (ions). In such ionic compounds the atoms pack themselves together as closely as possible. There is no preferred bond direction. The only factor influencing the structural pattern is the relative size of each atom. On the other hand, chemical combination involving elements of mid valence such as silicon is brought about by the sharing of electrons rather than by transference. Such bonding is strongly directional. As previously stated, in silica any bonds joining Si atom to the four adjacent O atoms are firmly symmetrically disposed in tetrahedral fashion.

To summarise, bonding can be wholly by electron transfer. This is non-directional and the atoms can be called + or – ions. On the other hand bonding can be by electron sharing. This is directional and the atoms are not charged. In fact, bonding is frequently neither wholly ionic nor wholly co-valent. In particular in silica it is partly co-valent and partly ionic.

Glass structure – melting. If sand is mixed with some soda ash and heated in an inert refractory container to a temperature of 1400°C (2550°F), it will form a molten glass. If the sand, which is simply granular quartz, is heated in the absence of the soda ash it will not melt at this temperature. The soda ash however, when melted together with the sand will melt and coat the sand grains with the liquid. Simultaneously, the soda ash (Na_2CO_3) gives off CO_2 gas leaving the alkali Na_2O. This in turn dissociates into the ions Na_1+, Na_1+ and $O_2–$. We then have the solid silica surfaces, at high temperature, in intimate contact with highly mobile alkali ions. Vigorous thermal vibrations cause a proportion of the Si-O bonds to be broken at any given instant. Under normal circumstances these bonds would rapidly re-unite, but in the present case those at the surface react with the alkali ions. When two tetrahedra are momentarily parted the $O_2–$ ion from the dissociated Na_2 quickly occupies the vacant site near the exposed Si_4+. This prevents the re-establishment of the silica-oxygen-silica bridge and the adjacent oxygen atoms then become described as non-bridging.

The two $Na_1–$ ions do not enter the network. They are

positioned in adjacent spaces and are loosely bonded to the non-bridging oxygens. In this manner, the surfaces of the sand grains are opened up and loosened, allowing the alkali ions to have access to the underlying silica network, where the 'softening up' process is repeated. In this way, the whole crystalline structure of the silica is eventually destroyed and in its place we are left with a random network rendered fluid by the inclusion of non-bridging oxygen atoms contributed by the alkali. In short, the inclusion of the soda ash has resulted in a drastic reduction in the melting temperature. Obviously, the greater the amount of alkali the greater is the fall in the melting temperature.

When the SiO_2-Na_2O melt is cooled fairly rapidly the random network is retained and a glass results. Some of the spaces in this glass are occupied by Na_1+ ions thus reducing the free space in the structure in comparison with that of the vitreous silica. This means that increased size of vibrations due to a rise in temperature can only be accommodated by more overall expansion. As a result, the effect of the incorporation of the soda ash has been to raise the coefficient of thermal expansion.

Potash (K_2O) is sometimes used as an alkali flux in glassmaking as a partial or total replacement for soda. Its fluxing action and the effects on the properties of the finished glass are similar to those of sodium. This is because the electron structure of the potassium atom closely resembles that of the sodium atom, and consequently the chemical and physical properties of the two elements are similar. Compared with other common constituents both Na_2O and K_2O increase thermal expansion greatly, although it is sometimes stated that the effect of K_2O is not as marked as that of Na_2O. This is correct when percentages by weight of Na_2O and K_2O are being considered as in the estimation of the thermal expansion of a piece of glass of given composition. However, the extent of a change in any physical property is usually dependent on the number of atoms or ions of the modifying oxides which have been introduced. The potassium atom is heavier than the sodium atom and when this has been taken into account it is found that the increase in thermal expansion per ion is actually greater for potassium than for sodium. This is to be expected since the potassium ion is somewhat bigger than the sodium ion. Perhaps surprisingly, silica glasses fused by a mixture of sodium and potassium oxides instead of one or the other alone, are found to be more chemically durable and of higher electrical resistance. A mixture of Na_1+ ions and K_1+ ions is apparently less mobile than the total number of Na_1+ or K_1+ ions alone. In practical terms this means that a glass fluxed with a mixture of soda and potash will prove more resistant to corrosion.

The main reason for including potash in the making of good quality domestic glass, particularly in cut glass, lies in its ability to enhance the refractive and reflective qualities of light.

If lime (CaO) is added to the melt of silica being fluxed with soda, the lime dissociates into Ca_2+ ions and O_2- ions. The latter attach themselves to any silicon atoms which happen to be temporarily detached from their respective former oxygen partners. This leaves 2 non-bridging oxygens for every O_2- ion from the lime. The introduction of lime thus causes the silica network to be opened up and softened as a result of the non-bridging oxygens. In other words, it acts as a flux in a manner similar to that of soda.

Excess CaO causes the glass to be very fluid when molten. This is probably connected with the fact that weight for weight CaO yields 11% more non-bridging oxygens than Na_2O. Unfortunately excess CaO causes the glass to be prone to devitrify (crystallise). This is probably because the composition of the crystals which form Na_2O, 3 CaO, 6 SiO_2, called devitrite, is such that its bond energy is low relative to the molten glass from which it separates.

It was earlier pointed out that the Na_1+ ions or K_1+ ions when dispersed in a silica network after the use of soda or potash as flux are very mobile causing the glass to be readily attacked by water. In fact binary silica-alkali glasses tend to be generally unstable. The main reason for using calcia as part of the flux is that the Ca_2+ ion is very much less mobile.

This is because of the double positive charge on the calcium ion which causes it to be more strongly bonded to a non-bridging oxygen than a singly charged alkali ion. Furthermore, since an appreciable proportion of interstices in the vitreous network are as a result of the use of lime as a part flux occupied by relatively immobile ions, the average distance which an alkali ion has to jump to find a nearby unoccupied site has been considerably increased. In effect, not only has the number of alkali ions been reduced but the mobility of those remaining has also been reduced.

Glazer's pie. This occurs when a stained glass artist is making up and leading a window on his bench. In the process of gradually adding glass and lead calme the centre of the window tends to rise from the bench forming a hump which is commonly known as 'glazer's pie'.

Glazes. Glazes used for ceramics are basically thin layers of glass. The materials are very similar to those used in glassmaking except for the fact that almost all glazes have a much greater proportion of alumina in their composition. The main reason for this is simply to stop the glaze running from the vertical or near-vertical surfaces of the pot when it has melted. The colouring oxides used in glazes are the same but are included in higher proportions than in glassmaking because of the very thin nature of the glaze layer. They are applied to ceramic forms to provide a smooth non-porous layer and to provide a range of coloured and decorative finishes. Glazes need to be calculated to have an expansion and contraction similar to the body to which they are applied. There is some latitude in this but if this is exceeded then the glaze will either craze or will tend to flake away from the clay body.

Glazing. The term used by stained glass artists to refer to the process of putting together a window on the bench.

Glazing bar. A part of a sash window which divides the glass into panes.

Glazing bench. The bench used by a stained glass artist for cutting glass. It often also serves as the bench for assembling and leading the work. It is usually fitted with drawers and trays for storage and sometimes part of the top also serves as a lightbox.

Glazing compound. Any material used to bed glass into a frame to provide a waterproof joint.

Glazing size. The actual size of a sheet of glass made to fit into a frame.

Glazing sprigs. The small headless nails used together with putty or glazing compound to fix glass into a frame.

Glory hole. A glory hole is a very basic but important piece of equipment used for re-heating hot glass quickly whilst it is being worked. The great majority of those in studios are simply made from a metal drum lined with ceramic fibre, open at one end and with a burner placed to fire through the side. In large studios and in industrial situations glory holes are sometimes made in the form of rectangular boxes with multiple ports so that more than one glassmaker can re-heat glass at the same time.

Occasionally glory holes are fitted with a sensor which ignites the flame as the glassmaker approaches and so reduces the overall fuel consumption. It is also common for them to be fitted with doors containing differing sizes of openings to suit the size of the glass objects being worked.

A layer of sand or refractory material is usually placed in the bottom of the glory hole to catch any glass which happens to drop off the iron whilst it is being re-heated.

Gob. The mass of hot glass gathered from a furnace onto a blowing or bit iron.

Goblet. The common name for a wine glass with a stem and foot. See **Blowing techniques**.

Gold. Au. A soft yellow malleable metallic transition element. It is unreactive so it is not affected by oxygen. It is used for colouring glass (see **Gold ruby**) and is often included in the form of gold leaf in both blown and kiln-formed ware. See **Gilding**.

Gold ruby. This is a rich colour produced by the inclusion of gold in the batch materials. See **Ruby Glass**.

Growen. An alternative name for Cornish stone.

Graal. Graal is a technique which was developed in order to create more precise decoration than was previously possible at the glassmaker's chair. It is reputed to result from the decision of the Orrefors factory to employ Simon Gate and Edward Hald to design new glass. The factory wished to improve its production of cased glass which was made in the style of Gallé. Simon Gate together with the factory manager and the master glassblower devised their own method which they called 'Graal'. A gather of clear glass was cased with a layer of

Drawing of a typical studio glory hole.

Re-heating glass at the glory hole. *Photograph courtesy of Hartley Wood & Co.*

coloured glass or, alternatively, a gather of coloured glass was cased with a layer of clear glass. It was then blown out into a bubble. Sometimes it was left as a bubble or opened out into a bowl. It was then annealed and allowed to cool. The layer of colour was cut, abraded by sandblasting or etched with acid to produce the required decoration. The bubble or bowl was then heated and picked up on either a punty or a blowing iron to be worked at the chair to the final form. This progressed from Gallé's method of cutting through the layers of coloured glass by working the glass further in the furnace to give more fluid effects. Simon Gate and Edward Hald had both trained as artists and came into the glass scene without any knowledge of the medium. They had a considerable effect on Orrefors and in the subsequent decade gave glass a completely new artistic integrity and established a tradition of employing excellent artists which has stayed with Orrefors to the present day.

The name 'Graal' refers to the legendary bowl in which the blood of Christ was collected as he hung on the cross.

Grain size. The size of grains is an important aspect of abrasives (see **Abrasives**) but is also relevant to the process of glass melting. Larger grains are measured in mesh sizes and fine particles in microns. The size of sand grains used in a batch has come under considerable attention in recent years. See **Batch materials**. Some recent research into the action of sodium sulphate has indicated that the use of fine particles increases the efficiency of the melting process considerably.

Gram. The unit of weight equivalent to one thousandth of a kilogram which is used as the fundamental unit of mass.

Granite. A very hard rock containing between 45% and 70% of feldspar, the rest being made up of quartz, mica and small amounts of other materials. It is classed as a feldspathoid and because of the difficulties of grinding such a hard material and the fact that it almost inevitably has an iron content, it is rarely used in glassmaking except for experimental purposes.

Graphite. A form of carbon used in powder form as a separator and in solid forms as a material for making moulds for glassblowing. Several of the small tools used by lampworkers are also made from or faced with graphite.

Grave sandblast. Deep sandblasting used to produce relief or modelled forms.

Graven. An alternative name for granite.

Greenockite. A mineral form of cadmium sulphide.

Grinding. The process of removing excess glass by use of abrasives or abrasive wheels. It is also used to describe the process of obscuring glass surfaces by using abrasives. See **Abrasives**.

Grinding machines. The machines for grinding decorative shapes into glass are usually glass lathes fitted with a horizontal shaft upon which various sizes and grades of abrasive wheels are attached as required. On a lesser scale, smaller abrasive wheels are often used on flexible drive machines and on intaglio lathes.

Machines for grinding flat faces, sometimes called flat mills, are, on the other hand, usually of wide, flat, circular cast steel plates mounted to revolve horizontally on a

The glass lathe which can be fitted with a variety of abrasive and polishing wheels for carving or decorating glass. *Courtesy of Gernot Merker.*

A grinding wheel fitted on to a screwed and tapered nose showing the lead core.

vertical shaft and fed with a slow stream of wet carborundum grit. Occasionally, the cast steel plates are replaced by large sandstone wheels. The operator holds the glass and moves it in a circular motion on the wet surface of the revolving plate. Reciprocating machines are also available for the same purpose and whilst they take much longer to achieve the same effect as that from the flat mills, they have the advantage that they can be left to carry on the process without requiring the constant attention of an operator.

Various types of machines using interchangeable diamond-faced plates and operating with either simple circular or complex orbiting movements are being constantly introduced but at the moment they are likely to be too expensive for most small workshops to afford.

The flat mill used together with abrasive powders as a general tool for grinding flat areas of glass. It is usually a very simple machine fitted with a heavy cast steel disc and driven through reducing pulleys by an electric motor.

Stainless steel splash guard

Rubber bumper

Cast iron grinding plate

Nylon balls

Cast steel base

Grisaille. A technique of painting simple designs in black on to clear or white glass.

Grog. Chamotte. Particles of fired refractory material used to re-inforce clay or plaster. Grog is often introduced into the various mixtures used to make moulds for glass casting and slumping. When introduced into the refractory clays used for making glass pots, grog has the effect of reducing the shrinkage, opening up the material to enable it to dry more easily and giving it some strength whilst the pot is being formed, dried and fired. Molochite is commonly used as a grog for the clay being used for glass pots. It provides mullite when fired. See **Chamotte**.

Growan. An alternative name for Cornish stone.

Grozing. The process of using a grozing tool or grozing pliers to nibble away at the edge of a piece of glass. It is usually necessary when trying to cut intricate shapes where a series of marks are made with a glasscutter and the small pieces removed by grozing.

Grozing pliers. Pliers used for nibbling away small areas from the edges of sheet glass.

Grozing pliers are used to break away small areas of glass from the edges of glass sheet which have been cut.

The reciprolap is an excellent machine made in the USA and marketed in Europe by Kurt Merker of Kelheim. The pan moves with a reciprocating action and with suitable abrasives and water, glass can be placed on to the pan and simply left to grind, leaving the glassmaker free to work on other activities. *Courtesy of Gernot Merker.*

Gypsum. $CaSO_4.2H_2O$. Alabaster. Hydrated calcium sulphate. The source material for plaster of Paris. If casts made from plaster of Paris are overfired, they can release toxic sulphur trioxide fumes into the workshop.

H

Haematite. Kidney ore. Iron ore usually composed of almost pure ferric oxide (Fe_2O_3) and known as kidney ore. It is red on the inside but on the outside is usually black or grey. It is the most common source of iron oxide used for processing into iron and steel.

The other forms are itabirite, specular iron and somewhat softer materials, raddles and red ochres, which were commonly used for body decoration by primitive tribes and as pigment by artists.

Hand press. A tool similar to a pair of pliers but with jaws shaped to hold small moulds. These were often used for producing numerous similar elements such as those used for making chandeliers.

Handlapping. This is the laborious process of rubbing down glass by hand which is mostly done in order to correct engraving mistakes or to eradicate small defects. It often follows work done with a wheel or with rotary diamond discs. Diamond hand pads of differing grades can be used at various stages but the traditional lapping tool is simply a small piece of thick plate glass three or four inches long which is fed with a paste of an appropriate grade of carborundum powder and water. The previous work with the wheel leaves a matt finish which will change its appearance as the handlapping progresses. Initially the paste could be of about 320 grit carborundum which would be used until the colour of the whole area matted by the wheel has changed. Using a handlap successfully takes quite a lot of practice and needs a great deal of care, particularly when working on a curved surface as it is all too easy to produce flat areas. Progression to finer grits will be necessary and it is vital that the lapping tool, the glass and the hands are washed very thoroughly between each change of grit.

Handles. See **Blowing**.

Hard glass. This need not be particularly hard in physical terms but refers to a glass with a high melting temperature.

Hartley. James Hartley in 1847 patented a method of making sheets of thin, cast plate glass by ladling directly from the furnace onto a casting table where it was rolled to form a rough but cheap plate glass suitable for glass roofing. From this rolled plate came the 'Cathedral' and figured rolled glass used by stained glass artists today.

Hartley Wood and Co. This factory was started by a descendant of James Hartley at Monkwearmouth in Sunderland. It specialises in the production of a wide range of coloured antique and cathedral glass for the stained glass trade. The antique glass is still produced in the factory by the old cylinder method. They also produced slabs (dalle de verre) and Norman slabs and now produce a range of coloured blown ware.

Health hazards. There are many health hazards associated with glassmaking and glassworking. Principally they concern the handling of toxic and corrosive materials, the release of toxic and corrosive fume, exposure to both heat and to heat radiation and to the inhalation of siliceous dust. There are many regulations in force to deal with all of these hazards and they are being constantly updated by the various responsible bodies. A list of some of these is given in the appendix section. See **Safety**.

Heat. Energy being transferred from one body to another as a result of differences in temperature of the bodies or systems concerned. Energy developing from the random movement of molecules possibly transmitted by convection, conduction or radiation.

Heat absorbing glass. Glass made to be opaque to infrared radiation but retaining a reasonable degree of transparency to most other radiation.

Heat exchanger. Something which will transfer heat from one material, usually a fluid or gas, into another. The common form is composed of a number of tubes through which air, gas or fluid is conducted to collect heat from the area surrounding the tubes. Several enterprising glassmakers have used this system to collect heat from the furnace exhaust flues and to then use it to heat greenhouses or to provide hot water for domestic purposes.

Heat forming. The process of forming glass objects by using heat. This can be by using glass from a furnace or by melting/fusing glass in a kiln.

Heat resisting glass. Glass, usually borosilicate, with a low coefficient of expansion making it resistant to thermal shock.

Hinterglasmalerei. The technique of painting the reverse side of a sheet of glass.

Holography. A method of projecting three-dimensional images which change according to the position of the viewer by means of laser light and interference patterns. A laser beam is split into two identical beams. The first of which is reflected by a beam splitter onto a lens which focuses it onto a mirror which in turn reflects it on to the subject and thence to an unexposed film. The second beam follows a similar path through its own beam splitter, lens and mirror to the subject and to the unexposed film. This is where the interference patterns come in because the light waves from the two beams do not match precisely and form interference patterns on the film. After the film is developed it is put into a holographic projector which is lit by a laser beam. This produces small points of light and shade in space to provide a three-dimensional image of the original subject which does not need a screen.

Humpen. An early form of large beaker or beer mug often decorated with coloured blobs and prunts or enamelled decoration.

Hyalith. This is a type of opaque red glass made by Bartholomaus Rosler in Southern Bohemia in the late 19th century in imitation of the Wedgwood ceramic 'Rosso Antico'. He later followed it with a black hyalith glass to imitate the Wedgwood 'Egyptian Black'. The patterns on the hyalith glass often also imitated those on the Wedgwood ceramics.

Hydrates. Compounds which hold chemically-combined water. There are several of these used in glassmaking. The clay used for making glass pots contains chemically-held water, known as the water of crystallisation, which is removed in the firing process. Other hydrates used in glassmaking are materials such as borax and borocalcite. In a furnace, the water is usually released during the founding process and is often useful in providing some stirring action in the melt.

Hydrofluoric acid. HF. The material used as the basis for most of the mixtures used for acid etching and for acid polishing. See **Acid etching** and **Acid polishing**.

An example of the traditional German humpen, dated 1691.
Courtesy of the Pilkington Glass Museum.

I

Ice glass. Craquelle. Overshot. Glass with a distinctive crackled surface. There are two techniques for producing ice glass and both are thought to have originated in Venice and then spread rapidly throughout Europe. The first of these seems very simple but requires some care. A gather of glass is taken from the furnace and blown out slightly before being plunged into cold water which causes surface cracking. It then has to be re-heated sufficiently for it to be worked into the required shape without losing the crackled surface. It is very easy to re-heat too much and then to lose the ice-glass effect. The other method is to put broken pieces of glass onto a warm marver plate and then to pick them up on to a bubble of glass. This is marvered or blocked into the surface and the bubble re-heated and worked into its final form. The crackled effect remains on the outer surface whilst the inner is smooth. See **Overshot**.

Apsley Pellat claimed to have re-discovered the technique in the 19th century but it seems probable that the technique was never really lost. The early work was made from clear glass in order to emphasise the crackled effect. Later the technique was expanded to include work made from coloured glass onto which small pieces of clear glass had been picked up from the marver. This was later given a further variation and the process was reversed so that small fragments of coloured glass were picked up on to a clear base.

Igneous rock. Primary rock. Rock which has been formed by molten minerals which have risen to the surface of the earth and then solidified. As they cooled they formed crystals, the size of which depending largely on the rate of cooling. Granite is a typical example of an igneous rock.

Ignition temperature. The temperature to which a substance must be heated before it will ignite and burn in air.

Illites. Hydrous micas. The term describes the various types of micaceous materials found in clays.

Ilmenite. $FeOTiO_2$. Ferrous titanate. A natural ore comprising iron and titanium oxides. It is a source material for titanium dioxide which is gaining increased usage as a nucleating agent in the manufacture of glass ceramics. The proportions of iron to titanium vary considerably. It is often used by potters to produce speckles in glazes.

Impressed decoration. The manipulation of hot glass allows for numerous methods of producing decorative

Tools with carved graphite heads used for producing impressed designs.

effects and that of pressing objects into the hot surface must have been one of the earliest. It was normal to drop blobs of hot glass onto a surface and to then press designs into them with stamps of carved wood, metal, graphite or even natural forms. An extension of this technique is to drop some hot glass on a marver plate and to impress this with some suitable design. The result would be then turned over, heated and picked up on to the surface of glass being worked.

In a reversal of this process articles can be pressed into the surface of damp moulding sand and blobs of glass dropped into the recess to pick up the pattern, texture or features of the original object. Extremely fine impressions were made by blowing into a mould. These are described by Apsley Pellatt in his *Curiosities of Glassmaking* in 1849. The text is interesting, so it is reproduced here in full.

In addition to Cameo incrustation which was patented many years since, a subsequent patent was secured for taking facsimiles of casts or dies from intaglios, and impressing them upon hollow glass vessels in intaglio. This plan of glass engraving has been chiefly adopted where numerous copies of elaborate devices have been required, such as badges of regiments, or arms upon decanters and table glass. The following is the mode of operating: Dust tripoli very finely pulverised upon the die or cast; then a larger coating of dry plaster of Paris and pulverised brick dust, with another layer of coarser plaster and brick dust; place the whole under a press which when screwed to its utmost allows water to saturate the pores of the impressed cake; and, when gradually dried, it will be fit for use. A brass mould (a) with a recess

to receive the cake and a hinged leverage to keep it in its position (b) is provided; so that the face of the cake (c), which is then embossed in relief, ranges with the circular form of the Glass vessel intended to be blown into it; and this, being heated to redness, is placed in the recess of the mould. In this state, the ball of hot Glass is introduced and expanded by the power of blowing, till it assumes the exact shape of the mould and the cake adheres to the Glass. The cake is then released by the lever and the Glass reheated, with the cake adhering to it, as often as necessary to finish the article, (as usually practised by blowers in ordinary moulded glass vessels), the cake and Glass being annealed together with its blowover, which is finished afterwards by the glass cutter. When the Glass is cold, it is released from its cake by the absorption of cold water, and the intaglio impression upon the glass will be found as sharp as the original die. A cake, once used, seldom answers for a second impression. Mr Tassie had, long before this process was patented, executed on the same principle imitations of small gems in solid Glass, very successfully, which suggested the application of the same invention to hollow vessles.

Incandescence. The intensity of light and heat which is used as an indication of temperature. It is useful as a rough visual guide to the temperature inside a furnace or a kiln and before the days of sophisticated temperature measurement would have been used by most glassmakers to gain an assessment of the condition or progress of the melt. It begins to show as a very dull red colour between 600° and 700°C (1110° and 1290°F), develops to a bright red at about 1000°C (1830°F), bright orange between 1150° and 1200°C (2100° and 2200°F), through yellow to white by 1300°C (2370°F) and an intense blue white at 1400°C (2550°F).

Modern visual pyrometers work by comparing the incandescence with a heated reference wire of known temperature.

Inclusions. A general term for materials or bubbles incorporated into glass objects as decoration. Industrially, this also refers to faults in the glass.

Indexing machine. This is rather like a much improved version of a potter's banding wheel and has a similar turntable. The big difference is that it also has a vertical adjustable steadying piece for the accurate application of guidelines around a glass form. Traditionally these lines would have been made with white ink or wax crayons but modern felt-tipped pens are much easier to use. Some indexing machines also have a facility for producing diagonal lines as well as the normal horizontal ones. Whilst it is intended for applying guidelines for cutters and engravers, it can also be used for the application of bands of coloured enamel or lustre.

The commercial indexing machine used to place regular lines or bands on glass which is to be decorated with cuts, printies etc.

Infrared radiation. Electromagnetic radiation in the wavelength 0.7 micromillimetre to 1 millimetre. Glass is opaque to infrared radiation of more than 2 micromillimetres and for applications where the infrared radiation is necessary, lenses need to be made from quartz, polyethyline etc. It is radiated from furnaces and glory holes and it is a potential health hazard to both skin and eyes.

Inlay. Small glass or metal pieces embedded into glass vessels or glass objects.

Instrumentation. Electronics has probably been the most rapidly developing factor affecting control engineering in recent times. It has meant that much of the glassmaking instrumentation which required constant human monitoring and adjustment can now be programmed to operate automatically with appropriate fail-safe elements and alarms included. In terms of furnace control, it has become common in industry to install fully programmed controllers but similar control of small studio furnaces is still something of a rarity.

Pyrometry has changed. Whilst thermocouples are still what they have been for many years, the pyrometer has changed from the old type of analogue indicator with its swinging needle and tendency to develop a gradual depreciation in its accuracy, to the modern solid state digital indicator with its proven reliability and precise

indication of temperature. The control of the power input by using a simple energy regulator is still used by many people to control the temperature rise but in most new systems this has been incorporated into a solid state controller/programmer.

The solid state devices vary from the simple indicator to those which can be programmed to carry out several changes over previously set times and at previously set temperatures. They can operate motorised and solenoid valves to control gas or oil fuel and air lines. They can monitor, indicate and, if necessary, record gas, oil and air pressure and flow, check for flame failure, instigate a programme of re-ignition and analyse exhaust gases to ensure effective combustion. All of the above are often used in industry but the process of founding is such that some degree of monitoring will always be required and glassmakers running small pot furnaces or day tanks will be unlikely to venture into the expense of installing a fully automated system. They are however, much more likely to use similar equipment to control electric current in kilns and electric furnaces.

The greatest studio use of programmable controllers has been with those glassmakers using kilns for casting and slumping etc. The basic unit in common use is one with eight segments and four independent stages, each stage comprising one ramp and one dwell. This means that the indicator-controller can be programmed to send the kiln to a set temperature in a particular time, followed by a soaking period which is then followed by a similar sequence to another temperature, probably for annealing, with two more similar sequences to bring the kiln down to an estimated studio temperature. The same indicator-programmer would control an annealing kiln in exactly the same way.

Heat fuses are often still used to avoid the possibility of a kiln overheating and in many countries it is mandatory to install a door lock on any kiln fitted with exposed elements. This has the effect of shutting off the power when the kiln door is opened. When installing a controller, it becomes necessary to allow for this and to ensure that the programmer will continue its programme at the point where the power was cut off rather than to abort its programme or to start again at the beginning.

Gas-fired furnaces and kilns can be operated by similar controller programmers but they need additional instrumentation in the form of gauges to indicate gas and air pressure, various solenoids and pressure switches to control the flow of gas and air, automatic ignition provision, atmospheric sensors to ensure efficient combustion and visual and/or audible alarm systems to indicate failures in the system.

Insulation. In glassworking this refers to the prevention of the loss of heat from kilns, furnaces, glory holes and lehrs etc. There are many differing materials used in this context and the designer must consider the hot-face temperature which is likely to be encountered, the material which will best stand this temperature and the physical strength required. He will then need to calculate the progression of materials needed to give an external temperature of less than 80°C (175°F). This is necessary because the materials which are likely to give the greatest amount of insulation are often less likely to stand high hot-face temperatures. A furnace is different from a kiln or glory hole as calculations need to take cognisance of the fact that it may need to stay at a high temperature for months on end whilst a kiln only needs to attain a certain temperature in a relatively short time and is unlikely to need to maintain that temperature for more than an hour or so. Modern glory holes in the studio tend to be heated very rapidly as required and then allowed to cool just as quickly. Even in production they are unlikely to stay in operation for more than part of the working day.

Manufacturers' specifications for furnace or kiln insulation will often give a graphic diagram to demonstrate the difference between the hot-face temperature and the cold face at different thicknesses. This refers to a constant situation and due allowance must be given to type of requirement. The progression of the heat through a material is subject to a time factor and when this is calculated, a glassforming kiln may need considerably less insulation material to achieve a suitable exterior cold face than may be first thought. Specifications of insulation and refractory materials tend also to give the hot-face temperature at which they can safely be used without deformation, their density, and their rate of heat conductivity. Another factor to be taken into consideration is that the more dense the material, the greater its capacity to store heat. Therefore heavy refractory material will absorb a lot of heat and will cause the kiln or furnace to take a longer time to achieve a temperature and, subsequently, a longer time to cool than if a lightweight insulation material is used. A dense firebrick will absorb four to five times the amount of heat than a similar insulation brick.

The sides of a kiln or furnace are often composed of layers of different materials rather than being made from one single type. This again depends on the nature of the usage. The hot face may well need to be of high refractory quality and have considerable physical strength as would be necessary in a furnace or of a much less dense material where these qualities are of much less importance as in a relatively low-firing glassforming kiln. In both cases it would be normal practice to use the data from the manufacturer to calculate the temperature drop across the inner layer thus finding the interface temperature at the next layer, then to fit a suitable insulation material to stand rather more than that temperature and carry out the same procedure to fit the outer layer of insulation. This should be calculated to give a cold-face temperature which would be safe to touch.

As heat will travel more easily through solid material than through air most of the insulation materials contain numerous fine sealed pores and are calculated to provide both insulation and an ability not to be deformed or melted at a given temperature.

Heat is transferred through insulation materials by:

- Conduction through solids
- Convection in gases
- Transmission of infrared radiation
- Molecular conduction in gases

The solids used are normally those giving low thermal conductivity which by virtue of the creation of numerous voids, present a low cross-section in the path of any conduction.

In many modern thermal insulation materials as much as 90% of the volume is taken up by air which is trapped in small cavities in which gaseous convection is virtually eliminated. The smaller the cavities can be made, the distance available for intermolecular collision is reduced.

Transmission by infrared radiation increases rapidly as the temperature rises so various materials are often introduced to reflect and to scatter the radiation.

Early insulation bricks were made by mixing clay with sawdust and forming the mixture into bricks from which the sawdust would burn out when the bricks were fired in order to produce a porous matrix. Production became more sophisticated and high temperature insulation bricks, known as HTIs, are now produced to withstand a range of hot-face temperatures. They are designated by the hot-face temperature Fahrenheit which they have been designed to withstand. Thus a brick HTI 23 would be designed to withstand hot-face temperatures of 2300°F (1260°C). For small furnaces HTI 28 grade bricks are commonly used. Higher grades are readily available but at a much higher price.

The production of ceramic fibre has made a considerable difference to the nature of high temperature insulation. It is basically an alumino-silica refractory material which is melted and then blown into fibre in a similar method to that used for the production of fibreglass. It is then formed into a number of different composite materials which have excellent insulation properties, have a degree of flexibility, but have a major disadvantage in that they have very little structural strength. They are produced in many forms: blanket, boards, loose fill, mouldable materials, tubes, modules, and when necessary, complex vacuum-formed shapes. There are several grades available, some of which can be used for temperatures up to 1600°C. They can be cemented to bricks or metal and can also be pinned with specially prepared ceramic and stainless steel fastenings. They have excellent resistance to thermal shock. They have little weight and do not store heat to any appreciable extent. They resist most chemical attack except that of hot alkaline and hydrofluoric acid vapour. One difficulty which can arise, particularly with some of the boards, is that they can have a shrinkage of up to 4% on initial firing.

The most efficient of the materials currently available for furnace and kiln insulation at the moment is 'Micropore'. This has a remarkably low thermal conductivity and is available in many forms. Unfortunately it has a top temperature limit of 1025°C (1880°F), so for furnace work it can only be used as back-up insulation to a more refractory material. It is rather more expensive than most of the ceramic fibre materials but the additional cost should soon be recouped in savings on fuel. Complex and very accurate shapes can be produced by the makers by the use of laser cutting equipment. They will only supply the material cut to size and packed in a special material which burns away once the micropore is in position and firing commences.

Whilst micropore is made from silica and titanium oxide, it is amorphous and the only crystalline silica dust likely to be encountered would result from contamination of a surface by alkali vapour together with subsequent firing to temperatures above 800°C (1470°F). This could cause the production of cristobalite. Alternatively, continued usage over 1000°C (1830°F) could also produce cristobalite. This in itself would not create any problem unless the material was broken up. It would therefore be most advisable to take all necessary precautions when renewing material which might have been affected in this way. To give some indication of the insulating properties of the material, if a hot-face temperature of 950°C (1740°F) and a normal outer cold face of 80°C (176°F) is assumed, as would be common in a glassforming kiln, and assuming a continuing exposure at this temperature, it has been calculated that:

9 inches of insulation brick plus 2 inches of mineral wool,
3 inches of ceramic fibre plus 2 inches of mineral wool,
4 inches of insulation brick plus 1 inch of micropore,
simply 2 inches of micropore

would all achieve the required temperature difference.

Bubble alumina and bubble mullite can now be formed into appropriate shapes by a process of chemical bonding to produce an insulating material which is highly refractory but which has much greater mechanical strength than the various forms of ceramic fibre. The process also offers the advantage that denser materials can be incorporated into the same casting as a solid layer. This means that material with the requisite qualities to form a hot face and/or to give mechanical strength could be effectively bonded to appropriate insulating layers in the same monolithic block.

Intaglio. This refers to any form of engraving which is cut or incised but it is now also generally accepted as referring to all work which is modelled into the glass as negative form, giving an impression of actually standing out as positive relief.

It is usually carried out by using a small lathe equipped with copper wheels which are fed with a mixture of oil and abrasives.

In Britain towards the end of the 19th century, a form of decorative engraving produced by using small stones on a lathe developed in the Stourbridge area became known as Intaglio and one of the original 'tag lathes' which had a variable drive provided by two horizontal

and adjacent cones is in the Science Museum in London. The glass was held against the underside of the stones in a similar manner to that employed in copper wheel engraving. This is in contrast to the method employed by the glass cutter who works the glass against the top of the stone and looks through the glass to see what is happening to the glass surface.

Intarsia glass. This was a type of three-layer glass made at the Steuben glass works in Corning, New York by Frederick Carder in about 1930. He made a gather of clear glass and covered this with a gather of coloured glass which was then blown into a bubble. He let this cool and then etched through the outer layer to form his design. The glass was then re-heated, picked up and covered again by a gather of clear glass and worked normally to produce the required shape.

Interaction. In glass terms this usually refers to the reaction of the various batch materials to each other during the founding process. It is a complex procedure during which eutectics are formed and reactions continue to take place at various stages. See **Batch melting**.

Interface. The layer at which two surfaces meet. It is a term most commonly used to describe the common surface layers of refractories and/or insulation materials in furnace or kiln building.

Interference layers. See under **Lustre** and **Iridescence**.

Interferometry. The precise measurement of length by the use of waves of light, sound or radio.

Investment. A general name to cover the various materials and mixtures used to make the moulds in which glass is to be cast.

Ion. A particle formed when an atom or group of atoms loses one or more electrons to give it a positive charge or when an electron or electrons have been gained to give a negative charge. See **Chemical bonding**.

Ion exchange. The process of ion exchange has become an important factor when considering the bonding of layers of enamel to glass and also in the nature of surface deterioration in glass. Ion exchange which results in smaller particles being incorporated into the glass surface or substrate to take the place of larger ones means the provision of greater access for moisture and alkaline or acidic materials to develop subsequent further deterioration. See **Decay** and **Enamels**.

Iridescence. In glass, this refers to the silky colour effects rather like those which become visible when oil is dropped onto water. They are usually made by coating the glass with a very thin (rather less than one micron in thickness) layer, consisting of a metallic or similar substance. The light from the top and bottom surfaces tends

to be reflected equally to blend together. If the peak wavelength of one coincides with the trough of the other the apparently lost energy re-inforces the other colours to emphasise their luminosity. The dominant colour effect produced in iridescence results from the particular materials used. It is an effect which often occurs naturally as a result of thin surface layers forming on glass which has been buried for some considerable time but is also one which has been deliberately exploited successfully over the years by several artists.

There are three popular techniques used to produce iridescence. They are:

1. The use of a reducing flame to affect metallic materials in the glass
2. Fuming
3. The application of lustres

The first two were often used together and after the initial production by Llobmeyr in about 1863, the techniques were exploited by Thomas Webb in England. There then followed enormous production and a flood of patents in the USA in the early parts of the 20th century. Tiffany, The Quetzal Art Glass and Decorating Company, The Durand Art Glass Company, The Union Glass works and lastly, but far from least, Frederick Carder at Steuben all produced iridised glass. Frederick Carder is thought to have introduced the technique of heating the glass in a muffle kiln and then spraying it with stannous salts dissolved in distilled water. Louis Comfort Tiffany also developed many variations, including one of incorporating thin threads picked up from the marver. He used several single coloured iridised forms but probably his most famous production was his variegated 'Peacock Ware'.

Iridised piece, 'Heart Attack', by Erwin Eisch.

INTRODUCTON OF METALLIC MATERIALS. The procedure of introducing metallic compounds into the glass melt and then exposing the ware to a reducing flame in the glory hole before putting it into the annealing kiln is quite straightforward and often happens unintentionally. For example, a copper blue glass can suddenly develop a copper red surface or a piece of lead crystal become a dirty grey colour simply as a result of an unplanned change in the nature of the flame.

FUMING. Fuming used to be carried out in many factories by simply placing a small tin at the mouth of the furnace with some stannous or silver salts in it and then dropping a small piece of hot glass into it from a bit iron. The glass being worked was then held in the resultant fumes until the required amount of iridescence was achieved.

A more common method used nowadays is to mix the salts to be used with distilled water or alcohol and then to spray them from a small plastic hand garden spray onto the piece of hot glass being worked. The type of small spray with a pistol-type lever which can be worked with one hand is ideal for the purpose. It is essential that the spraying is carried out in some form of box with extraction facilities or to spray directly under a strong extractor to ensure that fumes are carried away from the operator. The wet mixture can also be brushed directly onto the hot surface.

The metallic salt most commonly used for the purpose is stannous chloride. Variations in colour are often achieved by using stannous chloride to form about 90% of the material, with other metallic salts, either singly or together making up the other 10%. Small amounts of copper and silver salts are those normally used. It is necessary to be wary of some of the old recipes which can be found. These usually include bismuth nitrate, strontium nitrate and barium nitrate which whilst they may produce beautiful colours are now known to be particularly noxious and are best avoided for use in spraying techniques. Ferric chloride is sometimes used but it needs to be introduced in quite a different proportion. Up to 40% ferric chloride to 60% stannous chloride is usual.

LUSTRES. The application of lustre is the other popular technique for achieving metallic and iridescent surfaces. This has the advantage of being applied as a liquid onto cold glass which is then heated to produce the lustred effect.

Early lustres were made by simmering metallic salts in natural resin for some considerable time at a convenient point on the furnace structure where the necessary supply of constant heat would be available. The results would be mixed with a suitable medium such as an aromatic oil and, where required, thinned with turpentine.

Today they are made by specialist suppliers but the basic materials have not changed very much. The metallic salts, usually chlorates, are added to a resinate which together with the oil medium provides a built-in reducing agent as it burns out during firing. Lustres are generally available ready-for-use in whatever quantities are required. Unless there is likely to be a lot of use, there are

A large plate with lustre applied by free brush strokes.

advantages in buying fairly small quantities of some of the colours as they do not have a long shelf-life and soon turn into an unusable jelly.

This problem can be aggravated by buying from some retail outlets who may have already had the material in stock for some time. The manufacturers are usually ready to advise regarding colours which are likely to behave in this way. This can help when when you are enquiring about the date of any stock which you are considering purchasing.

The lustres are applied with a soft brush onto cold glass and care must be taken to ensure that the resultant layer is not too thick as this will result in uneven cover with occasional blank areas. A little practice will soon produce good results. In the early stages of firing, the kiln plugs must be left out to give some ventilation. It is also important to avoid a situation where the resultant fume is discharged into a studio where it can collect and be inhaled. Most of the bottled lustres are toxic to some extent so the usual precautions must be taken when handling them.

The most common effect is the form of iridescence known as 'mother-of-pearl'. It is provided by a thin layer of bismuth but a variety of colours are available which are often based on bismuth together with metals such as gold, silver, platinum and copper. There is some experimental work in progress involving the rare earth metals which could soon extend the range.

The following old lustre formulae date from well before the current specialist production and would be most unlikely to find favour with any of Health and Safety authorities operating today.

1. *Iron Lustre.*
 Boil together half a pound of rusty nails, half a pint of nitric acid and half a gallon of tar. Whilst boiling add two ounces of canada balsam.

2. *Iron Lustre.*
 (This name seems somewhat illogical as the recipe

Lustre used for the production of repetitive pattern.

Lustre used as a medium for landscape painting.

would seem to suggest a copper rather than an iron lustre.)

6 oz sugar
6 oz resin
6 oz sulphate of copper
half a gallon of turpentine

Simmer gently until little more than a quart remains.

3. *Gold Lustre*.
 Put 1 oz of gold into a bottle with 6 oz of muriatic acid and 3 oz of nitric acid and 1½ oz of green tin. Put into a jug 12 oz balsam of sulphur, add three

pints of turpentine and stir for one hour. Drop the solution of gold into it and stir gently for four hours.

4. Put 2 oz of muriatic acid and 1 oz of nitric acid into a glass bottle. Add a quarter of an ounce of yellow gold and let it stand in a warm place. When it ceases to work, add five grains of block tin and let it stand awhile. Put into a jug together with three and a half pints of turpentine and stir for four or five hours. When settled it is ready for use.

The above formulae are obviously not recommended either for use or experiment but serve to give a fascinating insight into the development of the material.

Iron. Fe. Iron is a malleable and ductile metallic transition element which has probably provided the greatest practical usage of all metals. It has been used for many centuries, firstly as a malleable material which could be worked either hot or cold, then as a brittle but strong cast material and later as the basis for the various kinds of steel used today. It is reactive and combines with oxygen, being oxidised by moist air. It is mined in many forms for smelting into the metal but it is also present in smaller quantities in a great variety of minerals. Unfortunately, many of them happen to be those used for glassmaking where the presence of iron is, more often than not, something of a nuisance.

It is a substance with a dual personality in relation to glassmaking. For those glassmakers who wish to have good clear glass or continuous runs of most specific colours, it is to be avoided if at all possible because of the need to introduce materials to counter the colour resulting from the iron oxide. Those who make cheap brown or green bottles ignore these considerations. They happily accept the cheaper sand and other batch materials and welcome the iron. Others use it deliberately in the form of an oxide batch addition, on its own or more often in conjunction with other colouring oxides, in the production of a wide range of colours, mostly yellows, greens and ambers. It is also used on occasions to tone down the rather brash blue colour produced by cobalt oxide.

It has an important finishing role in the form of rouge or mixed with cerium oxide as a polishing material for glass.

Sand which is free from iron in its make-up is a valuable and much sort after commodity to the glassmaker. (See **Batch materials**.) Refractory materials for furnace building and glass pot making with a very low iron content are also in considerable demand as any iron in these materials which happens to be in contact with the molten glass will soon invade the glass and affect its colour.

Iron ore is a very common material and it is found in various forms in deposits all over the world. As pure iron it is a rarity though haematite is very nearly pure, and is normally found in combination with oxygen, carbon, hydrogen and sulphur. The minerals with the highest

iron content are in great demand for smelting because they usually present the best economy of production. Iron and iron oxide are present in many substances and act as a natural stain in many rocks, clays and sands. They are used as a pigment in many paints and are widely used by potters as a clay and glaze colourant.

Iron oxide. FeO. Fe_2O_3, or Fe_3O_4. A strong and common colouring oxide which is responsible for the colouring properties of many minerals. It occurs naturally as an impurity in many of them. It is evident as the rust which forms on iron or steel.

As red ochre it has been used to decorate the human body in many tribal systems and is responsible for the red and brown colours in clay and for the resultant colour in the ceramic forms which have been made from such clays. It is used as a pigment in paints. The various ochres, umbers and indian reds used by artists are based on natural materials containing iron oxide.

The potter uses it as a colouring oxide much more than the glassmaker but it certainly is used for colouring glass, usually in conjunction with other materials. (See **Colours**.)

It has been introduced in excess quantities to make aventurine glass. Some care is needed when using steel blowing irons, punty irons etc. because it is very easy to overheat the irons and produce iron oxide scale which can pollute the glass. The ends of glass taken off the irons and used for cullet are also often affected by the iron oxide and generally known as 'Blacks'.

J

Jacks. Pucellas, tools. The glassmaking tool consisting of two polished steel arms protruding from a sprung section. It is used at the chair. There are various types including some which are made to hold two wooden or compressed paper pegs. See **Pucellas** and **Tools**.

Jacobite glass. Drinking glasses usually of simple design and often incorporating air twist stems. They were often engraved with various symbols and inscriptions relating to the Jacobite cause, the most popular of these being that of the Jacobite Heraldic Rose. They were used to toast the Young Pretender, Bonnie Prince Charlie.

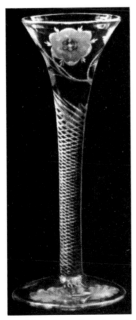

An example of a Jacobite glass showing the typical engraving on the bowl. They usually had an inscription around the rim.

Jade glass. A type of glass developed by Frederick Carder when working in America. It reflected his interest in reproducing the effects of various precious stones. It was basically a translucent white glass which was modified with additions of various colouring oxides. See **Carder**.

Jar mill. Ball mill. This is a mill used by glassmakers for grinding colours and powdered glass for preparing enamels or for producing small quantities of batch suitable for test melting. It is a smaller edition of the large ball mill which was commonly used commercially for the preparation of materials for the glass and ceramics industries. It comprises a porcelain jar into which the materials are placed together with some pebbles or ceramic balls and some water. It is then sealed and rotated on two spindles at such a speed that the material and the pebbles or balls fall continuously upon one another. This is continued until the material has reached the required particle size. See **Ball mill**.

Jar mill. This usually comprises an electric motor fitted with a suitable reduction gearbox driving rollers containing rubber wheels. A porcelain container rests on the wheels and rotates to grind down materials into finer particles.

K

Kalia. K_2O. Potassium oxide. It is often given the name 'potash' which is also, and more correctly, given to potassium carbonate. See **Batch materials** and **Potash**.

Kalium soda. NaKO. This is a term used when calculating batches containing feldspathic materials where it is impossible or difficult to separate or quantify the relative amounts of soda and potash in the feldspar.

Kaolin. Kao-ling. China clay. $Al_2O_3.2SiO_2.2H_2O$. A primary clay which because of its very low iron content fires white. It has the disadvantage of having little plasticity. However, because of its high alumina content, it is useful for its refractory properties, having an estimated melting point of something over 1770°C (3220°F). Because of this it is often fired and then ground to form Molochite grog for mixing with appropriate fireclays to make furnace pots. Its low iron content and its refractory qualities make it ideal for this purpose. It is found in deposits all over the world. In China it is known as Kao-ling which means 'High Ridge'. In Britain there are large deposits in Cornwall where it is known as 'China clay'. In the US it is more often referred to as 'Kaolin'.

Large quantities of the material are used in papermaking and in cosmetics and it is the basis of so-called 'China' ceramics and porcelain.

Kaolinite. $Al_2O_3.2SiO_2.2H_2O$. This term usually refers to a crystal lattice defining the structure of pure china clay. Almost all so-called clays contain kaolinite as the clay element in the material which also usually contains a wide range of other minerals.

Kaolinization. Used to describe the weathering, or chemical changes in rocks which results in the formation of laminated silicates such as kaolinite, mica and montmorillonite.

Kelp. Ash resulting from the burning of seaweed. It was a common source of soda as a batch material before the chemical conversion of common salt made soda more readily available.

Kelvin. Temperature measurements based on the Centigrade scale and introduced by Lord Kelvin at Glasgow University. It extends the Centigrade scale down to absolute zero which means that 0°K is the equivalent of -273°C and 100°C becomes 373°K. 'Degrees Absolute' are the same as degrees Kelvin.

Kick. A deep impression made in the base of a vessel to help it to stand properly. It has also been suggested that a kick was often made in order to reduce the amount of liquid that the vessel could contain and at the same time give an impression of containing more.

Kidney ore. A form of haematite which looks like a collection of kidneys with a shiny black surface.

Kilns. These are simply types of ovens into which heat can be introduced and stored as necessary in order to achieve particular temperatures. The glassmaker uses them for various processes in forming glass, casting, slumping and enamelling etc. and also for the annealing of glass ware. See **Annealing kilns**. Most of them are fired by electricity but many annealing kilns are fired wholly or in part by the waste heat from the glass furnace. Some casting/forming kilns are fired by gas or oil. Kilns for glassworking are basically the same as those used for firing ceramics except that as they are most unlikely to be used for temperatures above 1000°C (1830°F), the kiln materials need not have the same refractory and loading qualities. Enamelling and stained glass kilns need even lower temperatures. The lower hot-face temperature requirement means that more efficient and often less costly insulation materials can be introduced, as a result of which a greater volume to heat ratio can be achieved. Modern electric kilns suitable for casting, fusing, slumping, enamelling etc., are often made from ceramic fibreboards which are grooved as necessary to take the elements. Some adjustment to the firing programme may be required as whilst solid refractories tend to hold a lot of heat and so ensure slow cooling, particularly at the bottom of the range, ceramic fibre holds almost no heat and as a result, if the kiln is left to cool naturally after the glass has been held at annealing temperature, the fall can be far too rapid for thick glass to cool safely. Fortunately, fully programmable controllers are becoming the norm in glass studios which means that the possibility of too rapid temperature reduction can be avoided by automatic control.

Most standard ceramic kilns are either front loading or top loading types and many glassmakers have bought old models of these, ripped out the thick layers of insulation brick and replaced them with grooved ceramic fibre slabs. Anybody considering this activity must be aware of the possibility that asbestos may be present in old insulation layers and take suitable precautions. Ceramic fibre is a much more efficient insulation material than the

bricks and the same or similar elements can usually be fitted. Together with the lower top temperature required for glass casting and the reduction of the amount of heat absorbed by the refractories, the extra internal capacity can easily be accommodated and extra power is rarely needed.

Many glassmakers make their own kilns. Annealing kilns are fairly simple because of the low temperature requirement but kilns for glass casting and kiln forming need a little more consideration. The amount of insulation needs to be calculated carefully and the loading of the elements needs to be considered in relation to both capacity and the required temperature.

There are several excellent books available giving all the necessary details on kiln building and it would be advisable to study one or two of these before starting on this type of project. It is also advisable to look up the relevant regulations and to enrol the assistance of a good electrician. See **Electric elements, Refractories** and **Insulation**.

Knapping. The process of chipping away flakes of glass from the edges of slabs of dalle de verre. The same process has been used by some sculptors working in glass to carve the blocks of glass recovered from the bottom of a large glass tank or glass pot which has been allowed to cool whilst still containing some glass.

Kneading. A necessary process of spreading and stretching in the preparation of the refractory clays when building glass pots. It follows the action of the de-airing pugmill and extends a similar purpose in making sure that air bubbles are removed and that each lump is thoroughly mixed to a consistency similar to the others.

Knocking up. The process of straightening and repairing blowing irons, bit irons and punty irons.

Knop. Knops are the specially thickened parts, often cut and decorated, on the stems of goblets. There are several types – Inverted baluster, drop knop, acorn knop and cushion knop are a few. They are commonly found on the stems of baluster-type drinking glasses.

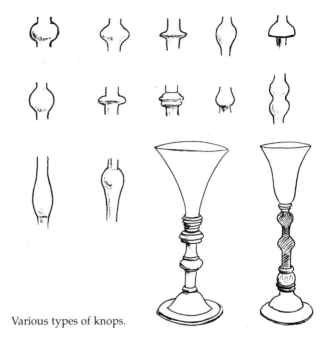

Various types of knops.

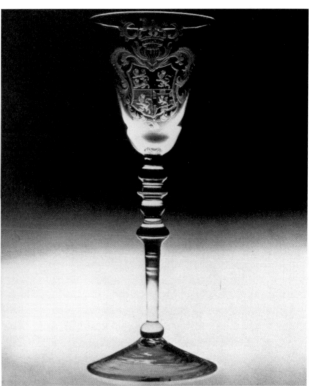

A Newcastle wine glass with several knops and a conical foot. It was probably engraved in Holland and bears the arms of Princess Anne, the daughter of George II, before her marriage to William of Orange. *Courtesy of Cinzano. Photograph by Peter Balmer.*

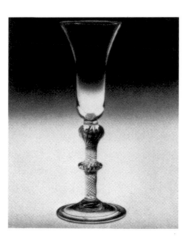

An English ale or champagne glass with two knops. This example has an air twist stem, a conical foot and a trumpet bowl. *Courtesy of Cinzano. Photograph by Peter Balmer.*

Kugler colour. Rods of concentrated colour for use by glassblowers were produced by Klaus Kugler at Augsburg in Germany. Whilst this firm is no longer in production, similar rods are produced by many manufacturers. Many glassmakers still refer to these rods as Kugler colour.

L

Ladles. As glassworking tools there are two different types. Both are essentially hemispherical metal bowls, the smaller of which is three or four inches in diameter, fitted with a handle and used for pouring hot lead into the centre of an abrasive wheel in order that it will fit a particular lathe mandrel. The other is a much larger piece of equipment consisting of a thick steel bowl varying from four to nine inches in diameter and fitted with a long handle up to six feet in length. This is used for emptying the glass from a furnace prior to re-charging, re-building or changing a pot.

Ladles made of glass were often made to match glass bowls used for drinks or fruit salads.

Lalique, René. (1860–1945). Lalique first became known for his production of glass jewellery inlaid with strongly coloured enamels in the Art Nouveau style. He was continually experimenting and his output covered a wide range of techniques on both window glass and various types of containers. After receiving a commission from Coty for a series of perfume bottles which he produced at Saint-Denis, he developed a series of cast and pressed forms and became interested in the possibilities of blown ware. In order to pursue this he eventually bought a factory in 1918 at Wingen-sur-Moder where he developed the work for which he became most famous. He produced what he called a 'demi-crystal' which was a good quality clear glass that he used for blown, pressed and cast pieces, often leaving the pieces with a frosted surface, sometimes with an iridescent finish. Onto this he sometimes used striking colour contrasts with designs which were occasionally abstract but tended to be more likely to be devoted to flowers, birds and female figures. He produced some very large individual vases by the cire perdue process. He was also interested in the possibilities of using mechanical techniques and developed a considerable amount of repetitive factory ware by using the power pressing process. After his death in 1945 the factory was taken over by his son Marc.

Lamination. The joining together of layers of glass either by fusing or by the use of adhesives. The adhesive technique is much exploited by modern Czech glass artists who often incorporate elements such as engraving or colour and then polish the results to a very high finish. Matéi Negréanu in France uses a similar technique to

Above. Laminated form, 'Vertical Waves'.

Right. Laminated and fused borosilicate form, 'Strata'.

Right. The effect caused by the inclusion of fine wire into laminated glass.

Laminated and fused form, 'Flower Head'.

Sound Effect', lampworked and lustred tubing.

produce his wavelike sculptural forms which he then sandblasts heavily to blend the edges together. A recent trend has been to produce glass furniture by glueing small pieces of float glass together.

Lamination by fusing gives totally different effects and much depends on the degree to which the fusing is allowed to progress. There has been a lot of experimentation in this area with much exploitation of the inclusion of cut lines and of the regular patterns of air bubbles which can be created in the glass.

Lamp black. A finely divided form of carbon used as a pigment for paints and as a filler.

Lampworking. Flameworking. The process of manipulating glass at a bench using a gas/air or gas/oxygen flame tool called a burner or torch.

This process is used in industry for making complex laboratory ware and by many individual lampworkers for producing such items as small animals and ships in bottles. There are artists who have taken the craft much more seriously and have produced vigorous and compli-

Right. Head by Pavel Molnar who introduces lampworked elements into cast forms.

cated sculptural forms. Some lampworkers have considerable skill in this work and individual pieces of scientific and industrial laboratory work demonstrate this to a very high degree. Some of these remarkable pieces of scientific equipment could often be appreciated for their sculptural form which in many cases can be more impressive than some that is presented as 'Art Work'.

Lampworking tools. The tools used by the lampworker are remarkably few and simple. Many of them are made by the craftsman for his own use. The main exception to this is the torch. Whilst many lampworkers use a simple hand torch as used for brazing or welding, others now invest in very sophisticated items with multiple heads which can be rotated into position very quickly and fitted with fingertip controls to adjust the size and quality of flame. Much use is made of blocks and rods of carbon, shaped as necessary to suit a particular purpose. Apart from this, some tongs and forceps, a glassblowing swivel, some rubber tubing, a small triangular file or a glasscutting knife, flameproof gloves and didymium spectacles are about all that is needed to make up the basic equipment. An annealing kiln should be used but for those who only make small work of thin section, a box of vermiculite is often used instead. Other lampworkers simply wrap the work in ceramic fibre to allow the glass to cool sufficiently slowly.

The lampworking bench is a strong table fitted with either a metal or a heatproof top. This used to be of asbestos but other substitute materials are now used.

The gas most commonly used for the process is propane but there is also some use of natural gas. The practical flame temperatures for natural gas/air are 1890°/1950°C, for natural gas/oxygen 2180°/2930°C and for propane/ air 1925°/2000°C. Acetylene whilst producing a much higher flame temperature is rarely used

Hand torch used for lampworking. Shown with stand.

because it tends to produce 'dirty' glass and is dangerous because it can ignite much more readily over a wider range of air/gas ratios than LPG.

Borosilicate rod or tubing is the most popular material for lampworking. Whilst it requires a higher working temperature than other glass it withstands thermal shock more readily, as a result of which control is very much easier. The major difficulty for several years has been that coloured rod or tubing has not been seen to be available in borosilicate so colouring has been traditionally carried out at the bench by using mixtures of oxides and fluxes either to coat the transparent glass or to mix with it. The situation is much better than it appears however and one firm in the USA is now producing a range of coloured glass and materials for use with standard borosilicate rod and tube. In Europe Schott produce their 'Duran' range of compatible clear and coloured rod and tube.

Rods or tubing made from soda-lime or lead-based glass are available but these are much softer than the borosilicate and are not always compatible with each other. Despite the lower temperature required and, particularly with the lead glass, the better heat retention, these glasses are rather more difficult to work, mostly because of the sensitivity to thermal shock. Some industrial lampworkers need to work fused silica rod and tubing for particular purposes but this material is unlikely to be used in studios.

Lanthanum. La. The first of the elements in the lanthanide series occupying the atomic numbers 57 to 71 in the periodic table. It is used in the production of some special optical glass. See **Optical glass**.

Lapping. Another name for flat grinding. This can be carried out on a flat mill or even by hand, using abrasive stones or diamond pads. Small diameter machines (15 in or 16 in diameter) fitted with interchangeable diamond discs are becoming increasingly popular for lapping processes.

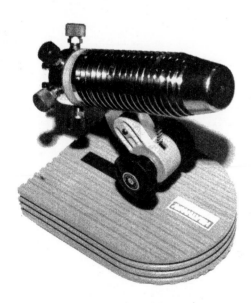

Bench burner for lampworking.

A small (18 in. diameter) flat mill or lapping machine which uses interchangeable diamond faced discs.

Lathe cutting. This refers to an old technique whereby glass blanks were set into a chuck on a lathe in a similar way to which wood or metal is held for turning today. Abrasives were held against the glass as it rotated until the glass attained the required shape. Finer abrasives would then be applied in order to produce a polished surface.

Lathekin. Lamekin. There are various spellings for these but all refer to various shaped pieces of wood or bone used for manipulating lead calme around pieces of stained glass.

Lathes. There are now two distinctly different types of lathes used for glassworking. The first consists of a hori-

zontal shaft to which are fitted abrasive wheels, to produce cuts, lines, carved, engraved and polished surfaces. The second has until recently been a much larger machine, unlikely to be found in a small studio workshop, which is used to rotate glass forms and tubes held in a suitable chuck whilst they are being heated, manipulated or fused together. This is a double-ended lathe fitted with a countershaft and two chucks and used by lampworkers. Smaller versions are now being produced which could well find their way into small studio workshops.

So-called cutting lathes are the larger of the first type and are fitted with either a tapered screw nose onto which the abrasive wheels are threaded as necessary or with a stepped cylindrical shaft where the wheels fit between two flanges and are held with a threaded nut. They need to run smoothly and with great accuracy. What may well appear to be the most simple of those available is by far the greatest favourite. This is the Spatzia Lathe. It is a well-proven design with solid bearings and a hardened shaft. Wide variations of speed to accommodate differing diameters of grinding wheels are provided by a range of stepped pulleys. There is no doubt that those who use this lathe become very reluctant to change it for a machine which might appear to be much more sophisticated.

A diamond lathe. *Photograph by courtesy of Gernot Merker.*

The type of lathe used by lampworkers in the manufacture of scientific glassware. *Courtesy of Heathway Engineering.*

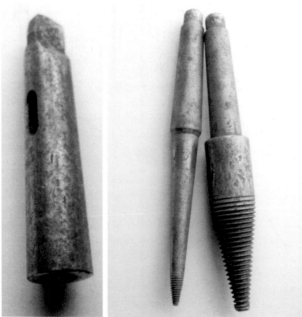

Left. Reducing mandrel for insertion into a glass lathe to take spindles of smaller morse taper.
Right. Taper screw noses for glass lathes.

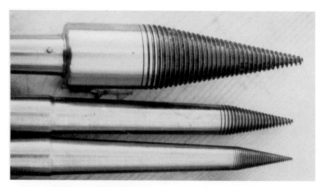

Lathe spindles for leaded stones.

Lathe spindles for flange fitted stones.

Many cutting lathes are provided with a shaft fitted with a morse taper hollow in the end. This can accommodate tapered spindles fitted either with various sizes of taper-screwed threads to fit leaded wheels or with flanges to take wheels with a cylindrical bore.

Modern types of cutting lathes tend to be fitted with tachometers to indicate the running speed. They have an automatic low starting speed to avoid the danger inher-

An intaglio lathe.

Leading apparatus for fitting lead into the centre of grinding wheels.

ent in starting a lathe set for a high speed with a wide diameter grinding wheel in place. An electronic speed control is often used to dispense with the necessity of changing belts from one pulley to another every time a different size wheel is fitted.

Lathes designed to operate with diamond cutting wheels are manufactured to very high specification as they run at much higher speeds. Apart from the high speed, they are basically similar to ordinary lathes but they are much more expensive.

Intaglio lathes are simply smaller editions of cutting lathes which use much smaller abrasive wheels for engraving.

Copper wheel engraving lathes are also similar in design but they are even smaller. They have a morse taper hollow in the end of the shaft to take the various spindles to which copper wheels have been fixed. The engraver would normally have a rack containing several of these spindles fitted with copper discs shaped to fit the type of work likely to be carried out.

There is little problem with dust in operating these lathes as cutting and intaglio engraving are essentially wet processes and the speeds involved are fairly slow. Rather more care is necessary when using diamond wheels as the extra speed can create a fine mist composed of water and glass particles. It is necessary to ensure that adequate eye protection is provided. Because of the amount of water used in the process, it is also essential to ensure that all electrical connections and equipment are well protected. An automatic circuit breaker is strongly recommended. The exposed spindle is also a source of danger to people with long hair which must always be tied back or covered in such a way that it cannot be caught by the rotating spindle. An extra safeguard can be provided by sliding a tube of cardboard over the exposed section of spindle.

Lattices. A term used to describe the regular three-dimensional structure of atoms or molecules forming a crystalline structure. The term is not appropriate to glasses as they are amorphous and do not have a regular three-dimensional structure.

Latticino. This refers to the Venetian technique of incorporating threads of white and/or coloured opaque glass into blown forms. It is thought to have originated from the Roman practice of making twists of white and clear glass to decorate the rims of vessels. Over the subsequent years these threads appeared in several places usually as surface decoration but the Venetians became extremely inventive and skilful in exploiting and extending the possibilities. Latterly, various modern glassmakers have explored the technique, often resorting to employing craftsmen from Venice to carry out the complex work.

The basic process of using these canes consists of placing lattimo cane together with clear glass canes if necessary, around the sides of a cylinder, heating them and then picking them up on a gather of glass. This is then marvered into a cylindrical shape, blown out and worked as required. Another method is to heat up sections of canes on a metal plate held near to the furnace mouth or on a heated marver plate. A parison marvered into a cylinder would then be rolled along the lengths of cane to pick them up. They would then be marvered into the parison and the result blown out and worked as necessary. See **Filigrana** and **Reticella**.

Lattimo. The cane containing twists of opaque white, or occasionally coloured, threads used for making the various types of filigrana.

It is made by heating lengths of opaque white, and occasionally coloured, cane either on a metal tray near to the furnace mouth or on a heated marver and picking them up on to a parison or alternatively by picking up individual canes with pincers and placing them against the hot parison. After re-heating and marvering the cane into the gather, a punty iron is attached to the end of the gather and twisted as it is pulled into a long cane.

A slightly more complicated lattimo is made by first picking up a single cane on the gather, marvering this into the surface, covering with a further gather of clear glass and then proceeding to pick up further lengths of cane.

The methods of making latticino.

A typical copper wheel engraving lathe.

Lawns. Fine mesh sieves used to separate various sizes of particles. They are available in a wide range of mesh sizes.

LCD and LED (liquid crystal display and light emitting diode). These are methods of reproducing figures and letters on various instruments such as pyrometers and controllers. An arrangement of bars is used to form the figures and letters. In the LED or light emitting diode an electric current flows in one direction giving coloured light according to the material from which it is made. The electrical circuits are varied as necessary to produce the pattern required for different letters and figures.

In the LCD or liquid crystal display, the liquid crystal forms the bars and is a material which is neither a true liquid nor a true solid. As its molecules are not locked in place, an electric current can be used to rotate them slightly reducing their ability to reflect light. This causes the bar to appear darker than its surrounding area and so form a letter, figure or diagram as required.

Lead. Pb. A soft, low-melting, dull grey ductile metallic element of Group IV in the periodic table. The metal is used for making the calme used by artists in the construction of stained glass windows. It is also the basis of the solder alloy which is used to join the calme together. Its oxide is the basis of much of the high quality lead crystal glass.

Lead antimoniate. $Pb_3(SbO_4)_2$. Antimoniate of lead. This material is best known as the paint pigment called Naples Yellow and was once popular in the manufacture of ceramic glazes as a source of a range of yellows.

Lead bisilicate. $PbO.2SiO_2$. The most popular form of lead frit used in the manufacture of glazes. Theoretically it is one molecule of lead oxide combined with two of silica. See **Lead frits**. It is finding an increasing role in glassmaking as the regulations relating to the use of raw lead oxides become more stringent. It is fritted to produce well below 1% solubility of lead oxide.

Lead calme. The strips of grooved lead used to contain the panes of coloured glass in stained glass windows. See **Calme**.

Lead carbonate. Pb Co_3. Used as a paint pigment (white lead or flake white), as a source of lead oxide in glazes and enamels, and as drying material in putty.

Lead crystal. The use of lead oxide as a flux in glassmaking was known in Roman times and was used over the years as an addition to the more common alkaline fluxes. The continuing search for a clear and bright glass evoking the qualities of polished quartz crystal eventually produced the Venetian 'Cristallo' which was a soda-lime glass of high quality. The lead crystal we know today came as the result of the experiments of George Ravenscroft who found after much difficulty that he could use a much higher proportion of lead oxide to produce a soft, low melting, brilliant glass of very high quality. He patented his findings in 1674 and managed to keep ahead of the field for many years before similar glass began to appear in other parts of Europe. The proportions of lead oxide in glass are now subject to international agreements relating to the accepted definitions of various types of lead crystal. See **Crystal**.

Lead cutting knife. Stained glass artists used to make these from a ground down palette knife but most of them now use the heavier type of commercial knife consisting of a heavy two-piece metal handle fitted with replaceable blades.

Lead cutting knife.

Lead frits. Several of these are available and were originally manufactured to reduce the exposure to lead poisoning in the ceramic industries. They are essentially materials which contain lead oxide and silica fused together in various proportions and often small quantities of alumina and titania are introduced to reduce the solubility of the lead. The most common of these are:

Lead bisilicate,
Lead monosilicate and
Lead sesquisilicate.

Of these, lead monosilicate seems to be the preferred frit in the glass industry as the solubility problems which are important in the making and use of glaze slop do not really apply in the use of batch material. Lead oxide in the form of litharge or red lead has been the traditional source of lead in glass batches but the developing concern with exposure to the metal has increased the use of frits. These have the advantage of being supplied in granular form which automatically reduces the dust problem. There is also the advantage of dependable and constant composition and of lower volatisation.

Lead mill. Lead mills comprise simple machines operated by turning a handle. This moves two milled wheels set into a strong steel frame, dragging lead through cheeks forming dies which turn the lead into the shape of calme required. Many small studios use these in Europe as they offer the opportunity of producing small lengths of clean lead calme as it is wanted, using scrap lead from many sources.

Moulds for casting the lead into suitable shapes are available from most stained glass suppliers. In the USA and in Britain it is more normal to buy calme (came in the US) which has been extruded in quantity, so that uniform stocks of the necessary profiles can be kept in the studio.

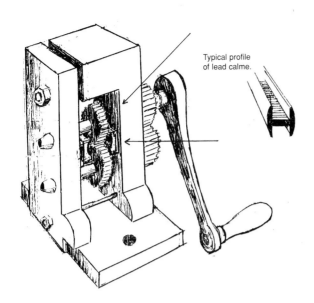

Lead mill.

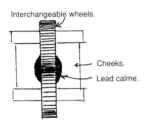

Interchangeable cheeks.

Cutting a mitre joint.

Completed mitre joint.

It has a slight disadvantage as the lengths of calme when cut to size need to be cleaned to a bright finish in the area where they are to be soldered.

Lead mould. This is a very simple metal mould in two hinged parts which can be clamped together in order to accept the molten lead. This emerges in a short but thick strip ready to be pulled through the lead mill for turning into calme.

Lead mould.

Lead oxide. PbO. Plumbous oxide. Lead monoxide. Litharge. Together with red lead (lead tetraoxide) it is the standard material used to provide the lead content of a batch. In the past, lead dioxide, lead trioxide, lead carbonate and lead sulphide (Galena) have all been used as sources of lead in glassmaking, but are less likely to be used now. Lead glass has long been a favourite material for people in small studios or workshops. It is low-melting, dense, brilliant, has long working properties, polishes well and is easy to cut and engrave. Despite all these positive attributes, it is being replaced by pelletised batch because of the environmental pressures and fears that the public are turning away from the use of lead crystal.

Lead poisoning. Plumbism. Whilst legislation relating to the toxicity of many materials used in glassmaking is of comparatively recent origin, there has long been considerable concern about the effects of lead. As a result there is a considerable amount of literature on the subject and in the light of the current environmental concerns the legislation on usage and threshold levels is constantly being updated.

In the ceramics industry, lead has been introduced in the form of a lead frit for many years and there has been a great deal of research into possible methods of replacing it wherever possible. Glass has not had to face the same problem until quite recently and it is still common to find lead being introduced into batch in one of the forms of lead oxide. The most obvious times of danger are when the batch is being mixed and charged into the furnace. The studio glassmaker who mixes lead batch must ensure that any batch mixing is carried out mechanically in a sealed container and must take all possible precautions when charging the furnace. Food and drink should not be taken into batch mixing areas, good personal hygiene is essential and a shower followed by a change of clothing is recommended after mixing the batch. A further possibility of exposure occurs from volatiles released during founding and, to a lesser extent,

when working the glass. To keep this in perspective, reported cases of industrial lead poisoning are very rare in most Western countries. It can however, be an insidious and gradual development so it would be prudent to take every possible precaution.

It is highly unlikely that acute lead poisoning could occur in a small workshop but the chronic form is less obvious to detect and could be a distinct possibility in certain circumstances. Dangers in charging and batch mixing have been mentioned but a less obvious source is that which results from the action of a flame directed at or across the surface of the metal. This tends to produce a tearing action which picks up volatile lead products. Some of this emerging through the gathering ports and can often be seen as a yellow deposit on the surrounding refractories.

Acute lead poisoning usually occurs through the ingestion of large quantities of inorganic lead. A sweet metallic taste in the mouth is quickly followed by symptoms of thirst and/or abdominal pain and vomiting. If death occurs it is usually within the first two days and is preceded by collapse and coma. Most people who receive early treatment survive but other symptoms may persist for some time. Acute lead poisoning is highly unlikely to occur from the type of exposure to be experienced in a small workshop.

Chronic lead poisoning is still unlikely but is possible. It results from the bio-accumulation of lead over a period of time to an amount greater than that which the body can assimilate without significant effect. Unfortunately, the build-up of material can take place without evident symptoms of any clinical state being recognisable. Even then, the earliest symptoms of lead poisoning can easily be attributed to other causes. They are: fatigue, lassitude, headaches, loss of appetite, facial pallor and muscular pain. These symptoms are obviously so unspecific that early diagnosis can only be expected if there is evidence of exposure and confirmation by biological tests. If however, treatment does not begin at this stage body functions begin to fail and the poisoning becomes more readily recognisable. Whilst some of the lead is thought to pass through the body within a week or so, some of it becomes stored in the tissue of the bones. Women are more susceptible to lead poisoning than men and carry an increased risk as child-bearing can be affected and the possibility of abortion increased.

Another aspect of lead poisoning has been given much publicity recently, some of it genuine concern, some of it politically motivated and some which could only be described as 'media alarmist'. This concerns the release of lead from containers such as decanters used to contain acid materials such as wine, fruit juice and vinegar. Much research has been and is being carried out into this problem in relation to lead-glazed ceramics where poorly formulated glazes created most of the original concern. As a result of this, comprehensive legislation has been introduced and gradually increased in many countries with particular reference to ceramics.

This area of concern is now being focused on glass containers with high lead content. It has already attracted attention in the USA, particularly in California, and as a result the sales of lead crystal have suffered a marked decline. Some European countries are following the same line and as a result many factories are now producing ware which is very low in lead or is completely lead-free. Others are looking at processes which produce a resistant coating by a process of ion exchange. Baccarat uses aluminium and researchers in Britain are using titanium and other metals with considerable success. The Baccarat process when using the standard 24-hour acetic acid test currently reduces the lead release to 12 parts per billion and the British glass system using titanium and undergoing the same test has reduced release to 2 parts per billion. They are also researching a simple system using ammonium sulphate which would satisfy the current European regulations but would not meet those in the USA.

The ion exchange solutions are, however, still expensive and could only be a possible answer for a large-scale industrial production. Certainly there is no indication that they would offer any solution to the problem for the glassmaker in a small workshop who might be affected by more stringent legislation.

Glafo at Vaxjo in Sweden have accepted the inevitability that public opinion and regulatory bodies are likely to insist on increasingly difficult standards, and are researching the production of leadless glass which has many of the qualities of crystal. It is the result of such research which in the long term is most likely to benefit the small-scale glass workshop. In Europe there is still a strong body of opinion amongst glass technologists who are convinced that the reaction has gone too far.

The concern with possible release from crystal decanters used for storing wine obviously has some legitimacy but to engender such concern over the possible release from a crystal goblet in normal use is bordering on the ridiculous. However, no doubt we shall have increasing statutory legislation before long which without necessarily defining the pros and cons will certainly define the production parameters.

Lead stretching clamp. A simple device usually homemade and used to stretch lead calme. This has the effect of holding the calme whilst it can be pulled to straighten out any kinks and curves.

Lead stretching clamp.

Lead stretching clamp.

Leading. The process of forming stained glass windows by joining pieces of glass together with lead calme. The term also refers to the pouring of molten lead into the centre of abrasive wheels around a tapered or parallel screw thread so that it will fit onto a lathe.

Leading apparatus for putting a lead core into abrasive wheels.

Grinding wheel after leading showing punch marks in the lead core where the wheel has subsequently needed to be trued.

Lehr. A type of oven or kiln used for annealing glass. In industry it usually comprises a moving belt which can have its speed regulated as necessary to suit the time required for a particular annealing programme. Various areas within the lehr can be pre-set to provide temperature-controlled progression along the belt. In small workshops it is more normal to find a kiln heated by electricity and/or waste heat from the furnace rather than the moving belt type of lehr. Electronic controls which can easily be programmed to provide a suitable annealing cycle are also becoming much more common in studio workshops.

Lepidolite. Lithium feldspathoid. An alumino-silicate with lithium as a base and containing varying amounts of fluorine. It is a natural material which is often mined for its lithium content which can then be turned into lithium carbonate for use in a glass batch.

Levigation. Levigation was one of the methods used for separating the slurry from the grinding process into useful particles. The process is simple and uses a levigation trough, a channel fitted with several horizontal strips across its width at short intervals. The liquid slurry containing the abrasive material is thinned considerably and then poured in the top end of the sloping trough and allowed to run over the succession of steps so that the abrasives collect against the steps as the thin liquid continues to run through the trough into a bucket or appropriate container. The coarser particles tend to be contained against the steps near to the top of the slope whilst the finer particles collect against the lower steps.

A levigation trough consists of a sloping channel fitted with a series of barriers as shown. If a thin slurry of mixed materials is poured in at the top and allowed to run down, the heavier and larger particles will tend to be caught by the earlier barriers and the finer particles by the lower barriers.

Libby-Owens process. A system of drawing continuous flat sheet, patented in 1905. The glass was drawn vertically for a short distance before it was bent over a roller and guided horizontally over flattening rollers prior to moving into a cutting and annealing area.

This process offered considerable advantage over the

Fourcault and Pittsburgh processes because these drew the glass vertically to a considerable height whereas the Libby-Owens process moved the glass horizontally, so permitting a continuous process and an easier access for cutting sheets to a required length. See **Sheet glass**.

Lime. CaO. Calcia. Lime is a term with different meanings for different people. It is commonly used to describe calcium hydroxide or slaked lime by gardeners and calcium oxide by builders. It is also often used to describe quicklime which is calcium oxide which has recently been calcined. To the glassmaker it is an alkaline flux usually introduced as calcium carbonate which plays an important role as a stabiliser. See **Batch materials**.

Lime feldspar. $CaO.Al_2O_3.2SiO_2$. Anorthite. See **Anorthite**.

Limestone. $CaCO_3$. This is a common sedimentary rock usually formed either from crystalline precipitates or from the shells of sea creatures. It has many uses in building, road making, cement manufacture, iron ore smelting, the ceramic industry and in glassmaking. It has various forms. Some of it is very hard, some of it is in the form of crystals of various sizes and some of it, particularly chalk and whiting, can be very soft. It has been used in glassmaking for many years as a source of calcia. Dolomitic limestone is a mixture of calcium carbonate and magnesium carbonate.

Ferruginous limestone refers to any limestone which is coloured by iron.

Linisher. A glass grinding and finishing machine fitted with endless belts coated with abrasive grains for grinding or cork granules for polishing. See **Abrasive belts**.

A compact wet belt linishing machine. *Photograph courtesy of Heathway Engineering.*

Lipper. A conical piece of wood used to shape the lip of a vessel.

Litharge. PbO. Massicot. Yellow lead oxide. Lead monoxide. One of the commonest forms of lead oxide used traditionally for glassmaking. See **Lead oxide** and **Batch materials**.

Lithia. Li_2O. Lithium oxide. Sometimes used as a strong flux in batches, often replacing part of the sodium oxide largely because it has a much lower coefficient of expansion and as such can be used to modify the expansion in a glass. Lithium is the lightest of the metallic elements which means that a small amount is as effective as a larger quantity of the other fluxes. When this is taken into account and the material considered on a weight for weight basis, it becomes much more economic than might at first appear. It is usually introduced as lithium carbonate. It increases the speed of the melt and gives a long working range to the glass but is more expensive than most of the other alkaline fluxes. It is used increasingly in the development of glass-ceramics where the system of $Li_2O.Al_2O_3.SiO_2$ has become the basis of much glass-ceramic production. It has also found considerable use in many special glasses, particularly those used for television tubes.

Lithium. Li. A silvery metal from Group I of the periodic table. Its chemistry is slightly different from the other metals in Group I because of the small size of the Li ions. It is a rare element found in spodumene, petalite and lepidolite.

Lithium carbonate. Li_2CO_3. Used to provide a source of lithium oxide in a batch. It is not found naturally and is prepared from various ores such as lepidolite, petalite, spodumene etc. It decomposes in founding to produce lithium oxide and carbon dioxide.

Lithium feldspathoids. These occur when lithium has replaced sodium and potassium in residual micafeldspar. They are: lepidolite, spodumene and petalite. They are mined to provide lithium and lithium carbonate.

Llobmeyr. The firm of Llobmeyr was founded in Vienna in 1823 and since then has maintained a considerable reputation for the production of glassware of particularly high quality. Much of the early work was quietly classical in design and the Llobmeyr name became synonymous with the finest engraved ware. This was not their only type of work, however: Ludwig Llobmeyr is credited with the first commercial production of iridescent glass in 1863 and he obtained several patents for the process. The technique was then extended in 1878 to include a crackled surface effect.

His nephew, Stephan Rath established a branch of the firm in Kamenicky Senov in Northern Bohemia in 1918.

This was a major development of a long established and particularly fruitful cooperation with the Bohemian engravers. The Llobmeyr studios became strongly associated with the glass school newly established at Zeledny Brod and with the Prague School of Decorative Arts. The Llobmeyrs lost their factories in what had become Czechoslovakia in 1945 but there are now signs that they will be able to re-establish some of their operations there. One of the Llobmeyr houses had been converted into a glass museum.

Lost wax technique. Cire perdue. This refers to the ancient technique traditionally used for the casting of bronze and precious metals but is now also widely used for casting glass objects.

The basic concept is that of producing a form in wax which, after being covered with a suitable investment to make a mould, is heated sufficiently in a burn-out kiln, or a double boiler for the wax to melt and run out. Glass is then melted into the space left by the wax to produce a replica of the original form.

The standard mixture used for the investment consists of equal parts of potter's or surgical plaster and powdered flint though there are several variations some of which are described under **Casting**.

If the glass casting is to be solid, the procedure is relatively simple. The solid wax form is placed in a suitable cottle making sure that sufficient extra wax has been added to the base of the form to allow for some spare glass fragments when the actual casting takes place. Risers are put in place as necessary and the investment is then poured over the form and allowed to set. When it has hardened and preferably left overnight to dry out, it can be heated as previously described so that the wax runs out into a suitable tray. The casting can then take place as described under **Casting**.

The moulds made for bronze and precision metal cast-

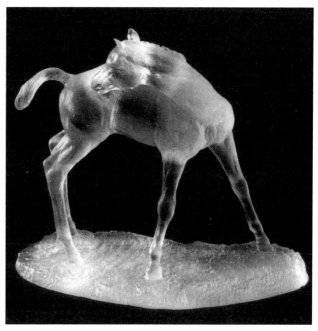
Lost wax casting by Colin Read from an original model, 'Bliss' by Gill Parker.

ing are often very complex. As the metals may be very thin in sections, the internal and external parts of the investment are often joined together through the wax layer to hold them in the correct alignment whilst casting is taking place. Glass is too fragile to be cast in very thin sections so moulds are not usually very complex and as a result the procedures tend to be somewhat easier.

If the form required is to be hollow then the procedure

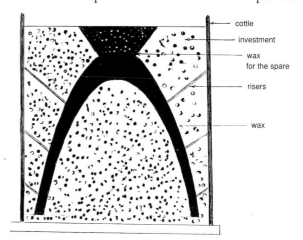

cottle

investment

wax
for the spare

risers

wax

(2) Hollow forms need a little more attention. The form is modelled or cast in wax as before with an extra cone on the base to take spare glass granules. The bowl is filled with investment and some of it is also poured into the bottom of the cottle. Once the two lots of investment have begun to set but are still wet enough to join together, the wax bowl is placed upside down onto the damp plaster in the cottle. If the two parts have become just too dry, a thin layer of fresh investment can be added before placing them together. Risers can then be inserted and the remainder of the cottle filled up with investment. When the mould is dry proceed as in (1)

cottle

investment

wax

risers

(1) This shows a solid head modelled or cast in wax. It is placed in a cottle as shown, risers inserted, and the investment carefully poured over and around it. When the investment has set, the mould can be removed from the cottle. When dry it can be placed in a burn-out kiln or a double boiler and heated until all the wax runs out.

is a little more complicated. Artists tend to evolve their own techniques but a common method is to make a hollow wax form, again adding some extra wax on the base to accommodate spare glass. It can then be filled with the

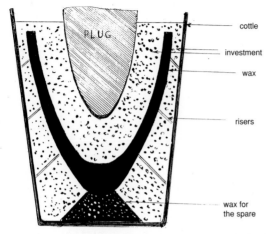

(3) This is a variation on (2) except that a plastic bucket is used as a cottle and the investment is introduced in reverse order with the wax bowl in an upright position. A temporary plug of wax, clay or wax covered wood can be pressed gently into the wet investment as shown to reduce the final mould thickness. The plug would be removed before melting out the wax.

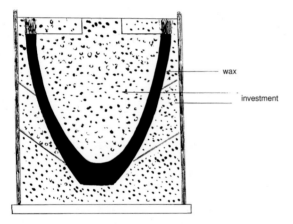

(4A) This shows a mould prepared for casting without the necessity of introducing a cone to hold spare granules. It is made as in (3) but the top is covered in investment except for some slots through which the granules can be introduced.

(4B) A top view of the same mould showing the arrangement of slots.

investment material. A cottle is then prepared wide enough to take the wax form and the layer of investment to go around it. Some investment is poured into the bottom of the cottle. When this just starts to harden, the wax form can be turned upside down into the flat bed of plaster in the cottle which should be still wet enough to bind to that inside the form. The risers can then be put in place and more investment poured around the form. When all the investment has set, the wax can be heated and removed and the glass casting can take place.

The range of wax mixtures used for the process is large. They need to be reasonably hard at room temperature, to soften sufficiently when handled to be malleable and need to melt below the boiling point of water. This enables the wax to be melted safely in a double boiler. Most of the traditional waxes are based on mixtures of beeswax and paraffin wax. Sometimes materials such as

(5) This mould is made as (4) in two separate sections.
When casting, some granules are placed on the base of the outer mould to just over the thickness of base required. The inner form is then precisely located on these granules and more granules packed in to take up all the space formerly taken up by the wax. When fired there will be some shortening of the length of the sides but the extent of this will depend on the nature of the glass and the firing programme. As the investment will be lighter than the glass, it will tend to float if the glass is heated until it becomes fluid so it may be necessary to place something over the top of the mould to ensure that this does not take place. A strip of kiln shelf, possibly with part of a firebrick on top would suffice.

In the examples showing a cone to hold spare granules, the finished casting would probably need to have the remainder of the cone sawn or ground off to form a proper base for the bowl. In the forms which are fired in an upright position, the top edge should find a reasonable level but some grinding and polishing might again be necessary.

The shrinkage and the type of surface of the cast glass is affected by the extent of the firing. If the glass granules are only taken to a temperature at which they will fuse together there will not be much shrinkage, the glass will tend to appear opaque and the surface will probably turn out to resemble grains of sugar which have become stuck together.

If the mould is taken to a temperature at which the glass becomes fluid, then any trapped air should escape through the risers and the glass level will fall as it replaces the air. This is the reason for the cones to hold spare granules to run into and fill the mould. The glass surface should be reasonably clean but may be matted and may need polishing

tallow or petroleum jelly are introduced to make the mixture more malleable and sometimes resins such as mastic, copal, damar or amber are introduced to stiffen it.

Most artists with access to appropriate dealers now use specially formulated micro-crystalline waxes for both modelling and for making lost wax moulds. These are readily available in a wide variety of specifications from suppliers specialising in providing materials and tools for sculptors.

The wax form is then coated with investment material incorporating risers where necessary and, if the form is to be hollow, filled with the same material to make a core. The resulting mould is heated in a burn out kiln to remove the wax. The mould is then used as appropriate to make the glass casting.

Loving cup. A vessel with two or more handles used to pass around at appropriate gatherings so that people can drink one after the other.

Low emissivity glass. Window glass with a special coating applied to one side allowing short wave solar energy to pass inside but reflecting the long wave energy generated by heating systems, lighting and the occupants back into a building. It is often used as part of double or triple glaze units and can be applied both to toughened and to laminated glass.

Low sol. Phrase used to describe frits containing lead oxide where the solubility is less than 5%. It is a term used more in relation to ceramics than to glass but as the tendency to turn to the use of frits rather than lead oxides in glass batch increases the term will become more relevant.

The term concerns the release of lead from both the materials and from glassware or ceramic ware. On glassware or ceramic ware, the surface is attacked by various acids such as wine, vinegar and fruit juices. Legislation is in place in most countries to define the limits to which the metal release can be accepted. Many technologists consider that the release of lead from well-constituted glass in normal use is unlikely to be sufficient to warrant the considerable concern now being expressed. Perhaps there should be more concern when high lead glass is used for the storage of acidic materials such as vinegar or home-brewed beer. The time factor is obviously of considerable importance in this instance. The use of other materials can often affect the solubility of lead considerably:

- Its solubility decreases as silica is increased.
- It also decreases considerably with the presence of alumina, titania and calcia.
- It decreases slightly with the presence of beryllia, baria, zirconia and zinc oxide.
- It increases in the presence of soda, potash, lithia and boric oxide.

Low thermal mass. The materials used for high temperature insulation usually contain numerous fine pores or air pockets producing areas of low thermal conductivity which together with their light weight makes them ideal for use in kiln and furnace insulation. These materials are often referred to as being of 'low thermal mass'.

Lustre. Lustre effects result from the development of a very thin layer of metal on the surface of the glass to give an iridescent effect. The metals commonly used are tin, bismuth, copper, gold, silver and platinum. The metal is dissolved in an acid to produce a salt which is added to a sodium resinate to produce a precipitate. This is suspended in an aromatic oil which together with the resin burns out in the firing to provide a reducing atmosphere which leaves a very fine film of metal on the glass. Many of the commercially-prepared lustres include bismuth with the metal resinates to add a typical mother-of-pearl iridescent sheen to the resulting colour. See **Iridescence**.

Lycurgus Cup (4th century AD). This is a bell-shaped cup with a frieze of figures, mostly in open work and depicting the death of Lycurgus. Its colour is mostly dull green, but, because of the effect of colloidal dispersion, probably of gold, in transmitted light the colour becomes a transparent wine colour with a little amethyst purple in parts. It is thought to have been carved from a thick walled blank which may have been mould blown.

Much of the open work consists of figures and entwining branches and is bridged to the main body of the vessel somewhat in the manner of the Roman cage cups. As the figures and the open work show little evidence of grinding, there is some conjecture that the cup may have been fire polished. An analysis of the glass shows that it is a soda-lime-silica with some manganese, a little gold and some minor materials (see frontispiece.)

M

Magnesia. MgO. Magnesia is a useful batch material. Whilst it performs a similar function to calcia it has the effect of inhibiting devitrification by lowering the liquidus temperature and at the same time increasing the available working time. It begins to act as a flux at 1170°C (2140°F) and is most effective between 1190°C (2170°F) and 1230°C (2250°F). Prior to 1170°C (2140°F) it acts as a refractory anti-flux. As a material acting outside glassmaking, it is a highly refractory material with a melting temperature of 2800°C (5070°F). It is known to improve the weathering qualities of glass sheet. It changes the colour obtained from cobalt oxide towards mauve. The most common batch sources are magnesium carbonate and dolomite ($CaCO_3.MgCO_3$). Dolomite has the additional advantage of introducing some of the calcia requirement of the batch in the same basic material. Very good quality dolomite is available in the USA where it is used in both flat glass and container production. Dolomite from Britain on the other hand contains too much iron to be of much use for colourless glass production and a better quality material is imported from Spain. It is used in its calcined form in the USA.

Magnesite. $MgCo_3$. A mineral form of magnesium carbonate used as a source of magnesia.

Magnesium. Mg. Magnesium is a very light, silvery-white metallic element from Group II of the periodic table. As powder or in thin sections it burns readily to form magnesium oxide. It is used in the formation of many alloys, particularly with aluminium, where it is used for the production of lightweight, high strength castings and extrusions. It is also used as an oxidising agent in the production of steels and copper/nickel alloys. Commercial production of the metal is normally by electrolysis of magnesium chloride but its compounds are found in plants, sea water and in many minerals, the main ones being magnesite, dolomite, talc, serpentine and asbestos.

Magnesium carbonate ($MgCO_3$) is another common source of magnesia and is obtained in the mineral form (magnesite) or is manufactured from sea water. It decomposes at 350°C (660°F) to form magnesium oxide and carbon dioxide.

Magnesium carbonate. $MgCO_3$. The normal batch material used to provide magnesia. It is obtained mostly from crushed magnesite or from sea water.

Magnesium sulphate. $MgSO_4$. Used in the ceramics industry as a glaze flocculant, but because it provides only about 16% as magnesia, it finds little use in glassmaking.

Magnetite. Fe_3O_4. Loadstone or heavy magnetic ore. This is a very hard crystalline form of iron ore used as a source of black iron oxide. It is found in both metamorphic and igneous rocks.

Mahlstick. Usually made from a short length of dowel rod and fitted with a soft rubber tip. It is placed on glass as a rest for the arm whilst the artist is painting.

Malachite. $CuCO_3.Cu(OH)_2$. Natural ore of copper carbonate usually having a bright emerald green colour which is easily crushed for use as a colourant or as a source of copper oxide.

Mandrel. When used in reference to glass lathes, a mandrel is a lathe shaft with an end which is hollowed out to take various spindles. It can also refer to a tapered tube which can be fitted into such a shaft to take smaller sizes of spindle.

Manganese. Mn. A grey metal somewhat harder than pure iron. It is used in many alloys, both ferrous and non-ferrous, and is particularly useful in the production of high tensile brass bars, sections and forgings.

Manganese carbonate. $MnCO_3$. Found as the ore rhodochrosite. It can be used as source of manganese dioxide. When heated, it converts quickly to manganous oxide releasing carbon dioxide in the process. It then takes up more oxygen to become manganese dioxide.

Manganese dioxide. MnO_2. Whilst it has some value as a glass colourant, its greatest use in glassmaking is that of a decolouriser. See **Batch materials**. During founding the manganese dioxide acts as an anti-flux and slows down the fusion process until the temperature reaches 1080°C (1980°F) when it releases part of its oxygen and becomes manganous oxide, thereby changing to an active flux which combines rapidly with the silica in the melt.

As a colourant it produces violets and plum colours. However, as the colours become dense the glass tends to stiffen considerably making it hard to work.

It occurs naturally in nature in the form of the ore pyrolusite and as part of several other ores often associ-

ated with iron ores. There are large quantities of manganese-based minerals in the form of nodules on the sea bed and work is being carried out, mostly in the USA, into recovering these as a source of both manganese metal and manganese dioxide.

Manganese dioxide is not generally considered to be particularly toxic but continuing exposure to the dust can lead to a condition known as 'manganism' which is easily mistaken for Parkinson's disease. It was commonly used by potters to give slightly silvery matt black surface to pots and those who used the material over a long time were particularly vulnerable to manganism.

Manganese monoxide. MnO. Occurs as manganous oxide in founding above 1080°C (1980°F) when it becomes an active flux and combines quickly with the silica in the melt. It is used to some extent as a decolouriser but it is also used as a colourant producing a range of purples and browns. See **Colours**.

It has the reputation of making the glass hard to work when sufficient oxide to produce a strong colour is introduced into the batch.

Mansell, Sir Robert. Mansell is considered to have been responsible for transforming glassmaking in England from a large, scattered number of small glasshouses into a considerable industry. He already had a successful career as an admiral who commanded the fleet at the siege of Cadiz in 1596 and was knighted by Queen Elizabeth. The royal proclamation by King James the First was in effect the granting of a royal monopoly for glassmaking to Sir Robert Mansell. He is reputed to have been involved in the introduction of laws which brought about the change from firing furnaces with wood to firing them with coal and as a result developed a large centre of glassmaking around the Tyne and the Wear which was a prominent coal-producing centre at that time. He is thought to be responsible for the introduction of looking glass plates and of importing craftsmen and glassmakers from Venice in order to instruct English glassmakers in methods of manufacture to improve the quality of English glass. He was also fortunate that the persecution of the Huguenots in Northern France had already led to the migration of very skilled glassmakers to England, several of whose names persist today in the areas around Newcastle-upon-Tyne.

Maquette. A three-dimensional sketch, not necessarily in glass, for a finished piece of work.

Marble. A fine, hard form of limestone once polished and used in slabs as marvers.

Marbles. Glass marbles can be made by using a small wooden block in a manner similar to that used for making paperweights. Commercial production, now sadly disappeared from Western Europe, is made by extruding rod which is chopped into small blocks whilst hot and passed along a series of grooved rollers from which the spherical marbles emerge at a considerable rate. They are still made in America and in China. An excellent collection of marbles is on permanent display as a tourist attraction at Teign Valley Glass in Bovey Tracey, Devon, England where there is also a wide range of marbles offered for sale.

Marbling. A process of floating and stirring a small amount of bitumen paint on water and then picking it up by carefully placing a sheet of glass against it. When dry, the glass is treated with hydrofluoric acid which etches the glass in the areas clear of bitumen.

Marinot, Maurice (1882–1960). Maurice Marinot was a successful painter who discovered glass when he visited a glass factory at Bar-sur-Seine in 1911. He then proceeded to work with a glassmaker to design and to produce pieces which he decorated by exploiting his experience as a painter using enamels and gold. Much of his design was based on human figures and heads. He continued in this way for several years and after 1919 he also began to exploit the possibilities of acid etching.

His work became immediately popular and his use of colour which gradually became richer and fine guaranteed continuing success. After 1927 he produced vases by what he called 'modelage à chaud' on which the decoration was often geometric. Some pieces also appeared to have been almost carved out of solid blocks.

Marver. From the French marbre (marble). This is a flat, cast-steel plate polished on one side, used for rolling a gather of glass in order to produce an evenly rounded parison with a surface which has been cooled sufficiently to give a resistance to the blowing action. Before steel plates became available, a marver would traditionally have been made from a slab of polished stone, probably marble.

Massicot. PbO. An alternative name for yellow lead oxide. Litharge.

Matt surfaces. These often occur naturally as a result of surface devitrification or from dusty surfaces on glass which is being re-heated and fused. They can be deliberately contrived either by sandblasting or by acid treatment. See **Acid etching** and **Sandblasting**. They were a common problem in the forming of plate glass by pouring hot glass onto a casting table. When this glass was needed for the manufacture of mirrors or for clear sheet material, it meant that a considerable amount of grinding and polishing was normally required.

Medium. A liquid which is used as a vehicle for holding coloured enamels, lustres and oxides in order that they can be painted or sprayed onto glass. They are usually of aromatic oil, oil and gum arabic or water and gum. When the enamel, lustre or oxide is fired on to the glass, the medium burns out.

Melt. This refers to the molten glass in a furnace.

Melting point. When a solid changes its state to that of a liquid and vice versa, the temperature at which this occurs is called the melting point. The heat causes the molecular bonds to break down at this stage and maintains an energy input at that temperature until the change to a liquid is complete when further input of heat causes the temperature of the liquid to rise.

In the case of crystalline material this change occurs at a particular point whereas in the case of amorphous solids which tend to consist of many different minerals with many different bonds the break down occurs progressively and as a result melting takes place over a range of temperatures until the whole becomes a liquid. The temperature at which this becomes complete is then considered to be as its melting point.

Mensuration. This refers to the process of measurement and to the various formulae involved. For example,

Area of a rectangle = base x height
Area of a triangle = 1/2 (base x perpendicular height)

Merese. A type of flattened knop on the stem of a drinking glass.

Mesh. The sizes of the spaces between interwoven threads arranged in a sieve and used for separating particle sizes of batch materials. There is a difference between the approximation of the smaller sizes used in lawns to those used for larger sizes usually called riddles. In the lawn sizes, there is an assumption that the size of the thread approximates to the size of the aperture so a 100s mesh will have 100 threads and 100 holes per linear inch resulting in a hole size of 1/200 part of an inch across. This is assumed in respect of sizes from 5s mesh to 350s mesh. Above a 5s mesh which is approximately 1/10 of an inch across, the sizes relate to the diameter of a particle which will pass through a mesh. Unfortunately, slightly differing standards are used in various countries. 1/100 parts of an inch is approximately 254 microns.

Metal. In glassmaking terms, the word 'metal' refers to the molten glass in a furnace. As a chemical, a metal is an element which readily forms positive ions. Metals are characterised by their opacity and their high thermal and electrical conductivity.

Metal leaf. Precious metals reduced to a very thin section. Gold and silver leaf are often used to decorate the surface of ancient glass forms and in recent years have often been picked up onto a gob or a parison from the marver, covered with another gather and then blown out to show broken areas of gold or silver in the glass. The remarkable boxes made by Fujita are a prime example of the use of gold and silver leaf in glass forms.

Metal release. There has been much concern and legislation for many years about the nature of metal release from ceramic glazes. The principal metals concerned are:

lead compounds
antimony oxide
arsenic oxide
barium carbonate
beryllia
cadmium and selenium compounds
copper oxide and carbonate
potassium dichromate
zinc oxide.

In glazes the greatest danger appears to evolve from low or underfired glazes and enamels which have been exposed to the action of acidic liquids such as vinegar or fruit juices.

Stringent regulations exist in most countries and ware must withstand exposure to 4% acetic acid for 24 hours at room temperature for flat or storage vessels and to withstand boiling of acetic acid for two hours followed by a cooling period of 24 hours for ware which is to be used for cooking. This standard is being changed in some countries by the use of weak hydrochloric acid to replace the 4% acetic acid. A standard of parts per million of metal released, according to the regulations of the particular country must not be exceeded.

In Britain the current regulation calls for levels of:

For flatware.	Lead	20 parts per million
	Cadmium	2 parts per million
For hollow ware	Lead	7 parts per million
	Cadmium	0.7 parts per million

Storage vessels with a capacity of over 1100 millilitres:

	Lead	2.0 parts per million
	Cadmium	0.2 parts per million
For cooking ware	Lead	7.0 parts per million
	Cadmium	0.5 parts per million

Glass does not present problems to the extent of that experienced with ceramic glazes as the melting process is much more likely to produce a stable material. Nevertheless, there is some disquiet, particularly in the USA about the possibility of the release of lead in lead crystal ware, particularly that used for storage. As a result there has been a considerable reduction in demand for high quality lead glass which has forced a change in the nature of batch being melted in many studio workshops. Fortunately, there has been a surge of activity in researching suitable batches containing little or no lead but with similar qualities of clarity and brilliance. See **Lead poisoning**.

Metallising. The process of depositing metals other than silver on to glass.

Metamorphic. Rock which has been in the process of change. For example, sedimentary rock under the influ-

ence of high pressure can become much more compact whilst retaining the same chemical composition. Slate and hard coals are examples of metamorphic rock. Metamorphic rock can descend further into the earth, become magma and eventually re-appear as igneous rock.

Mica. A group of alumino-silicate materials related to montmorillonite, clay and feldspar, the most common forms being those of muscovite and biotite. Water does not enter mica and it can be cleaved into very fine sheets. In Roman times it was often used in windows.

Microcline. Potash feldspar. Chemically similar to orthoclase but with a different crystal structure. It is often found in granites and other igneous rocks.

Microglass. The very thin glass used for covering slips on microscope slides.

Micron. One millionth part of a metre. The correct term is now the micrometre.

Mill. This is a general term to describe any machinery used for crushing and grinding materials into smaller particles. It is also used to describe some of the equipment which is used for shaping or for producing flat surfaces on glass.

There is considerable variation in the kind of sophisticated large apparatus which has been developed for crushing ore and minerals, but the one which has been in existence for very many years and is still used in many areas for grinding down to grit sizes is a very simple machine. It consists of a revolving heavy steel pan upon which two large, wide, steel wheels, often up to two metres in diameter, run freely on separate shafts and

Figure 1. Drawing of a traditional roller mill. These are often of large size but very simple in design. They usually consist of two heavy cast steel rollers which can be up to 8 feet in diameter. They rotate freely on a horizontal shaft and are driven by contact with a wide steel pan which is driven so that it rotates horizontally. There are several variations in design. Sometimes the pan is driven from underneath and the rollers operate on a single shaft as shown or it can be driven from above on a vertical shaft in which case each roller runs on its own individual shaft. The pan is usually fitted with holes to allow the ground particles to fall through. There is also a static blade which pushes the materials towards the centre of the pan.

revolve from contact with the steel pan and its contents. The minerals are simply shovelled onto the pan, often together with a little water, and are ground down between the pan and the wheels.

In recent years, machines called vibro energy mills based on a vertical vibratory system have been introduced and are considered to produce much more rapid results. Another type of mill which is commonly used is the Hardinge continuous mill. This has a conical shape and rotates horizontally. The larger materials tend to remain at the widest circumference and as a result have further to fall as the container revolves. Smaller particles gradually move towards the mouth where they emerge as powder.

The type of mill used for grinding a flat surface on glass is often called a 'flat mill' and consists of a flat and

Figure 2. One modern equivalent of the roller mill is the horizontal grinding mill. This is basically cone-shaped as shown and rotates horizontally.

circular cast-steel plate or a large circular stone with a flat face set to revolve horizontally on top of a vertical shaft. This is fed with a mixture of water and abrasive grit in the case of the steel mill and with water if it is of stone.

A recent addition to this type of machine is one in which the flat steel plate is replaced by a cast-steel pan which, instead of providing a grinding action by revolving, has an orbital movement. In this case it is charged with water and the appropriate grinding medium. The glass to be ground is placed in the pan and left to be ground by the orbital movement. This has the advantage of carrying out the process more or less automatically whereas the traditional flat mill requires an operator constantly to move the glass around the surface. Another recent variation is a machine fitted with a plate which has diamonds on its surface. The plates are interchangeable in order to produce various grades of abrasion as required.

Millefiori. Literally 'a thousand flowers' and used to describe small mosaic sections of glass made by fusing and marvering together regular arrangements of coloured glass cane, then pulling out the resulting thick form to produce a length of multicoloured cane. This is cut or chopped into small pieces. These are used mostly for picking up onto a gather of hot glass from the marver

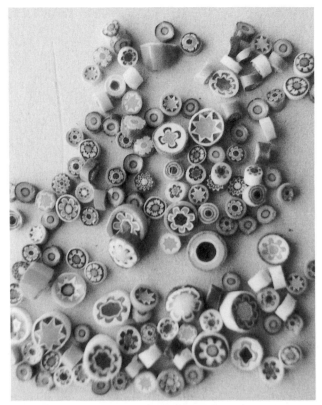

Small pieces of millefiori cut from cane and ready to be arranged for fusing prior to slumping into a millefiori bowl.

for inclusion into paperweights. There is also an occasional use for them in making small mosaic bowls.

Minerals. Mostly inorganic material with a specific chemical formula recovered from the earth by mining or quarrying. It normally refers to crystalline material but the term is also used loosely to describe materials such as the feldspars, clays etc., which have a variable composition and which do not form single crystalline structures. It is also used in industry to describe the various oxides, silicates etc., recovered from minerals for use in the glass-making process.

The rocks from which we extract the materials are either igneous, in which case they have been partly or completely molten, sedimentary, composed of deposits laid down by water, wind or ice, or metamorphic which refers to materials which have recrystallised under the effect of heat, pressure, time and stress. Examples of igneous rocks are granites and basalts. Among the sedimentary rocks are clays, sandstones and limestones. Those of the metamorphic are marbles and slates etc.

Mirrors. Glass provided with a reflective coating on the back. The coating used to consist of an amalgam of mercury and tin but is now almost always of silver deposited by a variety of methods. See **Silvering**.

Mix. The glass batch prepared for loading into the furnace.

A mixed media piece using steel, glass tubing and glass rods.

Mixed media. Until recently, forms of glass sculpture and glass vessels have been constrained by remaining wholly glass, apart from the application of some metals by gilding, electroplating etc. There is now a considerable amount of work, particularly as sculpture, in which glass is seen simply as an integral part of a structure which might contain a variety of other materials. It is relatively easy to use metal, ceramics and stone with glass as there seems to be a natural affinity between these materials but wood, whilst it can be very effective, seems to be much more difficult to marry to glass. Perhaps it is simply the fact that wood, as a warm organic material, has a character in contrast with the hard brilliance of glass. Two examples are shown, one with stone and the other with metal. The possibilities for exploiting the concept of mixed media are obvious.

Another mixed media piece using stone and glass.

Model. The original form from which a mould is made.

Modifiers. Used in the glass industry to describe the various oxides other than those which are the actual glassformers. They are mostly those concerned with producing a fluxing, stabilising or colouring action in the glassmaking process.

Mohs' scale of hardness. This was developed by Friedrich Mohs, a German minerologist, to give a convenient range of mineral hardness to be used as a point of reference for describing the hardness of other materials. It presents a convenient sequence rather than a regular progression. It is:

1. Talc
2. Gypsum
3. Calcite
4. Fluorspar
5. Apatite
6. Orthoclase feldspar
7. Quartz
8. Topaz
9. Corundum (alumina)
10. Diamond

Theoretically a material with a higher number will scratch a material with a lower number. This offers the opportunity to distinguish between minerals of similar appearance.

Moil. Overblow. A glassmaker's term for the glass left on a blowing iron after the piece being worked has been knocked off or transferred to a punty iron. The glass usually ends up in the cullet bin for inclusion in another founding. Moils were collected from a glass factory and used to establish some beautiful glass parterres in the garden of a museum at Theuern, Ostbayern in Southern Germany, by Ursula Merker of Kelheim.

Moils from factory waste used by Ursula Merker to construct a series of parterres in the garden of the Schloss Theuern.

Mole. A term which seems to crop up regularly in reference to material calculations is the 'mole'. This is one of the accepted international terms of measurement and is often used to indicate a sufficient weight of a material to be viable in a practical sense. Atoms and molecules are very tiny particles and are almost impossible to visualise as quantities. The mole is defined as having the same number of particles as are found in 12 grams of carbon – 12. This calculates as being 6.000×10^{23} (or 6,022 with 23 digits after 6). This means that there are 6.022×10^{23} atoms in a mole of a particular element or 6.022×10^{23} molecules in a mole of a particular compound.

For example, a mole of hydrogen will weigh 1 gram. As this is a standard reference point it means that a mole of an element such as aluminium with an atomic weight of 27 will weight 27 grams. It also means that a mole of silica with a molecular weight of 60.1 will weigh 60.1 grams.

For the purposes of measuring reasonable quantities a mole is very useful but when being used for comparative purposes it is probably just as convenient to use the atomic or molecular weight.

Molecular weight. The sum of the weights of all the atoms which make up a molecule.

Molecule. One of the groups of atoms of which substances consist. The smallest portion to which a substance can be reduced without losing its chemical identity. It is used as a theoretical unit in the consideration of batch recipes. In many covalent compounds the molecules consist of groups of atoms held together with covalent or with coordinate bonds. There are extremely small crystals which have no separate molecules and where in fact, the crystal itself forms the molecule. Ionic compounds also do not have single molecules as they consist of collections of oppositely charged ions.

Molochite. Calcined china clay often used as a relatively iron-free grog for re-inforcing the refractory clays used for making glass pots. When the china clay is calcined, the resulting Molochite contains mullite and amorphous silica glass which gives the material a low thermal expansion and high resistance to thermal shock. These qualities coupled with the low-iron content make the material ideal for use as a grog in pot making.

Molybdenum. A silver-white metallic transition element used in steel alloys to make high speed tools. It is used together with tungsten for making the special furnaces for melting silica. Molybdenum silicide is used for making high temperature electric elements. The oxide is a stabiliser and can be used in the production of yellows in glass.

Mono. In chemical terms it refers to a combination with one atom or with one molecule. For example, BaO refers to one atom of barium with one atom of oxygen.

Monoxide. A molecule which has one atom of oxygen combined with either one or two atoms of another element. For example:

CaO Calcia or calcium monoxide
K_2O Potash or potassium monoxide

Montmorillonites. A group of siliceous minerals with very fine, flat hexagonal crystals. They are related to kaolinite. Those which are most used are talc and bentonite.

Mosaic glass. The process of making mosaic glass is thought to date back to the 15th century BC. It involved making canes of coloured glass, sometimes involving several colours, and cutting them into small sections. They were often cut into beads and fused together to form plaques. Vessels were made by placing the small sections in appropriate arrangements onto a suitable fireclay form, using an adhesive to hold them in place as necessary, and then firing the whole until the mosaic pieces fused together. The results were then ground and polished. The Venetian millefiori were simply a development of this technique. It has surfaced at various times since and some contemporary artists have produced work based on the same method of making cane and then cutting it into short lengths to be fused together to make plates and bowls. The mosaics used on the walls of Byzantine churches were mostly made from tesserae (small squares of opaque coloured glass).

Moss agate. A type of glass produced by Frederick Carder in cooperation with John Northwood at Stourbridge for Stevens and Williams. It was made by overlaying lead glass on a gather of soda-lime glass. Powdered colour was then picked up from the marver and covered with another layer of lead glass. When the vessel was formed, cold water was introduced to crackle the interior soda-lime glass. It was then re-heated so that the cracks re-joined to give the characteristic appearance of what was then marketed as 'Moss agate' glass. See **Carder**.

Motors. Electric motors are an essential part of the glass workshop. They are used to power saws, grinding, cutting and engraving equipment. They are also used to drive the fans necessary for most burner systems and the compressors used for sandblasting etc.

In Europe they are used on either a single-phase or on a three-phase system. The single-phase uses 230 volts at 50 cycles AC and the three-phase 400/230 volts also at 50 cycles AC. Three-phase motors are generally smaller in relation to their power output than the single-phase motor. What is not generally realised is that three-phase motors produce a smoother rotation than the single-phase motors and this becomes very important to the artist using a cutting or engraving lathe who is constantly searching for the smoothest possible action.

Electric motors work because of the simple principle that a wire carrying a current is subjected to a force when it is in a magnetic field which can be used to turn the rotor, the size of the force being proportional to the strength of the field and the current in the conductor. There are several types available. See **Electric motors**.

Moulds. The negative form into which glass is either cast or blown. Moulds to the glassmaker are either those of metal, wood or graphite used for forming blown glass, metal moulds for pressed glass or those made from investment materials and used for forming glass in a kiln.

Glassmakers in small workshops do not normally need the expensive permanent moulds used in factories as they are rarely concerned with long production runs so they tend to make their own.

Simple box moulds can be made from slabs of wood. Moulds for bowl shapes are easily turned from blocks of wood. Cylindrical moulds are made from steel tubing and from various plaster/grog mixtures. Refractory cement mixtures can be used for more complex moulds. The plaster mixes for blowing moulds are usually formed from approximately 60% powdered flint or quartz together with 40% plaster. The dry components

Glass structure by Willi Pistor.

Above and right: Self Portrait by B. van Loo. Photographs by Edward Jacobs of Amsterdam.

'Eostra', engraved form by Alison
Kinnaird.

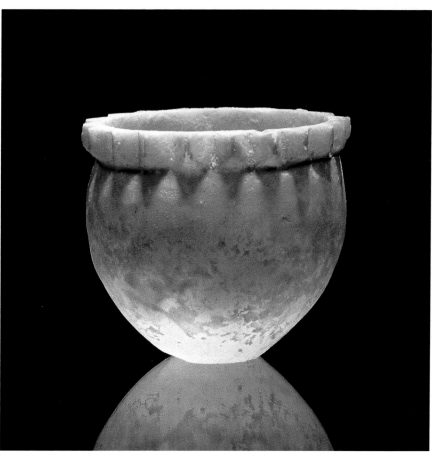

Pate de verre bowl by Margaret Alston.

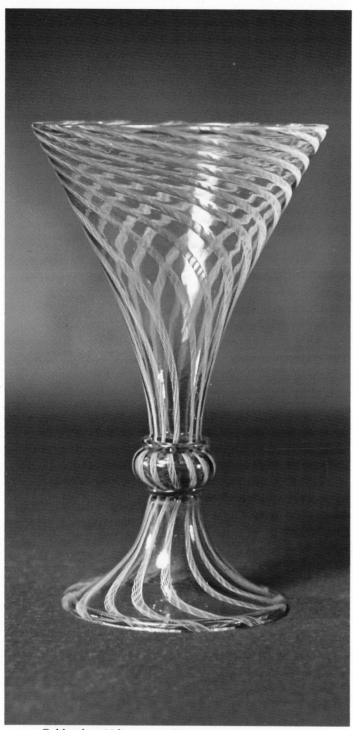

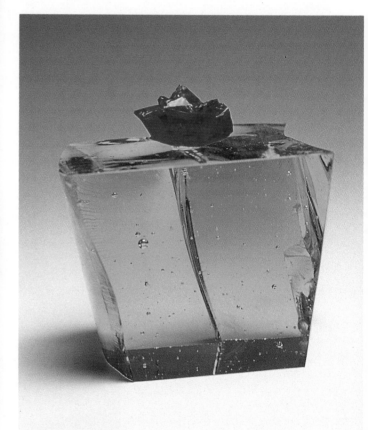

Goblet, late 16th century, Venetian style. Courtesy of Pilkington Glass Museum.

Red and Yellow Object by Anna Carlgren, 8 x 8 x 8 cm. Photograph by Durk Valkema.

Right: Tall cylinder, untitled, by Anneke Sandström.

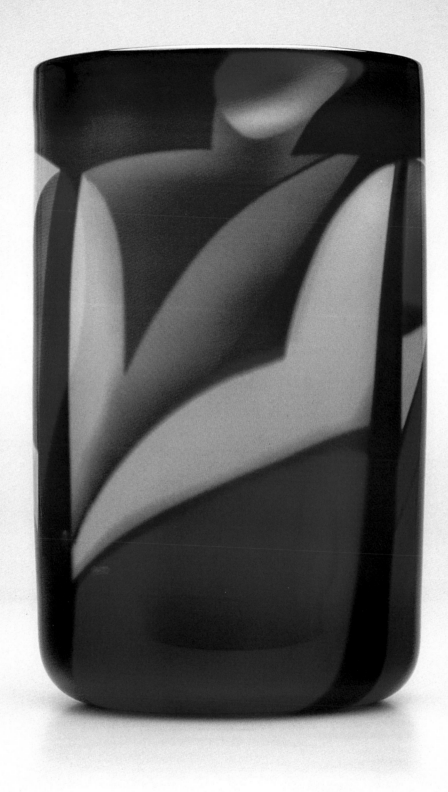

Top: Electroplated form by Keith Cummings. *Above:* Iridised bottles by Siddy Langley.

Cast and assembled figure in borosilicate glass by Charles Bray. Photograph by Roger Lee.

'Opalina' by Anna Carlgren. Glued, cut and polished object, 25cm high. Photograph by Durk Valkema.

Complex piece of cut, ground, assembled and polished
optical glass by Josef Tomecky. Photograph by Jean-Louis
Hess. Courtesy of Galerie H.D. Nick.

are often mixed in a domestic-type blender, sometimes together with some ceramic fibre before being introduced into the water. It is possible to blow several pieces from these moulds with careful use before they start to disintegrate. They always need to be pre-fired before use. Refractory cements such as Ciment Fondu and Secar make more permanent moulds when used with suitable refractory aggregates.

Both types need to be used wet and may need to contain small holes leading to the outside surface to allow steam to escape. The resin-bonded sands used in foundries for metal casting are also very good for making moulds for blowing. These foundries are usually willing to supply the small quantities required by the studio glassmaker. Simple moulds made from steel rods welded vertically from a steel base can be used to blow corrugated forms and loose moulds made from wire mesh can be used to produce individual pieces.

Moulds for slumping and casting glass are easily made from a mixture of 50% plaster and 50% powdered flint or quartz. Those used for slumping can often be used more than once but the casting moulds which are taken to a higher temperature tend to disintegrate rapidly. Some artists make their moulds for kiln work in two parts, the inner layer being similar to the mixture already described, the outer layer being of a stronger mix containing grog or Molochite and sometimes made with refractory cement rather than plaster.

Muff. The blown glass cylinder prepared for cutting into sheets.

Muffle kiln. When the kiln contains a permanent box-like structure heated by an external source so that neither flame nor direct heat from electric elements can impinge on the material being heated, it is known as a muffle kiln and the box is known as the muffle.

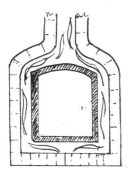

Section through a muffle kiln.

Muller. A piece of solid glass comprising a handle with a thickened and flattened base. It is used to grind enamels together with an appropriate medium to a fine, consistent material suitable for painting.

Mullion. The upright dividing piece between window lights.

Mullite. $3Al_2O_3.2SiO_2$. An alumino-silicate much used for refractory blocks in furnace construction. Its long, square-section, needle-like crystals give the material considerable structural strength. It is named after the natural forms found on the island of Mull and is often introduced into fireclay bodies used for making glass pots in the form of the calcined alumina, Molochite.

Murano. The glassmaking centre close to Venice which evolved when the glassmaking activities were moved from Venice to the marshy area around Murano because of the fear that fire might spread easily in the densely packed buildings of the city. It became famous for the production of Venetian glass over several centuries.

Muscovite. See **Mica**.

Musical instruments. Musical instruments made from glass were much more common than most people would believe. Music hall acts often presented simple arrangements of bottles which were partly filled and made to produce sounds by blowing across the tops. Goblets were also commonly used to produce sounds by running a finger around a wet rim. So-called 'Flip Flaps' were often made by the glassmakers. These consisted of a wide-bodied bottle with a slender neck and an extremely thin base which vibrated as the player blew down the neck. It produced a different sound as the air was sucked out, hence the name. Various types of trumpet were made all over Europe and the Orrefors factory in Sweden still has a works' band which plays instruments made from glass. The musical instrument which made the most impact in the past was probably the glass harmonica, reputedly invented by Benjamin Franklin in about 1760. It became very popular throughout Europe and America and some 300 compositions for the instrument have been found. It consists of a series of glass cups growing progressively smaller from one end to the other. They were mounted on a horizontally placed metal rods which rotated by means of an electric motor and separated from each other with cork rings. Gerhard Finkenbeiner of Waltham, Massachusetts, USA built up a considerable reputation for making glass harmonicas. Vera Meyer also from the USA bought one from him and has now built up quite a following and demand for her performances on the instrument.

There has been some recent research into the possible development of glass musical instruments in France. Two musicians made several instruments based on glass rod and tubing together with aluminium sheet and amplification systems to produce some very impressive sounds.

N

Natrium potash. NaKO. Also known as kalium soda.

Natron. Hydrated sodium carbonate found occurring naturally around soda lakes.

Natural glass. This is usually formed as a result of volcanic action when molten rock cools too quickly to assume a crystalline structure.

Obsidian is probably the most common and best-known form. It is a black glass rich in silica and results from the rapid cooling of molten granitic rock. It was much used by pre-Hispanic cultures in Central America for making ceremonial knives used for ritual sacrifice. It was also the material commonly used for the production of flint knives.

Some of the other examples, known as tektites are caused by meteorites falling from outer space and striking the earth. It has been suggested that these are the earliest known forms of natural glass, some samples having been dated at around 4500 million years old. Some of the glass is thought to result from the fierce impact on the Earth's surface.

Lightning striking the earth in sandy areas can vitrify the sand to form long tubes of silica glass called fulgarites. Some of these can exceed six metres in length.

The other form of natural glass is pumice. This is formed by volcanic action in which molten materials that would normally cool to a crystalline state are vitrified into a glassy form by rapid cooling. The gases released by the volcanic action are caught in the glass to form a foamed material which has been a valuable source of polishing material for many centuries.

Basalt is sometimes called a glass. In fact, it is a heavy, crystalline, iron rich material which very rarely forms a glass. There is one slight exception and that is in what has become known as 'Pele's hair' or Goddess's hair. This occurs when the molten basaltic volcanic rock is caught by strong winds and blown into thin strands. As these cool very quickly, they turn into a natural form of glass fibre.

Neodymium. Nd. A rare earth in the lanthanide series used in its oxide form both for colouring where it produces a range of violet-purples and as a decolourising agent to counter the effect of iron in the batch materials. Also used as the carbonate. Usually contains small percentages of other lanthanides.

Neon. An inert gas which has been used for many decades for the provision of illuminated signs. Glass tubing is bent to the necessary shape, evacuated and filled with neon gas. An electrical discharge then causes it to produce red light. Different colours can be obtained by using different gases. For instance, xenon produces blue light.

Nepheline – approximately $K_2O.3Na_2O.4Al_2O_3.9SiO_2$. A feldspathoid mineral often introduced into glazes and finding occasional use in glassmaking. The various feldspars are more likely to be used to introduce alumina into a batch but where nepheline is readily and cheaply available, it can prove to be an economically viable batch material.

Network. This refers to the arrangement of points where atoms or molecules of a solid material are located. Various types of diagram are used to show the three-dimensional illustrations of these. If the arrangement is a constant repeating pattern then it will indicate a crystalline structure and is called a lattice. If, on the other hand, the network is random than the material will be amorphous as in the case of glass.

Network showing (a) the regular arrangement of atoms in a crystal and (b) the irregular arrangement of the atoms in an amorphous material such as glass.

Newton. This is a measurement of force which is often used in reference to the testing of glass.

Forces of short duration are called impacts and this term is relevant when we speak of the impact strength of glass. The fact that a freely moving body when acted on by a constant force moves with a constant acceleration is used to provide a precise scientific definition of a unit of force. Namely:

'The unit of force is that force which, when acting on a body of mass 1 kg produces in that body an acceleration of 1 metre per second per second. (The force causes the velocity of the body to increase by 1 metre per second, every second.) The unit defined in this way is 1 Newton.'

Nichrome. A trade name for heating elements used in kilns and based on alloys of nickel and chrome.

Nickel. Nickel is a metallic transition element which is often combined in alloys with other metals. It is used as a component of brass and together with chromium for making stainless steel and electric elements. It is usually found in ores associated with arsenic and sulphur. In glassmaking, the oxide can be a colour modifier but as it tends to separate out of the melt above 1200°C (2190°F) its use is limited except in the production of special glasses.

Nitre. Saltpetre. Potassium nitrate. Used in small quantities in batches as part of the refining material.

Nitrides. Compounds of nitrogen with a more electropositive element. Boron nitride has become an important abrasive and silicon nitride is being increasingly used as a replacement for metals in situations where a very low coefficient of expansion coupled with strength is advantageous.

Nitrogen. A gas that makes up a large part of the normal Earth atmosphere. When gas or oil is being used for firing quite a lot of fuel can be expended on simply heating this material so it is essential to control the amount of excess air entering the combustion process.

There has been considerable concern lately with the production of nitrogen oxides in combustion and much research has been carried out and is currently progressing into methods of reducing these. Some involve the use of oxygen either on its own or together with air in burner systems. Others involve specially designed burners and also the injection of ammonia into the exhaust gases in the flues.

Nitrogen is pentavalent and forms many compounds. It is commonly used in the manufacture of fertilisers, explosives and disinfectants.

Non-return valves. These are valves inserted into gas and air lines in burner systems to ensure that gas, air or, in particular, a potentially hazardous gas/air mixture cannot flow back along the line.

They are designed so that the flow lifts diaphragms from a spring-loaded valve head and is then allowed through with very little drop in pressure. In the event of the slightest return pressure, the diaphragms fall back upon their seats and prevent any return flow.

Norman slabs. If a gather of glass is blown into a rectangular box, the sides and base tend to be thick in the centre and thinner towards the edges. The resulting form when cut into panels from the four sides and the base produces small sheets of glass of a character which were very popular for some types of glazing. They are rarely produced nowadays but factories producing stained glass will often make them to order. Why they should be called 'Norman slabs' is not apparent as there seems to be no evidence to associate them with either the Normans or with Normandy.

The production of Norman slabs.
1. A large gather is blown into a rectangular wooden box.
2. The shape as it is drawn out of the box.
3. The sections are shown as they are cut from the blown glass.

Nucleus. The central core of an atom which contains most of its mass.

O

Obsidian. A natural form of volcanic glass, usually black in colour. It was commonly used to form ceremonial knives in pre-Hispanic America. See **Natural glass.**

Ochre. General term for clay with a very high content of iron oxide. It is known mostly as a paint pigment but it has often been used as a polishing material for glass.

Off-hand working. Sometimes known as free blowing. It refers to glass which is gathered and worked without the use of moulds or machinery.

Ohm. A unit of electrical resistance. The resistance between two points on a conductor when a constant potential difference of one volt is applied between those points produces a current of one ampere in the conductor. See **Electrical terms.**

Oinochoe. Wine pourer. One of the Hellenistic pitcher forms used as a basis for core-formed vessels which in turn were used for perfume and oils.

Oligoclase. A feldspathic material mostly consisting of soda feldspar which usually also contains about 25% of lime feldspar.

Olives. Elliptical cuts or printies made into glass with suitably shaped wheels on a glass lathe.

Oolite. $CaCo_3$. Oolitic limestone. A form of limestone usually found in spherical shapes.

Opacifiers. Opal glasses have been in evidence for many years. The Venetians certainly produced an opal glass which is known as Lattimo.

Tin oxide, titania and zirconia tend to be used to produce the enamel type of opal which is usually a dense white because of the slow solution into the parent glass. This is in contrast to the rather milky translucent appearance of the opals produced by arsenic, antimony, the phosphates and the fluorides.

Other opacifiers include niobium pentoxide, zinc sulphide, cryolite, fluorspar (calcium fluoride) and bone ash. In more recent years fluorosilicate (Na_2SiF_6) has become available as a by-product of the fertiliser industry and is now used for the production of fluoride opals.

Making and handling opals in a studio has always seemed to produce problems. Phosphate opals probably present the least of these but much depends on the nature of the base glass. Because bone ash is essentially calcium phosphate, introducing it into a soda lime glass could easily introduce a surfeit of calcia into the melt with the result that it becomes too stiff to work easily. Barium and zinc glasses are popular as base glasses for phosphate opals as they seem to be able to hold the phosphate in solution. Lithia is also thought to help the melting process considerably. The amount of bone ash required can also vary a great deal from one base glass to another. Whereas about 7% might be required for a glass containing barium and zinc, as little as 2% would produce similar results in a high lead glass. Bone ash as supplied is a bit of a variable feast and industry often needs to turn to a chemically prepared product to ensure continuity of stable production.

Opal glasses are also notorious for changing as they are worked. When gathered there can be a normal transparent parison which will start to strike towards white in the re-heating. Continued re-heating creates more crystals and develops those that are already there resulting in the glass becoming too stiff to work.

Phosphate opals tend to be translucent rather than being truly opaque and in order to achieve an opal which is more dense some manufacturers add a little tin oxide. Fluorine opals present different problems. Most of these result from the fact that whilst a suitable batch can be calculated, there is a continuing loss of fluorine from the melt both during the founding and whilst the glass is standing or being worked. They also seem to react strangely to modifications when they are introduced to change the expansion to suit another glass, possibly due to changes in the nature of the phase separation.

Opal glass. Any glass with a white milky appearance.

Opaque glass. In stained glass terms this is used rather loosely to include glass which is translucent as well as that which is truly opaque. Any glass which is not transparent therefore becomes 'Opaque'.

Optical fibres. These are glass fibres forming a glass core of between 6 and 250 microns diameter which is surrounded by a glass or plastic cladding which has a lower refractive index. The interface between the core and the cladding acts as a mirror to reflect the transmitted light and allows a beam of light to travel considerable distances through the fibre. They are used for various medical instruments and for telecommunications.

Optical flats. Flat glass discs which have very accurately polished surfaces so that the variation from perfect flatness does not deviate more than 50 nanometres.

Optical glass. Much research has been carried out into the production of glass with all the qualities of homogeneity and refractivity necessary to provide ideal optical qualities. It must be free from seed and strain.

Optical glass used to be melted in fireclay pots and after much stirring to achieve homogeneity, allowed to cool. The pot would then be broken open and the lumps of glass carefully sorted into suitable pieces for cutting, grinding and polishing into lenses and prisms. Later, both pots and tanks used for melting optical glasses were often lined with platinum to avoid contamination by the refractories. Pots were often removed from a furnace to enable the glass to be poured into suitable moulds to form blocks sometimes as large as 2 metres square by 25 cm thick which would be annealed over several weeks. Much of the early research on optical glasses was carried out by Michael Faraday who investigated a considerable number of lead-borosilicate glasses in this context. Optical glasses based on lead usually have a refractive index in the range of 1/58 to 1.72. In many of the modern optical glasses lead oxide has been replaced by barium oxide. Lathanum oxide is also used to produce optical glass with special qualities of low dispersion and high refractive index.

Organic. Relating to matter which is, or has been, living. Organic chemistry refers to compounds containing carbon.

Ortho. A term used in chemistry to indicate a normal balance of atoms or molecules within a crystal structure.

Orthoclase. Potash feldspar. $K_2O.Al_2O_3.6SiO_2$. This is a natural potash, alumina, silica frit which can be found as large crystals or as parts of some granites. Potash feldspars are not always the pure orthoclase material and are often supplied as including up to 20% of other feldspars. It is used to introduce potash, alumina and silica as part of a batch.

Ovenware. A general name for domestic ware, mostly of borosilicate glass, which resists the thermal shock likely to occur in cooking processes.

Overlay. A layer of glass gathered over a layer of a different coloured glass.

Overshot. Craquelle. Ice glass. Glass which has been given a distinctly cracked surface. See **Ice glass**.

Oxford spar. A type of potash feldspar which is mined and used as a batch material in the USA.

Oxidation. The addition of oxygen to a compound. Any reaction which involves the loss of electrons from an atom.

In reference to practical glassmaking, it usually refers to the maintenance of an oxidising atmosphere in the furnace in order to prevent changes to the metal which might result from the action of a reducing atmosphere. The situation in which oxygen is lost is known as reduction. Reduction has been accepted as also relating to reaction with hydrogen. Latterly, a wider definition has emerged in which oxidation refers to a loss of electrons and reduction refers to a gain in electrons. The consideration of oxidation and reduction together has become known as 'Redox'.

Oxides. These comprise a combination of oxygen with another element and are essential to the process of glassmaking. The main glassforming oxides are: silicon dioxide (silica) SiO_2 and boric oxide, B_2O_3. Other oxides provide the materials which act as fluxes, anti-fluxes, stabilisers, opacifiers and colourants. See **Batch materials**. There is a wide range of colouring oxides and these are described under **Colour**. Some, particularly the monoxides such as cobalt oxide and copper oxide, act as fluxes during the founding processes whereas others such as vanadium and cerium act as anti-fluxes. Oxides of non-metals are covalent compounds with simple molecules (CO, CO_2 etc.) or molecular lattices such as SiO_2. They tend to be either acids or neutral. Oxides of metals are ionic and are generally basic or amphoteric.

Oxidising agent. Oxidant. Any substance which is capable of effecting the chemical change known as oxidation. It does this by being reduced itself.

Oxy-acetylene burner. Commonly a welding or cutting torch which burns a mixture of acetylene and oxygen in a fine jet to produce a tip temperature of 3300°C (5970°F). It is rarely used by lampworkers because it tends to produce 'dirty' glass and because acetylene has a much wider range of ignition in proportion to air than either natural gas or propane. This makes potential leaks much more dangerous. Oxy-propane is more normally used for general lampworking with glass and fused silica.

Oxygen. O. A colourless, gaseous element of Group VI of the perodic table. It is present in the atmosphere of the earth as about 28% of the total in volume. It is essential for combustion. It combines with elements to form oxides, many of which form the basis of the materials used to make glass.

Oxygen is increasingly used in furnace combustion systems as a possible method of reducing the amount of nitrox emissions. There is currently much research being carried out into its use in this context because of increasing environmental pressure and subsequent regulations.

Oxygen/carbon sensor. This is a useful electronic device which can be used to analyse the exhaust gases to show levels of carbon monoxide and carbon dioxide and so give some indication of the efficiency of the combustion.

P

Pad base. A bulb of glass attached to the underside of a piece of glass that is being worked and then splayed out to form a base.

Paddle. A small tool used by a lampworker. It consists of a slab of carbon fitted with a handle. It is used to marver and shape the rods or tubing being worked.

Painting. Glass painting is a term understood by the traditional stained glass artist to refer to the practice of applying water/gum arabic-based colour, usually browns or grey browns, to the inside surface of stained glass in order to produce the drawing, shading and matting required to indicate figures, drapery etc., or simply tonal modifications. It is applied in a manner similar to that of applying watercolour to paper. Enamel painting is something totally different and is based on finely powdered, low-melting glass particles ground together with aromatic oil and applied more likely artists' oil paint.

Both types of paint are fired onto the glass, but enamels have not been used to a great extent over the years for windows because the sheets of coloured glass used for such windows have tended to have widely differing coefficients of expansion. This has often caused enamel to flake off on cooling or, even worse, when a window has been *in situ* for some time. Another problem which affects both types of painting, but enamel rather more because of the higher firing temperatures required, is that some of the basic coloured glass changes colour during the firing. The selenium-cadmium based colours are the most difficult and it can be most disconcerting for an unsuspecting artist to find a rich transparent red changing to an opaque orange or even a grey black as a result of firing. Some of the beautiful carbon ambers can darken considerably. On the other hand, most blues and greens remain relatively stable.

It is essential to conduct tests on the glasses likely to be used in order to establish a list of those which change colour and those which are likely to create problems of incompatibility. When enamels are used commercially or in the studio, they are mostly applied to blown or moulded ware in which case the expansion of both the glass and the enamels will almost certainly have been checked beforehand. Despite all the possible disaster areas, many artists today are becoming increasingly experimental and modern stained glass windows often contain sections of fused colour, glass containing wire, glass fibre, other seemingly unlikely materials and vigorous applications of coloured enamel.

Another form of glass painting has emerged recently using the application of commercially-prepared colours in liquid form which do not need any firing. They are intended to replicate the effects of stained glass and have gained some popularity at the cheaper end of the market. They are not a serious contender to well-produced stained glass and just how permanent they will prove to be is something which might soon be evident.

Just as the glassblower needs to develop a constant awareness of the state of the glass on the end of his iron so a stained glass painter needs to develop a similar instinct for the condition of his paint. Much depends on knowing just how much water to introduce to make the paint work as intended and just how quickly it will dry on the glass. The paint always needs to be mixed and ground well on a palette (usually of thick plate glass) before use. The usual procedure is to form a small hill of the powder on the palette which is then opened out in the centre with a palette knife. A small amount of water is introduced, followed by some liquid gum arabic (about a quarter of the amount of water) and a little of the powder drifted from the sides of the hill and mixed in. More water is then added and more powder mixed in from the edges and the process repeated and turned over until the whole is formed into a smooth paste. The result should not be too runny or too stiff but only practice will establish both the right consistency and the right amount of gum to include to avoid creating a mixture which will set like concrete on the surface of the glass or which will be so dry and friable that it will come away to leave bare or badly textured areas.

There are two basic approaches to glass painting. The first is the traditional one used for many centuries, of painting a layer of thin paint called a 'matt' over the whole surface and then working back into this to reveal the light and colour as necessary. The second, which has become increasingly popular with modern artists, is to introduce the paint only where necessary to achieve the shading, linear qualities, tone or obscuring that is required. This tends to produce a more vigorous and spontaneous result. The paint can be applied either to a horizontal or a vertical surface. Most artists use a mixture of the two depending on just what effect they wish to create. When the glass is horizontal, smooth paint areas are produced whereas in the upright position whilst being better for seeing the work, considerable control is needed to avoid the problems of the paint running or creeping down the glass.

Palette. Most people think of a palette as being the shaped piece of wood used by painters to hold their colours but to the glassmaker it is a rectangular wooden tool for smoothing to the bases and rims of vessels. It also describes the piece of flat glass used for mulling and mixing glass enamels.

Pan. Common name for a large mill used for grinding raw materials, particularly shales, grogs and minerals. It consists of two large cylindrical wheels which rotate round a horizontal disc which sometimes has small holes in it; it also has sides to contain the material being ground. See **Mill**. The material is usually dry but where there is likely to be a dangerous dust problem and the resulting powder is not soluble, then sufficient water can be added to solve the problem.

Pandermite. A mineral containing both calcia and borates. It is of variable content and is rarely used because of the availability of more consistent sources of boric oxide.

Paperweights. These are one of the most popular forms of glassware made for general supply to the public. They are relatively easy to make and usually sell readily as the public often find them attractive and collectable. They can be found in infinite varieties, some highly imaginative and interesting and others downright garish. Many

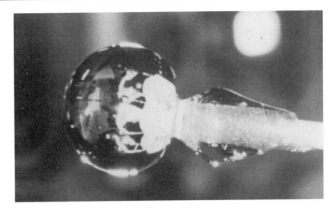
Paperweight ready to be cracked off the punty iron.

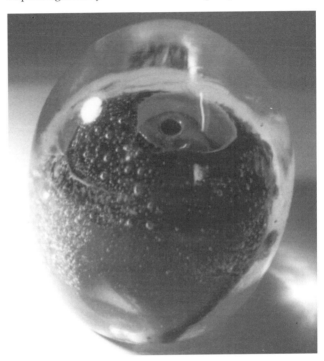
Paperweight incorporating bubbles.

Section through a cylinder incorporating short sharp spikes used for introducing air bubbles into a gather for making into paperweights. This is commonly called Spot Mould.

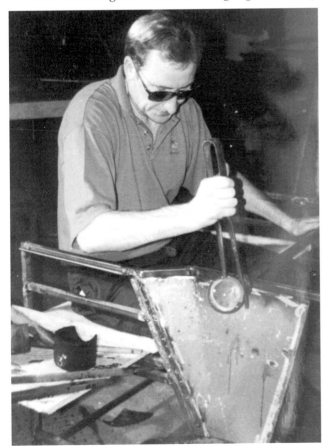
The paperweight being cut in with the pucellas.

makers produce runs of them as stock lines to supplement their other wares.

Most of them are made by making a gather and pressing this vertically onto millefiori cane or coloured glass pieces, shaping these as necessary and then covering the whole with a further gather of clear glass. This is then

blocked into a spherical shape and cracked off into the annealing kiln or lehr for annealing. A flat is then ground on the base. Bubbles can be introduced by simply poking a spike into the first gather. Fine misty swirls can be produced by picking up small amounts of find sand. Some are very complex with a great deal of work being carried out before the final covering gather is made. Oiva Toikka has produced interesting cubic paperweights and John Smith has made some very original whimsical pieces as shown here.

Paris white. An old name for whiting (calcium carbonate).

Parison. Paraison. The initial gather from a furnace formed into a bubble ready to be shaped and worked by the glassmaker.

Parrot nose shears. Shears which whilst they can be used for shearing have a part of the nose which can be used for holding punty irons when they are being attached to work in progress.

Particle size. Used to define very small grains of material, usually those of less than 50 microns. The term 'grain size' is usually reserved for those larger than 50 microns. In terms of the sizes relating to batch materials, extremely fine particles are not necessary. These are only likely to be required for decorating materials such as fine painting or silk screening enamels, and for the various abrasive materials used for fine grinding and polishing.

Smaller batch particles which could not realistically be described as 'Fine' do find some favour and much data is constantly appearing on optimum sizes for the particles of batch materials.

Parting agents. Materials painted onto the surface of models or moulds to enable casts to separate cleanly.

Pate de verre. (Literally, a paste of ground glass). Forms made from glass pastes have been produced since the manufacture of pre-blown glass from Phoenicia and Egypt. The process was revived by several artists working in France around the end of the 19th century and the beginning of the 20th century, particularly by Henry Cros, Francois Decorchement and Gabriel Argy-Rousseau. Other artists who became involved include: Albert Dammouse, George Despret, Ringel d'Illzach, Almeric Walter and Henry Cros's son Jean.

Gabriel Argy-Rousseau developed a mould using a mixture of sand, plaster and china clay which would stand his firing temperature of 880°C (1610°F). He also experimented until he found a method of compacting a paste of glass grains and organic gum against the sides of his moulds and then supporting this by packing the inside with asbestos fibre. The results resembled a thin, fragile crust of fused sugar. A similar process is used today by several artists. Most of them use a simple mixture of 50% plaster and 50% flint as a mould, apply the glass paste in layers in exactly the same way, compact it by rubbing it with the back of a spoon and packing the inside with ceramic fibre instead of the asbestos. Some artists use ceramic moulds but it is essential to apply a very good separator to a ceramic surface as taking a pate de verre piece from a mould is quite a delicate operation. Others have experimented with making a paste of glass grains and bentonite or with making a casting slip of glass grains, some china clay and a suitable deflocculant.

Two outstanding current exponents of the delicate pate de verre technique are Margaret Alston and Diana Hobson. See **Argy-Rousseau**.

The term has now become generally accepted as describing a wide range of cast glass objects which, strictly speaking, bear little resemblance to the concept of glass pastes. Some of them could be legitimately called pate de verre as they are produced by a process of sintering glass grains together in a suitable mould but many others result as very solid objects from more general casting techniques.

The Leperlier brothers in France, who are descendants of Decorchement, are very competent producers of thick section pate de verre by sintering in moulds. Tessa Clegg in England also produces thick section bowls by a combination of cire perdue and sintering.

Much of the work produced in moulds has a matt surface and is often then polished as required to produce a finer finish.

Pearl Ash. K_2CO_3. Potash. Potassium carbonate. This has been a common flux in glassmaking from the very early days. It can be produced by burning wood and similar vegetable matter. Nowadays it is usually introduced into a batch together with lead oxide when making lead crystal. See **Batch materials**.

Pegging. The process of pricking a gather of hot glass with a sharp pointed tool to introduce small air pockets which are usually covered with another gather to create tears or bubbles.

Pellets. Pelletised batch has suddenly become very popular with studio glassmakers. One of the primary reasons for this has been the shortage of good quality and dependable cullet and another has been the environmental pressure affecting the sale of lead-based glasses. The pellets are about the size of a pill and consist of batch which has been finely prepared and compacted into small solid forms.

Finding a good, long-working glass cullet without lead had become virtually impossible in many countries and a lot of glassmakers were thinking of turning to batch. However, Philips in Holland started to market their pelletised batch at just the right moment. They were willing to supply it in quantities suitable for small concerns, and it has obviously been a great success. It offers all sorts of advantages but the main ones are that there is

no exposure to toxic or irritative dust, the supply can be lead-based or completely lead-free, there is no mixing to be done, the quality is constant and the supply is regular, founding is easier and attack on the refractories is decreased. The glassmakers who are using the pellets seem to be very well-satisfied. Since they started this venture, Philips have increased their range of pellets and are perfectly willing to make them to a customer's own specification. They are now making pellets of coloured glass which are lead, cadmium and selenium-free and they also make colour rods and powders similar to those previously made by Klaus Kugler. See **Kugler colour**.

Periodic table. A diagram used to indicate the properties and characteristics of chemical elements by classifying them in a tabular form. First introduced using relative atomic masses by Professor Mendeleev in 1869 as his periodic law. The elements are arranged primarily according to their atomic number. The atomic number shows the number of electrons and thus, with a few exceptions, indicates the order of their atomic weights. The table is arranged so that there are vertical columns which are numbered from O to VIII in Roman numerals. These are known as groups. Lower down a group the atoms of the elements have the same outer shell structure but an increasing number of inner shells. Elements in the middle of the table tend to be classified as transition elements and the non-transition elements classified as main

group elements. The horizontal rows, called periods, are also numbered with Roman numerals from O to VI.

As the table indicates many related properties of the various elements, it has been used successfully to predict many previously unknown elements before they were actually discovered.

The vertical column O contains the inert gases helium, neon, argon, krypton, xenon and radon. They have no part in actual glassmaking because they do not combine with other elements. There is some usage of neon in particular by artists who produce sculptural forms based on neon-filled tubing.

The remaining vertical columns contain elements which can combine with other elements. The extent to which they do this relates to the electrons of the atom and is known as its valency, the number of electrons controlling the placing of the elements in the table.

The elements in column I are monovalent; those in column II are divalent, those in column III have a valency of three and so on to column VII with valencies of seven. Column VIII has elements of different valencies.

The elements from top to bottom of any group and from left to right along any period show an increase in atomic weight. Hydrogen is the lightest element and is at the top whereas the heavy elements such as gold, lead and the actinides are at the bottom.

Compounds formed by the elements to the top right of the table tend to be acids, for example fluorine, bromine,

	O	I	II	III	IV	V	VI	VII	VIII		
O								hydrogen 1　　H			
I	2 He	lithium 3　　Li	beryllium 4　　Be	boron 5　　B	carbon 6　　C	nitrogen 7　　N	oxygen 8　　O	fluorine 9　　F			
II	10 Ne	sodium 11　　Na	magnesium 12　　Mg	aluminium 13　　Al	silicon 14　　Si	phosphorus 15　　P	sulphur 16　　S	chlorine 17　　Cl			
III A	18 A	potassium 19　　K	calcium 20　　Ca	21　　Sc	titanium 22　　Ti	vanadium 23　　V	chromium 24　　Cr	manganese 25　　Mn	iron 26　Fe	cobalt 27　Co	nickel 28　Ni
III B		copper 29　　Cu	zinc 30　　Zn	31　　Ga	germanium 32　　Ge	arsenic 33　　As	selenium 34　　Se	35　　Br			
IV A	36 Kr	37　　Rb	strontium 38　　Sr	39　　Y	zirconium 40　　Zr	41　　Nb	42　　Mo	43　　Tc	44　Ru	45　Rh	46　Pd
IV B		silver 47　　Ag	cadmium 48　　Cd	49　　In	tin 50　　Sn	antimony 51　　Sb	52　　Te	53　　I			
V A	54 Xe	55　　Cs	barium 56　　Ba	lanthanides 57 to 71	72　　Hf	73　　Ta	tungsten 74　　W	75　　Re	76　Os	77　Ir	platinum 78　Pt
V B		gold 79　　Au	80　　Hg	81　　Tl	lead 82　　Pb	bismuth 83　　Bi	84　　Po	85　　At			
VI	86 Rn	87　　Fr	88　　Ra	actinides 89 to 106							

1. The standard periodic table.

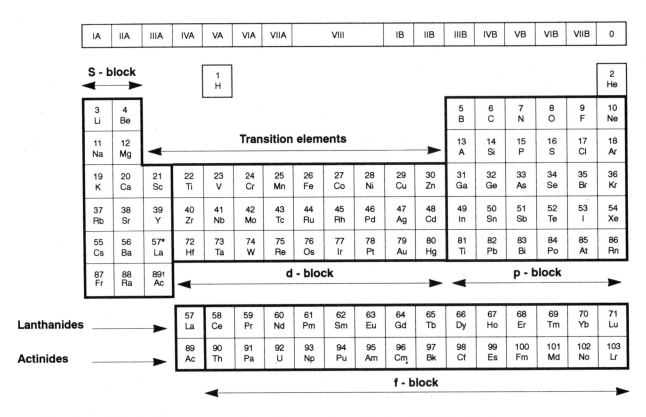

2. Periodic table in which the blocks are arranged according to the type of electron shell being filled.

chlorine and iodine (known as the halogens) form compounds which are strong acids whereas those towards the left and bottom of the table, such as sodium, potassium and lithium form compounds which are strong alkalis. Those in between tend to form amphoteric oxides. This indicates that the right-hand side of the table in Group VII tends to be considered as acidic and as the groups move to the left the acids formed become less strong until from Group III the compounds move towards alkalinity.

The table also indicates those elements which can be considered as being metals, those which are metalloids and those which are non-metals. In moving down a group, there is a tendency to indicate an increase in metallic character because of the increased size of the atom. In going across a period there is a change from electropositive (metallic) behaviour to electronegative (non-metallic) behaviour because of the increasing number of electrons in the outer shell.

Petalite. Lithium feldspar, typically $Li_2O.Al_2O_3.8SiO_2$. It may be used in a batch as a source of lithia and it usually contains small amounts of soda and potash. Lithia is an active flux with a low coefficient of expansion and it is increasingly being used in the field of glass-ceramics.

Phase diagrams. These are usually theoretical diagrams used to indicate what materials will react with others, at what temperatures and in what proportion.

Phase separation. In glassmaking this most commonly refers to the changes which occur when part or all of a molten amorphous glass begins to change to a crystalline state. It can however simply refer to the re-alignment of the molecules in relation to one another.

The terms phase separation, devitrification and glass-ceramics refer to processes which are often intermingled, one being necessary to the development of another.

It can happen when devitrification stones or areas are formed, when opal glasses strike and develop and when glasses are turned into glass-ceramics. The result is often visible as translucency or opacity. It was common in ancient glasses containing magnesia but did not always result in any visible sign as the pockets of phase separation tended to be minute and many of the glasses affected remained transparent. It is thought, however, that many surface pits which subsequently developed in ancient glass were caused by small areas of phase separation.

Phosphor bronze. A metal alloy of copper and tin with a small quantity of phosphorous. It is used to produce bearings and gears where there is likely to be heavy wear.

Phosphorite. $Ca_3(PO_4)_2$. A mineral which is sometimes used as a source of calcia and phosphorous pentoxide in glass batch. It was commonly used in the production of superphosphate fertilisers.

Phosphorous pentoxide. P_2O_5. A glassforming oxide

usually introduced into a batch for producing phosphate opals. It is often included as calcium phosphate from bone ash or from the mineral apatite.

Photochromic glass. Glass which changes in colour when exposed to light. This occurs because of small particles of silver halide which are suspended in the glass. It is often made by including silver halide in the batch but as this method tends to involve high melting point glasses, there is an expensive loss of volatile silver salts. Experiments are in progress to achieve the same effect by ion exchange followed by suitable heat treatment.

Piece moulds. Moulds comprising two or more parts in order that they can be used for successive casts and for complex models.

Pig. Heavy pieces of steel with a triangular section and with grooves cut into one edge. These stand in the gathering port and are used to rest the irons on when gathering. Many glassmakers make them out of 4 or 5 inch angle iron though they are readily available from commercial suppliers.

The type of pig usually made by the artist from short lengths of angle iron.

Pincers. Small, sprung tools used for pinching together areas of hot glass as a form of decoration. They are also used for removing unwanted objects such as stones etc., which may have been picked up in a gather.

Pittsburgh process. This refers to a method of producing continuous sheets of glass in which the glass was taken directly from the furnace and gripped at the edges so that it could be drawn as a long vertical sheet into a high tower. See **Sheet glass**.

Plagioclase feldspar. A group of feldspars including albite, oligoclase and andesite.

Plaster of Paris. Whilst plaster of Paris was known to be used by the Romans, it is thought to have arrived in Britain from France in the 18th century to be used for making plaster moulds for the pottery industry, hence the term plaster of Paris. It was then manufactured locally at Burton-on-Trent and was probably first used in Britain for casting glass in the late 19th century.

It is made from gypsum. The material is heated in steel containers until the water of crystallisation has been dri-

ven off. Technically it is a semi-hydrated calcium sulphate. In use, the white powder is added to water and mixed. After a few minutes it begins to form crystals and returns to a state similar to that of the original gypsum.

The strength and absorbency of the final plaster form and the speed of setting is affected by the proportions of water to plaster. The standard mixtures fall between 100 parts of water to 110 parts of plaster by weight and 100 parts of water to 140 parts of plaster. The former has greater absorbency but is light and not particularly strong. The second has less absorbency but is heavier and stronger. The stronger proportion also tends to set more quickly than the light mixture.

The setting can be retarded by introducing borax, weak acid, gelatine or alum and can be accelerated by introducing crystalline salts such as potassium chlorate, nitrate or sulphate and hot water. After the plaster has apparently set it will become warm, reaching its maximum temperature after approximately 30 minutes. At this stage it should be safe to move.

It is used by glassmakers producing kiln-formed glass as a mould material mixed with grog or similar material for casting and for producing slumped forms. It was also used extensively at one time by conservators for cementing sherds of glass together. Various plaster of Paris-based mould recipes are described under **Casting**.

Plasticine. Plastilinia. A modelling material often used for making the initial forms from which moulds are made for glass cutting. It does not have the tendency to shrink and harden which often causes problems when using clay as a modelling material.

Plasticity. The quality of allowing a material to combine some of the properties of a solid whilst retaining the fluidity of a liquid, thus allowing it to be modelled into forms which will hold their shape. Such a material is therefore non-elastic. It is an important quality in clay, the various types of which have differing degrees of plasticity. The particle size of a clay has a considerable bearing on its plasticity.

Secondary clays which have usually been affected by erosion from the original deposits, washed down valleys and re-deposited, tend to have very fine particles and as a result are usually plastic, unless they have been combined with amounts of other substances such as sand, which creates more friction. The larger particle size of china clays and refractory clays used for making glass pots produces more friction and therefore makes them less plastic and more difficult to work. They may need to be modified with additions of ball clay or bentonite to increase their plasticity in order to help with the forming processes. Additions of weak acid or a bacterial agent also often have the effect of increasing the plasticity of a clay.

Plate glass. Originally this referred to the hand-polished sheets of glass produced for making mirrors. Indeed, it is

still used to refer to any glass which has been ground and polished rather than that which is left as rolled or made by floating the hot glass on a bath of molten tin. The industry still uses the term in this context whereas the general public have adopted a much wider view and use it to describe any thick glass used for large windows or for such items as glass shelves, table tops etc., which are more likely to be of ordinary float glass.

The early making of such glass went through a variety of processes. Initially the glass was blown and spun into bullions. Later, the process developed into the blowing of cylinders which were opened up and then ground and polished on a table. Larger sheets were eventually made in France by a method of pouring molten glass onto a table before rolling it into plates. These again had to go through a laborious process of hard grinding and polishing before a method of grinding and polishing on a wide circular table (as much as 40 feet in diameter) evolved. This table was flooded with a layer of plaster of Paris into which the sheets of glass were pressed until the whole area was filled. Two large rotating cast iron discs were then lowered onto the surface of the glass and fed with an abrasive, initially in the form of coarse-grained sand. Both the table and the metal discs revolved to grind the glass, the grit size of the abrasive being gradually reduced until it became very fine. The abrasive removed from the table was re-assessed and re-used. Once the grinding was completed, the iron discs were replaced by felt pads fed with rouge and the same process continued until the glass was polished. When this was completed, the glass was turned over, then placed on a cloth base before the whole programme of grinding and polishing was repeated. The process of casting sheets which needed considerable amounts of grounding and polishing survived for about three centuries before any notable change was made.

The Belgian, Emil Bicheroux, improved the situation by pouring the molten glass directly from a pot through two rollers which had the advantage of producing glass which was more even in thickness and with less undulations, making the grinding and polishing process easier and more economical in terms of both time and material. Rollers had been used before but for the production of small width sheets of wired and textured glass. Another advantage of the Bicheroux process was that sheets of generous width became possible.

There were various processes of drawing sheets of glass vertically from the surface of the hot glass such as the Fourcault process and the Pittsburgh process. The disadvantage of these was that the glass had to be drawn vertically to a considerable height before being cut into sheets. An improvement came with the Libby-Owens process from America in which the glass was still drawn vertically but only for a very short distance before it was bent over a roller and then passed in a continuous ribbon over flattening rollers. This was generally suitable for window glass but it still needed grinding and polishing though the amount of finishing required was consider-

ably less than that which had been essential with earlier processes.

The early 1920s saw the introduction of a number of changes. The Ford Motor Company in America and Pilkingtons in St. Helens developed a method of directing the glass immediately into two rollers so that a continuous ribbon of glass flowed through to the annealing lehr. The Ford system was directed essentially to the requirements of the motor trade, so widths produced did not need to be large. Pilkingtons were faced with much greater problems in producing widths and thicknesses of sheet suitable to their requirements but eventually these were solved.

Both Ford and Pilkington then developed the system further and produced methods of passing the ribbon of glass through a sequence of automatic grinding and polishing wheels on its way to being cut into sheets and on to the annealing chamber. The really big breakthrough was achieved by Alastair Pilkington at St. Helens who had the brilliant idea of running the ribbon of glass directly onto a bath of molten tin which ensured a polished undersurface whilst the upper surface was heated by a flame to give a fire-polished finish. Whilst this still had to be ground and polished to produce plate glass, it has become the accepted method of producing what is now known as 'Float' glass and it has a surface very near to that of most plate glass. Factories all over the world now use the process under licence from Pilkingtons.

Plating. To a stained glass artist, plating means putting two pieces of glass into one calme. It is a term which also refers to the process of putting a metallic layer onto a glass surface as in silvering or electroplating. See **Electroplating**.

Platinum. A heavy, ductile and soft precious metal highly resistant to attack by most chemicals and to oxidation at high temperatures. Its most common association at the present time is with the manufacture of catalysts used in cars to remove various noxious materials from the exhaust gases. It is a popular metal for the manufacture of expensive jewellery and has found some use in medical practice as a base material for the cytotoxic drugs used in chemotherapy to fight cancer. It is often used for making crucibles for melting special glasses which could be contaminated by materials released from ordinary refractories. These are made in various sizes ranging from small laboratory-sized containers to those used in factory production.

Plinth. A base, support or pedestal on which a glass sculpture is placed.

Plumbic and plumbous. Refer to lead compounds. See **Lead oxide** and **Batch materials**.

Pneumatic. Refers to systems and tools driven by air pressure. These are increasingly used in small workshops

as they enable particularly small saws and abrasive diamond pads, which need a good supply of water, to be used with more safety than could be provided by using them with electrically driven drills or motors.

Pneumoconiosis. This is a general term describing the reaction to the accumulation of dust in the tissues to the lungs. The inhalation of dusts of various types over sufficient periods of time and at sufficient concentrations can result in fibrosis which is the formation of scar tissue. The common forms of pneumoconiosis are silicosis when the dust is silica, asbestosis when it is asbestos, and talcosis when it is talc. When the dust is coal dust, it is usually called coal workers' pneumoconiosis.

The major concern of glassworkers is with the exposure to silica from siliceous batch materials. There are three types of silicosis. They are:

- Classical or nodular silicosis caused by exposure over a very long time to low levels of dust.
- Accelerated silicosis which results from exposure to high levels of crystalline silica over a relatively short period (approximately five years).
- Acute silicosis which results from the exposure for as little as a few months to very high levels of the dust.

The main symptom of classic silicosis is an increasing breathlessness which becomes disabling and may lead to the possibility of early death.

Accelerated silicosis is initially similar to classical silicosis but progresses much more rapidly to the production of large lesions in the lungs and the possibility of death within ten years or so because of the reduced levels of oxygen in the blood.

Acute silicosis is much more rare. In it the air spaces in the lungs become filled rapidly and death usually occurs within a few months.

Siliceous dust finer than 3 microns can easily enter the lungs and settle there where it creates a dangerous, painful and potentially fatal condition. In normal circumstances larger particles tend to be filtered out nasally.

It is essential to be constantly aware of dust problems and to take all possible steps to avoid exposure.

If the permissible exposure limit is met, the risk is minimal. Grinding, polishing and sandblasting operations are the most obvious hazardous situations for providing exposure but batch mixing, founding and even making plaster mixes are also operations requiring care. Good quality respirators to the necessary standard are a valuable investment and should be used whenever possible.

Poisons. There are many materials used in glassmaking which can affect the human system. Some of them act when ingested, others as toxic gases or irritant dusts which may be inhaled, and others which can find their way through the skin.

Various batch materials which may be toxic are controlled relatively easily by good housekeeping and by taking well-established precautions, such as ensuring that mixing always takes place in a sealed container, that masks and suitable protective clothing are worn when founding, that no food and drink is taken into the vicinity, that showers are available for use on completion of mixing and founding operations and that all materials are suitably labelled.

There can be problems with volatiles, as toxic gases can be released from some materials in founding. Most of these find their way out through the flues and are becoming subject to much greater control as regulations increase because of environmental pressure. Some volatiles emerge from the furnace as the glass is standing or is being gathered and it is important that the pressure in the surface is such that they are forced out through the gathering port.

Many of the batch materials are essentially siliceous in character and the dust from this source, and from dismantling processes in furnace repair or renewal needs to be treated with suitable precautions.

Acid etching has its own peculiar hazards which must never be taken lightly. They are described under **Acid etching** and the danger of exposure to hydrofluoric acid, either as the liquid or as fumes cannot be overemphasised.

On what may seem to be a lesser note but nonetheless one which should be taken seriously is the effect of such things as thinners, cleaners, adhesives and mediums on the skin. The fumes from the various mediums in firing is also something which demands care.

Polariscope. Strain viewer. An instrument which can show stress in glass by using polarised light. Polarised light vibrates in one plane, so a material which will only pass light rays in the correct plane and absorbs the other rays, such as a polaroid film, provides the basis for the practice of strain viewing.

A polariscope consists of a sheet of polaroid film set in front of a light source with another sheet of polaroid, or more usually polaroid eye pieces, called the analyser, set about a third of a metre or just over a foot away. The polaroid in front of the light source and that in the eye pieces are set so that the planes at which they operate are at right angles to each other. When a piece of glass is held between the polariser and the analyser, any strain will show up as a pattern of light and dark areas.

The introduction of a special filter (tint plate) before the analyser shows the pattern as colours on a mauve background. For a given thickness, the intensity is related to the amount of strain. The colours will depend on the amount of strain but can also be affected by the thickness of the glass resulting in a thick piece suggesting more strain than a thin one. If there is no change in the appearance of the glass when it is placed in position, this will indicate that the annealing has been successful and there is little or no strain. Red and blue colours suggest fairly good annealing but bright reds with orange and green indicate that the annealing has been unsuccessful.

It is, however, possible for some of these colours to appear in a very thick sample when in reality there is not a lot of strain. Standard strain discs are available to enable comparisons to be made. These are usually provided in sets of five and have accurately calibrated amounts of strain in them. They are extremely useful as they make the assessment of the amount of strain much easier to define. Unfortunately for the studio glassmaker, the effects created by the polariscope are not easily visible in coloured glass.

Polishing. Glass is polished by three distinct methods:

1. By heat or fire polishing.
2. By gradually eroding the surface with subsequently finer abrasive particles.
3. By eroding the surface with a mixture of hydrofluoric and sulphuric acid.

Fire polishing simply melts the surface sufficiently for it to fuse into a shiny layer. The process of polishing with abrasives is one of reducing the fine variations in a surface by the use of finer and finer particles. This is explained under **Grinding** and **Polishing**. The use of acid is described under **Acid polishing**.

Polissoir. A polishing pad used for polishing plate glass.

Pollution. Over the last few years this has become a major consideration in many areas of the world. There has been much research and regulation emerging, particularly from the USA. With the formation of the European Community, statutes from various countries are being drawn together and considered in order to form comprehensive regulations to cover this area. Many industries will certainly be affected and glass will be no exception. Much has already been done and whilst it might be argued that all the small studio furnaces in Europe would only equate to one large industrial tank furnace, it is probable that many of the same regulations will apply. The major areas attracting attention at the moment are:

- Emissions affecting the ozone layer and causing acid rain.
- Toxic or carcinogenetic volatiles released into the atmosphere.
- Liquid waste which might affect rivers or water supplies.
- The disposal and recycling of solid waste.

The efficiency of furnace combustion systems is improving all the time but these improvements can only proceed within particular limits. The burning of fossil fuels results in the production of the oxides of carbon and nitrogen and to a lesser extent, those of sulphur. Some factories are transferring to electric furnaces to avoid this problem. Cynics might say that this is merely transferring the problem to the power stations. At the moment we are left with the fact that the necessity of industrial production and transport, and the need to save our environment is becoming an increasingly precarious balancing act with no easy solution in sight.

Volatiles from glass founding processes are causing some concern and there are likely to be increasing problems in achieving the projected limits, particularly in relation to the production of cadium/selenium reds. It is, however, very unlikely that these colours would be made in a small studio. Lead, and to a lesser extent barium, are also attracting stringent limits and these are much more likely to be used in a studio where the tendency to use open pots or small tanks would cause problems by sending any volatiles into the external atmosphere via the flues or into the studio through the gathering port. Pelletised batch which does not contain lead or barium has become readily available in Europe and many studios are turning to this material to avoid the problem. The other processes which provide noxious fumes are acid etching and acid polishing. Hydrofluoric acid is extremely corrosive and again the emerging regulations are likely to be very tight. These processes are not normally found in small studios, so they are not likely to affect many artist/craftsmen.

Liquid waste is not a great problem for glassmakers except for the few who indulge in acid etching and/or polishing. Industry might be concerned where coating procedures are used but even then it is a relatively simple matter to ensure that any effluent meets the necessary standard.

Solid waste is again more of a problem for industry than for the small studio. Considerable strides have been made in the re-cycling of container glass and perhaps this will soon spread to the flat glass scene.

Apart from the reduction in use of natural resources, there are obvious benefits from the reduction in the amounts of combustibles used because of melting more cullet than batch.

There have been imaginative projects in which ground waste glass has been used both for road surfacing and as a slow acting fertiliser. Also, as land-fill sites are becoming strictly regulated and expensive, so there will no doubt be pressure to find further uses for waste glass.

Packaging presents another problem for industry and several countries are now insisting that paper-based packaging products are the responsibility of the sender who will be required to ensure that such materials are re-cycled or returned and not simply burned or dumped.

Polyester resins. There are numerous varieties of these and they are often used for joining the glass elements in optical instruments. They are also commonly used for embedding purposes. It is important that they are applied in small quantities as they have a tendency to create heat. There is another disadvantage in that there is 8% shrinkage during curing. Most artists using resin for joining glass use clear epoxy resin.

Polyurethane foam. This is rather expensive for most

packing purposes but can be ideal for packing fragile materials such as artwork being sent abroad for exhibition purposes. It is usually obtained as a two-mix package but is available in many varieties. There is an isocyanate and a polyol which can be either a polyether or a polyester. The isocyanate used to produce flexible foams is generally based on toluene. When mixed there is an expansion to create a foam in about three minutes. The polyether foam is usually the preferable material for packing as polyester tends to disintegrate more rapidly on ageing.

Pontil. Punty. This term is used to describe both the solid iron rod to which a piece of hot glass is attached for further working after being transferred from the blowing iron, and to the mark which is left on the glass when it is finally removed from the punty iron. See **Blowing**.

Portland Vase. There is no experience more sobering to a glassmaker than that of coming face to face with something made in the distant past with the most elementary tools which shows the most incredible skill and patient work. The Portland Vase is such a piece. It was discovered in a sarcophagus near Rome in 1582 and bought by the British Museum from the Duke of Portland. It has an inner layer of blue glass covered by a layer of opaque white from which the unwanted areas have been ground away. The various figures and decoration were then carved with considerable subtlety in controlling the thickness of the opaque white to allow the blue undersurface to suggest the necessary tonal values.

The famous Portland Vase. This is a cobalt blue amphora cased with opaque white from which the design is cameo cut in relief. It has been broken and repaired. It was brought to England by Sir William Hamilton who sold it to the Duchess of Portland. It is thought to illustrate the myth of Peleus and Thetis. Dated between the 1st century AD and the 1st century BC. *Courtesy of the British Museum.*

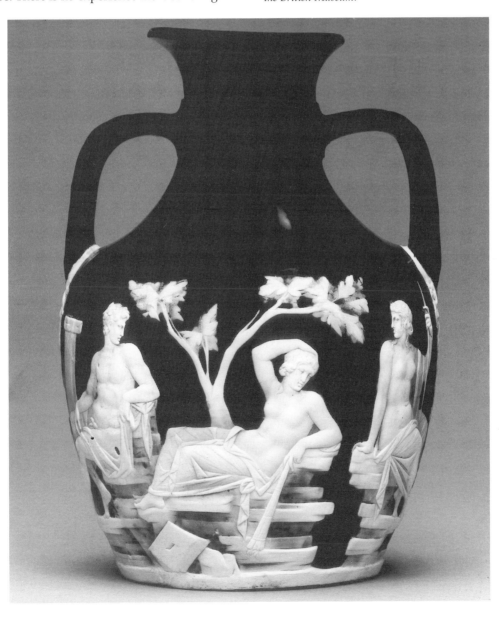

Post technique. A punty iron is usually attached to the glass being worked by a small amount of glass marvered into a narrow end. The post technique consists of forming a flat disc of hot glass (a post) on the end of the iron and attaching this to the base of the vessel being worked. A particularly large variety of post is used when making the glass cylinders used for producing sheets of stained glass.

Pot. To the glassmaker a pot is a refractory container which is placed into a furnace to contain the molten glass. It is traditionally made from fireclay by a process of building very similar to that of the potter making a coiled pot. Pots are made in several forms; some are completely open, some are half covered and others are completely sealed except for the gathering port. They are allowed to dry for several weeks before being placed into a pot arch and heated up slowly to a bright red heat before being transferred still at that heat into the furnace. Smaller pots for studio or small workshop use can now be obtained from commercial sources, and are made from a variety of cast refractory materials.

The pot arch is really a kiln in which the pot is heated before being transferred to the furnace.

A typical glass pot. *Photograph by courtesy of J. McCarthy and Co. Glass Pot Makers.*

Pot Trolley or Chariot. The traditional trolley manhandled by a team of men to transfer the glowing pot from the pot arch to the furnace.

Pot arch. This is a form of kiln which is used to heat up a pot to a temperature at which it can be placed into a hot furnace. The traditional method of pot arching is a very spectacular process. When a cracked or broken pot is to be changed, the firebricks are pulled away from the front of the furnace without reducing the firing so that the flames flare out in all directions. A gang of men approaches the furnace with a kind of chariot consisting of two long rods on wheels. The prongs of this chariot or

pot trolley are pushed under the cracked pot and the men press down on their end to lift the white hot pot from the floor of the furnace. They then draw away with the glowing pot balanced on the prongs and wheel it away to a place where it can be tipped. They then move to the pot arch and repeat the process to pick up the new equally glowing pot which they then trundle into the furnace and set it onto the base bricks. The furnace men then pick up the firebricks on long thin shovels and place them in position to cover the front of the furnace. The bricks are then coated with wet fireclay to seal the gaps. The furnace is firing away whilst all this is going on and the flames are belting out of the opening like a scene out of

Dante's Inferno. A more modern approach is to use a suitably protected fork lift truck and sectional furnace fronts. Many factories now bring the pot up the temperature in the furnace rather than in the pot arch because modern temperature control has become so reliable.

Pot glass. This describes coloured glass in which the colour is in the glass rather than just on the surface.

Pot rings. Gathering rings. Refractory rings floated on the surface of the molten glass in a furnace in order to provide a clean area free from cord and stones etc. from which the glass can be gathered.

Pot rings. These are usually made from fired fireclay and come in two interlocking halves. They float on top of the molten glass to provide an area of glass surface for gathering which is relatively free from cord and stones.

Potash. K_2O. CO_3 Potassium carbonate. Kalium oxide. The term is confusingly used to describe various potassium compounds including both potassium oxide and the carbonate. It is one of the major flux materials used in glassmaking, the others being soda ash which has by far the greatest usage and lithia which has relatively little use. It is not as reactive as soda but begins its fluxing action in the founding rather earlier. It tends to be soluble in water and needs to be kept dry. It is normally used in conjunction with lead oxide in the making of lead crystal. It also sometimes replaces soda ash in order to facilitate the production of certain colours. It can be introduced into the batch as potassium carbonate or as part of potash feldspar which also introduces some silica and alumina. See **Batch materials.**

Potash feldspar. $K_2O.Al_2O_3.6SiO_2$. Orthoclase. The commonest form of feldspar. It is sometimes used to introduce potash together with some alumina and silica into a batch.

Potassium carbonate. $K_2O.CO_3$. Potash. Pearl ash. The common source of potassium oxide in glassmaking. Traditionally it is derived from burned wood and other vegetable matter. Potassium carbonate in wood ash is largely soluble in water where it produces a caustic solution which was once used for cleaning textiles and as a basis for the production of soap. This solubility means that it can be recovered from the ashes by first being taken into solution and then evaporated out. In early glassmaking, the ash which would still normally contain small quantities of all sorts of other carbonates and some silica would simply be used more or less straight from the embers after some sieving in order to remove the coarser material.

Potassium dichromate. $K_2Cr_2O_7$. Occasionally used to introduce chrome oxide into a glass. Because it is combined with the potash it is more easily absorbed into the melt.

Potassium nitrate. Saltpetre. This occurs naturally as nitre and is a powerful oxidising agent. It is introduced in small amounts into batches to help the fining process.

Potassium oxide. K_2O. See **Potash.**

Pounce bag. A small cloth bag filled with whiting and used by stained glass artists to transfer designs by dusting the powder through pin holes in a cartoon or design.

Praesydium oxide. PrO_2. Praesydium is a metallic element of the rare earth group. Its oxide is occasionally used for colouring glass but tends to be too expensive for general use. It produces yellows when used in conjunction with zircon.

Press. A machine which can be either automatic or operated by hand for pressing glass into moulds.

Pressed glass. Glassware formed by pressure between a plunger and a mould. Much of the production of pressed

Typical example of pressed glass made to reproduce the effect of cut glass by Davisons of Gateshead.

glass is aimed at making cheap replicas of expensive cut glass and for mass production of forms which otherwise would need to be individually cast. As the plunger does not need to conform to the shape or decoration supplied by the mould an interior can be perfectly smooth whilst the exterior surface may be heavily patterned. It is a process also used for the production of much industrial glass and lenses for a wide variety of light assemblies.

Pressure gauge. A necessary accessory in a compressor system. This is used both to indicate the pressure in the pressure tank and that which is being applied at the air gun. It is usually fitted to units which also contain controls and filters.

Prince Rupert's drops. These are formed when molten glass is dripped into water as a result of which the surface becomes compressed. They are tear-shaped and they have interesting characteristics in that the thick end can withstand an extremely strong blow but the more fragile thin tail only needs to be broken for the whole to disintegrate into small particles. The thicker part of these drops is said to be stronger than steel and there has been some conjecture that small spherical shapes made in a similar manner could be used as ball bearings. This phenomenon led to the development of toughened glass as we know it today. They were introduced into England by Prince Rupert, a nephew of Charles II.

Printy. Small oval or circular depressions cut into glassware.

Prisms. Decorative features in stained glass windows consisting of pyramid-shaped bevels.

Propane. The most commonly used type of bottled gas for firing kilns and furnaces. A cubic foot of gas gives approximately 2558 BTUs. It is a gaseous hydrocarbon prepared from petroleum.

Prunts. There are two meanings to this term. Glassmakers think of prunts as being blobs of glass added to blown forms whilst a craftsman engaged in decorating glass by cutting would think of the term as referring to a printy which is a spherical depression cut into the surface of a glass.

The applied prunts were often impressed to give a semblance of fruit and sometimes turned into the form of claws. It is a technique which has survived since Roman times when they were particularly fond of applying small pieces of glass as decoration on vessels. In the 16th century a Bohemian pastor expressed the view that they were really applied to give clumsy people a better grip on the glass as by that time the small prunts had become quite large. They were often applied and then blown out as in the claw beakers. This was possible because the application of the blob of hot glass heated the skin of the vessel sufficiently at the point where it was applied for it

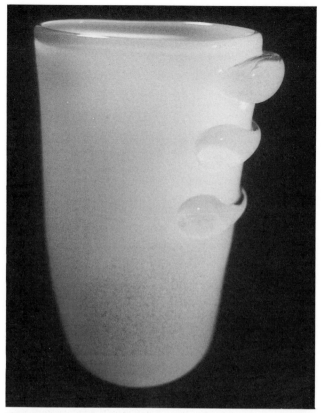

Vessel with prunts by Liz McClure.

to blow out from the form of the rest of the vessel which was too cool to expand. In the claw beakers the glass blown out into a bubble was grasped and pulled out to be attached lower down the vessel to form the claw.

Handles on glass vessels are inevitably a form of prunt which has been pulled out and joined to the vessel to form the handle.

PTFE. Polytetrafluoroethyline. This material has a low resistance to friction and is becoming increasingly popular for bearings and for the sliding rails on the benches of diamond saws. It is available in an aerosol form for use as a separator or release agent.

Pucellas. Tongs. Jacks. The tools used by the glassmaker to open out and shape hollow forms. See **Blowing**. (See photograph on page 48.)

1. Standard pucellas made by Ivan Smith.

2. Smaller pucellas known as 'wines' and used mainly for making goblets.

Pulleys. Over the years string, rope, strips of leather, woven cloth and latterly rubberised fabric have been used in conjunction with wheels to transfer power and to effect different speeds from a source to a working shaft. The wheels, known as pulleys, were for many years simply flat or with a slightly convex surface to take flat belts. However, over the last few decades the normal pulley for general use has been designed to take a belt with a 'V' section and it has become known as the 'V' pulley. This had the advantage of containing the belt and reduced the possibility of the belt losing contact and slipping off. It also meant a greater area of contact for the belt within less width thus making the possibility of having a series of stepped pulleys to make differential gearing much

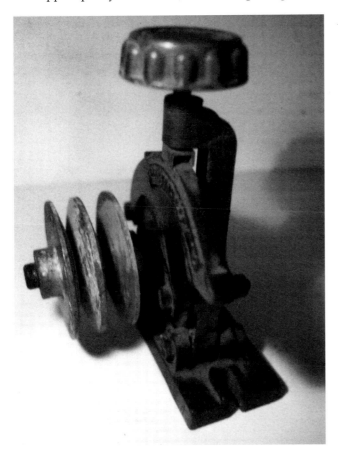

A type of variable speed pulley which works by moving the working part nearer to either the driving pulley or to the driven pulley. This has the effect of moving the centre element of the pulley to one side or the other and so altering the operative diameter of each side.

easier. A development from this produced pulleys which could be opened out or closed together to give some difference in ratios on the same pulley. The difference in speed from a source to a driven shaft would relate to the difference between the transmitting and the receiving pulley. For example, a common electric motor speed in Europe is 1440 revolutions per minute. To produce an effective speed of 720 rpm on the driven shaft would necessitate a 50 mm (2″) pulley on the motor and a 100 mm (4″) pulley on the driven shaft. To produce a higher speed on the driven shaft of 2880 rpm, a 100 mm (4″) pulley on the motor together with a 50 mm (2″) pulley on the driven shaft would produce the required speed. A formula to calculate the resultant rpm on a driven shaft would be:

$$\frac{\text{Speed of motor x diameter of motor pulley}}{\text{diameter of shaft pulley}}$$

This means that if a shaft is required to operate at a given speed and the motor speed is known, the ratio between the two pulleys can be calculated as: Speed required at shaft = speed of motor x diameter of pulley at motor over the diameter of pulley on the shaft.

The power transferred is affected similarly in that if the losses due to friction are ignored, halving the speed on the driven shaft would double the transmitted power whilst doubling the speed on the driven shaft would half the transmitted power.

A selection of pulleys. *Photograph from Bearing Services Ltd.*

Pumice. Powdered volcanic rock used for polishing glass. It is made from a type of foamed natural glass produced by the gas released during volcanic action. Most of the best pumice comes from Mediterranean islands and is available commercially in various grades. See **Grinding** and **Polishing**.

Punt. A spherical hollow in the glass made by cutting or grinding.

Purdah glass. Tinted but transparent sheet glass which is sandblasted to different depths in order to use the resulting variation in the amount of transmitted light to produce design or pictorial effects.

Purge. This usually refers to the procedure of blowing air through a furnace or kiln system in order to remove inflammable gases before instigating an ignition or re-ignition sequence.

Purple of Cassius. A purple crimson which was produced by adding a pigment made by precipitating a solution of gold with tin chloride resulting in a colloidal gold which was added to the batch. The colour needed to be 'struck' and did not appear until the glass was re-heated.

Putty. Used by glaziers to fix glass sheets into a frame. It is made basically from a simple, traditional mixture of whiting and linseed oil. It was once common practice to include some lead carbonate or litharge but because of growing environmental concern with lead products, it is rarely included today though some craftsmen still think that the inclusion of lead makes a better product. The material is the same as that used by stained glass artists and called by them 'Cement' for leading up their glass. However, it is sometimes thinned by introducing a little turpentine or turpentine substitute in order to make the process of rubbing the material into the lead calme easier. It is often replaced today by various commercially-prepared mastic materials supplied in tubes from which it can be extruded by the use of a suitable compression tool.

Putty knife. The knife used for the application of putty. There are several shapes available but the stained glass artist often modifies the commercial knife by grinding it to suit his or her own requirements.

Pyrex. The trade name for the borosilicate low expansion glass developed by Corning and used principally for making ovenware and tubing for scientific apparatus.

Pyrite. FeS_2. Iron pyrites. Known as fool's gold. Iron ore occurring as yellow crystals. It is often found in fireclay and because of its hardness is not easily ground down and removed. Any source of iron is to be avoided in fire-clays used for producing refractories which are to be used where there is possible contact with the molten glass.

Pyrolusite. MnO_2. An ore which is the main source of manganese dioxide.

Pyrometers. Meters used to indicate the temperature of a furnace or kiln. These were commonly of the swing-needle type, the needle being moved across a scale because of the small current generated by two dissimilar metal wires in a thermocouple. Almost all of those now used are of the electronic type with a digital display and they are often coupled with a controller. See **Instrumentation**.

Pyrometry. The process of measuring temperature and heatwork beyond the range of thermometers.

Q

Quarries. Panes of glass in either square or diamond shapes once popularly used in some windows. They were sometimes decorated by the application of paint or enamels with representations of plants and birds. They were produced in many areas from medieval times to the 17th century.

Quartz. SiO_2. Silica. This refers to the most common form of mineral silica. Large crystals are quite common, some of which are a milky white, others can be completely clear and transparent. It is a source of white sand when it has disintegrated and this is often ground down to provide batch silica. Other types of sand are also largely composed of quartz but with traces of other minerals. It is melted in special high temperature furnaces to provide the silica tubing used for so-called infrared heating elements and as supports for elements in kilns. It is a hard mineral and is used as one of the standards on the Mohs' scale. Powdered quartz is sometimes mixed with plaster of Paris to make moulds for casting or slumping glass.

Quartz is the last of the phases of silica resulting from the initial cooling of the Earth. The material starts as molten siliceous material and becomes in turn cristobalite, trydimite and eventually quartz. All the phases have similar chemical composition but differ in their molecular structure. See **Silica**. Quartz exists in two forms. The alpha form only occurs below temperatures of 573°C (1060°F) whilst the beta form exists only above this temperature. The change can occur in either direction and is known as the silica inversion. The difference lies in the angle of the silica-oxygen-silica bonds. This occurs because the silicon atom is just too large to fit tightly between the oxygen atoms and thus allows some adjustment to take place.

Quartz also provides several crystalline forms used for jewellery such as amethyst, rose quartz, blue quartz, onyx, carpelian and agate.

Small prepared quartz crystals are also used to provide accurate timekeeping in both watches and electronic equipment. A quartz crystal will be made to oscillate at a rate of 32768 cycles per second by a very small electrical current.

R

Raddle. Reddle. Ruddle. An alternative name for haematite and red ochre.

Radiation. The process of transferring heat by waves of energy. In a furnace or kiln all the hot objects radiate heat which is absorbed by cooler objects and has the effect of balancing out the distribution of heat.

Radical. A group of atoms which keep their identity when passing from one compound to another.

Random network. Random structure. A random network does not follow a regular pattern as in crystalline forms but tends to keep within distinct possibilities. Amorphous solids such as glass can be described as having a random network. One of the major characteristics of solids with a random network is that of having a range of temperatures over which they melt whereas solids with regular structures tend to melt at a given temperature.

Ranges. Narrow pieces of glass left after cutting sheet glass stock.

Rare earths. Lanthanides. A group of elements, 15 in number, comprising the Group IIIB of the periodic table plus three other similar elements – yttrium, thorium and scandium. They have increasingly been the subject of much research into the eventual possibility of use in colour and in special glasses. Lanthanum has been found to provide qualities of low dispersion and high refractive index in optical glass. Cerium and neodymium are used in decolourising and in control of UV absorption and others are used to control photosensitivity and absorption in various contexts. They are:

Lanthanum	La – atomic No.	57
Cerium	Ce	58
Praseodymium	Pr	59
Neodymium	Nd	60
Prometheum	Pm	61
Samarium	Sm	62
Europeum	Eu	63
Gadolinium	Gd	64
Thorium	Th	90

and in the yttrium or heavy group

Yttrium	Y	39
Terbium	Tb	65
Dysprosium	Dy	66
Holmium	Ho	67
Erbium	Er	68
Thulium	Tm	69
Ytterbium	Yb	70
Lutetium	Lu	71
Scandium	Sc	21

Raspberry prunts. These were very popular on drinking vessels made around the 16th and 17 centuries, particularly in the Rhineland and the Southern Netherlands. They were normally made from the common green forest glass. The prunts were applied as blobs of hot glass, sometimes coloured, and then a piece of metal or wet wood into which a cluster of indentations had been made, was pressed into the surface of each blob as it was applied. This produced the typical appearance of raspberries.

Ravenscroft, George (1618–1681). George Ravenscroft was commissioned to find a substitute for Venetian Cristallo. His early attempts failed because he achieved an excess of alkali which caused his glass to crizzle. After much experimentation he found success by substituting some of the potash with lead oxide and eventually replacing the English flints with sand. Despite this substitution, the glass was still known as 'Flint Glass'. The brilliance of the resulting glass made Britain the leader in the production of high quality clear glass for many years until the secret was eventually copied on the continent of Europe.

Raw. Used loosely to describe materials which have not been processed. It may cause some confusion because in addition to being used to describe materials which are more or less as they have been found, it may, as in the case of 'Raw Lead', be used to describe the various lead oxides to differentiate them from the various lead frits and from lead carbonate used in glass batch.

Reaction. The action of substances on others to effect a change. Fluxes react with glass formers and stabilisers in the founding process to produce glass.

Reamy glass. Stained glass term for glass which has been deliberately made to have a flowing surface texture. It is a similar effect to that produced by cords in normal glass production where it is considered to be a fault rather than a particular element of character.

Recuperation. The process of introducing pre-heated air into a combustion system. The air is usually heated by passing it alongside or through the flues carrying the exhaust gases. This has the effect of providing considerable improvement in the efficiency of the combustion. There are very simple methods for achieving this which are commonly used by studio glassmakers. However, in industry, it is now more normal to use special recuperative burners. See **Burners**.

Red copper oxide. Cu_2O. Cuprous oxide. See **Reduction**, **Colour** and **Lustre**.

Red lead. Pb_3O_4. See **Lead oxide**.

Redox. An abbreviation for 'Reduction-oxidation'. It is often used to describe the condition of the batch and the molten glass in the furnace.

Reduction. A process in which an electron is added to an atom or an ion. The one which is of greatest concern to glassmakers is that of removing oxygen from a molecule. Other common types are the addition of hydrogen to a molecule and the diminution of the positive valency of an atom or ion. It is something which can be used to good effect in producing metallic or iridescent surface effects on glass or in the attainment of particular colours. It can also be a disadvantage because if a furnace atmosphere is not sufficiently well monitored, a founding can go disastrously wrong. A common example is that of a furnace containing lead crystal when the accidental provision of a reducing atmosphere could cause the greying of the glass or even the creation of metallic lead particles. Another common occurrence is when a green or turquoise glass containing copper oxide is being re-heated in a glory hole, the incidence of a reducing flame will produce a thin copper layer on the surface. It can also be used deliberately in the founding to produce colours such as copper ruby.

Refining. Ensuring that a founding will produce a homogeneous glass by a process of chemical action and by holding the glass above its liquidus temperature so that bubbles are able to rise to the surface. The common refining agents are:

　　Arsenic
　　Antimony oxide
　　Ammonium nitrate.

See **Batch melting**.

Refraction. The change of direction which occurs when a ray of light passes from one medium to another. See **Refractive index**.

Refractive index. When a ray of light passes from one medium to another, it often changes its direction and is said to be refracted. The ratio of the sine of the angle of incidence to the sine of the angle of refraction is constant to a given pair of media and is known as the refractive index. It is also equal to the ratio of the velocity of light in the first medium to that of the second. It is generally assumed that one of the media is a vacuum. The refractive index is particularly important in assessing the qualities of optical glass.

Refractories. Material which will withstand high temperatures. A wide variety is available and the commercial production of precisely engineered refractories designed for specific purposes is now normal practice. Almost all of those used for glass furnaces were traditionally based on clay-related and clay-bonded materials. However, many modern refractories have moved away from this source. In glassmaking, it is essential to use materials which are as free from iron as possible, which will have sufficient mechanical strength and which will resist attack both from the hot glass and from any volatiles which may be released. Fireclays which form the base for many traditional refractories are composed of kaolinite together with some free silica and various impurities, but for practical purposes can be considered to be composed of alumina and silica. Both of these materials have high melting points, silica at 1713°C (3115°F) and alumina at 2050°C (3720°F). Interestingly 5% to 6% alumina together with silica will produce a theoretically lower melting temperature of approximately 1600°C (2910°F). When the proportions reach alumina 30% and silica 70%, the theoretical melting temperature returns to about 1713°C (3115°F) and with higher proportions of alumina, the melting point will rise smoothly until 100% alumina is reached.

As refractories consist of both crystals and glass, they tend to slump when they reach a temperature at which the glass content begins to melt. Most fireclays are more refractory than other clays because they tend to contain more alumina so, in general, the higher the alumina content the more refractory they become. Whilst the melting point might indicate a temperature at which a refractory would begin to fail, this can only be considered as applying to refractories which are not under load. Whilst under load, deformation can take place at temperatures more than 100°C (180°F) below a theoretical melting point.

High alumina refractories may contain anything between 45% and 80% alumina but they are expensive because of the cost of high firing and the cost of the calcined bauxite which needs to be introduced to achieve the high alumina level.

Sillimanite and mullite refractories are commonly used in glass furnaces. The terms overlap somewhat because the best mullite refractories have until recently been made mainly from sillimanite and kyenite. However, the use of kyenite has declined recently because of difficulties caused by variable quality and content, and most sillimanite is now made from a mixture of Molochite and calcined alumina. A certain

amount of mullite is formed whenever an alumina-silica compound is fired over 1200°C (2200°F), the amount varying in relation to the form, the firing and the impurities present. Mullite is important as it is the one alumina-silica compound which remains stable at temperatures approaching 1800°C (3270°F). Traditional sillimanite refractories were made by calcining raw sillimanite or kyenite at high temperatures and after suitable grinding, the result was mixed with sufficient fireclay and water to bind the mixture together and make it workable in preparation for the process of forming, drying and firing. Both sillimanite and mullite refractories are commonly used for the walls of tank furnaces where there is glass contact. Fusion cast zirconia/alumina/silica refractories are common for tank floors when the glass being melted does not have a high potash content. Molten glass attacks refractories largely because of the corrosive action of the alkali. The temperature and the porosity of the refractories are also important in this context. Coloured glasses can increase the tendency to attack refractory surfaces because dark glasses in particular are usually hotter on the surface than a similar clear glass.

Silica refractories, as high as 96% silica, are commonly used in industrial furnaces for tank roof and walls above the glass line. They tend to spall during heating and cooling at temperatures below 600°C (1110°F) but above this temperature they work very well though they may be gradually attacked by volatiles from the founding, releasing drops of silica-rich material into the melt.

Fusion cast refractories, in which refractory materials are melted in special high temperature electric furnaces until they become liquid and poured into moulds, made a considerable difference to the range of refractory blocks available. The commonest of these are ZAC or AZS which in its standard form has 32% zirconia and Monocast which is made from pure alumina. Other blocks containing higher proportions of zirconia (up to 94%) and blocks containing up to 26% Cr_2O_3 are available for the making of special glasses. Many refractories are now chemically-bonded with materials such as ethyl silicate instead of the traditional clay. There are several advantages to this. They can be manufactured very quickly as there is no necessity for a long drying process before firing. No clay is involved so there is little or no shrinkage either in the forming, drying or firing schedule. There is a much improved resistance to thermal shock.

Complex forms can be cast to fine limits and with pre-determined surface quality. Large forms can be made precisely which means that they can be installed easily and quickly thus considerably reducing the number of joints which are a major cause of difficulties with furnaces. These casts can be sufficiently precise to enable the refractories to be assembled dry.

Fusion cast refractories can also be made with various other materials quite easily. Calcined alumina, zircon, sillimanite, mullite, fused silica granules, silicon carbide etc. can be bonded in proportions to suit a particular requirement. Insulation is also something which can be built in. It is possible to prepare a cast with a suitable hot face which is backed up in the same cast with material which contains bubble alumina, bubble mullite and even ceramic fibre to produce a material with the necessary K value to suit the requirement. Crushed and powdered fused silica can also be chemically-bonded to provide furnace roof blocks. The resulting refractory also has a very high resistance to thermal shock.

One refractory material is produced naturally by nature – the raw material, diatomaceous earth. It is found in Denmark, France and the United States and is formed from the siliceous shells of tiny single cell organisms in former sea beds. The result is a very porous material which can be bonded with clay and fired into an effective, insulating refractory material or simply cut into suitable insulating blocks.

Various other refractories are produced specifically for insulation purposes and these are described under **Insulation**.

Refractory cements. These are numerous but the most popular are Ciment Fondu and Secar. Both are alumina-based. Secar has a higher temperature rating. They can be mixed with various refractories but need care as most casts involving these cements have very little mechanical strength until they have been fired to at least 900°C (1650°F).

Regeneration. This is a process which, like recuperation, uses the waste heat from the furnace to pre-heat the air which is being introduced as the source of combustion. Whilst the recuperator takes the heat from the exhaust gases and transfers it to the burner air on a continuous basis, the regenerator does this on a cyclic basis. This involves passing the hot exhaust gases over special refractory blocks so that they heat up. Once hot, the exhaust gases are sent through a different regenerator and cold air is passed over the hot blocks on its way to the burners. It then takes heat from the blocks and becomes pre-heated air. This cycle is reversed every few minutes to ensure a constant supply of pre-heated air to the burners.

Relay. A device which, by using a small current in one circuit, causes contacts to open or close in another. Relays are commonly used to operate switches or valves in furnace or kiln systems.

Release agents. These are used to ensure that materials used in casting will separate from the mould without damage. The particular release agent will depend on the materials being used. Porous materials such as plaster need to be sealed and usually the release is achieved by applying coats of shellac followed by soap. Proprietary release agents are available for use with various resins but wax, petroleum jelly and wax emulsions are often used. Silicone-based release agents are also readily avail-

able and can be applied by brushing or by spraying from a pressurised can.

Relief cutting. A form of decoration in which the background is removed by cutting to leave the pattern in high relief.

Resin resist. This is often wax-based. It is used on moulds in which epoxy or polyester resin is being cast or layered in order to ensure a clean separation when the resin has set.

Resist. This refers to any material which is applied to areas of glass to mask them from the effect of etching acid or from sandblasting. They were traditionally made from bitumen or wax or mixtures of the two but these have now largely been superseded by various plastic paints and film for both etching and sandblasting and by masking tape for sandblasting. See **Acid etching** and **Sandblasting**.

Reticella. Reticella bowls (Reticella – fine net) were made over a period from the 3rd century BC to the 1st century AD. One recent submission suggests that they were formed by winding twisted threads made from clear glass together with one or two white or yellow threads around a mould which was rotated on some sort of turntable similar to a potter's wheel. The thread would be applied by a technique similar to that used today by lampworkers. Other historians maintain that the twisted threads were formed into rings and arranged over a mould so that they fitted close together and were then heated until they fused. A further suggestion is that a hot gather with canes marvered into the surface was trailed around a mould in exactly the same way that a trail would be made around a glass form. Another suggestion is that the rings of twisted threads were arranged on a flat refractory surface and fused together before being

Reticella bowls. The method of manufacture of these small ancient bowls is still a matter of some conjecture.

Figure 1. This shows the method described by Keith Cummings in which twisted canes were formed into rings of various diameters. These were then arranged on the outside of a suitable mould and heated until fused together.

Figure 2. Rosemarie Lierke advances a theory that a form of primitive lampworking was used to apply the lengths of cane to a wooden mould which was rotated as the cane was applied.

Figure 3. She also suggests an alternative theory that cane was picked up onto a gather of hot glass, marvered in to the surface and then formed into a taper which was applied to the mould and twisted as the mould was rotated. In each of these two methods she suggests that the cane was pressed or tapped against the sides of the mould with a small wooden paddle.

laid over a bowl-shaped form and heated until they slumped into the bowl. This seems to have been the method used in recent attempts to make similar bowls.

There are other types of reticella bowls in which the threads are arranged in parallel lines across the bowl and fitted with a rim of twisted thread arranged around the circumference. The bowls are very fine and do not appear to have been polished in any way. There are several excellent examples of these bowls in the British Museum. The actual method used is a matter of conjecture as there is no factual reference to give any realistic information.

Producing similar forms would be a relatively simple matter with the availability of modern glassforming equipment and techniques. Several artists in recent years have produced work based on these forms and have used mosaic and ribbon techniques.

Reticello. Vetro a Reticello. This technique was probably inspired by ancient reticella bowls. It was developed considerably by the Venetians and resulted in some remarkably fine work produced by incorporating a network of threads into various glass forms.

There are several techniques used. The most common of these is that of picking up white threads arranged in parallel on a marver or in a mould onto a gather and, after blocking the threads into the gather, twisting it so that the threads run diagonally. Then it is blown out into a bowl which had been made previously using the same method but with the diagonals running in the other direction. The whole is then heated to fuse the two parts together and then blown and worked into the required form. A variation of this is to make an initial threaded gather, blow it out in exactly the same way, then to fold

one half into the other before sealing the end again and proceeding to blow it out as required. There is also a suggestion that instead of bending one half into the other, some glassmakers suck on the iron to produce the same result. (This is a hazardous operation as there are circumstances in which it would be possible to inhale very hot air. It is not recommended and the alternative should be preferred.) Wide bowls and plates are made by forming a parison as before, opening and spinning this out on a punty iron in the manner of making bullions. This is then fused to a similar plate made with the threads running in the other direction. There are obvious difficulties in this process, particularly in ensuring that the spacing of the lines is right, and it would appear to be a far more simple process to spin out wide bowls and plates from one of the forms previously described.

The most demanding part of the various reticello and filigrana techniques is that of producing lines which are reasonably equally spaced, particularly when producing the fine network arrangements by fusing one gather into a previously made bowl.

Reverse foil engraving. Gold or silver leaf was applied to the back of the glass and then engraved before being covered by varnish or another piece of glass.

Reverse painting. This covers a wide variety of approaches to painting onto the back of a sheet of glass with the intention that the result should be seen through the glass. It has been suggested that it is necessary to paint highlights before the background when using this technique but most experienced painters find no difficulty in handling the problem.

Rhodochrosite. $MnCO_3$. Manganese carbonate. Manganese ore.

Ribbon glass. The commercial version of this consists of rolled clear glass which has a series of parallel ribs on one surface. The term is also used to describe various bowls

Mould for casting a ribbon bowl.

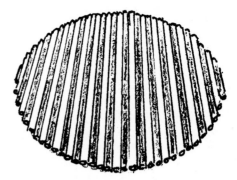

Figure 1. The cane laid out in lines to be heated until they fuse together to form a flat disc.

Figure 2. The disc arranged over a mould ready to be heated until the disc slumps into a bowl.

Figure 3. The ribbon bowl after firing and ready to be removed from the mould.

Figure 4. A variation in the arrangement of the canes prior to fusing.

Figure 5. The alternative arrangement for slumping in which the disc is placed into a shallow bowl for firing.

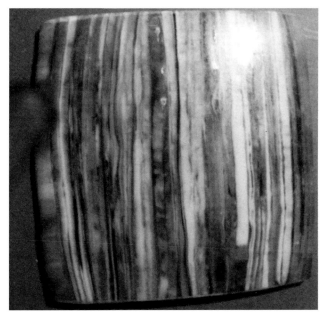

Canes fused together for slumping into a ribbon bowl.

and dishes made by fusing strips and rods of glass together and then slumping them into the required form. Sometimes lengths of lattimo, air twists and millefiori were incorporated. They were made as early as the first century BC and had a brief revival in popularity when produced in Venice in the 19th century. There is some debate about the finish of the ancient ribbon bowls: some maintain that they were hand polished on both surfaces, others that there was some fire polishing involved and there is also an opinion expressed that much of the polishing now evident was actually done in recent times.

The technique has been exploited recently with considerable success by Klaus Moje, Mikko Merrikallio and many others. In almost all cases in modern times, the procedure has been to fuse lengths of cane together on a flat surface and then to slump them into or over a dish or plate-shaped mould. There is some conjecture that, as in the case of the reticella bowls, they were made or at least completed on a surface which was turning and that the heated glass was patted into shape with a flat piece of wood.

Riddle. A container fitted with a coarse mesh for separating various sizes of solid materials.

Risers. The channels made in a mould to allow air to escape when glass is being poured or melted into it.

Rock crystal. Natural quartz. It is usually clear but can be almost translucent and was once, despite its hardness, in considerable demand for carving. The name was also given to a form of deeply-cut lead crystal glass produced in the Stourbridge area in the late 19th century and the early part of the 20th century. Initially the pieces were cut but later work was produced by using a dip mould and then finished by cutting and copper wheel engraving.

Rod. Solid lengths of glass of circular section often used by lampworkers for making decorative objects. Lengths of intensely coloured or opal rods are also often used by glassmakers for providing colour or for producing latticino effects on blown ware. They are obtained from specialist suppliers and are often known as 'Kugler' colours because the major producer of these rods for many years and the man who established a recognised standard was Klaus Kugler in Augsburg, Germany. See **Kugler colour**.

Rolled glass. Sheet glass often patterned, which has been produced by passing the hot 'metal' through rollers.

Roll-on enamels. Powdered colour made, in various grades, from ground glass for placing on the marver so that it can be picked up on to a gather of hot glass. See **Enamels**.

Römers. These were vessels, often very large, for drinking hock. They were usually made in forest-type glass, initially in Germany but later on throughout Europe. They had a deep foot which on early examples was made by trailing a thread around a wood core. Later römers had a blown foot and the thread was trailed on to this. They were usually decorated with prunts, most of which were impressed to suggest the form of a raspberry.

Rondels. Bullions. Circular crowns of glass which have been spun out on the end of a punty iron. They were the major source of sheet glass for many centuries. Unfortunately, only small panes could be cut from the crowns but, because they were made directly from blown and spun hot glass, they were much more brilliant than the other forms of sheet glass which were available.

Rotting. This refers to the process of deep etching. See **Acid etching**.

It is also a term used to describe a common form of glass decay usually caused by inadequate stabilisers in the batch and aggravated by damp conditions. It is the subject of much current research. See **Crizzling** and **Decay**.

Rousseau. See **Argy-Rousseau**.

Ruby. A transparent red variety of corundum which is used as a very expensive gemstone. Rubies are now being made synthetically and are increasingly used in lasers and in precision instruments.

Ruby glass. This is a term used to describe a wide variety of red glasses which have been produced by many different materials and processes.

From medieval times copper ruby has been the standard for producing the wonderful reds of most stained glass windows but there can be no doubt that gold ruby is the richest, the finest and, of course, the most expensive. It has been known from Roman times and it has

emerged at various times since. It was also the subject of much research in the 18th and 19th centuries. As a result of this research, many methods of making gold ruby have been produced. It was, and still is, a complex matter in which processes can go disastrously wrong. Gold is a very strong colouring agent and quantities as little as one part in 1200 will produce a very strong colour. As a result, it is usual to find a very thin layer of the ruby glass as a flashing on a clear or amber glass.

Some historians still maintain that gold ruby was discovered because glassmakers threw gold coins into the melt. This simply would not have worked. Gold needs particular preparation before its inclusion into a batch that will produce the required results. Most current batches for gold ruby are based on a high-lead glass with potash and some tin. The gold for the batch material was often dissolved in a mixture of hydrochloric and nitric acids and mixed with tin which had been dissolved in nitric acid, the mixture then being allowed to evaporate to a fine powder before being introduced into the batch. The ruby colour would not be apparent in the resultant glass until the ware was re-heated to enable the colour to strike.

At Hartley Woods of Sunderland, who were manufacturers of beautiful gold ruby sheets for stained glass windows, small melts of a basic highly-concentrated ruby were made which were then introduced into the main melt as appropriate to produce the required depth of colour. Most of the modern red and amber colours are based on cadmium-selenium and are in considerable demand for light signals and reflectors to various specifications.

Developing legislation, particularly in relation to the use of cadmium, gives rise to speculation that copper rubies may yet reappear in that context.

Ruby lustre. A copper or gold-based lustre giving a rich ruby iridescence to the surface of a glass.

Runners. The channels in a mould which direct the flow of glass so that it will fill the mould properly.

Rust. $2Fe_2O_3.3H_2O$. Hydrated iron oxide. This occurs on the surface of iron and steel as a coating when it is exposed to moisture and to air. It is sometimes used by potters to provide a source of iron oxide which is mixed into the clay so that it migrates to the surface and then breaks through the glaze.

In glass it is a nuisance as it can cause changes in colour. This is particularly important when making clear colourless glass and glassmakers need to take care to see that rust from the blowing, punty or bit irons does not fall into the glass. The remnants of glass knocked from the ends of these tools are often black because of the effect of the iron. If these ends are then used as cullet for re-melting they can colour the resulting glass.

Rutile. TiO_2. A natural ore which is a source of titanium dioxide. It also contains up to 15% iron oxide and is sometimes used by potters for producing speckled and broken colour effects in both glazes and clay. The darker ore containing up to 25% iron oxide is known as ilmenite. It finds occasional use by glassmakers as a source of titanium dioxide but is not generally suitable because of its high iron content. It is more common for glassmakers to use chemically-prepared titanium dioxide.

S

Safety. There has been considerable concern both with safety and with the necessary legislation which has been introduced over recent years and constantly updated by both national and international authorities. Much of this legislation provides what is often simple and possibly obvious commonsense precautions but there are a surprising number of occasions when it has the added advantage of pointing out particular hazards of which the glassworker may not be aware.

There is often an assumption that the person operating at his or her own studio or workshop is not affected by Health and Safety regulations but this is not so in Britain and it is likely that the same rules apply in many other countries. There is also a legal responsibility to any visitors, assistants and family who might be in, or who use, the studio.

When starting or taking over the running of a studio or workshop, it is essential to take the trouble to explore the relevant regulations and responsibilities. Some of those affecting people working in Britain and the European Community are noted in the appendix.

There are several areas of concern to people working in glass, notably:

1. The effects of heat and infrared radiation from the furnace and glory hole.
2. Fire or explosion arising from the fuel and burner system.
3. The handling of toxic, corrosive or irritant materials.
4. Fume from volatile materials in the melt, from iridising processes, acid etching, from exhaust gases and from the effects of heat on various mediums.
5. Dust from grinding, polishing, batch mixing and sandblasting operations.

The main problems arising from working at a furnace come either from heat exhaustion or the effect of radiation from the infrared, ultraviolet and soda wave lengths on the eyes and on the skin. The situation can be helped by the use of an exhaust hood over the furnace, not spending too much time in front of it, by the use of reflective screens and by developing the habit of constantly wearing appropriate eye protection. Perhaps surprisingly, burns from contact with hot materials are very rare.

Gas- and oil-fired furnaces give off considerable amounts of carbon dioxide and oxides of nitrogen. They also release various volatile materials as fume during the founding process, some of which can be toxic or corrosive. It is essential that the exhaust gases are properly ventilated and not allowed to build up in the studio.

Some artists iridise their ware by spraying a solution of tin nitrate or tin chloride onto the hot glass. It is essential that this is carried out with a purpose-built extractor hood which removes the fumes that are released when this material hits the hot glass. The firing of lustre in a kiln also produces fume which needs to be removed adequately.

Many of the techniques carried out on cutting and engraving lathes, polishing machines etc. can create a hazard because of glass breaking if the material being worked has not been properly annealed. Safety goggles are essential. As most of the operations are wet, the danger from dust is minimal but care should be taken when handling dry tripoli powder as this is highly siliceous.

Sand is now rarely used in sandblasting as more effective materials such as carborundum or alumina grains are readily available. If there is a need to use sand at all, full precautions against dust inhalation must be taken as even coarse sand produces fine dust which is almost pure silica when it is used for sandblasting. It is imperative that the dust collector in the sandblasting unit is working efficiently and that the cabinet door is well sealed.

There are obvious and particular dangers in the various processes of acid etching and these have been described earlier under **Acid etching**.

Safety in relation to the storage and the use of various fuels is now subject to considerable legislation in most countries and it is imperative that glassworkers make themselves aware of those which are in force in their own area.

SAFETY RELATING TO THE USE OF BOTTLED GAS. Bottled gas has largely been the province of the lampworker and the few glassmakers who operate a furnace or kiln on propane. With the increasing use of oxygen in furnace systems, the dangers associated with the use of bottle gas have become more relevant. The three gases used are likely to be propane, oxygen and, very occasionally, acetylene.

Propane is a gas which is heavier than air and because of this presents its own particular dangers as any leaks can collect in drains and/or low-lying areas. It will ignite easily from a spark or piece of hot glass or metal and is both a fire and an explosion hazard. In Britain, a characteristic fishy smell has been deliberately introduced to make any leaks easily detected.

Acetylene also has its own distinctive garlic smell and,

like propane, it is a fire and explosion hazard. As it is lighter than air, it is less likely to collect in pockets than propane and in most situations should soon disperse. It will, however, ignite much more readily and therefore demands even greater care and attention.

If there is a leak of either of these gases at the cylinder and the supply cannot be turned off by using the valves, it is strongly recommended that all sources of ignition should be eliminated, that the cylinder should be removed outside to a well-ventilated area, that any uninvolved personnel should be evacuated, that the supplier should be informed and in the case of LPG the fire brigade should also be notified. As propane is heavier than air, some care should also be taken that the cylinder is not placed where the leaking gas can collect in drains or hollow areas.

Oxygen is not considered to be toxic. It does not burn but aids the combustion of other materials including many which otherwise would not normally burn. It has no smell so leaks are not easily detected. It reacts with most elements but the manner of this reaction depends largely on the pressure, the temperature and the concentration. Even the lighting of a cigarette in an oxygen-enriched atmosphere can be enough to trigger a hazardous situation.

One cause of accidents involving oxygen often occurs when an operator uses grease or oil on valves. Oxygen can react violently with both oil and grease and can create ignition or even an explosion so care is necessary to ensure that greasy hands or rags are kept away from the cylinders and fittings.

Gas cylinders are designed to high standards, and, when owned by the suppliers, are maintained by them. They are responsible for ensuring that the cylinders conform to the required specifications. On the other hand, when the cylinders are owned by the glassworker, it is essential to ensure that all the relevant regulations are known as the responsibility for their condition rests completely on the owner. As a general rule, the cylinder outlets for combustible gases are fitted with left-handed threads and need anti-clockwise turns to tighten them and outlets for non-combustible gases are usually right-hand threaded and need clockwise turns to tighten. The taps on all the cylinders are usually right-hand threaded and are turned clockwise to close off the supply.

Cylinders are best stored upright, out in the open whenever possible, placed where there is no fire risk and well away from sources of ignition or heat. Oxygen cylinders in store should be kept well away from cylinders containing fuel gases, preferably at least three metres apart or separated by an appropriate fire wall.

One of the biggest dangers in any system employing pressurised gas is the possibility of what is called back-feeding when a gas at a higher pressure feeds back along a lower pressure line. This can lead to a flashback. There are several devices which can be introduced to reduce the possibility of this happening. Firstly, the hoses should be fitted with check valves. The correct pressure regulators and gauges should be used and they should be in good condition and set to the right pressure. Flashback arrestors with appropriate cut-off valves should be fitted as standard.

There are several publications which define codes of practice in using bottled gas. Those published by the IGC (International Gas Confederation) can be obtained from:

Publication de la Sondure Antogene
32 Boulevard de la Chapelle,
75880 Paris Cedex 18. France.

Those published by the BCGA can be obtained from:

British Compressed Gases Association,
St Andrews House,
26 Brighton Road,
Crawley, West Sussex. RH10 6AA.

Those published by the British Standards Institute from:

Enquiry Service,
BSI,
Linford Wood,
Milton Keynes, MK14 6LE.

For those using mains gas supply, there is also a publication *Code of Practice for the use of gas in high temperature plant* (IMI2) 2nd edition, available from, British Gas TCS, Derwenthaugh Rd. Swallwell-on-Tyne, Tyne and Wear. This is currently available at £10 and should be mandatory as a handbook for all those running a glass furnace.

Apart from the obvious dangers from leaks, the main hazards from running a furnace burner system occur when there has been a flame failure and when the gas/air mixture has been allowed to build up before a suitable source of ignition has been introduced. The methods of control for gas burners have been described earlier under **Burner control and Safety systems**.

SAFETY WITH BATCH MATERIALS. Many of the batch materials are either siliceous, irritant or toxic by ingestion, by inhalation or through the skin. Whenever possible batch should be mixed in a closed container and appropriate mask and protective clothing worn when handling the various materials. Ideally, a shower unit should be available for use after batch mixing and founding. Avoid eating or drinking in the batch mixing area.

SAFETY IN HANDLING CHEMICALS. The hazards associated with chemicals are inherent to the substance and there is rarely anything that can be done to change them. What can be changed, however, is the awareness and control of those hazards. Glassworkers often have to use quite a wide range of chemicals, some of which are toxic, some are corrosive, some are irritants, some may even be explosive. They can be in the form of solids, gases or liquids. They can all normally be handled with reasonable safety if the correct precautions are taken and they are treated with respect. Danger often occurs when familiarity leads to lower concern and sloppy operation.

The current danger signs for labelling materials etc. are:

The common ways for chemicals to attack the body are by swallowing and ingestion through the mouth, by absorption through the skin and by inhalation. The major precautions to take in avoiding these possibilities are cleanliness, adequate storage and labelling, installation and continuing maintenance of appropriate equipment, the wearing of appropriate protective clothing and masks, and access to relevant information.

The dangers from corrosive substances such as hydrofluoric acid and other etching materials are obvious and are described under **Acid etching**. The materials which can be classed as being irritants are much less obvious but can present a much more insidious problem. It is easy to disregard the possibility of the accumulative effects from occasional contact with solvents or similar substances. These often appear to be quite innocuous but can gradually degrease the skin, making it less resistant to other materials. As a result, various unfortunate skin conditions can develop.

Nowadays, chemicals are generally supplied with appropriate labelling to indicate the nature of any hazards and safety precautions that need to be taken. There are also exposure limits relating to chemicals in the atmosphere published by the American Conference of Government Industrial Hygienists and in Britain by the Health and Safety Executive. These limits are based on the concept of the Threshold Limit Value. This establishes the upper concentration for a chemical in air that a person can breathe in during an 8-hour period, five days per week, for an estimated 40-year working life. It also assumes that between successive 8-hour exposures there will be a 16-hour period in which the body can carry out its own detoxification process.

There are variations in these tables to allow for short-term exposure conditions and for cases where an absolute ceiling of exposure of any kind needs to be defined. The tables are constantly updated as there have been several cases where a substance which has been accepted as being relatively harmless for many years has suddenly been proved to present its own particular danger.

It is obviously impossible to list all the chemicals which are likely to be hazardous. Many of them have been indicated in the text but it must be the concern of each individual glassworker to ensure that he or she has the requisite information on both materials and processes.

Safety glass. Glass which when broken does not shatter into sharp fragments.

There are two main types of safety glass: 'Toughened' where the glass has been heat-treated and cooled rapidly, and 'Laminated' in which two or more sheets of glass are fixed together with a layer of a suitable plastic or some other re-inforcing material known as the interlayer or interleaf. The commonest material used for this purpose these days is a plastic of the vinyl-type which does not require any adhesive. The vinyl layer is assembled with its covering layers of glass in an air-conditioned room to avoid moisture and dust and is then heated and passed through rollers. Thicker layers of laminated glass are made either by introducing more layers or by using thicker glass. Appropriate thicknesses of these can be used as bullet or burglar resistant glasses.

'Toughened' glass is one which has been heated and then cooled sufficiently rapidly by the use of air jets played onto both sides to provide a tempered surface. This glass when broken shatters into comparatively harmless fragments with blunt edges. Sometimes where there is a particular requirement for maximum strength as in windows of pressurised vessels, the two processes are brought together and the layers of glass are toughened before they are laminated.

Saggers. Refractory boxes used in a kiln to protect glass which is in the process of being slumped or melted into moulds from the direct action of flame or flame-borne dust.

Typical fireclay saggers used to protect ware from direct flame contact during kiln firing processes.

Saltpetre. KNO_3. Potassium nitrate. Normally used in small proportions as an oxidising agent, particularly in crystal and optical glasses. It is not now commonly used in large-scale production because of its tendency to create noxious emissions.

Sand. SiO_2. Silica. Sand is a general term for accumulations of detrital sediment consisting largely of rounded grains of quartz but often also containing a range of other materials. To most people, it means sand castles on beaches or something to mix with cement for building purposes. To the glassworker it is the basic material from which the glass is made and for many centuries it was the

material commonly used for grinding and for rough polishing.

Glassmaking sands need to satisfy various criteria, particularly those of grain size and low contamination by iron, alumina and feldspathic materials. Very good quality sands are available in many parts of the world but chemical treatment of lower grade sands has improved considerably over recent years and many of these can now be used satisfactorily, particularly in the container and flat glass industries.

In Britain, the best glassmaking sand comes from Loch Aline in Scotland but it is expensive as it has to be mined. Good quality sands are still imported from Belgium, Holland, France and Germany but there are many British sources which are perfectly adequate after acid washing and suitable flotation processes. In the USA there are good deposits in Illinois, West Virginia and Pennsylvania but the sands on the West Coast contain high quantities of feldspar and even after treatment can still contain up to 10% alumina.

A typical Loch Aline sand would have an analysis of:

SiO_2	99.75	–	99.85
Al_2O_3	0.05	–	0.10
Fe_2O_3	0.009	–	0.013
CaO	0.01		
MgO	0.01		
Na_2O	0.01		
K_2O	0.005		
TiO_2	0.01		
Cr_2O_3	0.0003		

Sandblasting. The process of projecting abrasive material by the use of compressed air in order to matt or to penetrate the glass surface.

The system was invented by an American, Benjamin C. Tilghman in 1870. It seems that Mr Tilghman was inspired by the effect of the sand on domestic windows on the American prairies. His equipment was patented and shown in a Vienna exhibition, and was soon in use throughout Europe and America. Some of the early sandblasting was carried out by steam pressure but the means of providing compressed air progressed rapidly and this soon became the standard mode of operation. By the 1890s the equipment was remarkably similar in concept to that used today and in the first half of the 20th century large quantities of glassware and architectural glass was being decorated by sandblasting.

Whilst sand works reasonably well it should not be used because more effective abrasive materials with less toxic properties are now readily available. Fine dust from the sand is largely silica and creates considerable difficulties if it is allowed to accumulate in the lungs. See **Silicosis** and **Pneumoconiosis**.

Silicon carbide is a common material used for sandblasting but most people prefer electro-corundum (aluminium oxide). It is available in a variety of grit sizes but fine or very fine grains are the most popular.

Sandblasting is a process normally carried out in a cabinet which is designed specifically for the purpose, with built-in extraction facilities to remove any dust, and,

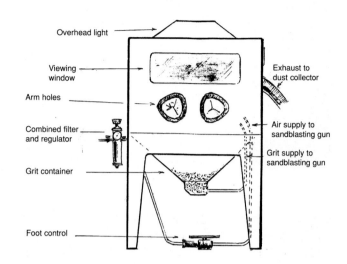

The standard sandblasting cabinet

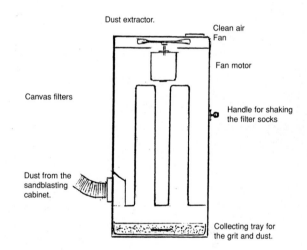

The dust extractor cabinet.

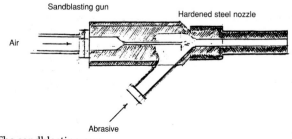

The sandblasting gun.

Sandblasted piece by Ursula Merker

Sandblasted goblet by Alison McConachie.

suitable air gun with appropriately sized nozzles for the type of work and a dust collector. In the most common system for glass decorating, the gun operates by a process of suction feed in which a thin blast of high velocity air creates a vacuum and sucks abrasive into its path from which it is projected through a nozzle on to the work. It is important to rotate the nozzle occasionally to avoid erosion at the point of entry of the abrasive particles. The spent abrasive and any heavy material removed from the surface of the glass falls to the base of the cabinet where it becomes available for further use.

In the dust collector a fan sucks in the dust through cloth filters which can be cleaned periodically by shaking. This releases the dust into a tray or drawer at the base of the cabinet.

Some larger installations operate on a pressure feed system. In this case air under pressure is released into a container holding the abrasive which is then projected through valves into a further stream of compressed air which accelerates it through a nozzle on to the work. In contrast, it is also possible to use a portable sandblasting gun with its own container for abrasive which it feeds partly by gravity and partly by suction into the path of

Blown forms, sandblasted.

at the same time, preserving the heavier abrasive by allowing it to fall to the base of the cabinet for further use. The dust extractor is similar to a domestic vacuum cleaner, the air being sucked through canvas socks which allow clean air to be filtered through whilst the dust is retained.

The necessary equipment consists of a cabinet as described, an air compressor and receiver with the necessary capacity, (approximately 14 cubic feet or 400 litres per minute at 80 pounds per square inch (5.6 kg per cc) would be normal though rather greater capacity would be needed if deep penetration or carving was wanted), a

the jet of air. Some guns have the container underneath the gun in which case the feed is by suction alone. The portable type of gun is particularly useful when having to work on large pieces of glass which will not fit into a cabinet or where glass is in a situation from which it cannot be easily moved. Suitable dust mask and eye protection is essential when using this type of gun.

Sandblasting glass usually requires that the areas not to be affected should be masked. This can be done by using wide masking tape, fablon or clingfilm which can be cut through and removed as required to allow access to the areas which need to be blasted. Another method is

simply to coat the areas to be masked with some suitable material such as poly-vinyl-acetate or the white type of adhesive commonly used for joining wood. There are specialist firms who will provide masks made by a photographic process to a specific design which simply needs to be fastened to the glass. If much sandblasting is envisaged, machines such as the DEK 65 are available which will print a rubber-based masking material directly onto flat or cylindrical glass.

The surface resulting from a sandblasting process readily picks up greasy marks from the fingers, so many operators treat the matted surface with polishing acid (a mixture of hydrofluoric and sulphuric acids, see **Acid polishing**). A short immersion will usually improve the surface considerably. An alternative is to give the surface a light rubbing with a very fine abrasive powder or with fine emery cloth.

Sand casting. This is a simple method of producing glass forms. It is reputed to have started because of the need to produce blown bowls which would fit onto the outside of another bowl usually made of silver. The inner bowl would be pressed into damp sand, removed carefully and glass would then be blown into the resulting depression to form the outer bowl.

It is now a common technique for producing quick

Sandcast figures by John Cook. Currently in the Corning Museum of Glass, USA.

Sandcast figures.

vigorous sculptural forms. Original forms or various elements are pressed into damp sand and large gathers of glass are then allowed to run into the newly-formed mould. The sand should be just damp enough to stay in place when pressed. If the sand is too wet, the resulting steam can easily bubble up through the glass and create large blisters. If it is too dry, then there is likely to be insufficient steam to provide a releasing barrier and the glass will pick up amounts of sand into its surface.

Sand core techniques. See **Core-formed glass**.

Sandwiched gold and silver leaf. This is a technique which is very popular with some studio artists but is certainly not new. It was practised in Hellenistic times as early as the third century BC. In the early techniques, the outer surface of one bowl was coated with gum upon which leaves of gold were pressed. These were then engraved with flowers, animals and human figures and the whole fitted carefully into an outer bowl which fitted just under the rim of the inner bowl. It was then heated slowly to seal the whole form together. There were several developments of the technique. The Romans picked up gold leaf onto a gather of hot glass which was then blown. Fine grains of gold were also sprinkled onto gath-

ers of hot glass and colloidal gold was often painted onto glass surfaces and then fired. Most glassmakers using gold and silver leaf today pick up the leaf from a marver and cover it with another gather before blowing the necessary form.

Santocel. A trade name for a silicone rubber matting agent often used to strengthen the surface of the silicone rubbers used in mouldmaking processes by restorers.

Sapphire. This refers to almost all the gem varieties of corundum except for ruby. It is mostly blue but can be yellow, brown, green, pink, orange and purple. It is used mostly as a gemstone but it also has a range of industrial uses.

Sassoline. A mineral found in Italy which contains boric oxide.

Satin glass. Glass with a fine matt finish. This can be achieved by light sandblasting or acid etching or by a combination of the two.

Saturation. The point at which a limit has been achieved for dissolving one material in another.

Sawing. The process of cutting and shaping glass by use of a diamond blade on a suitable motorised machine. This could be in the normal form of a circular saw or bandsaw fitted with an appropriate diamond blade and with provision for applying water and/or coolant to the blade. See **Diamond tools**.

The small air-driven diamond saw normally sold for cutting fibreglass which has much to offer in its manoueverability for use with glass.

Scale. Particles of metal from blowing and punty irons etc., which fall into the melt and become picked up in a gather.

Schist. A range of metamorphic rocks showing plate-like layers. They split readily in planes along the lines of the layers of the minerals. Mica is an obvious example which has been traditionally used as a heat resistant transparent sheet. It was once used by the Romans to provide windows panes.

Screen printing. The process of pressing enamels through a suitably masked silk, stainless steel, polyester monofilament or nylon screen in order to produce repetitive designs on glass. The gauze screen is stretched over a strong wooden or metal frame which should be sufficiently substantial to withstand any distortion which might be produced by the stretching process. Mesh sizes used vary between 80 to 200 approximately per linear inch depending on the type of work. In industry there is considerable use of light-sensitive emulsions to produce stencils. This can be hand-coated or used on a proprietary type of polyester support film. For the short runs likely to be wanted in a small workshop, a screen can be suitably masked and for flat glass, the enamel screened directly onto the glass. For industrial purposes and for blown ware, it is usual to screen the enamel onto transfer paper, and the design then applied to the glass in the normal way. The squeegees used today are usually of synthetic material such as polyurethane. It is important to maintain a good screening edge on the blade of the squeegee. Careful preparation of the colouring paste and control of viscosity are essential to the production of good printing.

Seam mark. In most moulded glass there tends to be a small ridge where the parts of the mould meet and this is known as the seam mark. On cheaper items the ridge tends to be left but on higher quality ware it is usually ground off and the piece then polished.

Sedimentary rock. Rock which has been formed by the effects of pressure, heat and/or chemical action on igneous material which has been eroded, degraded and re-deposited, usually in layers, and often at considerable distances from the original material. Sandstones, slates and some kinds of coal are examples of sedimentary rock.

Sedimentation. The natural process which separates fine and light particles from larger and heavier ones. It was a common method formerly used for washing and separating the minerals and ashes to be used in batch.

Seeds. Gaseous inclusions (small bubbles) in glass. They are usually caused by the release of gases from the batch materials which have not been removed in the fining process. See under **Batch melting** and **Defects**.

Seedy glass. Glass which contains seeds. Sometimes also refers to glass which has been deliberately produced to incorporate scattered bubbles in order to make sheets of glass, usually coloured, with an antique character.

Selenium. Se. A metalloid element of Group VI in the periodic table. It resembles sulphur. It is a glass former which is used in conjunction with sulphur to produce yellows and with cadmium disulphide to produce a range of red and orange colours in glass. It has the dis-

advantage of being volatile and because of its valency, capable of producing a range of colours. Unfortunately, these can easily turn out to be those which might not be intended so it needs careful control. It is toxic. Those suffering the effects of its toxicity tend to smell strongly of garlic. It changes its resistance with changes of light and because of this was commonly used in photographic light meters.

Separators. There are many materials used in casting and slumping processes to enable the glass to release cleanly from a mould or kiln shelf. Plaster of Paris, whiting, magnesium oxide, magnesium silicate, zirconium silicate and silica are all used for normal temperatures whilst for very high temperature usage boron nitride is an accepted separator.

Sepiolite. $3MgO.4SiO_2.5H_2O$. Hydrated magnesium silicate. A form of soapstone similar to talc. It is sometimes used as a thickening agent in conservation processes.

Series winding. This refers to the process of wiring a series of resistances to one another. See **Electrical terms** and **Elements**.

Servitor. The member of a glassmaking team or 'Chair' who gathers and prepares the pieces for the glassmaker.

Setting. Usually termed 'Pot Setting', it refers to the setting of a glass pot in a furnace.

To the stained glass artist, it refers to the fixing of the completed window into its situation.

Sgraffito. A method of decoration where two layers of coloured material are applied and the top layer is scratched through to reveal the lower.

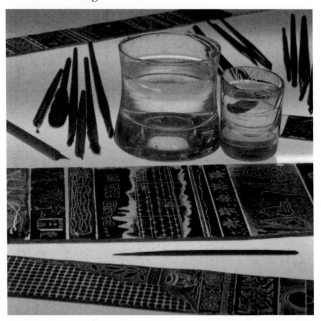

Experiments in sgraffito techniques. *Courtesy of Centro del Vidre de Barcelona.*

Shard glass. This term has come to describe a form of decoration in which coloured glass is blown out into a very thin bubble which is then broken into fragments or 'shards'. These are then laid onto a marver and picked up on a parison to be marvered into the glass before being blown out into a form. It is a technique often used by Asa

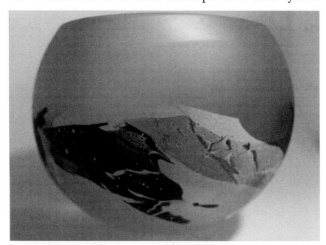

Shard glass bowl by Jane Charles.

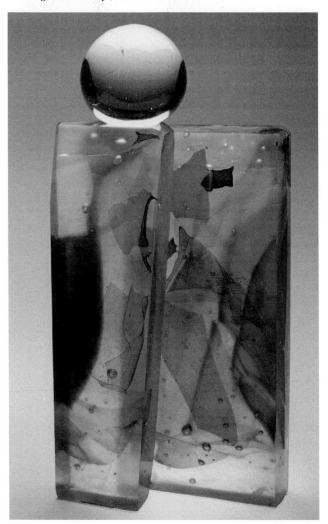

Cast blocks of glass incorporating shards of glass.

Brandt in Sweden and by Alison McConachie and Jane Charles in Britain.

The technique of picking up small pieces of coloured or opal glass is not new. The Romans used a variation of this technique and it has since been revived from time to time. Certainly the Venetians and the French used it. In Britain it was characteristic of much Nailsea ware and latterly Sowerby glassworks in Gateshead also used it.

Shards. See **Sherds.**

Shearings. Pieces of waste glass removed by the glassmaker as he trims the rim of a blown piece to enable it to be properly worked and finished. The pieces are also known as clippings or cuttings and usually find their way into the cullet bin.

Shears. Tools used by the glassmaker for trimming hot glass on the end of a blowing or punty iron.

Glassmakers' shears.

Sheet glass. Flat glass. Flat glass produced by blowing, drawing, rolling or floating. It is a term generally used to cover all the flat glass except for plate glass which is essentially that which has been ground and polished.

Sheets of glass were used for windows in Roman times together with thin slices of mica, alabaster and even shells. Initially they appear to have been made by a primitive form of casting where the glass was poured onto a slab and then stretched out by pulling with pincers. An alternative theory suggested is that it was poured into a shallow tray with a wet wooden base and either rolled or flattened into a rectangular shape. The early material tended to be blue, green and occasionally brown but eventually a pale yellowish-green glass was developed, one side of which was always rough from the sand which was placed on the casting tables as a separating agent.

There has been a suggestion that crown glass appeared in Samaria in early Christian times in the form of small bullions which were installed in pairs. Certainly, the Syrians made large flat dishes around this time and it would seem likely that this activity could lead eventually to the production of crowns. It was then some considerable time before crowns of sufficient size were made for cutting up into rectangular panes. The Syrians were active in making window crowns in the 8th century AD. Eventually the making of crowns spread into various Western civilisations and fine sheet glass made from crowns and turned into mirrors was exported from Venice as early as the 13th century.

The Venetians had the ability to produce good quality clear blown glass but seemed to have little interest in using this skill in the production of window glass. The windows that they did produce were necessarily small because they continued to spin crowns to provide them. These also tended to be made from green glass and often left the centre of the bullion in the pane. Crown glass whilst being limited in size did offer the advantage of being fire polished on both sides.

Sheet glass from blown cylinders was thought to have been produced in Germany as early as the 11th century and it seems strange that this method of producing sheet glass did not appear in Venice until some centuries later. One common explanation for this which has often been suggested was that the Venetians were content to specialise in the production of decorative glass and obtained any clear window glass that they might require from either France or Germany.

The building of the great European churches was probably the greatest stimulus to the development of window glass, most of it being produced by the cylinder method except in Normandy where they continued to prefer to spin out crowns. The same process also appeared and continued to be used in Britain where the crown glass was considered to be superior to cylinder glass for painting. This remained the accepted view for about a century and a half until Britain was the only European country regularly producing crown glass. Another method of making small panes of glass was that of blowing glass into a rectangular box and then cutting along the edges to make five small sheets. For some reason these came to be called 'Norman Slabs' though there is no evidence to suggest that they ever had any connection with the Normans or with Normandy. They have their own character, being thinner at the edges than in the centre so when coloured, panes have a greater depth of

colour in the centre. They are still made occasionally to order by firms specialising in making stained glass.

The French are credited with the re-introduction of the process of producing sheet by pouring glass onto a casting table with metal bars placed along the edges, spreading and rolling the glass until it became reasonably flattened then removing it to be annealed. If necessary the glass was then ground and polished. This resulted in the production of much larger sheets than was possible by either the crown or the cylinder method.

In the early 18th century there were some 90 glasshouses in Britain but all continued to produce sheets by the crown and the cylinder method and it was only in the late 18th century that the Cast Plate Glass Company was founded in St. Helens. Some of this lack of development in Britain prior to the founding of this company was probably due to the ridiculous tax systems which prevailed and tended to stifle any initiative. When this was abolished, it took some time before the industry started to move. One of the taxes had imposed severe constraints on the production of glass more than 1/9 of an inch thick so that any glass that needed to be ground and polished presented obvious difficulties. Robert Chance in Birmingham improved the production of sheet glass by having his glassblowers make much bigger cylinders which were cracked along the length when cool rather than having the cylinders cut with shears whilst still hot as was the practice in continental Europe. He then re-heated the cylinders and flattened them with a block of wood against a sheet of polished plate glass rather than onto the traditional bed of sand. This produced reasonably smooth, bright sheets rather than those which needed to be polished on one side. The Chances later improved the process to make what became known as the Chance patent plate.

One of the difficulties in polishing thin glass which would conform to the restrictions imposed by the tax system was that any glass which was not flat to start with needed so much grinding that it inevitably became far too fragile and either broke during grinding and polishing or was too thin to be reasonably safe to use. This problem was eventually solved to some extent by resting the glass on slates covered with wet leather which at least saved many pieces from being broken whilst they were being ground and polished. James Hartley in Sunderland introduced a method of making thin but rough sheets by ladling the hot glass directly from the furnace onto a casting table. The result was unpolished sheet glass which was cheap and in great demand for skylights etc. This process was improved by James Chance who passed the glass through two rollers and produced glass which was reasonably clear and bright on both sides.

In America a novel process was developed which enhanced the possibilities of the cylinder method considerably. The glass was ladled from the furnace into a reversible pot which sat on top of a heat source. A large drawing pipe was then lowered into the molten glass which hardened on the inside of the rim. The pipe was then raised whilst cool air was blown into it, the speed of the lifting pipe together with the amount of cool air was used to control the wall thickness of the resulting glass cylinder. This cylinder, which could be as much as 40 ft (12 metres) long was lowered from the vertical to a horizontal positon before being cut into lengths and then opened out and flattened.

Many attempts were made to draw glass sheets directly from the furnace but all the early attempts suffered from the fact that as the glass was drawn it reduced in width. Fourcault in Belgium managed to overcome this difficulty by using a refractory slab with a slot through it. This was floated onto the glass and then pressed down until it was just under the surface. The glass welled up through the slot where it was drawn away vertically by rollers. The thickness of the glass was again controlled by the rate of drawing. This process produced good glass sheet in the early stages but after a few days there was a tendency for the quality to decrease because of the amount of devitrified particles forming around the slot. A similar process developed in which as the glass passed through a slot the edges of the molten sheet were gripped by serrated wheels as it was drawn vertically before being bent over rollers to proceed horizontally. This process was further improved by a firm in Pittsburgh, USA. Air-cooled serrated wheels were used at the edge of the emerging sheet. These cooled the edges sufficiently for the glass to resist its tendency to reduce in width. They also reverted to the vertical drawing of the

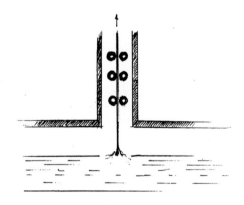

Diagram to show the general principle of drawing glass vertically from a furnace in the Fourcault and Pittsburgh processes. *Courtesy of Pilkington Glass.*

Diagram to show the movement towards horizontal in the Libby-Owens process.

sheet into a tower in order to avoid the marks on the glass which resulted from being bent over a roller as happened in the Bicheroux process. The sheets were cut into lengths at the top of the tower.

The other type of glass which was produced was 'Plate' glass. This was essentially glass which was ground and polished on both sides and was initially produced for the making of mirrors. The development of this is described under **Plate glass**.

Eventually in 1952, Sir Alistair Pilkington at St. Helens invented the process which revolutionised the production of both window sheet and plate glass by extracting the glass directly from the furnace to float on top of a bath of molten tin. This produced high quality material which became known as float glass. It had a polish on both sides and was perfectly flat. The process was taken up under licence by glass factories all over the world and is now the standard method of producing quality sheet glass.

Shellac. A resinous thermoplastic material secreted by the lac insect in S.E. Asia. It is commonly used for French polishing and as a separator in electronics. It is often used as a coating on resin glass fibre moulds to aid the separation of the mould from the built up or cast material for which it is used.

Sherds. Shards. Potsherds. An archaeological term to describe broken pieces of pottery or glass.

Shims. Thin pieces of metal inserted into a clay model to separate the various sections which will form a piece mould.

Shrinkage. The reduction in the mass of a material which can occur as a result of the loss of heat, by evaporation or by various physical and chemical actions. In glassmaking the shrinkage of glass objects after they have fallen to and below the annealing temperature is a major cause of stress. See **Annealing** and **Expansion**. In the making of glass melting pots, control of the shrinkage of the clay both during the making and in the drying is most important in avoiding the creation of faults in the pot which might only become apparent when it is brought into use.

Sick glass. This term is used to describe glass which is sweating, weeping or which has become crizzled. It often results from an excess of alkali and/or insufficient stabilising material in the batch and with humid storage conditions. The maintenance of a stable atmosphere seems to be an essential part of conservation. Brill observes that glass which over the centuries has reached some form of equilibrium can deteriorate rapidly if suddenly brought into a dry atmosphere. He states, 'Under such conditions hydrated glass can become de-hydrated and the crizzling fissures open up – this may happen in the course of a few months'.

Weeping glass produces small drops of moisture and/or a slippery surface in damp conditions because chemically uncombined alkali leaches out as a result of the action of water vapour. The very fine surface crazing known as crizzling is also due to the removal of alkali ions. There are many other factors in both the crizzling and weeping processes. Much seems to depend on the type of alkali present and a mixture of soda and potash seems to increase durability considerably over glass containing only one of them. The amount of calcia is also important as both low levels and very high levels reduce durability whereas amounts in the region of 10% mol increase the stability. It is a very complex subject and for every general statement which seems relevant there will be some fact which will emerge to contradict it. For those who wish to pursue the subject further, it is particularly well-covered in an excellent book *Conservation of Glass* by R. Newton and S. Davison. There has also been some recent research in a collaborative effort by the Conservation Department of the Victoria and Albert Museum and the Physics Department of Imperial College. Results of this research are expected to be published soon.

Siderite. $FeCO_3$. Chalybite. Ironstone. Mineral form of ferrous carbonate.

Siege. The floor of a glass furnace where the pots are seated and also the floor of a glass tank.

Sieve. A frame containing a mesh and designed to separate fine from coarse particles of solid materials.

Sight size. In windows this refers to the actual size of the opening which lets in light.

Silica. SiO_2. Silicon dioxide. Many millions of years ago when the planets were forming, masses of silica appeared as the result of the combination of two of the commonest elements, silicon and oxygen. At first, while the temperature remained high there was no orderly structure. In other words, there would be no sign of crystal formation. Si-O bonds were continuously forming, breaking and re-uniting. As the temperature reduced and the movement subsided, silica tetrahedra became more numerous but there would still be no ordered repetition of tetrahedra therefore no crystals. When the temperature reached 1713°C (3115°F) the situation changed. As a result of a reduction in the energy, each tetrahedron took up the best possible position relative to its neighbour. This configuration of linked tetrahedra would be the same within the silica which means that a repeated geometric pattern from one part to the next would be established and crystal growth would proceed.

The crystal formed by silica at 1713°C (3115°F) is called cristobalite. With further cooling the pattern is changed slightly at 1470°C (2680°F) at which temperature the cristobalite changes to a similar crystal form called tridymite. When the temperature reaches 870°C

(1600°F), there is a further and major change in pattern and the tridymite changes into quartz which remains the stable form of silica down to normal temperatures.

In general the silica tetrahedra tend to pack closer together at each successive transition from one crystal form to the next during the slow cooling process. Thus the density of the molten material would be 2.2 grams per cubic centimetre, that of the cirstobalite 2.3, that of the tridymite also 2.3 and the quartz 2.65. At each transition there is a re-arrangement of the structural geometry. Atomic bonds have to be broken and the tetrahedra reformed in their new positions. This process takes time and in the case of the tridymite-quartz transition, a relatively long time. However, at the slow cooling rate appertaining at the Earth's crust, there would be ample time for the transition to take place. This accounts for the fact that whilst other forms of silica can be found, by far the greatest proportion is in the form of quartz, either as rock

Garden sculpture made from fused silica.

crystal or as sand. It also occurs in combination with other oxides in the form of various silicates and is contained in most vegetable matter. It is estimated that some 60% of the Earth's crust is silica. With its high melting point of 1713°C (3115°F), for normal glassmaking it needs the addition of suitable fluxes to bring the melting point down to a practical level.

Silica is melted on its own for making silica glass. This is commonly used for the production of tubing for covering heating elements, and for the making of specific industrial components. It has a low coefficient of expansion and consequently is greatly resistant to thermal shock. As a batch material silica is the principal glassformer and practically all commercial glass has silica as its main constituent.

Silica gel. This uses the normal silica tetrahedron but as the atoms are joined loosely together rather than being in a regular lattice, silica gel is amorphous.

Silica glass. Vitreous silica. Fused silica. This is melted in special, high-temperature tungsten-molybdenum furnaces and is used largely for the production of tubing for so-called infrared heaters or for specialised equipment where resistance to both high temperatures and to thermal shock are required. See **Silica**.

Silica structure. If four tennis balls are arranged so that three of them are in close contact with each other on a flat surface and the other is placed on top so that it is then in contact with the others it forms what can be loosely described as a pyramid. There would be a space in the centre into which a small marble could fit. This arrangement represents the manner in which the four oxygen atoms are bonded to a silicon atom to form what is known as the silica tetrahedron (SiO_4).

Individual tetrahedra join together with common oxygen atoms to form a substance in which each silicon atom is bonded with two oxygen atoms. This satisfies the valency and results in a chemical formula of SiO_2. There are three possible formations in which two tetrahedra joined with a common oxygen atom can occur and when these formations are the same throughout a lattice it results in particular structures, namely: quartz, cristobalite and tridymite.

Whilst maintaining the same formula of SiO_2, various phases or silica conversions can occur according to the way in which the tetrahedra are bonded. If there is a regular arrangement then the material will be crystalline. If there is a random arrangement, it will be a glass. These phases can be referred to as alpha quartz, beta quartz, alpha cristobalite, beta cristobalite, alpha tridymite, beta tridymite, silica glass, silica gel etc. The crystalline forms probably have little significance to the studio glassmaker but are of considerable importance to the pot maker and to the makers of refractory products. Some of the phases occur as a result of heat. For example, alpha forms turn to beta forms and with even greater heat, crystalline

forms turn to amorphous glass. It is the resultant changes in behaviour which are of significance in relation to refractories. Clay containing cristobalite is used for making earthenware because the conversion from beta to alpha forms exerts a beneficial squeeze on the glaze. On the other hand, in stoneware or other refractory clays it tends to cause dunting. In a glass pot this would only occur if the pot was cooled down to below 280°C (540°F). It would therefore be a matter of some concern to those who work glass for a time and then allow the furnace to cool before re-lighting for another session.

The possible variations in the arrangements of the tetrahedra can also have a considerable effect on the density of a material. A form of silica with an open structure can have a specific gravity as low as 1.98 whilst a more compact structure could be as high as 4.35. Most of the silica used in glassmaking is in the form of sand which is largely composed of small grains of quartz. If quartz is heated to a temperature above 1713°C (3115°F), it melts and loses all its crystal characteristics in the process. If it is then cooled at a fairly rapid rate as might occur in the manufacture of some pieces of technical equipment and vitreous silica tubing, its behaviour is quite unlike that which occurred during the cooling of the Earth and the development of quartz. Each transition temperature is passed without the formation of any crystal. This happens because the silica and oxygen atoms simply do not have time to break the strong bonds between them and to re-unite in a denser and more orderly arrangement. Eventually, as it approaches room temperature, the viscosity of the silica is so high that it behaves as the rigid solid known as vitreous silica. During the formation of vitreous silica the density remains similar to that of the molten liquid. There are no regular repeated tetrahedra as there is in the crystalline form.

The cold rigid glass has a random structure similar to that of the molten liquid except that in the latter case the bonds are continually breaking and re-uniting giving the fluidity to the structure. The spaces in the random vitreous silica network vary in size but the average size is greater than it is in quartz. It is this openness which gives vitreous silica its low co-efficient of expansion. This is because an increase in the temperature of a solid causes the amount of vibration of the constituent atoms to increase. If the atoms are close together they must move apart to allow for this increase and, as a result, the body is forced to expand. In vitreous silica the atoms are able to find room for their increased vibrations in adjacent empty spaces so the material needs to expand very little.

When fluxes are added to silica to reduce the melting temperature they tend to fill in the available spaces and in a typical soda-lime-silica glass their atoms become closely packed and as a result the glass must expand to accommodate any rise in temperature. This produces a high coefficient of expansion.

Silicate. A compound in which silica and other oxides form a crystal structure. It refers to several substances which contain negative ions composed of silicon and oxygen. The natural silicates form the major part of most rocks. Prepared silicates are unlikely to form crystal structures and many of them could more properly be called glasses as they tend to be amorphous solids.

Siliceous. This refers to materials which contain a high proportion of silica. Siliceous dusts present particularly well-known hazards which can be responsible for the dangerous condition known as silicosis or pneumoconiosis.

Silicon. A metalloid element from Group IV of the periodic table and one of the most abundant elements on earth. It forms a wide range of compounds many of which are used in glassmaking.

Silicon carbide. SiC. A refractory and abrasive material made by heating together sand and coke to a high temperature. It is used mostly for making abrasives and grindstones but it is also used for making electric elements in the form of rods and for high temperature kiln refractories. It was also commonly used in the USA as a reducing agent in the production of ceramics. See **Abrasives** and **Elements**.

The carbides are amongst the most refractory materials known and tend to be very strong. Tungsten carbide is an example of a carbide which has achieved considerable success as a material for cutting tools. Many of the carbides, however, become brittle at temperatures above red heat. Silicon carbide is not affected in this way and is useful for making kiln shelves and supports. One of the reasons for this is that when the surface of silicon carbide oxidises, it turns into silica which forms a protective layer to prevent further oxidation.

Silicon nitride. A material formed by treating silicon, which has previously been pressed into a required shape, in a nitrogen atmosphere at about 1400°C (2550°F). The silicon then combines with the nitrogen to form silicon nitride (Si_3N_4). The particles become sintered together and make a dense, strong material with a negligible coefficient of expansion which is not wetted by molten metals. It is used to replace metals in situations where expansion due to heat would create difficulties. If silicon is partially nitrided, it provides a material which will machine as readily and as finely as brass so that shapes made to very close tolerances can be achieved. When the result is fully nitrided, there is no shrinkage in the process which means that very high precision articles can be made without the need for expensive grinding and finishing operations. It is often used to make bearings needed to operate at high temperatures and the possibility of its use for such things as turbine blades for aircraft is being investigated.

Silicone adhesives. Silicone rubber. An adhesive often used by glass artists for joining pieces of glass, particu-

larly when a degree of flexibility is required. It is usually sold as a clear sealant in tubes which fit into a compression gun. See **Adhesives**.

Silicones. Polmeric compounds containing chains of silicon atoms alternating with oxygen atoms and linked to organic groups. They form various materials including waxes and oils but silicone rubber is probably the form best-known to glassmakers. It is used as a setting material for windows where a degree of plasticity needs to be maintained. The same material is often used as an adhesive for sculptural work. See **Adhesives**.

There are basically two of these rubber type adhesives. Those based on silanes which have very good weathering qualities, are resistant to UV light and water but are not as strong as the elastomers. The one-part silicones are usually perfectly adequate for many of the adhesive requirements of studio glassmakers but they do have a considerable disadvantage as any of the material left exposed, such as on the edges of joined surfaces, will attract dirt onto and into the surface leaving unwanted marks or lines. Also, the acetic acid in some silicone rubbers may attack lead calme and is very irritant if allowed to rest on the skin.

Silicosis. A fibrotic disease of the lungs caused by the inhalation of free silica. It is one of the most common forms of pneumoconiosis and has been well-known for several centuries.

As much of the material in the crust of the Earth is in some form of crystalline silica, exposure could result from many sources and activities. Miners, foundry and pottery workers and stonemasons have all suffered in the past. Fortunately, as a result of increased legislation and monitoring of exposure levels in most industries, the effects of the disease have been drastically reduced. In industry the legislation operates reasonably well and dust levels can be successfully monitored. The individual glassmaker operating in a small workshop is not likely to have the necessary facilities for monitoring and because of this needs to take even greater precautions to ensure personal safety.

The habit of using a respirator when handling siliceous material and the use of a vacuum cleaner rather than a sweeping brush can easily reduce the exposure to a minimum. See **Pneumoconiosis**.

Sill. The weathering part at the bottom of a framed opening.

Sillimanite. $Al_2O_3.SiO_2$. Kyanite. Andalusite. Fibrolite. A hard refractory material for use in making glass tanks. It is also often made into kiln shelves.

Silver. Ag. A soft metallic transition element used for jewellery and photography. It is the basis for much yellow colour in glass.

Silver staining. A process which uses silver compounds to produce colours ranging from pale yellow to deep brown on sheet glass. The compounds are supplied as prepared powders by most glass or ceramic colour manufacturers. They must be well dispersed into an appropriate medium before use. They can be applied by brush, spray or screen printing but some tests may be necessary in order to achieve the required colour on a particular glass. The compounds are usually fired at temperatures ranging from 520°C (970°F) to 650°C (1200°F). Whilst the intensity of the stain will affect the colour, a dark colour will need the maximum firing temperature to suit the glass to which it is being applied. If a test is overfired, it will tend to show a blue iridescent and milky colour. After firing the glass will need to be washed to remove any iron oxide residue from the carrier. This should not affect the stain as this will have penetrated into the surface of the glass.

Silvera. A type of glass developed in Stourbridge about the beginning of the 20th century. It was produced by picking up a layer of silver foil onto a gather and covering this with a further gather of clear glass. Trails of green glass were often added before the glass was blown out and formed as necessary. Part of the silver foil became oxidised giving some warm yellow-orange colours. Fred Carder subsequently produced similar ware in the USA which he called Silverana.

Silvered glass. Mercury glass. This refers to a type of double walled ware in which a solution of silver nitrate was introduced between the walls through a hole in the base. The hole was then sealed to prevent oxidising and the result was an overall silver appearance.

Silvering. This usually refers to the deposit of a thin layer of metal, usually silver, onto one surface of polished plate glass in order to produce a mirror.

Early mirrors were coated with an amalgam of mercury and tin by a very delicate process developed in Venice but this was superseded by a method of chemical deposition of silver. In this process the glass is wiped thoroughly with a mixture of ammonia and whiting, washed with distilled water, then with stannous chloride and lastly with distilled water again. A silver salt together with a reducing solution is then poured onto the glass and left for an appropriate period of time which might vary between 3 and 20 minutes according to temperature.

A further development of this technique has been to use compressed air to vaporise an alkaline solution of silver nitrate and an aqueous solution of an organic chemical onto the glass surface. The layer of silver tends to be delicate and is sometimes covered by an electroplated layer of copper before covering with a coating of shellac and then paint. Later techniques include cathode splattering, electroplating and the application of gold or silver leaf. Silver leaf is also used by many studio glassmakers

and is picked up on to a parison from the marver. It is then usually covered with another gather. When blown out the silver tends to be pulled into small segments and provides a decorative effect.

Single embossing. This is a technique in which a piece of glass is treated with white acid and, after further masking, treated with another application of acid.

Single-phase supply. The normal 230 volt domestic supply in the European Community. It is often used for electric motors but it is not as efficient in this respect as three-phase supply. It is also limited in its possibilities as a power supply for kilns. See **Electrical terms**.

Sintering. The merging of grains of glass into a mass by heating until the surfaces melt sufficiently to fuse together. Several artists use this method of production both for fragile pâte de verre work and for pieces which, as the grains of glass melt in a container and run into the mould, should probably be more correctly called cast glass.

Size. The name for the various forms of glue, resin, shellac etc. used to apply gold or silver leaf to glass.

Slab glass. Dalle de verre. Cast rectangular blocks of glass about 20 cm thick used for some stained glass window applications. See **Dalle de verre.**

Glass being poured into a mould to form dalle de verre slabs.

Ceramic fibre paper folded and supported by lengths of kiln shelf for casting slabs in a kiln.

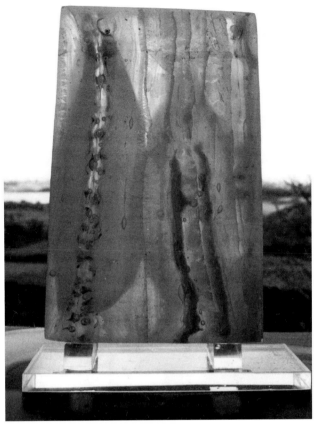

Slab made by melting glass into a ceramic fibre mould.

Slack. A term used by stained glass artists to describe a window which has been made too small for its location.

Slag glass. A process of producing an opaque, coloured and often marbled glass developed by Sowerby of Newcastle-upon-Tyne and reputed to contain slag from various local foundries. Most of the production was of cheap pressed glass and the process was soon taken up by other manufacturers.

Slag from founding processes is also used in the form of Calumite as a batch material in sheet glass and container production where the colour resulting from any iron residue would not be of great significance.

Slip. Clay thinned to a creamy consistency and used occasionally in the finishing processes of making glass pots.

Slip casting. A process of drying appropriately deflocculated clay slips against the sides of plaster moulds in order to produce repetitive forms. It is commonly used by glassmakers who need to make crucibles in which to melt colours or test batches. See **Crucibles** and **Deflocculation**. Moulds can be single pieces if the required shape is simple or can be made up of several interlocked pieces if the shape is complex, though this is unlikely if crucibles are being made. The slip is poured gently into the mould to avoid creating air bubbles and

topped up as necessary as the moisture is drawn out by the plaster until the desired thickness is evident at the rim. The surplus clay is then poured out and the cast clay left to dry until it is leatherhard. As it dries it shrinks from the mould and can then be removed quite easily. It then only remains to sponge out any irregularities and to fire to the required temperature when completely dry.

Slug. The wad of clay which emerges from a pugmill.

Slumping. The process of heating glass until it bends to conform to a shape defined by the containing mould or by supporting wires or rods. Ordinary soda-lime glass will begin to deform at about 600°C (1110°F) but rather higher temperatures or prolonged firings are likely to be needed if the glass needs to slump deeply or to conform to a complex shape. Interesting results can be achieved by heating sheet glass over holes cut into supported ceramic fibre slabs and allowing the glass either to slump to an inverted dome shape or even to run until it forms an irregular cylinder.

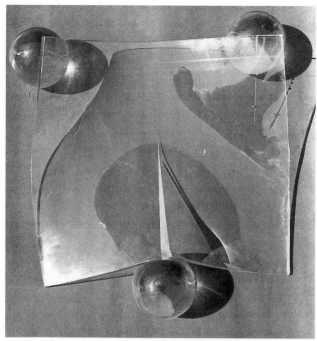

Figure 4. Glass after slumping across a similar but lower arrangement.

If a sheet of glass is laid on ceramic fibre paper placed on a kiln shelf so that both the fibre and the glass protrude over the edge it can be heated until the protruding part bends to the vertical. Alternatively, the temperature

Slumping techniques. *Figure 1* shows the possible arrangement of vertical rods joined by a length of nichrome wire on which a piece of glass is laid.

Figure 2. The result after heating.

Figure 3. Another possible arrangement of silica tubing laid across insulation bricks.

A glass slab laid across a kiln prop covered with a layer of ceramic fibre.

can be raised sufficiently for the glass to begin to flow, in which case it will probably produce a curtain effect.

Sheet glass slumped into simple folds can be used to good effect together with other elements or can be assembled into complex constructions.

Bubbles produced when air becomes trapped between layers of fused glass.

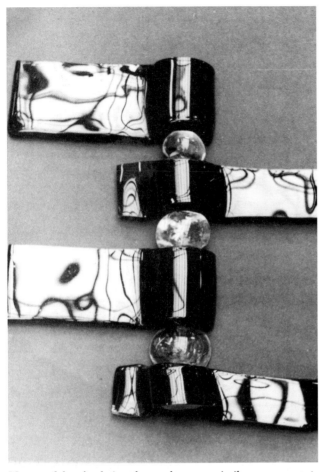

Narrow slabs after being slumped across a similar arrangement.

Arrangement of silica tubing ready to be covered by ceramic fibre paper to be used as a support for slumping.

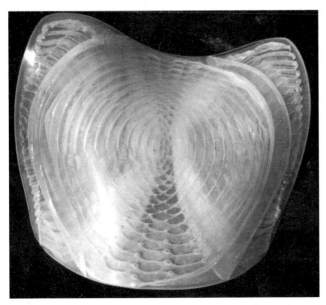

'Sea Creature.' Form fused and slumped in borosilicate glass.

Fused borosilicate glass after being slumped over the silica tubing.

A similar form, sandblasted and completed.

Slurry. The mud-like material produced by the result of grinding and polishing. It usually consists of a mixture of particles of glass, abrasives and water. It is often re-used with the addition of more abrasive. If allowed to settle in drains, it may set like concrete.

Smalt. Smaltz. The deep blue glass coloured by cobalt oxide. It is often ground down to powder for use in making enamels or as a material to be picked up from the marver.

Soda. Na_2O. Sodium oxide. Natrium oxide. The element sodium is very reactive and combines with other elements readily to form compounds. These compounds have a wide variety of uses: sodium chloride as common salt, sodium chlorate as a powerful weedkiller, hydrated sodium carbonate as washing soda and sodium bicarbonate as baking powder.

 In glassmaking sodium carbonate is the material most likely to be used to provide the sodium oxide in a batch. It can also be provided by sodium sulphate (saltcake) and by borax which also provides some boric oxide. It can also be provided by many of the feldspathic and feldspathoid materials which also provide some silica plus some alumina and small quantities of other elements. The ashes from sea plants such as barilla were for many years the primary source of soda ash. Chile saltpetre is also introduced as a fining agent. Calumite which is made from the waste slag from steelmaking is becoming increasingly popular as a source of sodium oxide.

Soda ash. Na_2CO_3. Sodium carbonate. The principal source of Na_2O and the most common network modifier used in glassmaking as it is very effective in reducing the fusion point of the silica. Often known simply as 'alkali' or 'ash', it has been used since the early days of glassmaking. It occurs naturally in quite large deposits but it was mostly made from burned kelp or marsh plants until it became available from various chemical processes.

Soda feldspar. $Na_2O.Al_2O_3.6SiO_2$. Albite. Occasionally used as a batch material to provide Na_2O together with some alumina and silica. It is the second most common of the feldspars and is often known as white feldspar. It often contains other feldspars so it is common to find some potash and calcia present in it.

Soda glass. Soda-lime glass. Soda-lime-silica glass. Glass which uses soda as its major flux or network modifier. This is by far the most common form of glass made and has been evident in the earliest examples of glass found. It is used to provide almost all current production of sheet and container glass, light bulbs etc. The lime acts as a stabiliser whilst the silica is the glass former. See **Batch**.

Sodium carbonate. See **Soda ash**.

Sodium chlorate. Weed killer.

Sodium chloride. NaCl. Common salt. It was reputed to have been used in the North East of England as a source of Na_2O during the 19th century but it is not used nowadays except for occasional research purposes because of the noxious emissions. It is also used in the refining of hard borosilicate glasses.

Sodium silicate. $Na_2O.SiO_2$. Water glass. A combination of approximately equal proportions of silica and soda. It is soluble in water, and used as a deflocculant in ceramics and as a hardener for concrete.

Sodium sulphate. $NaSO_4$. Saltcake. Once used as a major source of Na_2O because of its availability from the process of making hydrochloric acid. It has the useful property of dispersing scum on the surface of the melt. Its role had declined to that of occasional employment as a refining agent, but it is now used again in considerable quantities in the flat glass industry.

Soffietta. A curved metal tube fitted into a conical nozzle and used to place into the mouth of a vessel which is already on a punty in order that the vessel can be opened out or inflated by blowing air down the tube.

Solar control glass. Window glass which has been coated or manufactured to control the amount of infrared and sometimes, the ultraviolet radiation, from the sun. It is often used as part of double or triple glaze units but can be obtained as single sheets. It is also available in toughened glass.

Solder. The mixture of lead and tin used for joining lead calme.

Solder glass. Solder glasses are low-melting glasses used as glass to glass or glass to metal seals. They are made to melt at temperatures as low as 370°C (700°F) and are mostly lead borates. They are ground to powder, mixed with a volatile suspending liquid and applied to the surfaces to be joined. They are designed to fuse at such a temperature that the glass and/or metals to be fused will not distort.

Soldering. The process of joining calme together in glazing a stained glass window. The solder normally used for this purpose is sold in the form of a thin strip. The type which is hollow and filled with flux and the thick slabs sometimes used by plumbers are not generally found to be of much use in soldering calme. The standard procedure is to apply tallow or some other suitable flux to all the joints and to start to apply the solder from the outside working inwards. The soldering iron needs to be tinned before any soldering can take place. This consists of filing the end of the copper bit, dipping it into flux and then applying a thin coating of solder. The solder should then be held vertically to the lead and the soldering iron applied until the solder runs to the edges. At this stage the soldering iron must be removed immediately. If the iron is too cool, the solder will refuse to melt or will simply form a small hill. If it is too hot, there will be a danger of melting the lead calme and leaving a gap. If the solder does not spread evenly then the calme has not been cleaned thoroughly and this will need to be rectified and more flux applied before the soldering can continue. Too much solder on the joint can eventually lead to cracks and too little can create a weak joint which will eventually break. When soldering on one side of a panel is completed, the panel must be turned over very carefully and the soldering operation repeated on the reverse side.

Soldering irons. The name has become something of a misnomer. Originally they were probably made of iron but nowadays the business end is inevitably made from copper which does not rust and which conducts heat much more efficiently. The choice between electric and

Three different types of soldering iron heads.

gas-fired soldering irons is simply a matter of personal preference. Some artists will swear that one kind is far better and others will form exactly the opposite view. The gas-fired soldering iron has an advantage as it can reach its temperature very quickly and its temperature can then be readily controlled. Electric soldering irons can be obtained fitted with a suitable temperature controller and usually have a selection of interchangeable bits. It is also essential to have one which has sufficient wattage to enable it to be used continuously.

Solenoid. An electro-magnetic device commonly used for opening and closing valves on gas/air systems or to activate switching systems.

Solubility. An indication of the ability of substances to go into solution.

Spalling. The cracking away of small pieces of refractory material, usually because of rapid heating. These pieces, when they find their way into the molten glass, tend to cause stones and/or cords.

Specific gravity. The numerical indication of the relative weight of a substance to that of an equal volume of water. It is often used as a quick method of identifying samples of glass.

Specific heat. The amount of heat required to raise the temperature of a unit mass of a substance by one degree centigrade (1°C). This can be an important factor in calculating the nature of the refractories or insulation materials to be used in the building of a furnace or kiln. Most manufacturers give the necessary information in their product literature.

Spodumene. $Li_2O.Al_2O_3.4SiO_2$. Lithium feldspar. A common source of lithia in a batch. It usually contains small quantities of soda and potash in addition to the lithia, alumina and silica. Lithia is a strong, low-expansion flux which is being used increasingly in the field of glass-ceramics.

Spot mould. A mould fitted with spikes in its base and used by paperweight makers to produce air bubbles in the glass. The parison is simply pressed into the mould and then blocked into a spherical form. See **Paperweight**.

Sprue. The vertical channel in a mould though which any glass which is being poured or which leads from the cup-shaped volume which contains the spare glass runs into the main part of the mould.

Stabilisers. A modifying oxide added to a batch in order to stabilise the resultant glass.

Stained glass. This refers to the use of coloured or painted glass in decorative windows. The colour could

be achieved by fusing pigment onto the surface or by colouring the glass in the making process.

It is thought that the tradition of fragmentation in the design of stained glass windows in which relatively small pieces of glass are held in place with lengths of lead calme arose because in early days only small areas of coloured glass of varying thicknesses would have been available. The coloured glass used for stained glass windows is still produced by Hartley Wood and Co of Sunderland and in other centres both in the USA and in continental Europe using exactly the same process as that employed in medieval times. The lead calmes continue to be made in many parts of the world.

Windows are known to have existed in Roman times, some of which may well have been coloured but it is thought that the so-called stained glass windows as we know them derived from the Byzantine tradition of covering walls of churches with mosaics made from small rectangles of half vitrified glass. Windows were thought of as being 'Mosaic Windows' before the term by which they are now known was adopted. The other relevant influence, particularly on the development of painted windows, was that of the rich tradition of enamelling on metal in which much of the colour was enclosed by thin strips of metal. It is interesting to note that whilst the walls of Byzantine churches were covered in the gold and glorious colours of the mosaics, the builders of medieval churches had the sense to make their interiors subdued in order to emphasise the impact of the colours of the windows. Historically, the greatest proportion of stained glass work has been religious and full of Christian symbolism.

The introduction of glass enamels and silver stains brought about further possibilities in descriptive and figurative work but for hundreds of years there was really very little innovative development. Then the devastation produced by modern warfare and the advent of the modern movement in art opened up considerable possibilities for a new creative approach. In France there were three supreme examples provided by the painters Roualt, Leger and Matisse. Roualt trained as a stained glass worker and the nature of his subsequent painting developed naturally into the strong and colourful work he produced in his windows at Assy. Leger introduced the innovative use of slabs of dalle de verre into his work at Audincourt and whilst all these made use of the medieval traditional of keeping the interior of the church relatively subdued against the colour of the windows, it was Matisse in the chapel at Vence who really exploited this contrast of qualities. The atmosphere that he attained with his restrained and simple line drawings in the light and austere church punctuated by the wonderful colour from his windows is something that can only be fully appreciated by being there. Sir Basil Spence likened it to being transported into the heart of a pearl.

In the former West Germany after the Second World War there was a remarkable revival in stained glass work and this was clearly related to the abstract and expressionist movements in postwar German Art. In this work the lead calme has been used consciously as a linear element forming an integral part of the overall design both as line and as a containment of areas of colour. The most outstanding figure in the early years of this movement was Georg Meistermann and he was followed by several others in Germany, most notably, Ludwig Schaffrath and Johannes Schreiter. Their work had an effect on the stained glass movement in the United States. In Britain John Piper cooperated with the stained glass artist Patrick Reyntiens to produce impressive work at Oundle school and also at St Andrews, Plymouth. Marc Chagall produced a marvellous example of the painter's approach to stained glass at Chichester Cathedral. From these beginnings, a wealth of exciting, innovative and often wonderful work has been produced. Sometimes the elements of coloured glass have been fused together to form the window, so eliminating the necessity of lead calme altogether. Much more of the recent stained glass has been commissioned for placement in buildings rather than in churches and even when new work for churches has been commissioned, both abstract designs and a wider interpretation of Christian symbolism have proved acceptable.

Much of the so-called stained glass is not stained or even painted. Most of it is glass which has been coloured when it has been first melted and as a result the colour is in the body of the glass, or is a flashed layer, rather than as a layer of enamel or silver salt which has been fired on to the surface.

Fused work and work assembled in concrete or resin is now taking its share of the market and much more is now made of the sheer impact of colour and design than on literal or symbolic content.

STAINED GLASS COMMISSIONS. Unlike pieces produced by most glass artists who work either to exhibit or to sell in shops and galleries, most stained glass work is essentially commissioned in some way or another. This can be the first pitfall in the process. It is absolutely essential to ensure that the artist, the architect and/or the authority offering the commission are on the same wavelength. Any misunderstanding at this stage can prove to be most costly in terms of time, materials, reputation and money. It is also essential to have a signed agreement or contract for the work including a firm declaration of who will be responsible for installing it in its final position. Initial sketches and presentations are obviously of considerable importance and should give sufficient relevant information as well as an overall impression of the completed work. It is also important to stress that whilst a design indicates a basic idea for the completed window, in order for it to have life and spontaneity there must be some scope for the work to develop as it grows. A rigid application of the initial design can easily lead to something lacking in vitality. The costing of the initial submissions and possible subsequent modifications must not be underestimated as these may take an inordinate length of time.

The first step is to draw the design up to full size. There are two common ways of approaching this. The first is simply to make a line drawing in ink to show the areas outlined by the lead calme, introducing some tone if this is considered necessary and to deal with the colour with the actual glass on the bench, or on the easel. The second is to make a painting in full colour in order to establish at least an initial idea of the colour. In using either method it is important to keep the intention to develop the design in the glass. There is a vast difference between colour reflected from the surface of paper and that produced by light transmitted through a piece of coloured glass. If there are to be any vertical or horizontal supporting bars in the completed window, they should be shown on the cartoon as it is inevitable that they will influence the final design. The next step is to make a cartoon. This is an accurate tracing of the design including its perimeter. It is made on strong tracing paper. Some artists use carbon paper to take two copies at once, one of which is cut into the shapes of the various pieces of glass. These shapes are cut about 1 mm (1/16 in.) in from the line to allow for the amount taken up by the calme. They should be numbered in order to save the jigsaw problem of matching pieces to spaces.

In order to be able to view the window or section of the window whilst it is being made, a further tracing is drawn onto a sheet or adjacent sheets of plate glass. The lead lines are painted onto the glass with black acrylic paint or the traditional mixture of lamp black, water and a little gum arabic. This needs to be done very accurately using a 4 mm (3/16 in.) or 6 mm (1/4 in.) chisel-edged brush to produce a uniform line 9 mm (3/8 in.) wide. Once this has been completed, a small circular blob of plasticene or sculptor's modelling wax is pressed on each spot where the lead calme joins or crosses. The numbered pieces of thick paper are pressed into position to be replaced with the appropriate pieces of coloured glass when they have been cut and stained, enamelled and fired as necessary. This is then placed on an easel which usually has daylight behind it and the glass can then be viewed before it is finally leaded together.

The next step is that of glazing the window. Glazing is the stained glass term of the actual setting of the glass into the lead calme. This is carried out on a glazing table which can be any size to suit the type of work likely to be undertaken. A popular size would be about 2 metres x 1 metre or 7 feet x 4 feet. The top is usually made of thick softwood and cupboards and shelves to accommodate tools and materials are normally fitted underneath. Most artists begin at one side and work towards the other but when making windows to fit complex tracery it is often convenient to start at the centre and to work outwards.

The traced paper showing the cut-out lines is placed on the table. Straight laths of wood about 50 mm wide x 25 mm deep (2 in. x 1 in.) are tacked along one edge and the base of the tracing. Make sure that they are at right angles. Alongside this, suitable lengths of binder calme 10 mm (3/8 in.) wide, having been stretched and straight-

Leading up of a stained glass window. The lead calme is held in place by farrier's nails prior to soldering. *Courtesy of the Centre del Vidre de Barcelona.*

ened, are laid one piece being fitted into the opened out end of the other. Pieces of 6 mm (1/14 in.) calme are stretched and shaped to fit over the cut lines, opened out as necessary with a lathekin to accept the glass. The first piece of glass is introduced into the corner and tapped to ensure a good fit into the calme. It is then nailed in position with one or two farrier's nails. The area of the binder calme where the piece or pieces of thinner calme are to fit is opened out to accommodate this and the nails are removed. The lead calme is fitted to the next piece of glass and again secured in place with the nails. The remainder of the window is leaded progressively in exactly the same way. Once it is completed the joints are soldered on both sides. See **Soldering**.

The next step is cementing. See **Cementing**. This is to ensure that the final window is waterproof. The calme may need to be opened a little with a knife and a cement which consists of a putty made of whiting, plaster of Paris, linseed oil and a little turpentine, sometimes including some red lead, lead carbonate or litharge, is brushed into the calme with a stiff bristle brush. The calme is then pressed down. Any excess cement is lifted off with the brush and any oil remaining on the surface of the glass removed by first dusting it with a mixture of whiting and sawdust and by gently rubbing with a soft cloth.

Stained glass kilns. Over the years many types of kilns have been used for firing both silver stains and enamels onto stained glass. The first were probably fired with wood but since then they have gone through the usual run of coal and oil and they now tend to be fired either by electricity or by gas. Until quite recently the most common type has been an electric kiln with three distinct

areas. The first area simply consists of a section of shelves to hold trays of glass which have been fired or are waiting to be fired. The second is the actual firing chamber which is also made to accommodate several trays and the third, is an annealing chamber.

Over the last few years a shallow kiln made for firing single pieces has appeared on the market and this has proved to be very popular. Some of these have been electric with the elements normally fixed into the lid and others have been gas-fired and usually fitted with a series of porous ceramic elements situated in the lid to radiate the heat evenly over the glass surface.

Firing in the shelf-type kiln provides a good throughput because trays may be taken out of the firing chamber at an appropriate temperature and placed into the annealing chamber. The shallow top loader has the main advantage of allowing the artist to be able to see exactly what is happening on the surface of the glass by simply lifting the lid for a few seconds. It also offers the possibility of very fast firing if this happens to be required.

Stannic oxide. SnO_2. The white oxide of tin often used as an opacifier in glass and enamels. It is also used as a nucleating catalyst and, in the form of solid blocks, as the anode and cathode in electrically-fired furnaces.

Staple fibre. Short lengths of glass fibre.

Steel core lead. Lead calme which is fitted with a length of flat steel wire running through the centre. It is used where it is felt necessary to introduce some re-enforcement without having to resort to the fitting of visible re-enforcing bars.

Steuben. The famous glass works and glass museum at Corning, New York, USA. There is a viewing gallery at the factory where glassmaking demonstrations showing a wide range of techniques are available. Steuben glass is acknowledged throughout the USA as representing the finest quality. The work produced over the years has been targetted by many collectors and museums. The specialist production of fine pieces seems likely to continue in its excellent tradition. The Corning museum, which is close to the factory, holds what is generally acknowledged to be one of the best collections of both ancient and modern glass in the world.

Stibium oxide. Sb_2O_3. See **Antimony oxide**.

Stippling. Stipple engraving. A method of glass engraving by the use of a diamond or hard tungsten carbide point which is struck against the glass to produce small dots. These can be increased in density and depth as required to produce the necessary images.

It also refers to a process of giving a ripple effect on a glass surface by the use of an etching acid mixed together with an inert substance. The effect of the acid varies over surface of the glass.

Stoichiometric. This term is used with reference to burners and indicates a balanced flame. Chemically, it refers to a determination of equivalent weights of substances in chemical reactions.

Stone. An unintended inclusion in the melt. There are various types of stones but the main ones arise from unmelted batch, from materials which have become detached from the refractories or from crystals formed by devitrification. See **Faults**.

Stoppering. The fitting of a glass stopper into a bottle. When the glassmaker is in the process of making a bottle, his major concern will be with the external shape rather than with the internal profile of the taper in the neck. Forming the stopper will be one of making an approximation of the fit that will eventually be required.

In factory production the job of fitting stoppers fell to a particular craftsman who would have the advantage of having an assortment of both bottles or decanters and of stoppers to work with. Grinding stoppers to a reasonable shape was no problem but making the taper in the neck was rather more of a problem. It was done with metal reamers together with suitable abrasive powders but considerable care was needed to ensure that the glass did not become too thin or that the reamer became jammed.

The taper was finished by using the stopper itself as a reamer together with abrasive powder to grind away until a suitable fit was obtained. The normal procedure was to grip the stopper in a type of wooden vice, apply some silicon carbide powder and water and to rotate the bottle to grind the two elements together. The standard test on completion was to be able to pick up the bottle by lifting the stopper. When this was completed it was then necessary when making quality ware to polish both the internal taper and the stopper.

The advent of the electroplated diamond stoppering drills changed the process completely. They are now available in various sizes and angles of taper and they are used in a precision drill press which is fitted with a suitable central water feed. The normal taper for domestic ware is 14% and for scientific ware 10%. A hollow drill with a reverse of the same taper is used to grind the stopper.

Stopping knife. A general purpose tool usually made by the stained glass artist from a stainless steel table knife. It is cut down so that the blade is about 2 in. long and the end then shaped to a half round.

St. Helens, England. The location of Pilkington Glass Works and glass museum.

Strain. The force which develops between parts of solid glass in the cooling process. Usually this develops between the surface and the interior as a result of faulty annealing but it can also occur because of differences between the expansion of glasses which are joined

together or because of objects such as stones which may have formed or may have been included within the glass.

Strain cracking. Small internal cracks which develop in the walls of glass objects. They result from residual stresses and strains from faulty annealing or from the loss of alkali from the surface as a result of weathering.

Strain viewer. Polariscope. Equipment used to indicate the amount of strain in glass. It is normally a simple arrangement whereby light is projected through polarising film and through the glass to reveal any strain which becomes evident in the form of patterns of colour.

Stress. The force per unit area on a body which causes it to deform, the area being perpendicular to the force. Glass is a hard, unyielding substance so that when it is contacted by a hard sharp body, the area of contact can be exceedingly small. Consequently, though the force applied may only be moderate, the stress can be enough to break the surface of the glass.

The term is also used to refer to any tension or compression within the glass and is usually caused by ineffective annealing.

Striking. The process whereby a colour or opacity can be produced when a piece of glass is re-heated to a particular temperature. It is commonly used for developing the various ruby colours.

Striped silvering. Mirrors with part of the silvering removed to leave transparent, striped areas.

Strontia. SrO. Strontium oxide. This has been introduced in the making of television tubes to replace barium oxide and is usually used in the form of strontium carbonate, $SrCo_3$. It was also used in the process of making lustres for coloured iridescent surfaces but it is avoided now because of the release of toxic fumes.

Strontianite. A natural mineral containing strontium carbonate named after the village of Strontian in Scotland.

Strontium carbonate. $SrCO_3$. It is introduced into a batch as a source of SrO.

Substance. The thickness of sheet or rolled glass.

Sugar acid. This refers to a liquid or paste used for etching glass as a safer replacement for hydrofluoric acid. It often contains sugar to increase the viscosity. There are several recipes for this. A typical one is:

ammonium bifluoride	2 kg	Alternatively	4.5 lb
sugar	2 kg		4.5 lb
barium sulphate	250 g		9 ounces
demineralised water	2 litres		4 pints

See **Acid etching**.

Sulphides. Small ornamental plaques made from various materials resembling porcelain and added to glass forms as decoration. They were often presented as cameos which were themselves known as sulphides. James Tassie produced numerous examples based on heads of famous people and mythological figures. The reason for the name is something of a mystery as there is no evidence to suggest that sulphur was ever used in this context.

Sulphuric acid. H_2SO_4. Used together with hydrofluoric acid for the process of acid polishing. See **Acid polishing**.

Supercooled liquid. This refers to a liquid which has been reduced below its freezing point without it reverting to a crystalline state. Glass is probably the most common supercooled liquid. The terms 'Solid Solution' and 'Amorphous Solid' have the same meaning.

Surface tension. This refers to the tendency of a surface of a liquid to pull together. It accounts for the apparent phenomenon in which many free volumes of liquid tend to form spheres bound by a kind of skin in order to assume the smallest possible surface area. It affects glassworking because glass of a high viscosity tends to have a high surface tension whilst a more fluid glass tends to have a low surface tension. It is a quality which can be measured and one which affects both hand and automatic glassworking processes.

Suspension. A mixture in which small solid or liquid particles are suspended in a liquid or a gas.

Syenite. An igneous rock containing less than 10% of quartz. See **Nepheline**.

Synchronous motor. A type of electric motor which maintains a fixed speed despite variations in mechanical output.

T

Talc. $3MgO.4SiO_2.H_2O$. Magnesium silicate. French chalk. Steatite. A natural mineral source of magnesia for occasional use in glass batch as it decomposes at temperatures over 900°C (1650°F) to form magnesia, silica and water vapour. It is rather like soap to touch and very soft. It is used as a filler in papermaking and in paint and also as a fine, smooth, chalky material in cosmetics. The formula of the mineral tends to be variable and many samples contain iron, calcium and alumina, the iron content often making the material only suitable for coloured container ware or for sheet glass. The preferred sources of magnesia are dolomite, the mineral magnesite and processed sea water. See **Magnesia**.

Tank furnaces. Tank furnaces are essentially those which have a container for the hot glass built into the structure of the furnace. The refractories for these tend to be designed specifically for the type of glass which it is intended that the furnace will melt. Thus, the floor will be one kind of refractory, the walls another and those used above the glass line will be totally different. Designs for such furnaces are both varied and numerous. Small tank furnaces have long been popular with studio glassmakers and with appropriate care can often be used for a few years before needing a re-build. See **Furnaces**.

Tassies. Small, finely-cast glass reliefs, mostly of heads of famous and mythical people or casts of engraved gems, produced by James Tassie (1735–1799) in London. He came originally from Glasgow and after attending art school there became a stonemason before moving to Dublin where he met Dr Henry Quin who was the Professor of Physics at Kings College in Dublin. Dr Quin and James Tassie developed pastes of sulphur and, later,

A wax model and plaster mould for making a tassie replica.

a glass paste which Tassie used to produce his medallions. They used a fine white opal type of paste similar to pâte de verre made from a soft lead glass. It is thought that this was heated until it became sufficiently soft to press into a mould made from plaster and brick dust.

Tears. Air bubbles shaped like tears and deliberately introduced into the stems and knops of some drinking glasses. They sometimes occurred accidentally in early glass forms and it is thought that the habit of introducing them as tears developed from the necessity of turning some accidental bubbles into elements of design.

Teeming. The process of pouring hot glass from a pot.

Temperature. The term used to describe a measurement of heat. There are two common scales, that of Celsius (°C) in which freezing point is noted as 0°C and boiling point as 100°C and Fahrenheit (°F) in which freezing point is 32°F and boiling point 212°F. The formulae to effect conversion from one to the other are:

$$\text{Degrees Celsius} = (F - 32) \times 5/9.$$
$$\text{Degrees Fahrenheit} = (C \times 9/5) + 32.$$

See **Celsius**, **Kelvin** and **Fahrenheit**.

Tension. This refers to the effect created by stretching in order to increase area or volume.

Tesserae. Small and approximately square pieces of glass or ceramic material used for mosaics.

Tetroxide. An oxide which has four atoms of oxygen to one or three atoms of another element in the same molecule.

Therm. A unit of heat representing 100,000 BTUs. A therm is equal to 1.055×10^{-8} Joules.

Thermal conductivity. The passage of heat through a material. Metals and dense refractories usually have high conductivity whilst insulation materials such as ceramic fibre have low thermal conductivity.

Thermal endurance. A measure of the ability of glass objects to withstand thermal shock.

Thermal expansion. This refers to the amount by which a material expands according to the effect of heat. See **Coefficient of expansion**.

Thermal shock. The effect on a material of rapid temperature change. In glass it usually involves the stress which is formed as the surface expands or contracts more rapidly than the interior, often resulting in cracking or complete breakage. To counter this many kinds of glass have been developed with a low coefficient of expansion which reduces the effect of such stress. Glass also needs to be well annealed particularly when it is thick or when it has considerable variation in section.

Thermocouples. Probes inserted into furnaces or kilns to measure the temperature by creating a small electrical potential which is then conducted to the pyrometer or controller. There are several types:

Copper-Constantan. This is used for low temperatures and up to 350°C (660°F). It is very accurate but not much use for glassforming or annealing purposes.

Iron-Constanton. Used for temperatures up to 760°C (1400°F), it can be used for annealing kilns.

If the shield is not airtight, the moisture in the kiln can cause the iron to oxidise. This can eventually lead to the failure of the thermocouple.

Chrome – Alumel. This is the most common type of thermocouple and can be used up to about 1250°C (2280°F).

Platinum, 10% Rhodium-platinum and platinum 13% Rhodium-platinum. Both are used for temperatures up to 1450°C (2650°F).

Platinum, 30% Rhodium-Platinum 6% Rhodium. This can be used for temperatures between 800°C (1480°F) and 1700°C (3090°F).

Section through a typical thermocouple.

The type of sheath material can be important for glass furnaces where there is likely to be attack from hot alkaline glass. Those made from re-crystallised alumina are recommended for this purpose.

Thermotrophy. This refers to colour change effected by heat. Before the development of pyrometry, the temperature of a furnace was assessed by viewing the internal colour.

Thread testing. This is a quick method of making a test to check the compatibility of two different glasses. Two small pieces of glass are heated and pressed together and then heated again until soft and pulled apart to form a thread. If the glasses are compatible, then the thread will remain reasonably straight as it cools but if it develops a considerable amount of curve then the difference in expansion of the two glasses is likely to be too great for them to prove to be compatible.

Threading. This is a term which is now often used to describe the process of trailing which is a process of decoration. The bit gatherer prepares a small gather of clear or coloured glass which he offers to the glassmaker who attaches it to a parison and then rotates this so that threads of glass are pulled onto the surface. Sometimes these are left on the surface but more often than not the threads are marvered or blocked into the hot glass. The threads can be pulled with a hook in the manner of feathering in cake icing decoration and the glass then blown and formed into an appropriate vessel.

It is an old technique but one which was exploited considerably in the 19th century when the requirements of industrial production produced a mechanical device to turn the iron whilst the thread of glass was applied.

In addition to this process however, threading is a term which also embraces the various methods of using threads of glass which have been previously pulled into lengths and then either placed on the marver in set arrangements to be picked up on to a parison as before or incorporated into cast or fused pieces.

Threads incorporated into a fused panel.

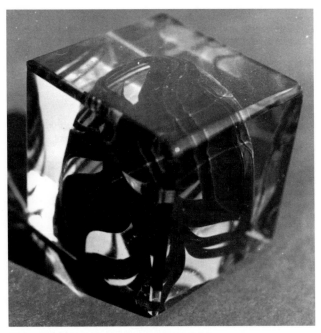

Threads incorporated into a paperweight.

Three-phase supply. In the European Community this is the normal 400/230 volt power supply. It is a supply in three lines and a neutral which enables the provision of higher power to motors and kilns than that normally available from a single-phase supply. It is normally used to power kilns of more than about 30 amps capacity and is often preferred for electric motors used to drive cutting and engraving lathes because of the greater availability of power and also because of the smoother transmission it provides.

Tiffany. Louis Comfort Tiffany was the son of the famous jeweller Charles Tiffany of New York. He was a painter who turned to interior design before becoming fascinated with Art Nouveau and the possibilities of glass. He patented a lustre technique in 1881 and some ten years or so later he started his own glass factory producing many innovative ideas including a wide range of iridescent and laminated pieces, many of them stunning developments of earlier and even ancient techniques. One of his popular creations was that of putting trails onto glass in a wavy form without marvering them into the body of the vessel to produce a representation of the Diatreta.

He gave the pieces this name but they really did not relate to the Roman Diatreta in substance as these were cut and carved out of the body of the glass. He developed 'Agate Glass' which according to some writers was formed from laminated glass which was cut to resemble the popular polished stone. Others maintain that the colours were introduced into a melt of glass in a furnace where after some stirring the glass was gathered and worked. This seems to be a much more likely method.

His 'Lava Glass' had trailed amber/gold glass on top of a surface roughened with powdered basalt. He developed a glass reminiscent of the old glass which had dete-

riorated in the soil and called it 'Cypriote Glass'. Much of his glass was iridised and was called 'Reactive glass'.

After 1918 the art world became influenced by cubism and Art Deco and the popoularity of Tiffany declined. His art director and personal assistant was a Joseph Briggs who came from Accrington in Lancashire in the north of England. He had the unhappy task of having to dispose of the accumulation of work and he brought a large number of pieces back to Accrington where he presented half of them to the town. They can now be seen as a fine and unique collection in the Haworth Art Gallery in the town.

Tin. Sn. A silvery metallic element from Group IV of the periodic table. It is much used as a protective coating on sheet steel. It has a very low melting point 232°C (450°F), and it is formed into alloys with many other metals. It is an important constituent of the solder which is used for joining lead calme.

Tin lustre. An iridescent layer on the glass produced either by the application of a solution of tin salts in resin which is then fired, or by the spraying of tin chloride or tin nitrate suspended in water or alcohol onto a hot glass in an extraction cabinet.

Tin is the basis of 'mother-of-Pearl' lustre and together with other metals is employed in most of the other coloured and iridescent lustres commonly in use. See **Lustre** and **Iridescence**.

Tin Oxide. See **Stannic oxide**.

Tinning. The process of coating the working tip of a soldering iron with a thin layer of solder prior to its use. It is essential that the working area of the iron be cleaned meticulously. If it has become pitted then it will need to be filed, firstly with a coarse file to remove the pitted areas then with a finer file to provide a reasonably smooth surface. It should be heated until the copper area changes colour when it should be dipped into a soldering flux to clean it further. Then it is either dipped into molten solder, or solder is applied to each surface from the solder stick in which case it needs to be rubbed onto the metal to achieve a thin, bright mirror finish. If the solder does not coat the copper properly it will probably be necessary to go through the process of applying more flux and trying again. If this still does not work it may even be necessary to go back to the beginning and to give the copper another run over with the smooth file before repeating the process of fluxing and applying the solder.

Titanates. Compounds containing titania.

Titanium. Ti. A white metallic transition element much used for expensive jewellery and for many high-tech non-ferrous metal applications.

Titanium dioxide. TiO_2. Titania. Used as an opacifier in

enamels and in glass because of its slow movement into solution into the parent glass. It is also much used as a nucleating catalyst in the production of glass-ceramics.

Tools. Glassmakers' tools are usually carefully maintained and are very precious to the individual glassmaker. They include pucellas or jacks; various types of shears; calipers; blowing, bit and punty irons; pincers; ladles; blocks and small individual tools specially made to suit a particular purpose.

Lampworkers' tools include various types of bench burner, carbon plates and reamers, spring calipers, rollers, cutting knives, and constricting devices.

Figure 1. Woods or wood jacks. These are made from spring steel and are fitted with wooden or compressed paper pegs.

Figure 2. Jacks, pucellas or simply 'tools'. The standard tool used by the glassmaker for providing many operations at the chair.

Figure 3. Wines. These are smaller pucellas used mostly for making drinking glasses.

Figure 4. Pincers. Used for pulling out lengths of glass, for handles and for removing unwanted material such as stones from a gather.

Standard type pincers.

Pincers with squared ends.

Leaf pattern pincers.

Screw type jacks

Jacks for wooden pegs.

Other types of pincers and small tools.

Toughened glass. Tempered glass. Sheet glass which has been heated until it softens and then cooled rapidly with air jets on both sides in order to produce a hard, toughened surface. The outer surfaces in being cooled are compressed by the inner layer which cools and therefore shrinks more slowly. The result of this is glass which has an increased resistance to both physical and thermal shock and which, when broken, forms small pieces which tend not to have any sharp edges and are therefore much safer than glass which has not been treated in this way. See **Safety glass**.

Tourmaline. A variable mineral form of crystalline borosilicate of aluminium with magnesium, sodium and iron. It is very hard. It is used as a gemstone and found in a wide variety of colours.

Tracery. Stained glass artists think of tracery as referring to the often complex shapes formed in stone at the top of a gothic window.

Trailing. See **Threading**. A method of producing lines of colour on a form by winding soft threads of glass around it.

Transducer. Energy is transformed from one form to another by a transducer. The term is used mostly in electronics but it could refer to a kiln which transfers energy in the form of electricity to heat energy.

Transfers. Decals. These are usually commercially prepared for use as decoration on mass-produced domestic ware but they have been exploited by some artist glassblowers who have picked them up onto a parison and then blown out a form from this. As the glass has expands with blowing, the original transfer enamel distorts to produce what are often bizarre results.

Transformer. A simple piece of equipment for changing the voltage of alternating current.

Translucence. This refers to the passage of light in which there is some scattering or diffusion of the light.

Translucent glass. Glass which is neither completely clear nor completely opaque.

Transparent. Permitting the passage of light with no significant deviation or absorption. It is possible for glass to be transparent to light but not to UV radiation.

Tridymite. Silica. One of the three common phases of silica.

Trioxide. An oxide in which three atoms of oxygen in one molecule are combined with one or two atoms of another element.

Trip switch. Earth leakage circuit breaker. A device to cut out the current as soon as it detects any leakage to earth. Some authorities insist on the installation of these. They are a valuable factor in the consideration of electrical safety.

Tripoli powder. A siliceous powder used in the glass polishing process. See **Glass polishing**.

Trumpet bowls. This refers to the types of goblet in which the bowl has been shaped like the open end of a trumpet. They are sometimes also known as tulip goblets. An example is shown in the illustration to the entry on **Knops**.

Tubing. Hollow rods of glass commonly used by lampworkers for the manufacture of scientific equipment or manufactured in quantity by industry for use in fluorescent lights.

Tungsten carbide. A black material made by heating tungsten with lamp black at 1600°C (2910°F). It is extremely hard and it is used for various types of cutting tools.

Turpentine. An oily liquid extracted from pine resin and used as a solvent for paints and enamels. It is also used for cleaning off any linseed oil left on the glass after cementing lead calme and also as a thinner for oil-based paints and enamels.

Turquoise. A hydrated phosphate of aluminium and copper used as a pigment in paints in the past and valued as a semi-precious stone. It is often used to describe the colour produced by the introduction of copper oxide into an alkaline batch.

Twaddell. °TW, degrees Twaddell. This is a term which refers to units used to relate the specific gravity of solutions and suspensions. It is mostly used to refer to the nature of suspensions of clay materials used for slipcasting crucibles.

Twists. A form of decoration popularly used in the stems of British drinking glasses. See **Air twists**. Opaque twists were also used in much Venetian ware. See **Lattimo, Latticino, Reticella** and **Filigrana**.

Lampworking tools.
1. Yoke with revolving wheels for working rod and tube.
2. Graphite paddle
3. Rotating restricting device.

U

'U' values. These are constantly being quoted in respect of the heat loss through materials. They are used when referring to losses from buildings and as such are often in evidence when considering the installations of windows. In addition to the heat loss indicated, glass also allows solar heat to pass into a building. When this is taken into consideration, the term is modified to be called effective 'U' Value. To give examples of some approximate 'U' values, clear window glass would be 5.4. Double glazing about 2.8 and low emissivity glass about 1.9.

Ultrasonics. Humans have a normal hearing range of sounds in the 20–20,000 hertz or cycle range. Sounds above 20,000 hertz are what are normally known as ultrasonics. High frequency sound is used for a wide range of purposes but that which may provide the greatest benefit to the glassmaker is one of cleaning dirty or greasy glass. If objects containing dirt and/or grease are subjected to ultrasound at 25,000 hertz by energy from an ultrasonic generator, the molecules of the dirt or grease are vibrated violently until they become sufficiently loose to be released from the surface of the article to be cleaned.

In use, the pieces of glass are usually placed into a stainless steel bath, in a wire basket if necessary, containing a solution of dilute ammonia. The bath is then vibrated ultrasonically for about three minutes. There is a risk in using this treatment for overpainted or enamelled glass as it may suffer under the process and pieces of this material may become loose.

Ultraviolet radiation. UV. This is electromagnetic radiation having wavelengths between that of violet light and long x-rays (between 400 nm and 4 nm). It is produced by mercury vapour lamps and is used to activate some forms of glass adhesive. Ordinary glass absorbs UV radiation and lenses, etc. made for use with UV are normally made from quartz.

Undercutting. When glass is engraved in high relief parts of the glass can be cut away underneath the surface and this is known as undercutting. It can be carried out to the extent that the surface is entirely suspended over the rest of the glass leaving an open space as in the Ditreta or cage cup glass. See **Cage cups**.

Uranium glass. This became very popular at the beginning of this century. It was a slightly iridescent greenish-yellow glass but despite the very low radioactivity of both the uranium oxide and the resultant glass, its manufacture has virtually disappeared with the developing public awareness of and concern with the dangers of radiation.

Uranium oxide. U_3O_8. An oxide once commonly used to produce yellow-green glass. It can be used to produce orange and red colours behaving in a similar way to chrome oxide. See **Colours**.

Urundum. Silicon carbide. An alternative trade name for carborundum. See **Abrasives**.

V

Valency. The combining power of an atom, equal to the number of hydrogen atoms that hydrogen could combine with or displace in a chemical compound, hydrogen having a valency of one. The valency depends upon the number of electrons in the outermost shell of an atom as these are generally the ones available for sharing or transferring with other atoms for the purpose of bonding.

Hydrogen has a valency of one, oxygen two, barium two etc. The list of valencies is shown on page 00. This means that for hydrogen to join with oxygen to form water two atoms of hydrogen are required to one of oxygen producing the symbol H_2O. If barium combines with oxygen to form barium oxide, the two valencies are equal resulting in a formula of BaO.

In order for bonding to take place the resulting molecule must be more stable than the individual atoms involved. When the atoms are extremely stable as in the case of the inert gases in group O, the molecules contain only one atom and are not reactive. These atoms have a complete outer ring of electrons and so have a stable arrangement which indicates that they cannot find energy improvement in bonding. Atoms can achieve a stable arrangement by gaining, losing or sharing electrons. Elements can therefore be noted as being (a) electropositive elements with atoms which release electrons fairly easily, (b) electronegative elements which readily accept electrons and (c) elements which neither tend to gain or lose electrons. The type of bonds can therefore be classified as:

Electropositive element + electronegative element = Ionic bond
Electronegative element + elecronegative element = Covalent bond
Electropositive element + electropositive element = Metallic bond

The size of an atom is also important because it can determine the number of other atoms that can be fitted around it in the creation of bonds. The potential of an atom in this respect is indicated by its coordination number.

The sodium atom has only one electron in its outer shell and as it can readily supply this electron for bonding it is electropositive. Calcium has two electrons in its outer shell and as these are similarly available it is also electropositive. Chlorine on the other hand is only one electron short of completing its outer shell and will tend to accept electrons to make this up and so is electronegative. When the two react they form calcium chloride, $CaCl_2$.

Compounds with ionic linkage have positive and negative ions regularly arranged to form a lattice. There is a non-directional electrostatic attraction which means that considerable energy is required to break the lattice. This is why such compounds tend to be hard and to have high melting and boiling points. Compounds which are covalent bonded are usually composed of discrete molecules and are often gases, liquids or solids with low melting points. The major exceptions to this are diamond and silica which are both covalent and very hard. This is because they form three-dimensional structures rather than arrangements of discrete molecules.

Valves. Devices used to control the flow of air or fuel in combustion systems. They can be simple, hand-controlled types, solenoid operated or they can be motorised in situations where regulated degrees of control are required.

Vanadium pentoxide. V_2O_5. This has an occasional use as a colourant, producing weak yellows in conjunction with tin oxide or blue in conjunction with zirconia.

Vaporisation. The property of a liquid or solid to turn into a gaseous state. In the melting process many of the batch materials release volatiles. The various carbonates introduced into a batch release carbon dioxide which assists the founding process as the bubbles moving through the molten glass help to form a homogeneous mixture. Some glasses also release volatiles whilst they are standing or being worked. This can change the composition of the surface layer of the glass sufficiently to create cords.

Vasa Diatreta. Cage cups. Vases in which the main glass body is surrounded by a net of glass attached by small connecting pieces. It is produced by completely undercutting part of the surface. See **Diatreta** and **Cage cups**.

Vehicle. Medium. A material used to contain enamels, lustres etc. for application to glass.

Venturi. The type of burner in which a stream of gas or oil under pressure passes through a nozzle at a high velocity and so induces the necessary input of primary air through the burner to produce an effective flame. The venturi burner is not normally used for natural gas systems but it is still fairly common for use with fuels such as propane which are provided at much higher pressure and as a result provide the necessary velocity for the burner to work effectively. Most modern small glass fur-

naces work on a forced air system but venturi burners are often found on glory holes. See **Burners**.

Vermiculite. Hydrous silicates occurring as decomposition products of micas. After slow heating they swell to make a very light refractory material often used as an insulating material. It is sometimes mixed with alumina cement and used as an exterior layer on kilns and furnaces. Lampworkers often keep a box of vermiculite on the bench and place small glass forms into this, covering them to enable the glass to cool slowly.

Verre Eglomise. The process of applying gold or silver leaf to the back of a sheet of glass, engraving it and then covering it with a layer of varnish, or another sheet of glass.

Vetro a Fili. Ware originating in Murano and consisting of pieces incorporating parallel lines of lattimo threads.

Vetro a Reticello. Similar ware to above but with the threads arranged to cross diagonally to form a pattern of lines in a kind of network.

Vetro a Trina. Vetro Filigrana. Lace glass. Alternative names for filigrana.

Vinamould. A hot melt plastic often used as a mould-making material for casting plaster or as a form for making plaster moulds.

Viscosity. This refers to the state of the fluidity of molten glass and reflects the internal friction amongst its particles and molecules. A glass which is stiff and difficult to work is said to have a high viscosity whilst one which runs easily and is very fluid is said to have a low viscosity. The viscosity of a glass can usually be affected by heat. Raising the temperature of the melt will tend to reduce the viscosity. Some batch materials are very useful in reducing the viscosity of a melt and others need to be held within strict limits to avoid the possibility of increased viscosity.

Vitreous enamel. Enamel which is made from powdered glass, and/or materials which will turn to glass in the firing process. This is the most common type of enamel and has been the traditional material used for both stained glass and for the decorating of vessels. It needs to be fired to a temperature at which it will bond to the glass surface. It differs from the cold painting enamels in that these mostly contain paint pigments rather than glassy materials. See **Enamel**.

Vitreous silica. Silica glass. Vitreous silica is produced when silica is melted at high temperatures, shaped as necessary, and then colled sufficiently rapidly to form a glass. It has a particularly low coefficient of expansion, making it highly suitable for situations where excellent resistance to thermal shock is required. Apart from various specialist technical applications it is commonly used to enclose electrical elements in domestic and industrial heaters. See **Silica glass** and **Silica structure**.

Vitrification. The process in which a material assumes a wholly or partly glassy form. This mostly affects glass-makers when a refractory has been heated to the stage that some of its material begins to change into glass. This may simply result in sealing the refractory or at worst it can start to cause it to sag and collapse.

Potters use this process in making what is called stoneware pottery. Whilst ordinary earthenware is porous and needs to be glazed to make it waterproof, stoneware is sealed by the formation of glassy areas which fill the spaces between the refractory particles.

Vitrify. The process of turning materials into glass.

Vitrolite. The trade name for sheets of opal glasses produced in various shades and degrees of translucency. It is used for external and internal facings.

Volatiles. Materials which vaporise during the melting process.

Volcanic glass. There are several forms of glass which result from volcanic activity. The best known of these are pumice (a glassy foam) and obsidian. See **Natural glass**, **Obsidian** and **Pumice**.

Voltage. This refers to the value of an electromotive force. This is normally expressed as volts. It becomes important to ensure that equipment bought in one country will operate on the voltage of that in which the equipment is to be installed. In Britain, there are two voltages available. The normal household supply is a single-phase supply of 230 volts but the three-phase supply usually provided for industry at 440 volts can be available and is particularly useful when there is likely to be a heavy loading such as that required for a large electric kiln. Some hand tools are now required to be operated on 110 volts to lessen the effect of electric shock and this is normally achieved by the use of a suitable transformer. See **Electrical terms**.

W

Waldglas. See **Forest glass**.

Waste moulds. Moulds which are likely to be used only once. This means that they do not need to be made in sections as they can be destroyed as the casting is removed. See **Casting**.

Waster. The name usually given to unsuccessful products which are thrown away, or, if suitable, used as cullet.

Water. H_2O. Water is not of great concern to the glass-maker as most of the batch materials are relatively dry though some of them, particularly sands, are kept at a specific moisture content to assist the founding. Some of them are hygroscopic and will absorb water if given the chance. Modern storage of these materials would suggest that this is likely to be well-controlled. Some water is chemically combined in a few materials but this is usually released as steam in the founding and often assists the fining process by producing large bubbles. Water used for diamond tools and for grinding processes is thought to be best introduced at room temperature and reinforced by the addition of suitable coolants.

Water plays a considerable role in the weathering and decay of glass by dissolving materials from its surface. See **Decay**, **Sick glass** and **Weathering**.

A more positive use of water has evolved in a system in which it is directed under very high pressure through specially formulated nozzles to cut glass. The manufacturers of the equipment say that the water is ejected at speeds approximating to twice the speed of sound. As it leaves the nozzle the water can be fed with abrasives to increase the cutting action. The system has become very popular with the producers of sheet glass, particularly for the cutting of thick float glass. It also offers a considerable advantage over traditional cutting methods in that cutting can take place at virtually any angle.

Waterglass. Sodium silicate. Various combinations of soda and silica which are water soluble. It is used both as a glue and as a material for hardening concrete. Potters use one form as a deflocculant in slips.

Waxing up. The process whereby a stained glass artist drops small blobs of molten beeswax onto the gaps between pieces of stained glass laid on a table in order that they can safely be held up to the light.

Weathering. A term used by potters for the process of leaving clay to the effect of the weather in order to improve plasticity.

In glass terms it more commonly refers to the effect of rain and damp conditions on glass. Water is by far the most common of the agents affecting the weathering of glass. Some glasses are much more readily affected than others and faults both in the nature of the batch and in the actual founding can contribute considerably to the degree of weathering attained. Water tends to be absorbed into the surface of the glass over a period of time causing certain of the materials to be hydrolised, decomposed and released. This in turn opens up the surface to further attack resulting in alkaline salts dissolving into the water to leave a siliceous skeleton. The initial evidence of attack is likely to be a slightly roughened surface with the possible formation of an iridescent or opalescent layer.

Dilute acid with the exception of hydrofluoric acid is likely to present very little weathering effect but dilute alkalis in solution will attack glass much more readily. This becomes particularly obvious when glass such as dalle de verre is set directly into concrete. It soon starts to produce cracks in the glass from which sodium silicate emerges to form a white deposit. It is common practice to give the parts of the glass slabs in contact a protective layer of bitumen before setting them into the concrete. Epoxy resin has also found increased usage for setting dalle de verre as a more suitable replacement for the concrete. See **Decay**.

Weeping. A form of decay in glass in which small blobs of moisture appear on the surface. See **Decay**.

Weeping glass. See **Sick glass**.

Wheel cutting. The use of various types of abrasive wheels to produce a wide range of decorative facets, cuts, olives and printies. See **Cutting**.

Wheel engraving. This term usually refers to the type of engraving produced by the use of copper wheels but it can also include engraving produced by using small abrasive wheels. See **Engraving** and **Intaglio**.

Whimsies. Amusing objects made in glass. It is also the term used in the USA for referring to objects made by the glassmakers in their own time or when not under supervision. See **Friggers**.

Whimsies. These are not strictly whimsies as known in the US but are unique but very whimsical sculptures by John Smith of Stourbridge. He calls them 'Toys' but they usually comprise glass elements which swing or rotate as required.

White acid etching. A form of acid etching which completely obscures the glass. See **Acid etching**.

White lead. $PbCO_3$. Lead carbonate. Used as the pigment flake white in painting and as a source of lead oxide in batches. It was commonly used together with whiting, linseed oil and a little turpentine substitute to make putty for glazing windows and as the so-called cement that stained glass artists use to seal the lead calme to the glass in order to make the resulting window waterproof.

White spirit. A turpentine substitute made from petroleum and used as a solvent for paints and enamels.

Whiting. $CaCO_3$. Calcium carbonate. This is usually made from crushed limestone, chalk or seashells. It is used to introduce calcia as a stabilising oxide in batch. See **Calcia** and **Batch materials**.

Willemenite. $ZnSiO_2$. Zinc silicate. A crystalline zinc mineral occasionally used as a source of zinc oxide in glass batch.

Witherite. $BaCO_3$. Barium carbonate. A natural mineral form of barium carbonate often found in conjunction with lead. The sources are far from prolific and most of the barium carbonate used for batch purposes is now made from barium sulphate which, as the mineral barytes, is much more common.

Wired glass. Glass in which wire mesh is enclosed during the rolling process. This is thought to have been developed in the early part of the 19th century when glass began to be used increasingly for roofs and canopies. The possibilities of danger from falling objects from higher buildings became obvious and called for some suitable solution to the problem. Initial attempts suffered from the difficulty of finding a suitable metal mesh to incorporate into the sheets of glass. A form of nickel steel was found to have a suitable coefficient of expansion but unfortunately created considerable amounts of fume when introduced to the hot glass. The first attempts by Pilkingtons at St. Helens consisted of using ordinary chicken netting which had twisted joints in the wire but the amount of strain introduced into the glass led to too many failures. At the end of the century, they tried a square mesh with welded joints and a thinner gauge of wire which worked well and is now the basis of the wired glass provides today. Wired glass provides an element of safety because when it is fractured or broken the pieces of glass are held together by the wire.

Close-up of part of a wired glass sculpture showing the pockets of gas which can form along and at the overlap of the wires.

Wollastonite. $CaSiO_3$. A natural form of calcium silicate. It is not used to any extent in glassmaking because of the availability and low cost of calcia and silica.

Wood ash. Whilst wood ash is a popular component of glazes for the studio potter largely because of the subtle colour and degrees of opacity which it provides, it is now rarely used by the glassmaker. Wood ash was the traditional source of alkaline fluxes for glassmakers. It provided mainly potash with some magnesia and calcia together with a little silica in the batch. Some vegetable ashes and those from burnt seaweed have also been used as a source of soda ash. See **Batch materials**.

A few modern glassmakers have experimented with the use of wood ash in paperweights and as a surface decoration on some lampworked glass.

Woods, Wood jacks. Tools similar to pucellas but with wooden rods forming the operative parts. They are used wet to open out and to form blown glass.

Y

Yards of ale. These have been made in Britain since the 16th century and consist of a spherical chamber holding about a pint of ale with a long neck opening out to a bell-shaped end. These were traditionally about three feet or just under a metre long, hence the name. They are still very popular in the North East of England and the glass-makers are often proud of their ability to empty the glass at one swallow without spilling a drop.

Yoke. A yoke is a Y-shaped piece of metal, usually brass or bronze, fitted with two steel spheres which can rotate at the base of the 'V'. It is used as a rest for the blowing or punty iron when work is being re-heated at the glory hole. It is essential to ensure that the spheres can turn freely so that the irons can be turned without incurring any judder.

The yoke as used as a rest for blowing and punty irons at the glory hole.

Z

ZAC. Abbreviation used to describe zircon-alumina electrocast refractories.

Zaffre. A source of cobalt colourant imported from Germany.

Zinc blend. ZnS. Zinc sulphide. The main source of zinc oxide. It is often found in limestone and together with lead sulphide.

Zinc calme. A type of stained glass calme which is often used in America as an alternative to lead calme.

Zinc oxide. ZnO. A fluxing and stabilising oxide with a low expansion coefficient. When a batch seems to have a high calcia content, it is sometimes substituted by studio glassmakers for some of the calcia because it tends to make the glass easier to work. It is also used as a paint pigment known as Chinese white and as a mild antiseptic in zinc ointment.

Zirconia. ZrO_2. Zirconium oxide. Zirconium dioxide. A refractory material often used as a separator in kiln work and often introduced into several types of kiln shelves and furnace refractories. It is sometimes used as a substitute for tin oxide as an opacifier. In amounts above 8% it makes glass very viscous so its usage tends to be limited. It is used as an opacifier in enamels and it is also used as a nucleating catalyst in glass-ceramics.

Zirconia has found an increasing role in the production of refractories used in glass tanks where particularly corrosive glass is being melted. Most standard high temperature refractories have a high alumina content and as this is corroded by the action of the molten glass the alumina released tends to form stones and cords. Replacing much of the alumina with zirconia in fusion cast refractories has considerably reduced this tendency.

Zirconium oxide. ZrO_2. Zirconia. See **Zirconia**.

Zirconium silicate. $ZrSiO_4$. A highly refractory and hard mineral found in association with igneous rocks and as the gemstone zircon. It is sometimes used in place of zirconia in batch but it is increasingly used in the manufacture of furnace refractories and kiln shelves. It is harder than quartz and it is used in ball mills for grinding minerals and also as an abrasive and polishing medium on glass.

APPENDIX OF TABLES

Approximate analysis of various refractories

One of the items which tends to confuse the situation is that firebricks are generally classified by the percentage of alumina that they contain. Thus a firebrick 52 would contain 52% alumina. On the other hand high temperature insulation bricks (HTIs) are classified according to their hot face temperature in Fahrenheit. This means that an HTI 25 is designed to stand a hot face temperature of 2500°F. Unfortunately, to further confuse the issue, ceramic fibre insulation materials are classified in Europe by their hot face temperature in centigrade so a ceramic fibre board or material 1260 is designed to stand a hot face of 1260°C.

Refractory	Al_2O_3	SiO_2	TiO_2	Fe_2O_3	ZrO	Cr_2O_3	Others
42 Firebrick	42	52	1.5	2.7			1.8
52 Firebrick	52	41	1.7	3.1			2.2
AZS 33	50	15			33		1.0
AZS 41	46	12			41		1.0
AZSC	32	13			26	26	3.0
High alumina	95	1					4.0
High zirconia	1	4.5			94		0.5

Insulation refractories					
HTI 23	43	57			
HTI 26	58	42			
HTI 30	72	28			
Ceramic fibre 1260	48	52			
Ceramic fibre 1400	35	50		15	
Microtherm	2.37	64.68	31.90		1.05

Mohs' scale of hardness

1	Talc
2	Gypsum
3	Calcite
4	Fluorspar
5	Apatite
6	Orthoclase
7	Quartz
8	Topaz
9	Corundum
10	Diamond

Table of the elements

Element	Symbol	Atomic weight	Valency
Aluminium	Al	27.0	3
Antimony	Sb	121.8	3
Arsenic	As	74.9	3
Barium	Ba	137.3	2
Beryllium	Be	9.0	2
Bismuth	Bi	209.0	3
Boron	B	10.8	3
Cadmium	Cd	112.4	2
Calcium	Ca	40.1	2
Carbon	C	12.0	2 and 4
Cerium	Ce	140.1	4
Chlorine	Cl	35.5	1
Chromium	Cr	52.0	3
Cobalt	Co	58.9	2 and 3
Copper	Cu	63.5	1 and 2
Fluorine	F	19.0	1
Germanium	Ge	72.6	4
Gold	Au	197.0	–
Hydrogen	H	1.0	1
Iron	Fe	55.8	2 and 3
Lead	Pb	207.2	2 and 4
Lithium	Li	6.9	1
Magnesium	Mg	24.3	2
Manganese	Mn	54.9	2, 3 and 4
Nickel	Ni	58.7	2 and 4
Nitrogen	N	14.0	3
Oxygen	O	16.0	2
Phosphorous	P	31.0	3 and 5
Platinum	Pt	195.1	–
Potassium	K	39.1	1
Praseodymium	Pr	140.9	4
Selenium	Se	79.0	2, 4 and 6
Silicon	Si	28.1	4
Silver	Ag	107.9	1
Sodium	Na	23.0	1
Strontium	Sr	87.6	2
Sulphur	S	32.1	2 and 4
Tin	Sn	118.7	4
Titanium	Ti	47.9	4
Uranium	U	238.0	3, 4 and 5
Vanadium	V	50.9	2, 3, 4 and 5
Zinc	Zn	65.4	2
Zirconium	Zr	91.2	4

Conversion factors for raw materials

Raw material	Formula	Molecular weight	Oxides supplied	% by weight	Material to oxide	oxide to material
Alumina	Al_2O_3	102.0	Al_2O_3	100.0	1.000	1.000
Borax hydrated	$Na_2B_4O_7 10 H_2O$	381.4	B_2O_3	16.3	0.163	6.164
			Na_2O	30.8	0.308	3.247
Boric acid	H_3BO_3	61.8	B_2O_3	56.3	0.563	1.776
Sand	SiO_2	60.1	SiO_2	100.0	1.000	1.000
Barium carbonate	$BaCO_3$	197.4	BaO	77.7	0.777	1.288
Dolomite	$CaO, MgO, 2CO_2$	184.4	CaO	30.4	0.304	3.290
			MgO	21.9	0.219	4.574
Feldspar	$K_2O, Al_2O_3, 6SiO_2$	556.7	K_2O	16.9	0.169	5.910
			Al_2O_3	18.3	0.183	5.460
			$SiO2$	64.8	0.648	1.544
Limestone	$CaCO_3$	100.1	CaO	56.0	0.560	1.785
Litharge	PbO	23.2	PbO	100.0	1.000	1.000
Lithium carbonate	Li_2CO_3	73.9	Li_2O	40.4	0.404	2.473
Magnesium carbonate	$MgCO_3$	84.3	MgO	47.8	0.478	2.092
Potash	K_2CO_3	138.2	K_2O	68.2	0.682	1.467
Potassium hydrate	$(KOH)_2$	112.2	K_2O	83.9	0.839	1.191
Potassium nitrate	KNO_3	101.1	K_2O	46.6	0.466	2.147
Red lead	Pb_3O_4	685.6	PbO	97.7	0.977	1.024
Soda ash	$NaCO_3$	106.0	Na_2O	58.5	0.585	1.710
Sodium nitrate	$NaNO_3$	85.0	Na_2O	36.5	0.365	2.743
Strontium carbonate	$SrCO_3$	147.6	SrO	70.2	0.702	1.425
Zinc carbonate	$ZnCO_3$	125.4	ZnO	64.9	0.649	1.541

Refining agents

Raw material	Formula	Molecular weight	Oxides supplied	% by weight	Material to oxide	oxide to material
Ammonium nitrate	NH_4NO_3	80	decomposes			
Antimony oxide	Sb_2O_3	291.5	Sb_2O_3	100.0	1.000	1.000
White arsenic	As_2O_3	197.8	As_2O_3	116.2	1.162	0.861

Colouring materials

Raw material	Formula	Molecular weight	Oxides supplied	% by weight	Material to oxide	oxide to material
Cadmium sulphide	CdS	144.4	CdO	88.9	0.889	1.125
Cobalt oxide	Co_3O_4	240.8	CoO	93.4	0.934	1.070
Chromic oxide	Cr_2O_3	152.0	CrO_3	131.6	1.316	0.760
Chromium trioxide	CrO_3	100.0	CRO_3	76.0	0.760	1.316
Gold chloride	$AuCl_3$	303.4	Au	64.9	0.649	1.540
Manganese dioxide	MnO_2	86.9	MnO_2	Rarely contains more than 85% MnO_2.		
Nickel oxide	Ni_2O_3	165.4	NiO	90.3	0.903	1.109
Potassium chromate	K_2CrO_4	194.2	Cr_2O_3	39.1	0.391	2.555
			(CrO_3)	51.5	0.515	1.942
			K_2O	48.5	0.485	2.062
Potassium dichromate	$K_2Cr_2O_7$	294.2	CrO_3	68.0	0.680	1.471
			Cr_2O_3	51.7	0.517	1.935
			K_2O	32.0	0.320	3.122
Selenium	Se	79.0	Considerable volatile loss in founding. Usually impure.			
Silver nitrate	$AgNO_3$	169.9	Ag_2O	68.2	0.682	1.466
Vanadium oxide	V_2O_5	182.0	V_2O_5	100.0	1.000	1.000

Opacifying agents

Raw material	Formula	Molecular weight	Oxides supplied	% by weight	Material to oxide	oxide to material
Calcium flouride	CaF_2	78.1	CaO	71.8	0.178	1.392
			F_2	48.7	volatilisation loss	
Cryolite	Na_3AlF_6	210.0	Na_2O	44.3	0.443	2.258
			Al_2O_3	24.3	0.243	4.118
			F_2	54.3	volatilisation loss	
Calcium phosphate	$Ca_3(PO_4)_2$	310.2	CaO	54.2	0.542	1.844
			P_2O_5	45.8	0.458	2.185
Tin oxide	SnO_2	150.7	SnO_2	100.0	1.000	1.000
Zirconium oxide	ZrO_2	123.2	ZrO_2	100.0	1.000	1.000

Length equivalents

1 metre	=	100 centimetres	=	39.3696 inches
1 centimetre	=	10 millimetres	=	0.3937 inches
1 yard	=	3 feet	=	0.9144 metres
1 foot	=	12 inches	=	30.489 centimetres
1 inch	=	0.0833 feet	=	2.54 centimetres

Weight equivalents

1 tonne	=	1000 kg	=	2204.61 lb
1 kg	=	1000 gm	=	2.2046 lb
1 gm	=	.001 kg	=	0.0353 oz

There are differences in some of the UK (Imp.) weights and those of the USA.

1 ton	=	20 cwt		
		2240 lb (UK)	=	1016.06 kg
		2000 lb (US)	=	907.18 kg
1 cwt	=	112 lb (UK)	=	50.803 kg
		100 lb (US)	=	45.359 kg
1 lb	=	16 oz	=	453.6 g
1 oz	=	0.0625 lb	=	28.35 g

Decimal multiples and sub multiples as powers of 10

Multiple	Prefix	Symbol
10	deca	da
10^2	hecto	h
10^3	kilo	k
10^6	mega	M
10^9	giga	G
10^{12}	tera	T
10^{15}	peta	P
10^{18}	exa	E

Sub multiple	Prefix	Symbol
10^{-1}	deci	d
10^{-2}	centi	c
10^{-3}	milli	m
10^{-6}	micro	u
10^{-9}	nano	n
10^{-12}	pico	p
10^{-15}	femto	f
10^{-18}	atto	a

Metric multiples		multiply by	
P	pico	0.000 000 000 001.	1 UK billionth
n	nano	0.000 000 001.	1 UK milliardth
u	micro	0.000 001.	1 millionth
m	milli	0.001.	1 thousandth
c	centi	0.01.	1 hundredth
d	deci	0.1	1 tenth
da	deca	10	ten
h	hecto	100	one hundred
k	kilo	1.000	one thousand
my	myria	10,000	ten thousand
M	mega	1,000,000	one million
G	giga	1,000,000,000	one UK milliard
T	tera	1,000,000,000,000	one UK billion

Approximate calorific values of fuels used for studio furnaces.

Fuel	Chemical analysis		average value	amount of fuel per 1,000,000 Btu.
Electricity			3413 Btu/kW	300kWh.
Town (coal) gas	H_2	50%	550 Btu/cu. ft.	1900 cu. ft.
	CH_4	30%		
	CO	10%		
	others	10%		
Methane	CH_4	100%	990 Btu/cu. ft.	1010 cu. ft.
Natural gas	CH_4	90%	1020 Btu/cu. ft.	980 cu. ft.
	C_2H_6	10%		
LPG propane	C_2H_8	100%	2500 Btu/cu. ft.	400 cu. ft.
LPG butane	C_4H_{10}	100%	3200 Btu/cu. ft	315 cu. ft.

Units of capacity. *Relative values.*

It is essential to understand that there are differences in the volumes indicated in Imperial or United Kingdom gallons, pints and fluid ounces to those indicated by the same terms but in US measure. It should also by noted that whilst there are 8 pints in each of the US and UK gallons, there are 20 fluid ounces in the UK pint whilst there are 16 fluid ounces in the US pint.

One cubic metre	= 1000 litres or one stere
One litre	= 1000 cc
	= 0.2199 UK gallons
	= 1.7598 UK pints
	= 35.196 UK fl. ounces
	= 0.2642 US gallons
	= 2.1132 US pints
	= 33.8112 US fl. ounces
	= 61.025 cubic inches
One cubic yard	= 27 cubic feet
One cubic foot	= 1728 cubic inches
	= 28.317 litres
	= 6.237 UK gallons
	= 7.481 US gallons
One cubic inch	= 16.387 cc
	= 0.5768 UK fl. ounces
	= 0.5539 US fl. ounces
One UK gallon	= 4 UK quarts
	= 8 UK pints
	= 4.5461 litres
	= 0.1603 cubic feet
	= 1.201 US gallons
One UK pint	= 20 UK fl. ounces
	= 0.5683 litres
	= 568.5 cc
	= 1.201 US pints
	= 19.22 US fl. ounces
	= 34.677 cubic inches
One UK fl. Oz.	= 28.122 cc
	= 0.961 US fl. ounces
	= 1.734 cubic inches
One US gallon	= 8 US pints
	= 3.7853 litres
	= 0.8327 UK gallons
	= 231 cubic inches
One US pint	= 0.4732 litres
	= 473.2 cc
	= 0.8237 UK pints
	= 16.6528 UK fl. ounces
	= 28.875 cubic inches
One US fl. ounce	= 29.573 cc
	= 1.0408 UK fl. ounces
	= 1.805 cubic inches
One cc	= 0.06102 cubic inches
	= 0.0352 UK fl. ounces
	= 0.0338 US fl. ounces

Grit Sizes

There is an increasing movement, particularly in Europe, towards the use of metric measurement for indicating grain or grit sizes rather than the traditionally accepted wire mesh standard. With this in mind the following table gives an approximation of the relevant micron sizes equivalent to the standard mesh numbers.

Mesh no.	Size in microns
80	191
100	150
120	125
150	105
180	87
220	68
240	63
280	54
320	43
400	30
600	20

A micron is equal to a thousandth of a millimetre.
25 microns = one thousandth part of an inch.

Metric conversions

Grinding wheel diameters and thicknesses.

Metric (mm)	Nominal imperial inches
6	0.25
8	0.3125
10	0.375
13	0.5
16	0.625
20	0.75
25	1.00
32	1.25
40	1.5
50	2.00
57	2.25
63	2.5
80	3.00
90	3.5
100	4.00
114	4.5
125	5.00
150	6.00
180	7.00
200	8.00
230	9.00
250	10.00
300	12.00
356	14.00
406	16.00

BIBLIOGRAPHY

Beard, Geoffrey (1976), *International Modern Glass*, London: Barrie & Jenkins.

Borax Consolidated Ltd. (1965), *Glasses*, London.

British Museum (1968), *Masterpieces of Glass*, London.

Brooks, John (1975), *Glass*, Sampson Low.

Buys, S. and V. Oakley (1994), *The Conservation of Ceramics*, London: Butterworth & heineman.

Challis and Roberts (1980), *Caution*, Sunderland University.

Chandler, Maurice (1967), *Ceramics in the Modern World*, Aldus Books.

Cummings, Keith (1980), *The Techniques of Glass Forming*, London: Batsford.

Doyle, P.J. (1979), *Glassmaking Today*, Portcullis.

Flavell, R. and C. Smale (1974), *Studio Glassmaking*, Van Nostrand Reinhold.

Fournier, Robert (1978), *Electric Kiln Construction for Potters*, Van Nostrand Reinhold.

Fournier, Robert (1992), *Illustrated Dictionary of Practical Pottery*, London: A&C Black.

Fraser, Harry (1995), *The Electric Kiln*, London: A&C Black.

Gregory, Ian (1995), *Kiln Building*, London: A&C Black.

Hamer, Frank and Janet (1991), *The Potter's Dictionary*, London: A&C Black.

Haynes, Barrington (1970), *Glass Through the Ages*, Harmondsworth: Penguin.

Labino, Dominick (1966), 'The Egyptian Sand Core Technique,' *Journal of Glass Studies*, VIII.

Lewis, R.J. and G.G. Hawley (1993), *Hawley's Condensed Chemical Dictionary*, Van Nostrand Reinhold.

Lierke, R. (1993), *Glastech*, no. 12.

Matcham, Jonathan and Peter Dreiser (1982), *Glass Engraving*, London: Batsford.

McGrath, Raymond, A.C. Frost and H.L. Beckett (1961), *Glass in Architecture and Decoration*, London: The Architectural Press.

Merker, Gernot (1994), *Glasgravur in Europ*, Ostbayern, Germany: Bergbau und Industrie Museum.

Merker, Gernot (1989), *Glasschliff in Deutschland*, Ostbayern, Germany: Bergbau und Industrie Museum.

Metcalf, R. and G. Metcalf (1972), *Making Stained Glass*, David and Charles.

Newton, R.G. (1978), 'Colouring Agents used by Medieval Glassmakers,' *Journal of the Society of Glass Technology*, June.

Newton, R. G. (1980), 'Recent views on ancient glasses,' *Journal of Glass Technology*, vol. 21, no. 4.

Newton, R.G. and S. Davison (1989), *Conservation of Glass*, London: Butterworth.

Olsen, Frederick (1983), *The Kiln Book*, London: A&C Black and Pennsylvania, USA: Chilton Book Company.

Pellatt, Apsley (1849), *Curiosities of Glassmaking*, Boque.

Petrova, Sylva and Jean-Luc Olivie (1989), *Bohemian Glass*, Flammarion.

Polak, Ada (1975), *Glass. Its Makers and its Public*, London: Weidenfeld and Nicolson.

Polak, Ada (1962), *Modern Glass*, London: Faber and Faber.

Reyntiens, Patrick (1977), *The Techniques of Stained Glass*, London: Batsford.

Rhodes, Daniel (1969), *Kilns*, London: A&C Black and Pennsylvania, USA: Chilton Book Company.

Rush, James (1987), *A Beilby Odyssey*, Nelson and Saunders.

Sax, Irving (1975), *Dangerous Properties of Industrial Materials*, Van Nostrand Reinhold.

Scholes, S. R. (1935), *Modern Glass Practice*, Industrial Publications Inc.

Schuler, F. (1970), *Flameworking*, London: Pitman.

Vose, Ruth Hurst (nd), *Glass*, Connoisseur.

West-Oram, F.G. (1979), 'Raw Materials for Glassmaking,' *Journal of the Society of Glass Technology*, December.

Weyl, W.A. (1976), *Coloured Glasses*, Society of Glass Technology.

Williams Thomas, R.S. (1983), *The Crystal Years*, Stevens and Williams Ltd.

JOURNALS, PERIODICALS ETC

British Artists in Glass Bulletin, Broadfield House Glass Museum, Barnett Lane, Kingswinford, W.Midlands DY6 0QA.

The Glass Cone, Journal of the Glass Association, Broadfield House Glass Museum, Barnett Lane, Kingswinford, W.Midlands DY6 9QA

Glass Technology, The Society of Glass Technology, Thornton, 20 Hallam Gate Road, Sheffield S10 5BT.

Glass Engraver, The Guild of Glass Engravers, Unit 27D, Thames House, South Bank Business Centre, 140 Battersea Park Road, London SW11 4NB.

The Journal of the British Society of Scientific Glassblowers, 21 Grebe Avenue, Eccleston Park, St Helens, Merseyside WA10 3QL.

Neues Glas, Verlagsgesellschaft Ritterbach GmbH, PO Box 1820, D– 50208 Frechen, Germany.

La Revue de la Ceramique et du Verre, 61 Rue Marconi, 62880 Vendin–La–Vieil, France.

Glass Review. 28, Rinja 13, 11279 Praha 1, Czech Republic.

Professional Stained Glass, 245 West 29th Street, New York, NY 10001, USA.

Stained Glass, 4050 Broadway, Suite 218, Kansas City, MO 64111, USA.

'Fusion'. The Journal of the American Scientific Glassblowers Society, 1507 Hagley Road, Toledo, Ohio 43613, USA.

Glass (Journal of the European Glass Industry), International Publications, 2 Queensway, Redhill, Surrey RH1 1QS.

Crafts Magazine, 44a Pentonville Road, London N1 9BY.

American Craft, The American Crafts Council, New York.

Craft Australia, Crafts Council of Australia, 27 King Street, Sydney 2000, Australia.

Crefft, Welsh Arts Council, Museum Place, Cardiff CF1 3NX.

Publications on Health and Safety

Control of substances hazardous to health regulations (UK, 1988) Health and Safety at Work Act (UK, 1974)

BS4163 Recommendations for health and safety in workshops of schools and colleges.

BS2092. Protection of eyes regulation.

HMSO 1975. Safety in the operation of ceramic kilns.

Department of Education and Science memorandum 2/65 on the use of poisonous substances.

T. Challis and G. Roberts, *Caution. A guide to safe practice in the arts and crafts*, Sunderland Polytechnic, 1984.

Addresses

HMSO Books, Freepost, London SW8 5DR.

British Standards Institute, 2 Park Street, London W1A 2BS.

ROSPA. The Royal Society for Prevention of Accidents, Cannon House, The Priory, Queensway, Birmingham B4 6BS.

Center for Safety in the Arts, 5 Beekman Street, NY, NY 10038, USA.

Back Pain Association, Grundy House, Teddington, Middlesex TW11 8TD.

SUPPLIERS OF MATERIALS AND EQUIPMENT

Blowing irons, punty irons, bit irons etc.

Essemce Tools, S-36102 Emmaboda, Sweden.

Glassworks Equipment Ltd., Park Lane, Halesowen, Worcestershire, UK.

Kurt Merker, Postfach 1328, D93304 Kelheim, Germany.

Marine quality stainless steel is good for bit irons.

Tools, tweezers, shears etc.

Ivan Smith, Woodside, Sneads Green, Droitwich, Worcestershire, UK.

Essemce Tools, S-36102 Emmaboda, Sweden.

Kurt Merker, Postfach 1328, D93304 Kelheim, Germany.

H. Putsch & Co., Machinenfabrik, Postfach 4221, 58 Hagen, Germany.

Glassworks Equipment, Park Lane, Halesowen, Worcestershire, UK.

Marvers

Glassworks Equipment, Park Lane, Halesowen, Worcestershire, UK.

Kurt Merker, Postfach 1328, D93304 Kelheim, Germany.

These can be obtained as polished cast steel slabs from most metal suppliers.

Barrows, pigs, trees, pipe rollers, chairs, cracking off machines, linishers etc.

Glassworks Equipment, Park Lane, Halesowen, Worcestershire, UK.

Kurt Merker, Postfach 1328, D93304 Kelheim, Germany.

Essemce Tools, S-36102, Emmaboda, Sweden.

H. Putsch & Co., Machinenfabrik, Postfach 4221, 58 Hagen, Germany.

Engraving and cutting lathes

The most popular lathes are made by Spetzia and are marketed by Kurt Merker, Postfach 1328, D933 Kelheim, Germany.

Other lathes are available from:

Essemce, Postfach 36102, Emmaboda, Sweden.

Glassworks Equipment, Park Lane, Halesowen, Worcestershire, UK.

Diamond lathes are available from:

Kurt Merker, Postfach 1328, D83304 Kelheim, Germany.

Diamond Boart, Avenue du Pont de Luttre 74, B.1190 Brussels, Belgium.

Diamond saws, drills, cutting and grinding tools

Diagrit Diamond Tools, Staplehurst, Kent, England.

Habit Diamond, Roxby Place, London SW8 and Doncaster, S.Yorkshire DN5 8PU, England.

D.K. Holdings, Staplehurst, Kent TN12 0QN, England.

Diamant Boart UK Ltd., Daventry, Northants, NN11 4DX, England

Van Moppes, Gloucester, GL1 5NG, England.

De Beers, Ascot, Berks., SL5 9PX, England.

Shaw Diamonds, Waterloo Road, London, NW2 7UN, England.

Mineraux et Machines, 120 Rue de Comcelles, 75017 Paris, France.

Degame, 7 Ave. de Stinville, BP 79 94223 Charenton le Pont Cedex, France.

Denver Glass Machinery Inc., 3065 So. Umatilla Street, Englewood, Colorado, 80110, USA.

Gryphon Corporation, 101 E. Santa Anita Avenue, Burbank, California 91502, USA.

Lunzer Inc., 330 W. 42nd Street, New York, 10036, USA.

CR Loo Inc., 1085 Essex Avenue, Richmond, California 94801, USA.

Tungsten carbide tools

Carbide Tools Ltd., 68 Downsway, East Preston, Littlehampton, Sussex BN16 1AE, England.

Cintride Ltd., Ashford Road Works, Bakewell, Derbyshire DE4 1GL, England.

Silicone rubber

Ambersil, Whiting Road, Basingstoke, Hants. RG24 0WS, England.

Dow Corning Hansil Ltd., Wintersells Road, Byfleet, KT14 7LH, Surrey, England.

Electric elements and element wire for kilns

Kanthal, Box 502, 5734-01 Hallstahammar, Sweden.

Kanthal Corporation, 119 Wooster Street, PO Box 281 Bethel, Connecticut, USA.

Kanthal Ltd., 1 Sneyd Trading Estate, Sneyd Hill, Burslem, Stoke-on-Trent, ST6 2EB, England.

Kanthal GmbH., Aschaffenberger Strasse 7, Postfach 147, D-6082 Morfelden –Walldorf, Germany.

Kanthal S.A., 300 Rue Salvador Allende, B.P. No. 38, Z.I. de Colombes, F 92704 Comombes, France.

Kanthal Australia Pty Ltd., Corner O'Connor and Chiffley Streets, PO Box 9, Smithfield, NSW 2164, Australia.

Silicon carbide elements for kilns and furnaces
Kanthal Ltd., Inveralmond, Perth PH1 3EE, Scotland.

Controllers, pyrometers etc.
Eurotherm Controls, Faraday Close, Durrington, Worthing, West Sussex BN13 3PL, England.

DMG Controls, 19 Bridgewater Road, Hertburn Industrial Estate, Washington, Tyne and Wear NE37 2SG, England.

Gulton Division, Veeder Root SARL, 8 Place de la Loire, Silic 422,94583, Rungis CEDEX, France.

West Instruments, 1900 County Trail, East Greenwich, Rhode Island, 02818-0962, USA.

The Industrial Pyrometer Company, 66-76 Gooch Street, Birmingham B5 6QY, England.

Stanton Pottery Supplies, Canal Lane, Westport Lake, Tunstall, Stoke-on-Trent ST6 4NZ, England.

Warner Instruments, PO Box 604, Grand Haven, Michigan 49417, USA.

General suppliers of glass, colours and equipment for studio and stained glassworkers
Stained Glass Supplies, 41-49 Kingsland Road, London N2 8AD, England.

A. Pfann, Naarderstraat 73-75, 1211 AK Hilversum, Holland.

Bullseye Glass Co., 3722 SE 21st Avenue, Portland, Oregon 97202, USA.

Hollander Glass Co., 140 58th Street, Brooklyn, New York, NY 11220, USA.

Spectrum Glass Co. Inc., PO Box 646, Woodsville, Washington 98072, USA.

Franciscan Glass Co. Inc., 100 San Antonia Circle, Mountain View, California 94040, USA.

S. A. Bendheim Co. Inc., 61 Willet Street, Passaic, NJ 07055, USA.

Jennifer's Glassworks Inc., 4875 South Atlanta Road, Smyrna, GA 30080, USA.

Glasscutters
Shaw Abrasives, Waterloo Road, London NW2 7UN, England.

Radcliffe & Co., Horsham, W.Sussex, RH13 6EH, England.

Protective spectacles
Jencons, Cherry Court Way, Leighton Buzzard, Bedfordshire LU7 9UA, England.

Colour rods, grains and powders
Schott Glass, Drummond Road, Stafford, England.

Schott-Weisenthalhutte GmbH., D7070 Schwabisch Gmund. Perenweg 3, Postfach 1169, Germany.

Friedrich & Scheibler GmbH., 8950 Kaufbeuren-Neufgabonz Sudentenstrasse 100, Germany.

Plowden and Thompson Ltd., Dial Glassworks, Stourbridge DY8 4YN, England.

Philips Lighting BV., PO Box 150, 9670 AD Winschoten, The Netherlands.

Zimmerman Color Glass, PO Box 6, D-87656 Germaringen, Germany.

Northstar Borocolour, Suppliers of borosilicate rods and colours for lampworkers, Northstar glassworks, 9450 SW Tigard Street, Tigard, Oregon, 97223, USA and Hohlglas GmbH, Horst Geisdorf, Hamelerwalder Strasse 23, 3156, Hohenhamein, Germany.

Pelletised batch
Philips Lighting BV, PO Box 150, 9670 AD Winschoten, The Netherlands.

There is also some indication that production of batch pellets will soon begin in the Czech Republic.

Chemicals and raw materials
Glassworks Services Ltd., Unit 11, Broomhouse Lane, Edlington, Doncaster DN12 1EQ, England.

Enamels and decoration materials, oxides etc.
Johnson Matthey, Colour and Print Division, Cresswell, Stoke-on-Trent ST11 9RD, England and Postbus 23, 6200 AA Maastricht, Netherlands.

Degussa. Geschaftsbereich, D-6000, Frankfurt 1, Germany, and Paul Ungerer House, Earl Road, Stanley Green, Handforth, Wilmslow, Cheshire SK9 3RL, England.

Blythe Colours, Cresswell, Stoke-on-Trent ST11 9RD, England.

W. G. Ball, Longton Mill, Stoke-on-Trent ST3 1JW, England.

Malkin Ltd., Campbell Road, Stoke-on-Trent ST4 4ES, England.

Ferro Ltd., Wombourne, Wolverhampton WV5 8DA, England.

Ferro, PO Box 6088, 3002 AB Rotterdam, Netherlands.

Marabu (cold colours for stained glass), Marabuwerke, GmbH. D7146, Tomms, Germany.

Ceradel Socol, Limoges, Vallauric e Paris, France.

Linishers
Heathway Engineering, Featherstone Road, Wolverton Mill, Milton Keynes, MK12 6LA, England.

Kurt Merker, Postfach 1328, D93304, Kelheim, Germany.

Essemce Tools, Postfach 13602, Emmaboda, Sweden.

Lustres
Johnson Matthey, 73 Hatton Gardens, London EC1 and Cresswell, Stoke-on-Trent, ST11 9RD, England.

Heraeus, Postfach 1553, Heraeusstrasse 12-14, W6450 Hanau, Germany.

Heraeus Inc., 111 Albert Avenue, Newark, NJ 07105, USA.

Hereaus Ltd., Silica and Metals, Stoke-on-Trent, Staffs., England.

Ferro Ltd., Wombourne, Wolverhampton WV5 8DA, England.

Stained glass sheet
Hartley Wood & Co. Ltd., Portobello Road, Monkwearmouth, Sunderland, Tyne and Wear, England.

Stained Glass Supplies, 41, 49 Kingsland Road, London E2 8AD, England.

Lampworking torches

J. Young (Scientific Glassware) Ltd., 11 Colville Road, Acton, London W3 8BS, England.

European Technical Glassblowing Tools, 5 Pennswood Drive, Walmey, Sutton Coldfield, W.Midlands, England.

Glastechnische Maschinenbau und Vertriebs GmbH, Lahnswegberg 5-7D 6301 Wettenberg, Germany.

T. W. Wingent and Co., Cambridge, England.

Burners

Stordy Combustion Engineering, Heathfield Road, Wombourne, Wolverhampton WV5 8BD, England.

Stordy Combustion Engineering, Whitloofstraat 111, B-1130, Brussels, Belgium.

Stordy Combustion Engineering, Jolweg 24, 1435 ER Rijsenhout, Holland.

Stordy Industrie Feuerungstechnic GmbH., Osterbrookweg 21, 2000 Hamburg-Schenefeld, Germany.

Hotwork Developments, Dewsbury, W.Yorks. WF12 9DB, England.

Nu-Way Ltd., PO Box 1, Vines Lane, Droitwich, Worcs. WR9 8NA, England.

G. P. Burners Ltd., Doprcan, Swindon SN3 5HQ, England.

NAO (UK) PO Box 560, Ascot, Berks., England.

Birmingham Burners (Walsall Ltd.), W.Midlands WS1 3LH, England.

Perrymatic, Littlehampton, Sussex BN17 7EF, England.

White's Burners, Industry Road, Newcastle-upon-Tyne NE6 5TP, England.

Maxon Combustion Systems, Chantry House, High Street, Coleshill, Birmingham B46 3BP, England.

Maxon Corporation, PO Box 2068, Muncie, Indiana, USA.

Hotwork, PO Box 23189, Lexington, Kentucky 40523 3189, USA.

Fans for furnaces

Alldays Peacock Ltd., Moor Street, W.Bromwich B70 7AQ, England.

The Shipley Fan Company, Shipley, W.Yorks. BD17 7BA, England.

Industrial Fans Ltd., Redditch, B97 6DE, England.

Novenco Airex Ltd., Rotherham, S.Yorks, S61 3TA, England.

Secomak Ltd., Stanmore, Middlesex, HA7 1BE, England.

Kilns

Kilns and Furnaces Ltd., Keele Street, Stoke-on-Trent, Staffs. ST6 5AS, England.

Laser Kilns Ltd., 1 Coopersdale Road, London E9 6AY, England.

Fordham Thermal Systems, 37 Mildenhall Road, Fordham, Cambridgeshire, England.

D. J. Webb, Fieldfare, School Lane, Bednall, Staffs., England.

Furnaces

Small studio furnaces are being made by Sismey and Linforth of Unit 94, Hemming Road, Washford, Redditch B98 0AE, England.

Refractories

Hepworth Refractories, Genefax House, Tapton Parek Road, Sheffield S10 3FJ, England.

K.E.R. Monolithics, PO Box TR2, Leeds LS12 4UH, England.

Dyson Refractories, Stannington, Sheffield, S.Yorks., England.

G.R. Stein Refractories, Sheffield, S.Yorks. S10 3FJ, England.

Steetly Refractories, Dudley, W.Midlands DY5 4TY, England.

Burn Fireclay, Stobswood, Northumberland NE63 5PZ, England.

Parkinson and Spencer, Halifax, W.Yorks., England.

Morganite Thermal Ceramics, Neston, South Wirral L64 3RE, England.

B.T.M. Refractories Ltd., Unit 40, No.1 Industrial Estate, Medomsley Road, Consett, Co. Durham DH8 6SS, England.

Insulation materials (ceramic fibre etc.)

M. H. Dettrick Co., Ltd., Priorswood Place, East Pimbo, Skelmersdale, Lancashire WN8 9QB, England.

Carborundum Company, Accrington, Lancashire.

Cape Insulation Products, Washington, Tyne and Wear NE38 8JL, England.

Cape Industrial Products, Petershead Road, Glasgow G21 4AU, Scotland.

Micropore International, Hadzor, Droitwich WR9 7DJ, England.

Morgan Matroc Ltd., Bewdley Road, Stourport on Severn DY13 8QR, England.

Morganite Ceramic Fibres Ltd., Tebay Road, Bromborough L62 3PH, England.

Insulation bricks

A. P. Green, Refractories, Mexico, Missouri 65265, USA.

K.E.R. Monolithics, P.O. Box TR2, Whitehall Estates, Leeds LS12 4UH, England.

M. H. Dettrick Ltd., Priorswood Place, East Pimbo, Skelmersdale WN8 9QB, England.

Grinding and polishing wheels. Abrasives

The Carborundum Co. Ltd., Trafford Park, Manchester M17 1HP, England; Niagara Falls, New York, USA, and Niagara Falls, Ontario, Canada.

Universal Grinding Machine Company, Stafford, ST16 1EA, England and at One, Gibraltar Plaza, Prudention Business Campus, Horsham, Pennsylvania, USA.

D.G.A. Abrasives, 92 Dovedale Road, Ettinghall Part Farm, Wolverhampton, England.

Unicord Abrasives of Canada, 192 Pearl Street East, Brockville, Ontario.

W. Canning Materials Ltd., Birmingham B18 6AS, England.

Flat bed grinding machines

Jen Tools, 40 Haniforth Street, Hadfield SK14 8BG, England.

Kurt Merker, Postfach 1328, D-93304 Kelheim, Germany.

Essemce, Postfach 13602, Emmaboda, Sweden.

Turner Machine Tools, 63/68 Princip St., Birmingham B4 6LP, England.

Heathway Ltd., Featherstone Road, Wolverton Mill, Milton Keynes MK12 6LA, England.

Adhesives
Ciba-Geigy Plastics, Duxford, Cambridge CB2 4QA, England.

Dow Corning Hansil Ltd., Wintersells Road, Byfleet, Surrey KT14 7LH, England.

Loctite, Whitestown Industrial Estate, Tallaght, Dublin 24, Eire.

Rod, tubing and glass supplies for lampworkers
Schott Glass Ltd., Drummond Road, Stafford St16 3EL, England.

ORGANISATIONS AND SOCIETIES

British Artists in Glass, c/o Broadfield House Glass Museum, Barnett Lane, Kingswinford, West Midlands DY6 9QA.

The Glass Association, Broadfield House, Glass Museum, Barnett Lane, Kingswinford, West Midlands DY6 9QA.

The Glass Circle, The Old Rectory, Walderslade, Dover KT15 5AT.

British Society of Master Glass Painters, 11 Landsdowne Road, Muswell Hill, London N10 2AX.

Worshipful Company of Glaziers and Painters of Glass, Glaziers Hall, 9 Montague Close, London Bridge, London SE1 9DD.

British Glass Manufacturers Confederation, Northumberland Road, Sheffield S10 2UA.

The Society of Glass Technology, Thornton, 20 Hallam Gate Road, Sheffield S10 5BT.

Guild of Glass Engravers, Unit 27D, Thames House, South Bank Business Centre, 140 Battersea Park Road, London SW11 4NB.

The British Society of Scientific Glassblowers, 21 Grebe Avenue, Eccleston Park, St. Helens, Merseyside WA10 3QL.

The Crafts Councils of the various countries usually have an information service to provide addresses/telephone numbers, details etc. of artists and organisations operating within their areas.

The Crafts Council, 44A Pentonville Road, London N1 9BY, Great Britain. Tel. 0171 278 7700.

The Crafts Council of Australia, 100 George Street, Sydney, New South Wales 2000, Australia. Tel. 02 241 1701.

The Canadian Crafts Council, 46 Elgin Street, Suite 16, Ottawa, Canada K1P 5K6. Tel. 613 235 8200.

Crafts Council of Japan, 503 Yoyogi 4-28-8.Shibuya –Ku. Tokyo 151.

Crafts Council of New Zealand, 22 The Terrace, PO Box 498, Wellington 1. Tel. 044 727 018.

American Crafts Council, 40 West 53rd Street, New York, NY 14830. Tel. 212 956 5371

INT Nat. de Nouvel Objet Visuel, 27 Rue de l'Universite, F75007 Paris, France.

Artists in Stained Glass (AISG) Canada. c/o Ontario Crafts Council, 35 McCaul Street, Toronto M5T 1V7. Tel. 416 977 3511.

Districts de l'Exempio Adjunctament de Barcelona, Casa Elizaldo, Valencia 302, Spain.

The Glass Art Society Inc., PO Box 1364, Corning NY 14830, USA. Tel. 607 936 0530.

The Stained Glass Association of America, 4050 Broadway, Suite 219, Kansas City, MO 64111. Tel. 816 561 4404.

MUSEUMS AND GALLERIES

Specialist glass museums

There are several specialist glass museums indicated in the list below and whilst most of them have comprehensive collections, a few specialise in modern studio glass rather than covering a wide historical range. It must also be said that some of the large national museums such as the Victoria and Albert Museum, the British Museum etc. which cover many materials and activities have glass collections which in the overall context of the museum collection may be relatively small, but may still be much larger and of much greater significance than those of many of the specialist glass museums.

Several of the factories such as Crystalex in Novy Bor and Llobmeyr in Vienna also maintain their own glass museums but mostly these refer to their own products.

Many museums and galleries in Germany, Scandinavia and Britain are closed on Mondays whilst many of those in France and Holland close on Tuesdays.

Broadfield House Glass Museum, Compton Drive, Kingswinford, W.Midlands DY6 9QA. Tel. 01384 273011.

Situated near the centre of the historic Stourbridge glass-making district, Broadfield House focuses on locally made glass from the 19th and 20th centuries, in particular the range of coloured glass and crystal made in Stourbridge during the Victorian period. The museum however also has a good collection of glass from other parts of Britain as well as some continental pieces, and there is a growing collection of modern studio glass.

The museum provides an information service on all aspects of glass and acts as a point of contact for the Glass Association and for British Artists in Glass. There is also an excellent library and collection of archive material which can be consulted by prior arrangement.

The Corning Museum of Glass, 1 Museum Way, Corning, NY 14830-2253, USA. Tel. 607 937 5371.

This is possibly the major specialist glass museum in the world and has some 26,000 pieces including a superb collection of high quality ancient, antique and 20th century glass. It is beautifully arranged in a circular corridor to present the glass in a time scale. Seven corridors lead from this which show the evolution of the glass industry. It also holds what is reputed to be the largest library on glass in the world with some 50,000 books and 700 periodicals. It opened its purpose designed premises in 1980.

At the Steuben works nearby there is a viewing gallery where both blowing and cutting processes can be observed.

Glasmuseum, Strandvejen 8, DK8400 Ebeltoft, Denmark. Tel. 45 8634 1799.

A wonderful museum which is unique in that all the exhibits are of modern studio glass and have either been loaned or donated by artists from all over the world at the request of the founder, Finn Lynggaard. There are some 1500 pieces representing about 500 artists from 40 different nations these are being constantly revised as the artists produce new work. This means that the exhibits are of a very high standard and the number of visitors increase considerably every year. This is an exceptional museum situated in a former customs house in a small seaside resort and is supported by a voluntary committee of friends. It also has a glassworking facility in the grounds. The Glasmuseum is open daily in May, June, August and September from 10 am to 5 pm. In July it is open daily from 10 am to 5 pm and in the rest of the year it is open Monday to Saturday 1 pm to 4 pm and on Sundays from 10 am to 4 pm.

Pilkington Glass Museum, Prescott Road, St Helens, Lancs. Tel. 01744 692499.

This glass museum is located in the grounds of the head offices of Pilkington Glass at Prescott Road, St Helens and was established in 1964. It is an excellent museum which provides not only fine examples of a wide range of glass but offers a considerable amount of illustrated information on the materials, equipment and processes involved. Its aims are to show how glassmaking techniques have evolved over the years and to display the various end products including the result of much modern development. The Pilkington factory has been primarily concerned with the production of sheet and plate glass but the museum has been careful to avoid concentrating on this aspect to the exclusion of other types of production.

Centre International du Vitrail, 5 rue de Cardinal Pie, 28000 Chartres, France. Tel. 37 21 65 72.

This centre is situated in a beautiful half-timbered building and aims to develop an awareness of stained glass, particularly to artists, historians and to cultural and scientific organisations. It holds regular exhibitions, has a study and research centre together with a considerable library of books, magazines and slides in its documentation centre.

The exhibition hall is open every day from 9.30 to 12.30 and from 1.30 pm to 6.30 pm.

The documentation centre is open Monday, Tuesday, Thursday and Friday from 2 pm to 5 pm. hours.

The Glasmuseum, Sars Poteries, Northern France.

The local priest in this small town used to visit his parishioners and see examples of glass that were formerly produced in the area before the glass works closed down. He became so enthusiastic that he stopped being a priest and opened his glass museum. He has also started glass workshops which hold regular courses and as a result his collection continues to grow. At first it consisted largely of local production but, because of his conferences and courses, it now holds a fine collection of studio glass.

USA

Degenhart Paperweight and Glass Museum, P.O. Box 112, Route 22 and 1-77, Cambridge, Ohio 43725, USA. Tel. 614 432 2626.

This museum specialises in glass from the locality and in 20th century American paperweights.

The Jones Gallery of Glass and Ceramics, East Baldwin, Maine 04024, USA Tel. 207 787 3370.

Specialises in 19th and 20th century art glass and in 19th century pressed and pattern glass.

Greentown Glass Museum, P.O. Box 187, Greentown, Indiana 46936, USA. Tel. 317 628 7511.

A small historical society museum specialising in glass made by the Indiana Tumbler and Goblet Company.

Wheaton Museum of American Glass, Wheaton Village, Millville, New Jersey 08322, USA. Tel. 609 825 6800.

Specialises in the development of the American glass industry and houses a working replica of a glass factory.

The John Nelson Bergstrom Art Center and Mahler Glass Museum, 165 North Park Avenue, Neenah, Wisconsin 54956, USA. Tel. 414 722 3348.

A small museum specialising in glass paperweights and Germanic drinking vessels.

New Bedford Glass Museum, P.O. Box F-655, New Bedford, Massachusetts 02742, USA. Tel. 617 994 0115.

A small museum (2500 objects). General coverage of glass production from 1880.

National Heisey Glass Museum, 167 West Church, P.O. Box 27, Newark, Ohio 43055, USA. Tel. 614 345 2932.

Small museum (3000+ objects) produced by the Heisey Company from 1896.

Sandwich Glass Museum, P.O. Box 103, Sandwich, Massachusetts 02563, USA. Tel. 617 888 0251.

Small museum (5000+ objects) specialising in the work produced by the glass factories of Sandwich, Cape Cod.

Fenton Glass Museum, 420 Caroline Avenue, Williamstown, W. Virginia 26187, USA. Tel. 304 375 7772.

Small museum (7500 objects). Specialises in work produced by the many factories of the Ohio valley.

The Morse Gallery of Art, 133 East Wellbourne Avenue, Winter Park, Florida 32789, USA. Tel. 305 644 3686.

This houses a small specialist collection of Tiffany and Art Nouveau glass.

UK

The Turner Glass Museum, Sheffield University, Department of Materials.

The new gallery houses a varied exhibition of glass collected over many years by the late Professor Turner and then donated to the University. It consists mostly of historical pieces but does contain some modern studio glass.

Europe

Kunstsammlungen der Veste Coburg.

The Kunstsammlungen der Veste Coburg is a museum regarded with much affection by many studio glassmakers. It has an excellent collection of glass produced over many centuries but it has also established its own separate museum of modern glass which is situated in the Orangerie Schloss Rosenau about six kilometres outside Coburg. This collection has been built up selectively into what is probably the largest collection of modern glass in Germany. It organised an excellent competition, The Coburger Glass Prize, in 1977 for European studio glass with a subsequent exhibition and a similar event in 1985. The two competitions captured the imagination of studio glassmakers and brought a very good response. They also developed a considerable recognition of the nature and activities of the museum.

The Stichting National Glass Museum, Lingedyjk 28, 4142 LD Leerdam, Holland. Tel. 03451 – 12714.

The National Glassmuseum is situated near the famous Leerdam glass factories on the river Linge. It houses a large collection of 19th and 20th century glass including an important collection of Dutch glass including tableware and unique pieces from the Leerdam factory. It also organises six exhibitions every year.

Glasmuseum, Frauenau, Germany.

This is a small museum at Frauenau which is a glassmaking town in Bavaria. It has a good collection of pieces from the locality and a collection of modern studio glass which is being built up rapidly as a result of the frequent symposia and summer courses held in the town.

Glasmuseum Rheinbach, Himmeroder Wall 6, 53359 Rheinbach, Germany. Tel. 02226 14224.

The Glasmuseum Rheinbach specialises in Bohemian glass from the 17th to the 20th century. It also has a fine collection of studio glass. There is a glass school, the Staatliche Glasfachschule Rheinbach, which is situated nearby and there are several glass workshops situated in the neighbourhood. The museum is open 10-12, 2-5 Tuesdays to Fridays and from 2-5 on Saturdays and Sundays.

Glassmuseum im Wilden Mann, Passau, Germany.

Kunstmuseum Dusseldorf im Ehrenhof, Glasmuseum Hentrich, Ehrenhof 5, D-40479 Dusseldorf 30, Germany. Tel. 0211 899 2462.

This is one of the major glass collections in Europe consisting of some 6000 pieces of which 3000 are permanently on show. The Glasmuseum Hentrich, whilst being part of the Kunstmuseum is situated in its own separate premises. It covers a wide range of work but probably has the finest

collection of glass of the Art Nouveau period in the world. It has become well-known throughout the studio glass movement because of the activities of its director Dr Helmut Ricke who has been in considerable demand as an authority and consultant for many exhibitions and symposia.

Glasmuseum Immenhausen, 3524 Immenhausen, Bahnhof 3, Germany. Tel. 05673 2060.

This is a small specialist glass museum attached to a glasshouse. It is open Monday to Fridays from 9 am to 5 pm, Saturdays from 10 am to 1 pm and Sundays from 10 am to 5 pm. The glasshouse is open until 3 pm.

Musee Suisse du Vitrail, Au Chateau, CH1680 Romont, Switzerland. Tel. 037 52 10 95.

This collection consists of both old and contemporary stained glass, including church windows, paintings on glass panels and modern works of glass art. It also holds temporary exhibitions and is the home of the Swiss stained glass research and information centre. It is beautifully housed in an old Savoyard Castle and is open from 10 to 12 am and from 2 to 6 pm. From April to October it is open every day except Monday. From November to March it is only open Saturdays and Sundays.

Forderkreis Wertheimer Glasmuseum E.V., Muldenstrasse 24, 97877 Wertheim, Germany. Tel. 093 42 68 66.

The museum was founded by Dr Hans Luber, a glass physicist who was also one of those responsible for starting much of the local glass production in 1950. His aim was to communicate the nature of the various types of glass to the general public. The collection covers some 3500 years of glassmaking and includes both utilitarian and technical glasses. It also contains some modern studio glass. The Museum is open 1st April to 31st October, 10-12 and 2-6 pm Tuesday to Friday and from 10-12 noon on Saturdays.

Smalands Museum, Sodra Jarnvagsgatan 2, Box 102, S 351 04 Vaxjo, Sweden. Tel. 0470 451 45.

Smalands Museum has about 20,000 pieces ranging from the 16th century in its collection and represents about 350 years of Swedish glass history. There are examples of blown, pressed, engraved and cut glass together with glass by many 20th century artists.

Archives containing literature, production catalogues, photos etc. are available to people doing research.

The museum hopes to move to new premises soon.

Centre du Verre, Musee des Arts Decoratifs, Palais du Louvre, 107 Rue de Rivoli, 75001 Paris. Tel. 42 60 32 14.

This is a specialised part of the Musee des Arts Decoratifs in the Palais du Louvre. It has a fine collection of French glass but also covers a wide range of glass from other countries. It is gradually building up an excellent collection of work by modern artists. It has available about 4500 slides for study purposes and maintains dossiers on some 300 contemporary glass artists. It also holds a considerable library of both books and catalogues and 85 specialist periodicals. It is advisable to check the opening times for the glass gallery in advance. The glass study room and the documentation area are open every Thursday afternoon from 2 pm to 6 pm.

Museums with Glass Collections

Australia	
Melbourne	Victorian Art Museum
Perth	Art Gallery of Western Australia
Austria	
Innsbruck	Tiroler Landesmuseum
Vienna	Österreichisches Museum für Angewand Kunst
	J & L Llobmeyr, Works Museum
Belgium	
Charleroi	Musee du Verre
Liege	Musee du Verre
Canada	
Ottawa	Museum of Man
Quebec	Musee du Quebec
Toronto	Royal Ontario Museum
Czech Republic	
Hradec Kraliove	Regional Museum
Liberec	North Bohemian Museum
Jablonec and Nison	Museum of Glass & Jewellery
Kasperske Hory	Sumava Museum
Novy Bor	Glasmuseum
Prague	Museum of Decorative Arts, Prague
	National Gallery, Prague
Denmark	
Ebeltoft	The Glass Museum, Ebeltoft
Eire	
Dublin	The National Museum of Ireland.
Finland	
Rihimaki	The Finnish Glass Museum (Suomen Lasimuseo) Tehtaankatu 23, 11910 Rihimaki. Tel. (9) 14 741494.

The museum is closed on Mondays and throughout January. There is a permanent display of 300 years of Finnish glass. The museum also arranges special exhibitions of Finnish and international glass. The museum building is an old glass factory which was re-designed by Tapio Wirkkala.

France	
Chartres	Centre International du Vitrail. 5, Rue de Cardinal Pie Chartres. Tel. 37 21 65 72. The museum is open every day from 9.30 to 12.30 and from 1.30 to 6.30.

In addition to the exhibition centre there is also a research facility and a centre of documentation.

Paris	Musee des Arts Decoratifs. Centre du Verre

Rouen | Musee des Beaux Arts

Germany
Arnstadt | Museum der Stadt
Berlin | Markisches Museum
| Kunstegewerbe Museum Schloss Kopenick
Coburg | Kunstsammlung der Veste Coburg
Darmstadt | Hessiches landesmuseum
Dresden | Staatliche Kunstsammlung Grunes Gewolbe
| Museum für Kunsthandwerk, Schloss Pilnitz
Dusseldorf | Kunstmuseum Düsseldorf in Ehrenhof
Frankfurt | Museum für Kunsthandwerk
Halle | Staatliche Galerie Moritzburg
Hamburg | Museum für Kunsthandwerk
Karlsruhr | Badisches Landesmuseum
Kassel | Staatliche Kunstammlungen
Koln (Cologne) | Kunstgewerbe Museum
| Romisch Germanische Museum
Leipzig | Museum Des Kunsthandwerks Grassimuseum
Munchen (Munich) | Bayerisches National Museum
Nuremburg | Germanisches Nationalmuseum
Regensburg | Museum der Stadt Regensburg
Rheinbach | Glasmuseum and Glass school
Trier | Rheinisches Landesmuseum
Weimar | Kunstammlung (Schloss)

Holland
Amsterdam | Rijksmuseum
| Stedlijk Museum
Den Haag | Gemente Museum
Leeredam | National Glass Museum
Rotterdam | Museum, Boymans van Beuningen

Hungary
Budapest | Muzeul de Arta

Italy
Milan | Musee Civic Archeologico
Murano | Musee Vetrario
Venice | Treasury, St Marks Cathedral

Japan
Kyoto | Museum of Modern Art
Sapporo | Hokkaido Museum of Modern Art
Tokyo | National Museum of Modern Art

Russia
Leningrad | The Hermitage Museum
Moscow | The Pushkin Museum

Slovakia
Kamenicky Senov | Municipal Museum
| Glass School
Zeledny Brod | Municipal Museum
| Glas skolen

Sweden
Stockholm | The National Museum
Vaxjo | Smolands Glasmuseum

Switzerland
Lausanne | Musee Des Arts Decoratifs
Geneva | Musee Ariana
Zurich | Kunstgbewerbmuseum
| Museum Bellerive

USA
Anchorage | Museum of Fine Arts of Alaska
Arizon | The Bead Museum
Atlanta | High Museum of Art, 1280 Peachtree Street
Belleview | Bellevue Art Museum, 301 Bellevue Square
Chicago | Art Institute of Chicago, Michigan Avenue
Cincinnati | Cincinnati Art Museum
Cleveland | Cleveland Museum of Art, 11150 East Blvd.
Corning | The Corning Museum of Glass, 1 Museum Way
Detroit | Detroit Institute of Arts, 5200 Woodward Avenue
Douglas Hill | The Jones Museum of Glass and Ceramics
Huntington | Huntington Museum of Arts, Park Hills
Indianapolis | Indianapolis Museum of Art, 1200 W.38th Street
Los Angeles | Museum of Decorative Arts, 5905 Wilshire Blvd.
Neenah | Berstrom-Mahler Museum, 165 N. Park Avenue
New York | The American Craft Museum, 40 W. 53rd Street
| The Cooper Hewitt Museum, 2 East 91st Street
Norfolk | The Chrysler Museum, 245 West Olney Road
Oakland | The Oakland Museum, 1000 Oak Street
Providence | Museum of Art, Rhode Island School of Design, 224 Benefit Street, Rhode Island
Richmond | Virginia Museum of Fine Arts, Boulevard Avenue
Seattle | Seattle Art Museum, Volunteer Park
Toledo | The Toledo Museum of Arts, Box 1013
Washington | National Museum of American Art, Smithsonian Institution
Wausau | Leigh Yawkey Woodson Art Museum

Museums with glass collections in Great Britain
Accrington | The Haworth Art Gallery (Small collection of Tiffany glass)

Bath	The Assembly Rooms		The Science Museum, South Kensington
	Victoria Art Gallery		
Bedford	Cecil Higgins Gallery		The London Museum
Belfast	The Ulster Museum, Botanic Gardens, Belfast		The Wallace Collection
			The William Morris Art Gallery, Walthamstow
Cambridge	The Fitzwilliam Museum		
Cardiff	The National Museum of Wales	Manchester	The City Art Gallery, Mosely Street, Manchester
Durham	The Bowes Museum		
Edinburgh	The Royal Scottish Museum	Newcastle	The Laing Art Gallery, Higham Place, Newcastle upon Tyne
Ely	Stained Glass Museum		
Gateshead	The Shipley Art Gallery, Prince Consort Road, Gateshead, Tyne and Wear	Oxford	The Ashmolean Museum
		Sheffield	The City Museum
			The Ruskin Museum, Norfolk Street, Sheffield S1 2JE
Glasgow	The Kelvingrove Museum and Art Gallery		
	The Burrell Collection (Stained Glass)	Sunderland	City Art Gallery and Museum
		Warrington	The Warrington Museum and Art Gallery
Leicester	Leicester Museum		
London	The British Museum		
	The Victoria and Albert Museum, South Kensington		

There is a small museum dedicated to glass marbles at Teign Valley Glass, Bovey Tracey, Devon TQ13 9DS.

SCHOOLS AND COLLEGES
OFFERING COURSES IN GLASS

The courses available vary considerably in both aims and content. Some are essentially industry-orientated and often reflect the traditions of the locality in which they are based. Some are courses which lead to a degree in three-dimensional design, fine art or some similar qualification but have a major emphasis on glass, whilst others are concerned simply with providing what is largely practical experience in glassworking for those who enjoy the process or wish to gain sufficient knowledge and skill to open a studio or workshop without studying to obtain academic qualifications.

There are also many other courses available which lead to qualifications in glass technology but, whilst glass technology is extremely useful, this study is not likely to be seen as a major route towards small workshop production.

Some of the schools and colleges offering a major emphasis on one type of course will often provide others. For example, several colleges offering specialist three or four year degree courses may also run courses at a lower level and/or summer schools which are designed purely to provide enjoyment and are non-vocational.

Prospective students, particularly those looking for a suitable degree or vocational course, are strongly advised to obtain a prospectus, research the college, school or university thoroughly, making a visit if possible, before applying for admission. The standard and the nature of the courses offered changes very quickly and a venue which has enjoyed an excellent reputation for many years can decline considerably because of the movement of key staff or because of administrative problems. Administrators are often forced into becoming increasingly concerned with monetary matters rather than with high academic standards and the suitability of the education provided.

The names attributed to educational establishments can also be confusing as these can have different meanings from one country to another and may even differ within a single country. 'University' is a reasonably standard term for a place of learning which offers courses leading to degree or postgraduate qualifications. In many countries, the word 'Academy' refers to an establishment with similar aims. Both 'College' and 'School' vary considerably in meaning. In Britain, a university can have several 'colleges' which usually offer residential and administrative bases for the students. It can also have a 'School' of Art or Design in which the actual teaching process is carried out.

A College of Art or a Technical College, existing entirely separately from a university may be an establishment offering only low level courses. On the other hand, it may also, whilst not being formerly associated with a university, offer

degree level courses and, as in the case of the Royal College of Art in London, operate solely at postgraduate level. This breadth of meaning for similar words is common in other countries and can be very confusing to the prospective student, particularly when seeking the opportunity to study abroad.

In Britain there are several colleges offering degree courses and one which specialises in industrial and practical activities. They are:

Edinburgh College of Art, (Heriot Watt University), Lauriston Place, Edinburgh, Scotland. Tel. 0131 229 9311.

Sunderland University, Faculty of Art and Design, Backhouse Park, Ryhope Road, Sunderland, Tyne and Wear. Tel. 0191 5152000.

Wolverhampton University, Glass Dept., Molineux Street, Wolverhampton WV1 1SB. Tel. 01902 313002.

Manchester Metropolitan University, Dept. of 3D Design, Victoria Building, Cavendish Street, Manchester M15 6BR. Tel. 0161 247 2000.

De Montfort University, Glass Dept., PO Box 143, Leicester LE1 9BH. Tel. 01533 551551.

West Surrey College of Art and Design, Faulkner Road, The Hart, Farnham, Surrey GU9 7DS. Tel. 01252 722441.

University of Central England in Birmingham (UCEB), Ceramics with Glass Dept., Corporation Street, Birmingham B4 7DX. Tel. 0121 331 5819.

University of Central Lancashire, Glass Dept., Victoria Building, Preston, PR1 9BH. Tel. 01772 201201.

Middlesex University, Faculty of Art and Design, Cat Hill, Barnet, Herts. EN4 8HT. Tel. 0181 368 1299.

Staffordshire University, College Road, Stoke on Trent, Staffs. ST4 2DE. Tel. 01782 744035.

Buckinghamshire College of Brunel University, Glass and Ceramics Dept., Queen Alexandra Road, High Wycombe, Bucks. HP11 2JZ. Tel. 01494 450951.

The Royal College of Art, Department of Ceramics and Glass, Kensington Gore, London SW7 2EU. Tel. 0171 584 5020. (Offers postgraduate courses in both ceramics and glass.)

The following colleges offer specialist courses in architectural glass:

Chelsea School of Art, Manresa Road, London SW3 6LS. Tel. 0181 749 3236.

West Glamorgan Institute of Higher Education, Architectural Glass Dept., School of Art, Alexandra Road, Swansea SA1 5DU. Tel. 01792 203482.

Clwyd College of Art, Design and Technology, Grove Park, Wrexham, Clwyd LL12 7AA. Tel. 01978 291955.

The college which offers various practical rather than academic courses in glass is:

Brierley Hill International Glass Centre, Moor Street, Brierley Hill, West Midlands DY5 3EP. Tel. 01384 455433 Ext. 267.

Several glass artists in Britain have completed their courses at one of the universities and have then taken a further course at Brierley Hill or at the Orrefors-Kosta Glass School in order to improve their practical skills before setting out into the studio glass world.

Many academic courses, particularly those in the USA, have been organised on a modular basis. This means that they tend to provide studies in various subject blocks and offer the opportunity for students either to specialise completely in one area or to obtain a series of qualifications, often called 'Credits' in a broader range of areas. Critics of the system suggest that it requires much more administration and raises difficulties for the teaching staff. It is also said that there may not be sufficient depth in the various areas to provide what might be necessary to pursue a career. Much of this criticism can be refuted to some extent if the various areas are sufficiently related. For instance, a module of painting or fine art could be particularly useful for somebody wishing to study stained glass as a main area. Studies in design or sculpture would obviously be useful to students wishing to take glass as their main subject.

One aspect of this system is that in the USA it has become possible to obtain a credit in one college and to use this in conjunction with qualifications from another. It seems likely that as many other countries are organising courses on similar lines, it could be possible in the future to obtain these credits from a wider range of establishments.

A selection of colleges and universities offering glass courses in the USA is:

Anderson University Glass Program, 1100 E. Fifth Street, Anderson, IN 46012.
The Tyler School of Art, Temple University, Beech and West Penrose, PO Box 233, Elkins Park, Pennsylvania, PA 19126.
Massachusetts College of Art, 621 Huntington Avenue, Boston, MA 02115.
Rhode Island School of Design, 2 College Street, Providence, RI 02903.
California College of Arts and Crafts, Oakland, CA 94618.
California Polytechnic State University, Glass Program, St. Luis Obispo, CA 93407.
California State University, Glass Program, 1250 Bellflower Boulevard, Long Beach, CA 90840.
Cleveland State University, Glass Program, Cleveland, OH 44115.
Illinois State University, Normal, IL 61761.
University of Hawaii, Department of Art, 2533 The Mall, Honolulu, HI 96822.
University of Illinois, Urbana/ Champaign, IL 61802.
New York University, N.Y.E.G.W., 647 Fulton Street, Brooklyn, NY 11217.

Ohio State University, Glass Program, 146 Hopkins, 128 North Oval, Columbus, OH 43210.
University of Wisconsin, River Falls, WI 54022.

In addition there are specialist glass schools which provide mostly non-academic courses but which may also provide the possibility for students to gain credits towards a degree from one of the universities. It would be essential for people requiring such credits to ensure that they are available before embarking on such a course. These are:

Pilchuck Glass School, 107 South Main Street, Seattle, USA 98104.
Penland School of Crafts, Penland, NC 28765.
Haystack Mountain School of Crafts, P.O. Box 87GL, Deer Isle, Maine 04627.
Camp Colton Glass Program, Camp Colton, HWY 211 Colton, OR 97017.
Summervail Workshop, P.O. Box 117, Minturn, Colorado 81645.
New York Experimental Glass Workshop, 647 Fulton Street, 3rd Floor, Brooklyn, NY 11217.

Australia
Caulfield Institute of Technology, Caulfield East, VIC 3145.
Royal Melbourne Institute of Technology, Latrobe Street, Melbourne, VIC 3000.
Sydney College of the Arts, PO Box 226, Glebe, NSW 2037.
Canberra School of Art, P.O. Box 1561, Acton 2601.

Austria
Glasfachschule, Kramsach, 6233 Kramsach, Tyrol.
Hochschule für Angewandte Kunste, Kopal Platz 2, Vienna 110.

Belgium
Mutsaertstraat Academie, Koninklijke. 2000 Antwerp.
The National Higher Institute and Royal Academy of Fine Arts, Antwerp. (Glass painting only)
The Institute for Artistic Crafts (IKA), Goswin de Stassartstraat 98, 2800 Mechelen. (Hot and cold working)
St Lucas Institute, Ghent.

Canada
Alberta College of Art, Calgary, Alberta.
Centre Des Metiers Du Verre, 1200 Rue Mill, Montreal QUE H3K 2B3.
Ontario College of Art, Toronto ONT M5T 1W1.
Sheridan College, SOCAD, 1430 Trafalgar Road, Oakville, Ontario ONT L6H 2L1.
University Du Quebec, 7815 Des Fresnes, Trois Revieres, Quebec G8Y 1E2.

Czech Republic
There are several glass schools in the Czech Republic but some of them such as those at Novy Bor are attached to factories and may not be available at this time to external students or to the general public.

Vysoka Skola Umlecko Prumyslova. Nam Krasnoarmejcu 80. Praha 1. (This is the famous 'UMPRUM' at which Stanislav Libensky was professor for many years.)

The Secondary School of Glass making, Novy Bor.

Denmark

The Danish Design School, Stransbouleuarden 47, 20100 Copenhagen.

Eire

Glass Department, National College of Art and Design, Kildare Street, Dublin 2.

Finland

Commercial Institute for Industrial Arts, Helsinki.

France

L'Atelier Verre de l'Ecole des Arts Decoratifs de Strasbourg, 1, Rue de Academie, Strasbourg 67000. Tel. 88 35 38 58. Fax 88 36 29 58.

CIRVA (Centre Internationale de Recherche du Verre et Arts Plastiques) 62 Rue de la Joliette, Marseille 13002. Tel. 91 56 11 50 Fax 91 91 11 04.

Centre Internationale du Vitrail, 5 Rue de Cardinal Pie, Chartres, France. (Occasional courses relating to stained glass.) Tel. 37 21 65 72 Fax 37 36 15 34.

Musee-Atelier du Verre. Post box 2. 59216 Sars Poteries, France-Nord. (Summer schools only.) Tel. 27 61 61 44. Fax 27 61 65 64.

La Plate–Forme Verriere, Vannes le Chatel 54112. Tel. 83 25 47 38 Fax 83 25 46 08.

Germany

Erwin-Stein-Schule, Staatliche Glasfachschule Hadamar, Mainzer Landstrasse, D65589 Hadamar. Tel. 49 6433 2001. Fax 49 6433 6627.

Staatliche Glasfachschule Rheinbach. Zentrum für Glass-Keramik-Grafik, Zu den Fichten 19, D53359 Rheinbach. Tel. 49 2226 4425 Fax 49 2226 17051.

Staatliche Akademie der Bildenden Kunste. Am Weissenhof. D 70191 Stuttgart. Tel. 49 711 25750 Fax 49 711 2575225.

Staatliches Berufsbildungszentrum für Glas Zwiesel, Fachschule-Berufsfachschule-Berufsschule, Fachschul Strasse 15-19, D94227 Zwiesel. Tel. 49 9922 2053 Fax 49 9922 6977. (This is currently the only school in Germany with hot glass facilities).

Bild-Werk Frauenau, D94258 Frauenau. Bavaria. Tel. 49 9926 1759. (Summer school only)

Holland

The Gerrit Rietveld Academie, Frederick Roeskestraat 96, Amsterdam. (Famous glass school developed by Sybren Valkema.)

Hungary

The Hungarian High School for Applied Arts, Glass Section, Budapest.

Italy

Conservatorio Europeo Di Artie, Via Saccina 7, 00184 Roma.

Japan

Aichi University of Education, Aichi-Ken. 448.

Niijima Art Centre, 122 Setayama Niijima, Tokyo 10004.

Swedish Centre, Tokubetsu-cho, 2-3-1 Swedish Hills, Villshikari-gun, Hokkaido 061 37.

Tama Art University, 1732 Yarimizu, Hachioji, Tokyo 192 03.

Toyama City Institute of Glass Art, 80 Nishikanaya, Toyama-shi, Toyama-ken, 930 01.

Tokyo Glass Art Institute. 333-1, Ichinotsubo Nakahari-ku, Kanagawa.

Norway

Statens Handverks og Kunstindustri Skole (SHKS), Ullevalsveien 5, Oslo 1.

Poland

Higher School of Fine Art, Glass Section, Wroclaw.

Rumania

Nicolai Grigorescu Institute of Fine Arts, Glass Section.

Russia

Academy of Creative Arts, Moscow.

Slovakia

The school at Zeledny Brod has offered summer school courses and it is likely that other schools will follow this example.

The Secondary School of Glass making, Zeledny Brod.

The Secondary School of Glass making, Kamenicky Senov.

The Academy of Creative Arts, Bratislava.

Spain

Centre del Vidre de Barcelona, Comptes de Bell-lloc 192, 08042 Barcelona.

Sweden

Orrefors-Kosta Glaskolen, Box 500, 382 00 Nybro.

Konstfachskolen, HKS Box 27116, 10252 Stockholm.